Encounters in Video Art
in Latin America

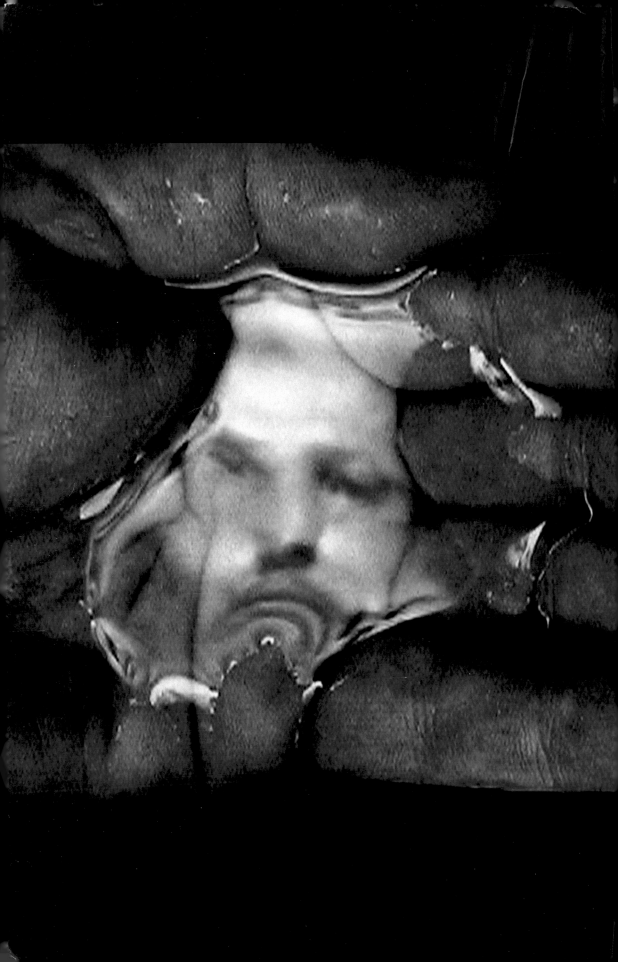

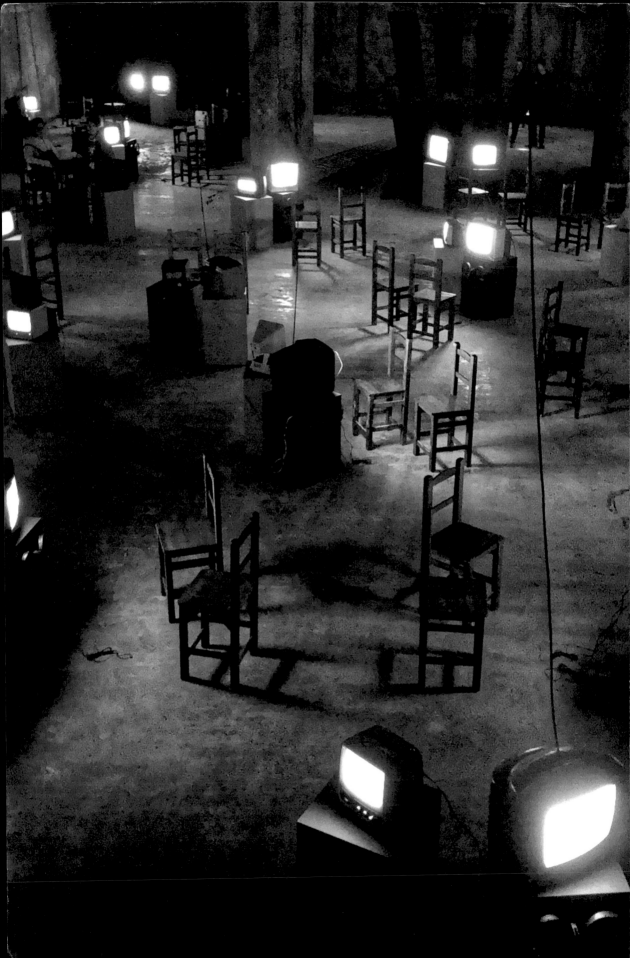

Encounters in Video Art in Latin America

EDITED BY ELENA SHTROMBERG
AND GLENN PHILLIPS

Getty Research Institute
Los Angeles

Getty Research Institute Publications Program
Mary E. Miller, *Director, Getty Research Institute*

© 2023 J. Paul Getty Trust

**Published by the Getty Research Institute,
Los Angeles**
Getty Publications
1200 Getty Center Drive, Suite 500
Los Angeles, California 90049-1682
getty.edu/publications

Laura Santiago, *Editor*
Jim Drobka, *Designer*
Victoria Gallina, *Production*
Karen Ehrmann and Adriana del Moral, *Image
and Rights Acquisition*

Distributed in the United States and Canada
by the University of Chicago Press

Distributed outside the United States and Canada
by Yale University Press, London

Printed in China

Library of Congress Cataloging-in-Publication Data
Names: Shtromberg, Elena, editor. | Phillips, Glenn,
 editor. | Getty Research Institute, issuing body.
Title: Encounters in video art in Latin America /
 edited by Elena Shtromberg and Glenn Phillips.
Other titles: Issues & debates.
Description: Los Angeles : Getty Research Institute,
 [2023] | Series: Issues & debates | Includes bibli-
 ographical references and index. | Summary: "With
 engaging essays and insightful interviews, this
 volume examines how artists have experimented
 with the medium of video across different regions
 of Latin America since the 1960s"— Provided by
 publisher.
Identifiers: LCCN 2022019877 (print) | LCCN
 2022019878 (ebook) | ISBN 9781606067918 (paper-
 back) | ISBN 9781606067925 (adobe pdf)
Subjects: LCSH: Video art—Latin America. | Art, Latin
 American—20th century. | Art, Latin American—21st
 century.
Classification: LCC N6502.57.V53 E53 2023 (print) |
 LCC N6502.57.V53 (ebook) | DDC 777.098—dc23
 /eng/20220709
LC record available at https://lccn.loc
 .gov/2022019877
LC ebook record available at https://lccn.loc
 .gov/2022019878

Cover: Videotape titled *Archivos X: Cronología de
video arte en México, 1977–2009* (detail), from Ximena
Cuevas's collection. See p. 145.
p. ii: Oscar Muñoz (Colombian, b. 1951). Video still
from *Línea del destino* (detail), 2006. See p. 189.
p. iii: Installation view of the *Wenu Pelón* exhibition
at the Museo Arqueológico de Santiago (detail),
2015–20. See p. 207.
Frontispiece: Installation view of the *Retro Visión
Espectral: Aproximaciones a una historia del videoarte
en Colombia* exhibition at the Museo de Antioquia,
Medellín (detail), 2019. See p. 103.

Every effort has been made to contact the owners and
photographers of illustrations reproduced here whose
names do not appear in the captions or in the illustra-
tion credits at the back of this book. Anyone having
further information concerning copyright holders is
asked to contact Getty Publications so this informa-
tion can be included in future printings.

Contents

ix Acknowledgments

1 **Introduction**
Elena Shtromberg and Glenn Phillips

SECTION 1: ENCOUNTERS

15 **Encounters: CAYC and the International Encuentros**
Glenn Phillips and Sophia Serrano

82 **Photo Essay**

SECTION 2: NETWORKS AND ARCHIVES

91 **Imagined Video Archives: Strategies and Conditions of Video Art Collections in Latin America**
José-Carlos Mariátegui

110 **La portapak en Latinoamérica: The Gendering of Video Art in Argentina, Brazil, Chile, Colombia, and Mexico**
Gabriela Aceves Sepúlveda

134 **Video: A Laboratory for Experimentation**
Interview with Ximena Cuevas

SECTION 3: MEMORY AND CRISIS

149 **Memory and Forgetting in Video Art from Latin America**
Elena Shtromberg

163 **Festival Franco-Chileno de Video Arte: A Space of Resistance under Dictatorship and Expansion in Democracy**
Sebastián Vidal Valenzuela

181 **A Threshold of Suspension**
Oscar Muñoz

SECTION 4: INDIGENOUS PERSPECTIVES

195 **The Image before the Image**
Francisco Huichaqueo in collaboration with Juan Juenan

209 **Handing Over the Camera: Two Episodes in Video Art and Anthropology**
Benjamin O. Murphy

227 **Reflections on Vídeo nas Aldeias**
Interview with Vincent Carelli

246 Bibliography
264 Contributors
265 Illustration Credits
266 Index

Acknowledgments

At its core, video art from any geographic region is an art of telling stories through an electronic medium, first analog, then digital. It is therefore an impossible task to be thorough or complete in acknowledging the many voices that led us to the artists we contacted and corresponded with; the critics whose texts helped us understand the aesthetic, scholarly, and cultural roles that video played in specific contexts; and the curators who had been tireless in not only recognizing but also championing artists, even when they did not command popular success. We began in 2012 and it is only now, ten years later, after multiple screenings, a survey exhibition titled *Video Art in Latin America* (LAXART, 2017), and this book, that the project comes to some sort of culmination. It was never our intention to tell "The" story of video art in any comprehensive way but rather to show the multiplicity of stories that coexist in Latin America and elsewhere, providing a kind of map for others to expand and clarify with their own investigations. During this decade, we have met with hundreds of people who facilitated this work—and without whom the different phases of this project would not have been possible.

Two extraordinary research assistants, Audrey Young and Sophia Serrano, deserve special mention for their tireless efforts to see this project through. Others at the Getty Research Institute (GRI), including Samantha Gregg, Sue Kang, and Jennifer Park, provided complex and essential logistical and organizational support for our workshop, screenings, and research activities. The GRI's former director, Thomas Gaehtgens, along with deputy director Andrew Perchuk and head of research projects Rebecca Peabody, provided continual support for this project as it grew in scope and ambition. The research and planning stages were significantly supported through travel and research grants from the University of Utah's Department of Art and Art History, the

College of Fine Arts, the University Research Committee, and the Center for Latin American Studies. A workshop held at the GRI in 2016 helped shape this project, and participants offered crucial advice: Rodrigo Alonso, Ernesto Calvo, Gilles Charalambos, Solange Farkas, Alanna Lockward, José-Carlos Mariátegui, Enrique Rivera, and Erandy Vergara. Also helpful were conversations with Barbara London and our consultation of the video collection at the Colección Patricia Phelps de Cisneros facilitated by Gabriel Pérez-Barreiro, director and chief curator. We are extremely grateful to the founder and former director of LAXART, Lauri Firstenberg, and the current director, Hamza Walker, and deputy director, Catherine Taft, for hosting and supporting the exhibition at LAXART in 2017. Thank you to Peter Kirby for his work editing videos for screenings. The show was presented as part of Pacific Standard Time: LA/LA, a series of more than seventy exhibitions celebrating Latin American and Latinx art across Southern California in 2017, supported by the Getty Foundation.

At GRI Publications, we would like to thank Gail Feigenbaum and Michele Ciaccio for supporting this book proposal. Laura Santiago edited the manuscript with an extremely sharp eye for details, improving the manuscript at every stage. We also send our appreciation to Jim Drobka, who designed the book, and Victoria Gallina, who coordinated the book's production. Thank you to all the contributors to this book, who shared their unique perspectives on the history of video art in Latin America: Gabriela Aceves Sepúlveda, Vincent Carelli, Ximena Cuevas, Francisco Huichaqueo with Juan Juenan, José-Carlos Mariátegui, Oscar Muñoz, Benjamin O. Murphy, and Sebastian Vidal Valenzuela. We would also like to thank the anonymous peer reviewers for their work on the early drafts of the proposal and manuscript.

Throughout this project, whether traveling in person or corresponding from a distance, we have benefited tremendously from the generosity of artists, curators, critics, and archivists who have been willing to share their knowledge and recollections of the history and impact of video art on artistic communities throughout Latin America. Though we cannot include every person who has influenced our research, what follows is a partial list of those we met either in their country of origin or elsewhere in our journey and to whom we wish to offer our thanks. We apologize for overlooking anyone who has played a pivotal role along the way.

Argentina: Rodrigo Alonso, Andrés Denegri, Gastón Duprat, Sabrina Farji, Sara Fried, Gabriela Golder, Jorge La Ferla, Diego Lascano, Marta Minujín, Charly Nijensohn, Agustín Pérez Rubio, Ricardo Pons, Graciela Taquini, Carlos Trilnick

Bolivia: Alejandra Alarcón, Narda Alvarado, Rodrigo Bellott, Sandra de Berduccy, Julio González Sanchez, Gaston Ugalde

Brazil: Sonia Andrade, Lucas Bambozzi, Julia Brito, Paulo Bruscky, Vincent Carelli, Lia Chaia, Marcos Chaves, Analívia Cordeiro, Eduardo de Jesus, Mauricio Dias and Walter Riedweg, Solange Farkas, Anna Bella Geiger, Cao Guimarães, Tadeu Jungle, Lucia Koch, Maria Laet, Laura Lima, Pablo Lobato, Ruy Luduvice, Cinthia Marcelle, Musa Michelle Mattiuzzi, Paulo Meira, Marta Mestre, Gisela Motta and Leandro Lima, Rodrigo Moura, Guilherme Peters, Berna Reale, Rosângela Rennó, Marília Andrés Ribeiro, Daniel Roesler, Eder Santos, Cristiana Tejo

Chile: Claudia Aravena Abughosh, Paul Birke, Sybil Brintrup, Paula Honorato Crespo, Paz Errázuriz, Carlos Flores Delpino, Juan Forch, Soledad García, Jesús Monteagudo Guerra, Francisco Huichaqueo, Germán Liñero, Justo Pastor Mellado, Gonzalo Mezza, Néstor Olhagaray, Gonzalo Pedraza, Enrique Ramírez, Nelly Richard, Enrique Rivera, Lotty Rosenfeld

Colombia: Omaira Abadia, Gilles Charalambos, Colectivo Zunga, Juan Manuel Echavarría, Andrés García La Rota, Helena Producciones, Jorge Jaramillo, Mariana Jurado Rico, Andrés Matute, Oscar Muñoz, José Alejandro Restrepo, Sofía Suárez, Liliana Vélez, Tatyana Zambrano

Costa Rica: Jorge Alban, Ernesto Calvo, Javier Calvo, Maria José Chavarría, Marco Guevara, Habacuc, Federico Herrero, Edgar León, Priscilla Monge, Fiorella Resenterra, Marton Robinson, Gabriela Sáenz-Shelby, Antonieta Sibaja, Manuel Zumbado

Cuba: Tania Bruguera, Sandra Ceballos and Elizabet Cerviño, Humberto Díaz, Felipe Dulzaides, Frency Fernández, Jorge Fernández, Luis Gárciga, Glenda León, Luisa Marisy, Adrián Melis, Dalcysi Moya, Lázaro Saavedra

Dominican Republic: Joiri Minaya

Ecuador: Adrián Balseca, Cynthia Bodenhorst, Saskia Calderón, Karina Cortez, Jenny Jaramillo, Fabiano Kueva, Paulina León, María Belén Moncayo, Patricio Palomeque, Gabriela Rivadeneira, Ana Rodríguez, Unidad Pelota Cuadrada, Pancho Viñachi, Cristóbal Zapata

El Salvador: Ronald Morán

Guatemala: Regina José Galindo, Sandra Monterroso

Honduras: Pável Aguilar, Adán Vallecillo

Mexico: Mauricio Alejo, Magalí Arriola, Tania Candiani, Raúl Cordero, Daniel Monroy Cuevas, Ximena Cuevas, Mario García Torres, Sol Henaro, Karla Jasso, Fernando Llanos, Pancho López, Mónica Mayer, Cuauhtémoc Medina, Yoshua Okón, Gilberto Pérez, Marta María Pérez Bravo, Grace Quintanilla, Teresa Serrano

Nicaragua: Jessica Lagunas

Panama: Brooke Alfaro, José Castrellón, Maria Raquel Cochez, Donna Conlon and Jonathan Harker, Orlando Hernández Ying, Pilar Moreno, Johann Wolfschoon

Paraguay: Erika Meza and Javier Lopez, Joaquín Sánchez

Peru: Gabriel Acevedo, Mabel Allain, Castor Andino, Karen Bernedo, Angie Bonino, Patricia Bueno, Tania Castro, Ángela Delgado Valdivia, El Galpón Espacio, Rafael Hastings, Cristian Alarcón Ismodes, Diego Lama, Sharon Lerner, Miguel López, Natalia Majluf, José-Carlos Mariátegui, Jerry B. Martin, Marco Pando, Antonio Paucar, Juan Javier Salazar, Emilio Santisteban, Elena Tejada-Herrera, Jorge Villacorta, Eduardo Villanes, Maya Watanabe, David Zink Yi

Puerto Rico: Javier Bosques, Elvis Fuentes, Karlo Andrei Ibarra, Jason Mena, Nelson Rivera Rosario, Quintín Rivera Toro, Marxz Rosado Ríos, Beatriz Santiago Muñoz

Uruguay: Enrique Aguerre, Verónica Artagaveytia, Patricia Bentancur, Aníbal Capoano, Pau Delgado Iglesias, Ángela López Ruiz, Adán Medrano, Clemente Padín, Martín Sastre

Venezuela: Alexander Apóstol, Carola Bravo, Nayari Castillo, Magdalena Fernández, Nan González, Luis Mata, Juan Carlos Portillo, Mariana Rondón, Antonieta Sosa

—Elena Shtromberg and Glenn Phillips

Elena Shtromberg and Glenn Phillips

Introduction

At its origins, video art was defined by the features of the new technology that brought it into being, allowing artists the potential for instant recording, transmission, and playback. The possibility of critiquing the dominance of mass media and television broadcasting while also adapting its mechanisms drew artists who sought to offer an alternative mode of communication. Because access to the technologies was inconsistent, available in cities like New York and Tokyo but prohibitive in most other parts of the world, the history of video art is marked by staggered and multiple points of development. Early experimentation with video in Latin America was often affected by—and effectively ended by—changing political environments, before independently reemerging in new contexts years or even decades later.

In general, however, delayed access to the video apparatus in Latin America deferred its widespread use within artistic spheres until the late 1970s and 1980s. It then became an important medium for the expression of dissent during an era dominated by military-regime governments. Given the close relationship between those regimes and the media conglomerates controlling television broadcasting, the portable video camera represented a decentralized media outlet for voicing opposition to State violence. The relationship between television and video art can hardly be overstated, having defined not only the early phases but also the following four decades of artist videos. The attempt to transform the viewer of video from a passive consumer of to an active participant in mass media—one who reflected critically on television programming—was a thematic tendency in many video works. Charged with a critical voice that aimed to interfere in a particular social or political context, video art often denounced exploitation resulting from excessive physical and psychological violence. In more contemporary manifestations of video

1

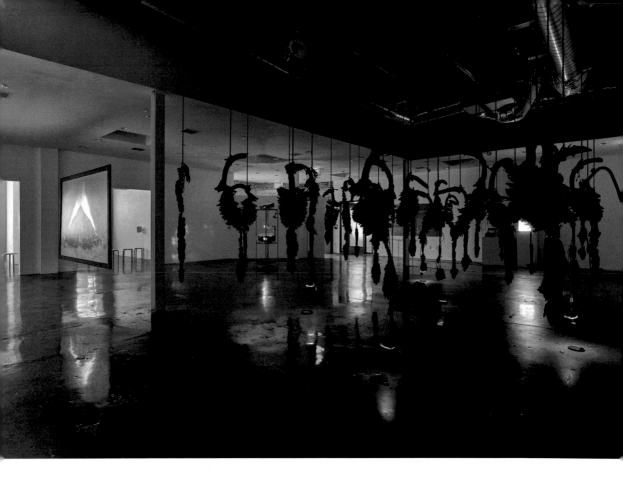

art in Latin America, artists continue to pursue the social commitment of earlier work while also exploring themes related to gender, ethnic, and racial identity as well as the consequences of social inequality, ecological disasters, and global violence, maintaining a characteristic openness to aesthetic experimentation.

The investigation that led to this volume began as a research project, Video Art in Latin America, initiated at the Getty Research Institute in 2012, expanding into an exhibition of the same name organized at LAXART during the fall of 2017 as part of the initiative Pacific Standard Time: LA/LA (figs. 1, 2). However, the origins of this project stretch back even further, to 2004 and 2005, when we developed two screening programs for the Getty Research Institute: "Pioneers of Brazilian Video Art 1973–1983" and "Surveying the Border: Three Decades of Video Art about the United States and Mexico." These projects initiated some of our first interviews and visits with video artists, curators, and critics in Latin America, as well as years-long conversations about additional work to be done. Yet, when we began the Video Art in Latin America research project in 2012, we still had little sense of the scope of what we were undertaking. Combining Shtromberg's expertise in Latin American art and Phillips's extensive curatorial work with video art, we set out to document and map the activity of early video art throughout the most

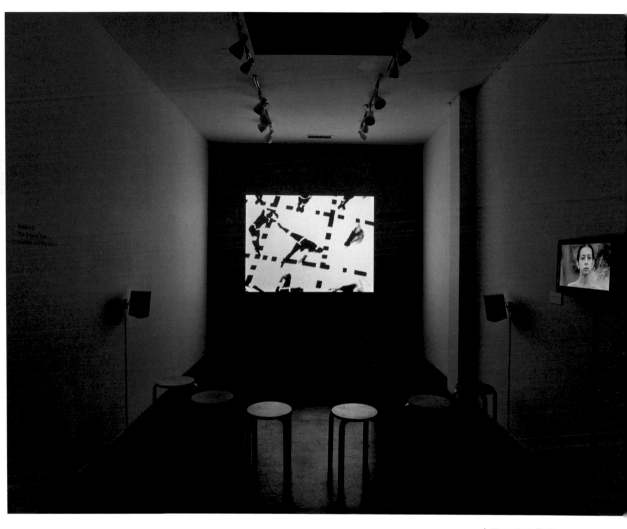

| Fig. 1. Installation
view of the *Video
Art in Latin America*
exhibition at LAXART,
Los Angeles, 2017.

| Fig. 2. Installation
view of the *Video
Art in Latin America*
exhibition at LAXART,
Los Angeles, 2017.

prominent artistic centers in Latin America, mindful of including those stories that are often not addressed, such as those from Central America and the Caribbean. Nearly 500 studio visits and more than 3,300 surveyed artworks later, we realized that any comprehensive idea of a map was all but impossible. Instead, we proposed to initiate documentation of works and major activity, publications and archival holdings, however inconclusive, which could later be a starting point for others to expand. This seemed especially important when considering the gaps in scholarship on even the most important video work from Latin America. Consider, for example, the ambitious *Mapping Video Art* visualization project, initiated by the Institute of Fine Arts Research Labs at New York University, in which "its creators aim to make visible the 'movement' of the medium as it grew in global reach from 1963 onward," by tracking activity from 1963 to 2013.[1] The map that emerged from their research would lead one to believe that video art was almost exclusively concentrated in Europe and the United States with two lone circles in all of Latin America—something we knew to be inaccurate and worthy of immediate critical attention. A key objective of our project had been and continues to be a more global understanding of video art histories that puts the more dominant works in dialogue with lesser-known ones.

The span of the project was vast, covering territory we identified as central for video art production, whether large or small, as well as other cities where we knew more persistent probing would bring us into contact with unexpected disclosures. In gathering copious amounts of data, culled from conversations with video artists, curators, critics, institutions and collections, and the many publications and texts they shared with us, we quickly realized the need for organizing the information we came across. The idea of thinking about the video production thematically, through topics and strategies that surfaced across broad swaths of work, seemed the only way to move forward in the monumental task.

Our research phase took us to twenty-one cities. There, our stays were organized by rigorous schedules of meetings with too many curators, critics, and artists to include here. We also extended our meetings via telephone and email to involve the dozens of additional artists living in areas that we could not travel to. Further investigations kept revealing growing networks of activity, new voices, and works that ultimately could not all be accounted for. As we encountered and were captivated by more contemporary and recent works, it became clear that we needed to expand beyond our initial objective of documenting only early video histories. Our conversations and research, together with the thousands of works we viewed, led us to recognize that certain thematic concerns could be detected and followed across works from not only different decades but also vastly different regions. The best path forward was to describe the tendencies and themes we identified among both distinct historical periods and diverse regions within Latin America. Narrating this

history from the perspective of thematic constellations, across time and place, allowed us to diverge from the more prevalent model of looking at a country's national history or tracing the development of the medium in a specific time frame. That is not to say that we are in any way critical of scholarship of this nature, much of which had been foundational to our research, especially in our initial understanding of the region's activity. Nevertheless, we found the thematic model enabled us to consider works of art from the earliest experiments with video alongside more recent ones, tracking how not only certain technical advances but also ideological and political contexts surfaced in unique but enduring ways. Such thematic parallels would also allow this work to be considered in light of more global video art, empowering audiences to identify and reflect on certain patterns that provoke compelling insight into the medium and the rapid technological changes it undergoes.

One question that we were often asked is how we define video art, a question that was and continues to be increasingly difficult to answer. Barbara London has expressed that "video was shaped by its DNA—new technology, real-world politics, and the persistent mutability of contemporary art."[2] Today, it is hard to speak of "video art" when the dominant digital mode eliminates traditional borders between video, film, and documentation, and when lines have always been blurry between art, independent film, and alternative modes of broadcast. Yet our answer lies partly in the ambivalence and flexibility of the medium itself: every artist we met considered their work to be video art, even if their individual definitions of the term may differ. We were also open to video registers of performances that could and did stand on their own as art works, as well as moving-image works that may have been produced without a video camera, such as computer-based animations or text- and photo-based works that have been electronically assembled.

As our research project expanded to include a survey exhibition that participated in the Pacific Standard Time: LA/LA initiative, we continued to rely on the idea of thematic constellations to organize and present the many years of research we had undertaken. Our research has always been guided by the networks resulting from the availability of and access to video equipment, the prevalent influences and training artists received, and the history of circulation and exhibition of key video art works from Latin America and elsewhere. Access to video equipment has and continues to be something that cannot be taken for granted. Prohibitively expensive early on, the equipment was often imported by artists from elsewhere as a novelty, eventually making its way into the hands of distinct groups of artists. Different from film in many ways, video was not and continues not to be (with few exceptions) taught as a medium in its own right in most of the art schools we surveyed throughout Latin America. Overwhelmingly, the artists we spoke to told us of their training in more traditional media such as painting, sculpture, and

some photography, often turning to video and its close ally, performance, to develop more experimental, if not politically challenging, work.

The 2017 exhibition at LAXART, part of Pacific Standard Time: LA/LA, presented the work of sixty-five artists from twenty-one countries[3] and was organized around six thematic categories: Defiant Bodies, Economies of Labor, Borders and Migrations, States of Crisis, Memory and Forgetting, and the Organic Line. A special screening at the Getty Center also explored the theme of Dissonance.[4] Collectively, we found these themes flexible enough to provide frameworks for productive artistic dialogues across different generations of artists and geographies. The themes encompassed topics ranging from legacies of abstraction to new forms of activism; from issues of identity to critiques of mass media. Throughout all areas, we saw a commitment to alternative media circuits and to accommodating dissident voices, which has been present within video art from its earliest origins.

Encounters in Video Art in Latin America is intimately related to the research we conducted for our exhibition but is by no means an exhibition catalog. For this volume, we present recent scholarship covering a broad set of historical and theoretical approaches in the form of commissioned essays and interviews with leading artists and with established and emerging scholars from the Americas. In addition to exploring the history and current state of video throughout the vastly diverse regions of Latin America, such as Central America and South America, the volume also includes firsthand testimonials by prominent artists working with video. As these texts elucidate, the rich terrain of video experimentation throughout the region often presents parallels in themes and styles by artists working in different regions or historical periods. Several of the dominant themes that we identified became the distinct sections organizing this volume: Encounters, Networks and Archives, Memory and Crisis, and Indigenous Perspectives. The first section, Encounters, presents a longer-format historical essay that aims to track some of the earliest histories and international video networks that were forming throughout Latin America in the 1970s. The remaining three sections each comprise three texts, including two scholarly essays and a text by or an interview with an artist. These artist contributions, from pivotal figures in the history of video art, were crucial to our understanding of the emergence and expansion of this medium. In many instances, artists have played multiple roles as artist, collector, archivist, and curator, and we felt strongly that they deserved a prominent position in this volume. The sections do not function as tightly circumscribed categories, and there is significant overlap among them, in both the influences and artists addressed and the content of each text. Like a network, each bleeds into the other in what we hope allows readers to make productive connections.

The Encounters section contests the image of early video art being a primarily North American, European, and Japanese phenomenon by

tracing some of the earliest histories and international networks that were established throughout Latin America in the 1970s. The focus of this section is Jorge Glusberg, a controversial art critic, curator, and business entrepreneur. During the 1970s, the Centro de Arte y Comunicación (CAYC) in Buenos Aires, an art center directed and funded by Glusberg, was an important site of activity for video artists in South America. In 1977, Glusberg wrote one of the earliest essays summarizing what he identified as unique about Latin American video art. "Europeans," he wrote, "engage in theoretical discussions of political problems," whereas "Latin Americans necessarily include these problems in their works, since they live them daily."[5] Glusberg referred to video as an "alternative television" and the artists as "operators" who would "convert their lives and their art into testimonies of the struggle for liberation in the countries in which they are working." Not only did Glusberg provide artists with access to video equipment, but he also organized a series of ten Encuentros Internacionales Abiertos de Video, which took place between 1974 and 1978 in London, Paris, Ferrara, Buenos Aires, Antwerp, Caracas, Barcelona, Lima, Mexico City, and Tokyo, bringing the work of video artists from Latin America in contact with a broader audience and establishing international exchanges between artistic centers around the world. This section provides a comprehensive historical overview of all ten Encuentros, and in the course of charting this history the essay also outlines some of the earliest histories of video art in countries such as Argentina, Brazil, Mexico, Peru, and Venezuela. Based on extensive research and interviews, Glenn Phillips and Sophia Serrano examine the scope and nature of the Encuentros, which have until this point had an often cited but fairly elusive history. Though the success of the Encuentros was mixed at best, they show that video art was being produced all throughout Latin America in the 1970s, even if many of those works now appear to be lost.

The second section, Networks and Archives, includes scholarly texts by José-Carlos Mariátegui and Gabriela Aceves Sepúlveda, followed by an interview with the video artist Ximena Cuevas. The three texts expand on the networks initiated by artists, whether through individual and personal connections, professional relationships, or institutional affiliations, all of which influenced different archival presentations. In "Imagined Video Archives: Strategies and Conditions of Video Art Collections in Latin America," Mariátegui, a cofounder of ATA (Alta Tecnologia Andina), a platform for archiving and disseminating Peruvian video, presents an extensive and one-of-a-kind survey on the current state of video collections and archives throughout Latin America.[6] The initial motivation of many of the earliest archives was to safeguard the large number of audiovisual works that were frequently in precarious states of conservation, many of them in need of identification and preservation. Efforts by individuals, often self-directed, replaced what should have been institutional management in this task, compensating for a lack of

museum interest and institutional support. The unique requirements for conserving analog and digital materials, involving a constantly evolving and diverse number of formats as well as a material that gets increasingly unstable over time, complicated such efforts. Furthermore, audiovisual works challenged existing archival classification, which was developed primarily for cataloging still images. These considerations thwart a straightforward history of audiovisual archives in Latin America, many of which adopted organizational and preservation strategies that were specific to their needs and resources. In his essay, Mariátegui focuses on four of the most dominant models in preserving, cataloging, and exhibiting works of video art in Latin America: video art festivals (explored in further detail in Sebastián Vidal Valenzuela's essay), museums and institutions, personal initiatives, and exhibitions.

In "La portapak en Latinoamérica: The Gendering of Video Art in Argentina, Brazil, Chile, Colombia, and Mexico," Aceves Sepúlveda examines the ways in which women artists deployed new portable video equipment to transgress dominant narratives about technology and gender, allowing these artists, many of them pioneers of the medium in Latin America, to challenge media representations in art and explore representations of femininity on their own terms. She examines the driving themes and affinities in the artists' work, including the work of Marta Minujín in Argentina, Pola Weiss in Mexico, and Sandra Llanos-Mejía in Colombia, alongside Anna Bella Geiger, Letícia Parente, and Sonia Andrade in Brazil and Lotty Rosenfeld, Diamela Eltit, and Gloria Camiruaga in Chile. Aceves Sepúlveda claims that by gendering video, artists adapted alternative relationships to technology, imagining a unique sensibility that questioned authority and power on screen and off. Through their practices, tacitly or actively, they opened up spaces for other female artists to experiment with new technology, and they serve as role models that engender new networks.

In "Video: A Laboratory for Experimentation," Elena Shtromberg and Glenn Phillips interview the Mexican video artist Ximena Cuevas, who recounts the early artistic experiences that led to her unique approach to the medium in addition to her critical work as an independent archivist of Mexican video art. Raised by a father who was a famous artist (José Luis Cuevas), Cuevas was privy to a world populated by the most prominent artists and filmmakers of the time, leading her to envision ways of telling stories early on in life. In the interview, Cuevas discusses the important events that led to her career as one of the leading voices working with the medium. Her more recent efforts at documenting the history of video art in Mexico are not distinct from her artistic work; instead, they build on her experiences at telling stories through video. Cuevas's significant video compilation on this history comprises two different parts: Anatomía del videoarte (Anatomy of video art), documents the use of sound and other facets of the moving image; the other,

Cronología de video arte en México, 1977–2009 (Chronology of Mexican video art, 1977–2009), unique in Mexico, involves organizing the work of artists who donated their collections. Never meant to be comprehensive, the history that Cuevas compiles is partial and subjective, like many of the archival initiatives that Mariátegui describes and, indeed, like the history of video art itself.

The section Memory and Crisis explores how video art and its production, circulation, and exhibition addressed moments of political and social crisis, responding to censorship and violence in authoritarian regimes and acting as unique harbingers of memory in circumstances that constantly threatened its erasure. Elena Shtromberg, Sebastián Vidal Valenzuela, and Oscar Muñoz emphasize video as a medium for political resistance particularly amid periods of violent conflict in Latin America. In "Memory and Forgetting in Video Art from Latin America," Shtromberg turns to the work of the artists Oscar Muñoz, Clemente Padín, and Ernesto Salmerón to position video as a radical tool that generates alternative historical narratives and collective memories. Noting both the importance and the limitations of documentary accounts of complex national traumas, Shtromberg examines how video art can enact both the subjective dynamics of memory and memorialization, along with the equally significant mechanism of strategic forgetting. Muñoz performs this dynamic through his looping attempts to paint a self-portrait in water on hot concrete, perpetually reinforcing the impossibility of capturing the image as well as the importance of continuing to try. Padín deploys the vulnerability of videotape itself, playing and replaying camcorder footage of protesters in Montevideo until the images have enacted their own erasure, thus using the medium's features to perform the disappearances the military regime normalized during its reign. For Salmerón, the discovery of repressed footage from INCINE, a propaganda organ for the Sandinista revolution during the 1980s, allowed the artist to confront historical erasures in Nicaragua through a lyrical remixing of archival and historical fragments. All three artists highlight the complex, fragmentary, and shifting nature of historical memories that are constantly in process of being returned to, subverted, and rewritten.

In "Festival Franco-Chileno de Video Arte: A Space of Resistance under Dictatorship and Expansion in Democracy," Vidal Valenzuela traces the history of the video festival, detailing how it created productive spaces for debates about the new technology and for reflections on political dissent in Chile during the regime of Augusto Pinochet. The author describes how the festival came to be considered a countercultural space by providing an alternative to television, then dominated by the regime's propaganda. While there were other spaces at this time for the exhibition of video art in Chile, in general its circulation was sporadic and irregular, making the festival the most important space for presenting video work exclusively. Even more importantly, the festival was open

to the public. In this way it became a model platform for neighboring countries. Additionally, the festival generated a point of encounter between France and Chile, facilitating the exchange of video works, artist correspondence, and the production of critical texts internationally. Vidal Valenzuela recounts the details of each iteration of the festivals, including the inaugural festival, in which video performances by Carlos Altamirano in *Panorama de Santiago* (1981) and Carlos Leppe in *Cuerpo correccional* (1981) were outliers. The festival was also a seminal platform for showing the work of women artists making video, such as Diamela Eltit, Gloria Camiruaga, Lotty Rosenfeld, Marcela Serrano, and Magali Meneses, among others. After the arrival of democracy in Chile in 1990, the scope of the festival shifted, and in 1992, it expanded its presence to Colombia, Argentina, and Uruguay, changing its name to the Festival Franco-Latinoamericano. The legacy of the Franco-Chileno festival in Chile was channeled into the Bienal de Video y Artes Electrónicas in 1993, still operative today as the Bienal de Artes Mediales.

Muñoz, in his essay "A Threshold of Suspension," reflects on his poetic fascination with the moment when an image becomes—or attempts to become—photomechanically fixed in place. The process itself has varied dramatically, from the earliest years of photography when subjects would need to remain still for minutes at a time, to the near-instantaneous methods of today. Both the notion of capturing, or fixing, an image and the mechanical and chemical processes that do so have offered a profoundly fertile realm for Muñoz's work, often expanding into a larger consideration of memorializations and erasures regarding systemic violence in Colombia and Latin America. In Muñoz's *Aliento* series, for instance, images printed on mirrors remain invisible until the viewer fogs the mirror with her breath. Muñoz's videos often linger upon performing (and frequently failing in) the act of fixing an image. This is nowhere more true than in the continually failing attempt to paint his own portrait in *Re/trato*, also discussed by Shtromberg in her essay. A brief interview with Muñoz provides some additional context about his work.

The fourth section, Indigenous Perspectives, elaborates on the shared histories between the medium of video and the complex topic of representation by and of Indigenous peoples from the standpoint of the art world. Essays by Francisco Huichaqueo and Benjamin O. Murphy and an interview with Vincent Carelli focus on video practices in and by Indigenous communities, emphasizing video's role in self-representation and activism. It was clear from the moment we met that Huichaqueo, a Mapuche activist, artist, and curator, had a singular and exceptional voice that demanded a broader public both in and outside of Chile, where he resides. His moving text, "The Image before the Image," written in collaboration with the poet Juan Juenan, reflects on the challenges and triumphs of working with video as a form of both political disruption and aesthetic rumination. In a constant navigation between two cultural

spheres—his traditional, spiritual one and the Chilean one in which he works professionally—Huichaqueo is driven by an interest in the spaces where the Mapuche people and Chileans relate to their shared but troubled history. Striving to create a new and different space for Mapuche art, Huichaqueo presents Mapuche artistic expression as dynamic and changing, well beyond the confines of the exotic that it is often reduced to in existing institutional protocols. He recalls an anthropology conference where the question of whether having access to a camera was forcing the Mapuche people to lose their culture and identity was problematic, since a culture is never fixed and static. While recognizing the importance of spirituality, Huichaqueo also strives to introduce other dimensions such as happiness, love, beauty, and even the erotic into his work, even when this is seen as inauthentic to Mapuche art and therefore controversial. His work *Wenu Pelón/Portal de luz* (2015), at the Museo Arqueológico in Santiago, was an attempt to reactivate the installation of archaeological Mapuche objects, all of which were historically and spiritually valuable for the community. It was the first time that the museum had invited a Mapuche artist to be involved in the curatorial staging of the space. Huichaqueo took on the task of restructuring and decolonizing the space, which had been guided by a Western logic, toward a more active relationship between the exhibited works and the viewer. By activating the objects with his video work, Huichaqueo allowed the viewer more intimate views not only of the objects but also of the constantly changing perspectives afforded by the visuals projected into and onto them. The resulting installation reminds the viewer that Mapuche culture should be represented through multiple aesthetic perspectives and visions, none of which is easily grasped in a single viewing.[7]

In "Handing Over the Camera: Two Episodes in Video Art and Anthropology," Murphy compares the artist Juan Downey's works with the activist Vincent Carelli's decades-long project Vídeo nas Aldeias (VNA; Video in the Villages), which brings video to Indigenous communities. Murphy discusses how Downey's 1976 *Video Trans Americas*, based on a series of trips throughout the Americas in 1973 and 1974, transposed the common avant-garde video tropes of live feedback and audience participation into a series of encounters with Indigenous communities in Central and South America. Working with a portapak, Downey videotaped different communities and then showed them tapes not only of themselves but also of other Indigenous communities from his travels. In doing so, Murphy notes that anthropology becomes an "endless crossing of views onto other views that breaks apart the binary relationship presupposed in an anthropology of documentation." As Murphy notes, in the 1980s, Carelli would embark on a similar and ongoing initiative, Vídeo nas Aldeias, which seeks to train Indigenous groups in the use of video technology and to establish communication networks between disparate communities across the Amazon region. With the aim of bringing

greater agency to communities in terms of their self-representation and documentation, VNA has also produced a compelling body of video work whose dissemination spans the worlds of video art, independent cinema, and Indigenous media collective networks.

In his interview for this volume, Carelli discusses his ongoing projects and the many obstacles he has faced in recent years. He recounts his early career and the work that led to VNA, including collaborations with the filmmaker Andréa Tonacci and the Centro de Trabalho Indigenista (Center for Indigenous Work), as well as a brief period working for the Fundação Nacional do Índio, the Brazilian governmental agency for Indigenous affairs. Lacking stable institutional support, VNA has been subject to wildly varying levels of funding or interest during different political eras. Carelli discusses the history and current situation of State repression of Indigenous rights and the many movements within Brazil that have fought for greater autonomy for Indigenous peoples.

In its entirety, this volume does not pretend to chronicle or represent a comprehensive history of video art activity in Latin America. Instead, we hope that the multiplicity of perspectives presented here serves as a point of departure for both more expansive and more detailed scholarship on specific artists, countries, or, more broadly, the state of video art outside of perceived centers of activity. Throughout the research phase of this project, we were continually impressed by the wealth of publications we encountered and by the generosity of the artists and curators who wished to share copies of catalogs, books, and sometimes quite rare historical volumes. Many of these books are little known in the United States and rarely available in libraries. We quickly realized that we needed to schedule time in each city for organizing shipments of books back home. We began traveling with our own boxes and packing materials, as we typically shipped between fifty and two hundred pounds of books to Los Angeles from every city that we visited. More than 450 of these books were available to visitors as a reading room in the exhibition at LAXART, and they are now available to researchers in the library of the Getty Research Institute. We hope *Encounters in Video Art in Latin America* attests to the continuing vibrancy and vitality of interest in video that is shared by artists and writers across Latin America, and we also hope that it can be a resource for new avenues of research and books to come.

Notes

1 See *Mapping Video Art*, https://ifa.nyu.edu/research/projects/mappingvideoart.

2 Barbara London, *Video/Art: The First Fifty Years* (New York: Phaidon, 2020), 10.

3 The twenty-one countries are Argentina, Bolivia, Brazil, Chile, Colombia, Costa Rica, Cuba, Dominican Republic, Ecuador, El Salvador, Guatemala, Honduras, Mexico, Nicaragua, Panama, Paraguay, Peru, Puerto Rico, the United States, Uruguay, and Venezuela.

4 Another screening at the Getty Center looked at recent video from Central America and the Andes, and a project at the Rubell Museum in Miami looked at video art from Brazil.

5 Jorge Glusberg, "Video in Latin America," in *The New Television: A Public/Private Art: Essays, Statements and Videotapes, based on "Open Circuits: An International Conference on the Future of Television,"* ed. Douglas Davis and Allison Simmons (Cambridge, MA: MIT Press, 1977), 204.

6 For more on ATA, founded in 1995, see http://ata.org.pe.

7 This was a work that we eagerly pursued for the LAXART exhibition, though the practicalities of borrowing the archaeological objects proved to be prohibitive.

SECTION 1
ENCOUNTERS

Glenn Phillips and Sophia Serrano

Encounters: CAYC and the International Encuentros

From 23 to 25 January 1974, the Argentine cultural critic, curator, author, and professor Jorge Glusberg participated in various screenings and panels at the now infamous Open Circuits International Conference on the Future of Television at the Museum of Modern Art (MoMA) in New York City, as a representative of "third world" video artists.[1] In addition to discussing the constraints that artists in the Southern Hemisphere face in not only producing their work but also exhibiting it in museums, Glusberg showcased a collection of videotapes that featured the newly formed artist collective El Grupo de los Trece, which operated under his auspices at the Centro de Arte y Comunicación (often called CAYC) in Buenos Aires.[2] As part of CAYC's experimentation with new theoretical approaches to creative praxis and exhibition, Glusberg also announced his plan to organize ten Encuentros Internacionales Abiertos de Video (International open encounters on video, hereafter referred to as Encuentros). These Encuentros would mirror international artistic events that had been developing globally throughout the 1960s, and they were designed to reflect Glusberg's utopian vision for the future democratization of video technology. In texts accompanying the Encuentros, Glusberg regularly positioned video as a tool for social change; for example, at the Paris Encuentro, he wrote: "Video can help strengthen and foster the effects of social change . . . ultimately joining the forces that are attempting to reorganize global imbalance for underdeveloped countries."[3] In other words, the purported goal of these Encuentros was to break the confines of the museum and bring the burgeoning medium of video en masse to the people. Instead of curating a select group of artists for the festivals, Glusberg, who directed and led the initiative, accepted videotapes sent to CAYC to screen from anywhere in the world. Admission was free to all, and there were no juries or prizes. His contribution to the publication of

15

Open Circuits' proceedings states: "the real common preoccupation is no longer to create a new art, but to contribute towards the development of a new culture."[4] Alongside the screenings, the Encuentros would consist of workshops, performances, symposia, roundtables, and lectures to engage the public with the vast potential of video. Though Latin American art often played an important role in the focus of these events, the overall nature of the Encuentros was unquestionably global in scope. Between the mid- to late 1970s, the Encuentros would be held at the following locations:

> Institute of Contemporary Arts, London, 4–5 December 1974[5]
> Espace Pierre Cardin, Paris, 20–25 February 1975
> Palazzo dei Diamante, Ferrara, 25–29 May 1975
> Centro de Arte y Comunicación, Buenos Aires, 31 October–
> 14 November 1975
> Internationaal Cultureel Centrum, Antwerp, 16–22 February 1976
> Museo de Arte Contemporaneo, Caracas, 20–25 January 1977
> Fundació Joan Miró, Barcelona, 23–25 February 1977
> Galeria Banco Continental, Lima, September 1977
> Museo de Arte Carrillo Gil, Mexico City, 14 November–
> 2 December 1977
> Sogetsu Kaikan, Tokyo, 20–27 May 1978

Many scholars of the history of video art will have encountered one or more publications from the Encuentros at some point during their research. Individual publications from these events have spread widely across libraries and archives throughout Europe and the Americas, although no publicly accessible collection currently appears to hold a complete set of materials produced for the Encuentros. For the scholar, the Encuentros brochures often present a point of dissonance against received narratives of early video history: familiar names float against a sea of obscure figures and collectives, and submissions are listed from dozens of countries[6] that have not always been emphasized as having active video art communities in the mid-1970s. Many of the individual works listed as being screened at the Encuentros may have been lost forever,[7] and further research on a number of the lesser-known individual participants has so far yielded few results. Do the Encuentros document a much broader prevalence of artistic activity and exchange than we have understood, or were they too fleeting in their implementation and too varied in the quality of works presented to have a lasting impact? In either case, the Encuentros certainly represent the most ambitious attempt in the 1970s to pursue a vision of video art as a global medium and to present works from across Latin America alongside works produced elsewhere in North America and in Eastern and Western Europe and Japan.

The idealistic positioning of the Encuentros as a generator of a new social revolution via videotape was, however, more limited than what

Glusberg proposed at his MoMA talk in January 1974. The sheer demand of technological resources necessary to screen every tape submitted would prove highly problematic. Accounts of the Encuentros often mention that these technological difficulties made it hard to give the general public a sense of the current state of the video art world but that they nonetheless provided a substantial forum for generating connections and interest surrounding the medium. As the Colombian artist Raúl Marroquin commented about the Paris Encuentro: "if [the purpose] is to show the public what video art is, I don't think we have gotten anywhere, but if it is to serve the artist as a forum for meeting with others and all kinds of exchange then the situation was what it set out to do."[8] These technological challenges aside, the logistics of planning such an event would also prove frustratingly complex; telegrams between hosting organizers and Glusberg show extensive debate on issues such as when the Encuentro would be held, how to obtain proper travel documentation, how to publicize the event, and how they would financially split the publication of the catalogs. Amid this frenzied planning, tapes would be lost or go missing in transit, performances and guests would fall through, dates would be postponed, and, in the cases of the Antwerp and Mexico City events, catalogs would go unpublished.

Despite the great ambition of the Encuentros, very little about these events can be found in the major international art periodicals; any mention or documentation of the events is almost entirely absent from publications such as *Afterimage* (London), *Aperture, ArtForum International, Art Press* (Paris), *Studio International, Art Bulletin, Video Guide, The Video Show*, and *Video Networks*. Therefore, our principal sources of published information about the planned events are the Encuentro catalogs that were produced for eight of the ten events, though discrepancies certainly existed between the printed schedules and the actual flow of each event. These small booklets, some of which are now quite rare, give a fascinating, albeit perhaps not always accurate, look at the Encuentros and their activities.

The majority of the Encuentro catalogs were produced by CAYC's own publisher, Ediciones Argentinas in Buenos Aires, sometimes before and sometimes after the events, though for the Encuentros held in Caracas and Lima the booklets were published locally. They range in language from English to French, Spanish, and Japanese, and some are bilingual. The catalogs often contain an essay by Glusberg and/or co-organizers and guest artists, then list the name, country, and works of all the artists and groups who had submitted to the Encuentro. Glusberg would distribute these booklets both in person and alongside his mailings of CAYC's colored, stylized *gacetillas* (bulletins), a trademark of the institution (figs. 1, 2). These bulletins informed international audiences of upcoming events, calls for submissions, reviews, and other news and achievements from CAYC, though the volume of flyers was deemed by some as excessive.[9] Luis Camnitzer, a critic of CAYC's emphasis on

Fig. 1. *Video tapes argentinos,* bulletin for CAYC video event, 2 May 1974.

Fig. 2. *Video tapes: Toward a Future of Television,* bulletin for CAYC video event, 9 June 1974.

integrating its artists into the "mainstream" amid the political landscape of Argentina in the 1970s, denounced this approach: "Promotional material was incessantly sent to all individuals with some degree of power in the international cultural scene, and CAYC became a caricature of solicitation."[10] However, despite their frequency, the bulletins unquestionably played a major role in maintaining CAYC's networks of collaboration and global visibility. The presence of these bulletins and booklets in a vast array of institutional and personal archives worldwide today attests to the impressive network for circulating information that Glusberg constructed for himself and CAYC, and it speaks to his desire to establish Argentina as a leading voice in the global landscape of conceptualism arising in the 1960s and 1970s. Perhaps more importantly, this drive toward international acknowledgment and recognition in the art world also highlights the paradoxical issues that arose amid the limited resources, oppressive regimes, and hyperviolent conflicts that were so prevalent in Central and South America during this time.

Keeping in mind these circumstances, this chapter demonstrates how the Encuentros, an often overlooked component within the early history of international video art, exemplified the ways in which the new medium was utilized, circulated, and displayed during the 1970s. In addition to geographic diversity, the included tapes reflect a vast array of stylistic and thematic traits that were emerging in early global video art. The impetus for this current study was our desire to systematically compile information about all ten Encuentros and to create a set of reference materials that may be used by scholars wishing to explore further avenues of investigation. What follows is a description and analysis of the early history of Jorge Glusberg and CAYC, and a presentation of the historical context and development of the ten Encuentros presented between December 1974 and May 1978.[11]

JORGE GLUSBERG AND THE EARLY YEARS OF CAYC

Jorge Glusberg (25 September 1932–2 February 2012), active from the late 1960s to the 2000s, is unquestionably one of the most prolific figures in the history of Argentine art. In addition to directing CAYC, Glusberg's extensive tenure includes founding the Bienal Internacional de Arquitectura de Buenos Aires in 1985, serving as president of the Asociación Argentina de Críticos de Arte (1978–86; 1989–92), codirecting the Comité Internacional de Críticos de Arquitectura (1978–2012), directing the Museo Nacional de Bellas Artes in Buenos Aires (1994–2003), and serving as professor at numerous international universities (for example, he was the cochair of the International Center for Advanced Studies in Art at New York University with Angiola Churchill from its founding in 1979 through 1994).[12] From an early age, Glusberg demonstrated a proclivity for his future career. The Argentine artist Leopoldo Maler, who

had known Glusberg since they were three or four years old, recalls that "at the age of twelve he already had a geology museum on the patio of his house, with rocks and small animal bones on display; in this sense he was always an organizer."[13] Glusberg did not attend any college or university (though he later received an honorary doctorate in architecture from the Universidad Villareal de Perú); thus, in the realm of cultural theory and criticism, he was self-educated.

By his twenties, Glusberg, like many other middle- and upper-class Argentine youth, would become enamored with the rapid cultural changes happening in Buenos Aires in the mid- to late 1950s as various new institutions, exhibitions, and publications fostered interest and awareness.[14] This cultural change was due in large part to the political turmoil of the period; in 1955, a military coup violently ended Juan Perón's presidency and installed the Revolución Liberadora, which, among many changes, emphasized foreign investments and international influences. Directly following the coup, Jorge "Coco" Romero Brest (who would become a model for some of Glusberg's activities) was named the director of the Museo Nacional de Bellas Artes in Buenos Aires and put in charge of drastically modernizing its exhibitions and collections. In 1956, the Museo de Arte Moderno was created in Buenos Aires, and in 1958 it was announced that the nonprofit Instituto Torcuato di Tella would be opening a center for the visual arts that would focus on many of the most experimental tendencies in Argentine art. In 1963, Romero Brest would transfer over to the Di Tella institute and oversee its expansion to comprise the Centro de Artes Visuales (CAV). By the mid-1960s, the institute would produce several notable installations and exhibitions, including projects that reframed television as an artistic medium, giving birth to what would become "video art" in Argentina.[15] Among the first of these instances was the exuberant installation by Marta Minujín and Rubén Santantonín, *La Menesunda* (Mayhem; 28 May–11 June 1965), which was an immensely popular sculptural environment that used closed-circuit cameras to transmit images of the visitors to screens in one of its rooms.[16] In 1967, David Lamelas would contribute to the Di Tella show *Experiencias visuales* with his piece *Situación de tiempo* (Situation of time), his last installation in Argentina before he moved to London. In this work, Lamelas aligned seventeen monitors set to television static, transforming and repurposing the viewer's traditional expectations surrounding the TV set and its appearance in an art setting.

During this period, Glusberg worked mostly as an entrepreneur, founding his company Modulor, which specialized in lighting needs for public and private spaces such as banks, stores, offices, theaters, and stadiums. This company fostered Glusberg's interest in architectural and multimedia installations, furthering his involvement in the art world. Modulor would come to provide material support for many of Glusberg's art activities, including equipment necessary for developing films, videos,

| Fig. 3. Advertisement for Modulor on back cover of *Testigo,* no. 3 (July–September 1966).

| Fig. 4. Advertisement for Modulor in *Testigo,* no. 5 (January–March 1970).

and installations at CAYC.[17] Modulor was also financially intertwined with Glusberg's work as a writer and critic. For example, from 1966 to 1970, editions of the literary/arts journal *Testigo* that featured Glusberg's essays "Un intento de acercamiento al pop-art" (An attempt to approach pop art), "Pop art, un nuevo código" (Pop art, a new code), and "Films realizados por pintores europeos" (Films made by European painters)[18] also featured full-page sponsorship ads from Modulor (figs. 3, 4).

Despite being a major site of conceptual innovation in Buenos Aires in the 1960s, by 1968, the financial and political struggles of the Instituto Torcuato Di Tella hit a critical point.[19] That same year, the Centro de Estudios de Arte y Comunicación (CEAC) was created under the direction of Glusberg, who was likely looking to the activities of Di Tella and Romero Brest as models to build upon.[20] From 1968 to 1969, CEAC held its activities and exhibitions at the Galería Bonino, and by 1969 to 1970, it had changed its name to the Centro de Arte y

Comunicación (CAYC) and transitioned to the gallery at Calle Viamonte 452 in the Retiro neighborhood.[21]

The early activity of CAYC emphasized technological experimentation, conceptual art, and new forms of communication. Like Romero Brest, Glusberg aggressively pursued participation in the global art scene, both by fostering an international program at home and by sending CAYC shows abroad.[22] In 1970, for instance, Glusberg invited the US American curator Lucy Lippard to present *2,972,453* (Buenos Aires's population at that time), the third iteration of her "numbers" shows, each of which included a changing international roster of conceptual artists along with a catalog of loose index cards printing the artists' proposals and instructions.[23] Glusberg exhibited conceptual art from Argentina and elsewhere in Latin America under the rubric of "Arte de sistemas," which would also be the title of the large conceptual art survey presented at CAYC in July 1971. This show, translated as *Art Systems in Latin America*, would be revived in 1974 for a five-city European tour, with three of those cities also serving as venues for the first three Encuentros. In the early years of CAYC, performances and activities were documented on 16mm film using the center's R16-B Beaulieu Automatic. In 1990, Glusberg recalled that he purchased a Sony Portapak in New York City in 1969; he then brought the Portapak back to CAYC to document its work and events (Sony would also be a sponsor for many of the Encuentros).[24] The production of CAYC's films, videos, and photos was supported by CAYC's media collective Ediciones Tercermundo (Third World Editions), which Glusberg founded with Pedro Roth and Danilo Galasse. Roth recorded CAYC's activities in Buenos Aires and accompanied Glusberg on many of his travels, while Galasse often served as an additional cameraperson or as editor, though sometimes in the catalogs Glusberg is credited as operating the camera himself. During this time, the group switched frequently between film and video, and some events were documented on both. For example, one of CAYC's earliest media pieces, *El Grupo de los Trece* (1973; *The Group of Thirteen*) is found listed both as a thirty-minute ½-inch reel black-and-white videotape as well as a thirteen-minute 16mm black-and-white film.

In addition to their own tapes, CAYC increasingly showed tapes that artists had produced on their own or working at other institutions. Katarzyna Cytlak traces the earliest instances of video exhibition at CAYC to cultural events in which Glusberg featured the work of Juan Downey, Angelo de Aquino, Rafael Hastings, and Bernardo Krasniansky.[25] Videotapes specifically produced by CAYC begin to regularly appear and be discussed at CAYC's events starting in late 1973 and throughout 1974.[26] These events leading up to the London Encuentro in December of 1974 can be considered "pre-Encuentros" and were highly significant to Glusberg's conception of video.[27] They also demonstrate how Glusberg would acquire equipment: in June 1974, the announcements for the lecture series Video Tapes: Toward a Future of Television say that the four talks

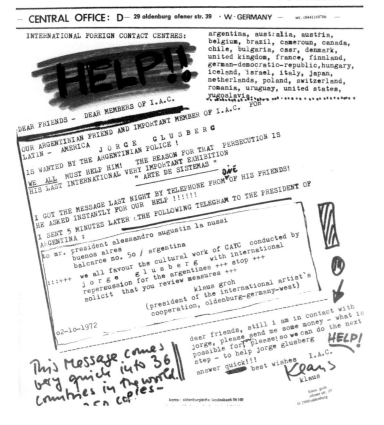

Fig. 5. Flyer calling for international aid for Jorge Glusberg after his arrest in 1972.

were made possible by Labadié (Argentine Laboratory of Electronic Industries), which specialized in closed-circuit security camera systems and had recently sold new equipment to the art center.[28]

By 1974, CAYC had successfully established itself as a leading influence in the early development of Latin American video art (and, more broadly, conceptual art). However, though many of Glusberg's writings focused on video as a new form of visual communication, CAYC's own videos in the earliest years could best be characterized as documentary and promotional materials. As mentioned earlier, the continuous assertion of CAYC as the representative of the Latin American avant-garde was not without controversy. On the one hand, Glusberg would comment to colleagues that global visibility protected CAYC and its artists from the silencing that so many creative voices faced in Argentina.[29] For example, in 1972, when Glusberg was arrested for the scandal caused by the exhibition *Arte de sistemas*, important international figures in the art world were quickly sent telegrams urging them to pressure the Argentine authorities to release him (fig. 5), and CAYC members put together a film to document the shutdown.[30]

On the other hand, scholars and journalists have often pointed out CAYC's problematic relationship with the entities and governments its work often sought to critique. In 1971, CAYC drew criticism for participating in a satellite event of the São Paulo Bienal, despite a worldwide boycott of the event over the "'repressive tactics' of the Brazilian military regime."[31] CAYC claimed it was not directly participating in the Bienal, but artists claimed otherwise. Coverage of the boycott in the *New York Times*, for instance, noted that "Mr. Glusberg is getting together a show for the Bienal that, he says, will be separate from the official one. But the artists contend that his exhibition will actually take place under Bienal sponsorship. A second letter has been circulated by Gordon Matta-Clark, a New York artist who declined an invitation to participate in Mr. Glusberg's show."[32] This political tension created by CAYC's quest for recognition in the mainstream and its engagement with problematic organizations was a persistent issue for Glusberg that polarized his surrounding critics and artists. However, amid this criticism, many would also come to his defense. In 1974, the Colombian artist Raúl Marroquin published a defense of Glusberg in his art journal *Fandangos:*

> Fandangos knew CAYC and Jorge Glusberg long before Phandangos was Vandangos (from the Bienal of Medellin). Fandangos knows as well what is it to work as an artist with ethical and political compromises in South America (political repression, economical difficulties, "Art scenes," pseudocritics, pseudointellectuals, and all the sickness that exists at all levels of our "underdeveloped" societies. Anyway after jail, persecution, etc. etc. CAYC and Glusberg are still alive and bringing out of our land interesting shows from artists who are searching for alternative possibilities in the "very difficult" Latin-American Art world). . . . Bravo por CAYC, Bravo por Jorge Glusberg.[33]

Glusberg's company Modulor, a lucrative business crucial in funding and producing CAYC's extensive exhibitions and events, was also a source of criticism. Like many cultural organizations and institutions in the 1970s that emphasized modernization, Modulor had a complex relationship to the Argentine state. In his essay "Cultural Reconversion," Néstor García Canclini discusses how the military government, which forcibly took power through a coup d'etat in 1976, embraced CAYC as a positive representation of Argentine progress and contracted Modulor for the lighting of the soccer stadium that was being built for the 1978 World Cup in Argentina.[34] A documentary news segment from 12 November 2003 details an even more extensive involvement between Modulor and the Argentine dictatorship:

> The boom of the company [Modulor] began in the World Cup of 1978 when it illuminated all of the stadiums, except that of Vélez

Sarfield. The planetarium, the newly formed building for Argentina Televisora Color, that exits on the brand new highways, the aeroparque and the Airport Ezeiza, several prisons, the central market, and the Cacciatore management schools were all also illuminated by Jorge Glusberg's company.[35]

This same documentary would raise numerous other allegations against Glusberg's activity as director of the Museo Nacional de Bellas Artes,[36] sparking a public debate that would eventually lead Glusberg to step down from the museum and that riddled the later years of his career with controversy and criticism.

We can therefore understand CAYC's activity and role in the modernization and development of conceptualism in Latin America as operating within the tensions of these conflicts of interest; its promotion of video art was no exception.[37] It is also important to acknowledge that CAYC was by no means alone in its complicit behavior toward corrupt political or commercial entities. While García Canclini uses CAYC as a case study, his essay points out the numerous museums and publications that this applied to in the horrific era of the Dirty Wars of the 1970s and 1980s, during which US-backed regimes employed brutal anti-leftist tactics such as kidnapping, torture, and execution to consolidate authoritarian power. This complex relationship between art institutions and compromised sources of funding and support caused a crisis in cultural production during this time: "Under these conditions, pressure is very strong to go along with the noncritical, playful style of the art of the end of this century, devoid of social concerns and aesthetic risk."[38] Such contradictions would be typical for any number of Latin American institutions with financial prosperity and global mobility, and this complex history has been a key component of reflecting on this period as many states have transitioned back to democracy.

THE ENCUENTROS BEGIN: THE I INTERNATIONAL OPEN ENCOUNTER ON VIDEO, ICA, LONDON, 4–5 DECEMBER 1974

Ten months after the Open Circuits conference in New York, the first "official" Encuentro began on 4–5 December 1974, as a two-day portion of Latin American Week, a symposium that ran from 28 November to 6 December 1974 and served as the inaugural event to the opening of *Art Systems in Latin America* at the London Institute of Contemporary Arts (ICA). An almost identical video event had been organized for the previous Antwerp iteration of *Art Systems in Latin America*, except that the video screening was not included under the "Encuentro" title. As the only Encuentro that did not feature a widely broadcast open call for tape submissions, the London Encuentro is particularly important in giving some insight into what Glusberg considered important pieces

of early Latin American video art, as well as what works he had access to at this point.

Planning for the overall symposium and exhibition was a collaborative effort between Glusberg and Julie Lawson, then the assistant director of the ICA, while the portion featuring video was more specifically co-organized between Glusberg and the British writer, critic, and curator Edward Lucie-Smith. On 10 June 1974, Glusberg wrote to Lawson, exclaiming: "It seems to me that it is a fantastic idea that we can make the exhibition 'Art Systems in Latin America' in the ICA. . . . Simultaneously, along with the exhibition, I propose to carry out a series of films, video tape and audiovisual projections, and one or two Latin American electronic music concerts as we have done during the first week in Antwerpen."[39] For logistical reasons, Glusberg and Lawson focused on inviting Latin Americans who were already working in Europe. This included the artists Jacques Bedel in London, Nicolás García Uriburu in Brussels, Lea Lublin in Paris, Jonier Marin in Paris, Raúl Marroquin in Amsterdam, Marie Orensanz in Milan, Arnoldo Ramírez Amaya in Paris, and Antonio Trotta in Milan; the Cuban novelist Guillermo Cabrera Infante in London; and the Argentine magician Finita Ayerza, also in London. Many of these same figures would also travel to Paris and Ferrara for the second and third Encuentros.

The programming for Latin American Week was expansive, with two dance performances by the Argentine choreographer and dancer Ana Kamien;[40] several lectures, including one by Glusberg titled "Art and Ideology in Latin America"; a screening of films produced under the umbrella of CAYC's Third World Editions; a roundtable on "Art and Culture in the Countries of the Third World"; the Symposium on Art and Politics coordinated by Guy Brett; a discussion on experimental film in Europe and Latin America by Leopoldo Maler; several performances and experimental concerts; and, of course, the International Open Encounter on Video.

Taking place within the broader activities of Latin American Week, the London Encuentro itself was much smaller in scale than its successors would be, and the films and videos screened were exclusively by artists from Latin America (see photo essay fig. 1). The first day included a panel on video attended by a mix of people from the European and Latin American art world.[41] As the summary reads: "This encounter intends to establish a closer approach between European and American video operators."[42] For the second day, the catalog lists a mix of tapes including *Eh Joe* (A. Dondo and J. Glusberg, 1973) and *The Group of Thirteen* (1973), as well as tapes made by Latin Americans including *Road* (Jaime Davidovich, 1972); *Kidnappening* (Marta Minujín, 1973); *Julian Cairol's Portrait* (Marta Minujín, 1973); *Topless on Tahiti Beach* and *Video 1–M5* (Felipe Ehrenberg, 1973); *The Walkers, The Listener, The Love Letter,* and *The Magazine Reader* (Raúl Marroquin, 1973–74); and *Coleridge's Dream* and *Walking and*

Whistling (Antonio Trotta, 1974). Most of these tapes would serve as "staples" for the Encuentros moving forward and would be the common representatives of Latin American videos for the global audiences of the ten editions.

While the majority of the tapes named above are no longer available, descriptions of the works in the Encuentro catalogs suggest a range of approaches to video, from documentary to performative to conceptual experiments with space and time. *Road*, one of Jaime Davidovich's earliest works, visually tracks the median of an Ohio road for twenty minutes. It was originally exhibited at the Akron Art Museum to bring "the outside space into the inside space" of the museum.[43] Minujín's *Kidnappening* documents her 1973 Happening in which audience members were blindfolded and kidnapped from a garden party at MoMA in New York. Marroquin's short experimentations document simple personal and domestic actions: for example, in *The Listener*, a man sits in his living room reading, smoking, and listening to the radio.

That so many of these videos were produced by Latin Americans living abroad speaks to the dispersed transnational nature of early Latin American video art from its beginnings, but CAYC heavily marketed these works to US and European audiences as representatives of video art *from* Latin America. This is understandable, considering that access to video equipment was fairly scarce in most parts of the world at this point. While the United States and Germany had particularly active video art communities, with institutions such as Electronic Arts Intermix and The Kitchen in New York and the Video-Forum at the Neuer Berliner Kunstverein in Berlin, all founded in 1971, most cities did not yet have organizations devoting substantial resources to video art. At Open Circuits, Lucie-Smith commented on the difficulties of fostering video art in England, citing expensive equipment and a belief by many art institutions that video was an amateur or inferior medium. In fact, there *were* artists and groups all across England who were experimenting with video at this point, though only a limited number had been recognized by major exhibition spaces. As Lucie-Smith put it, "a frequent source of conflict between Community Arts groups and the official arts establishment in Britain is the question of standards of excellence."[44] In the history of exhibitions at the London ICA, multimedia had been employed in shows such as *Cybernetic Serendipity* (2 August–10 October 1968) and *Electric Theater: 25 Artists Working with Light, Sound, and Space* (18 March–18 April 1971), but the Encuentro would unquestionably be the ICA's most ambitious dive into video, even if for only two days.[45] The technical challenges proved daunting. When Glusberg wrote that he was bringing an Ampex-Toshiba videotape reproducer[46] and had follow-up questions about voltages and cycles, Lawson marked this bullet point with a large "?."[47]

Some experimental use of video had already been broadcast in the United Kingdom when in 1972 the British government started issuing

broadcasting licenses to cable television companies who then broadcast their own experimental programming.[48] Glusberg was very interested in the British television industry and had asked Lawson if she could arrange for CAYC to tour the BBC studios during which a video documentary could be made about how it was operated and organized; conversely, CAYC was also hoping to conduct video interviews with a variety of literary and cultural figures that it would then broadcast on Argentina's state channel of radio and TV.[49] And, as in all of the locations the Encuentro visited, Glusberg would solicit copies of tapes from local artists and collectives. Tapes from the Great Georges Community Arts Project from Liverpool, the Action Space collective, Reindeer Werk (Dirk Larsen and Tom Puckey Will), and the pioneering artists David Hall and Steve Partridge would appear at various editions of the Encuentros in the years to follow.

The London Encuentro would set the tone for CAYC's overtly political and technologically oriented focus for its future events. Though Caroline Tisdall doesn't explicitly mention video in her review, she comments that artists from *Art Systems in Latin America* and Latin American Week are more preoccupied with "cultural revolution rather than aesthetic change."[50] Peter Fuller's review of *Art Systems in Latin America* pushes further on the actual presence of politics in the work presented in London and overall provides a highly negative response to the exhibition: "Although I agree with Glusberg that the art of contemporary Latin American countries must be seen in the context of their historical and political development, I am critical of the specific position which he adopts—and I do not see the present exhibition as providing evidence in support of it."[51] He also goes on to relate the show to CAYC's prior show at the Camden Arts Center, *From Figuration Art to Systems Art in Argentina* (1971), which featured British, German, and North American artists, and argues that Glusberg was problematically developing his concepts of Latin America from within the "cultures of the 'First World.'"[52]

Shortly after the London Encuentro, the Serpentine Gallery held *The Video Show* (1–26 May 1975), organized by Susan Grayson and John Howkins, which showcased dozens of artists and institutions working with video in the United Kingdom, as well as an extensive list of video artists from elsewhere in Europe and the United States. CAYC was included in this exhibition as a collective of artists, and its catalog page lists several works that had screened at the London Encuentro, crediting the works *Eh Joe*, *The Group of the Thirteen* [sic], *Luis Benedit at the CayC*, and *Homo Sapiens* to Third World Editions and also noting that Glusberg's Modulor and the closed-circuit security video company Labadié had lent the equipment.[53]

THE II INTERNATIONAL OPEN ENCOUNTER ON VIDEO, ESPACE PIERRE CARDIN, PARIS, 20–25 FEBRUARY 1975

The second Encuentro would greatly expand on the London symposium in terms of attendees and tapes exhibited, and the bulletins and catalog for this edition were widely distributed via CAYC's mail networks throughout Europe and the United States. Covering the event in his publication *Fandangos*, the artist and participant Marroquin noted:

> Finally Paris has been introduced to video and the dillema [*sic*] that come with it. . . . There were approximately 100 artists from all over the world speaking 5 different languages at the same time and yet trying to discuss something as vague as video art (or non art) and agree on something. There were several roundtable discussions but little dialogue was allowed because, Mr. Glusberg later said, it was more important to have the documentation for the South American artists as a didactical basis than for the audience . . . but still it was a success; more people had visited this show than any other in the history of Espace Cardin and more young people had visited (500 on the opening evening).[54]

While the London Encuentro was part of a bigger symposium that included film, theater, music, and numerous other events not related to video, the Paris event eliminated the title "Latin American Week" and inaugurated the opening of *Art de systèmes en Amérique Latine* by focusing primarily on video (fig. 6). It was sponsored by Sony France, S.A., and

| Fig. 6. Installation shot of the *Art de systèmes en Amérique Latine* exhibition at the Espace Pierre Cardin, Paris, 1974.

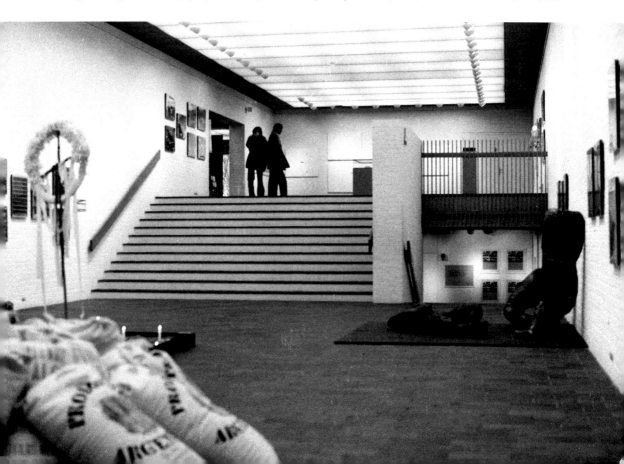

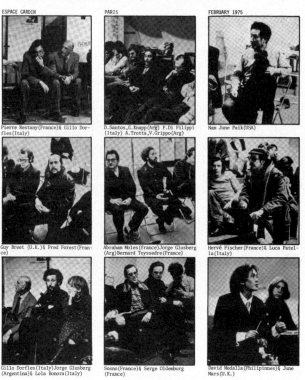

Fig. 7. Bulletin for the Second International Open Encounter on Video in Paris, with images from the event.

Fig. 8. Bulletin for the Second International Open Encounter on Video in Paris, with images from the event.

organized by Glusberg, who in the catalog also credited a group that included Maria Gloria Bicocchi (the founder of the Florence-based video organization art/tapes/22), the critic Gillo Dorfles, and the artist Fred Forest, among others, for their assistance with the event.[55] Another note says that SABENA, a Belgian international airline, provided Latin American artists with transportation to Paris. The catalog, which is in French, features an essay by Glusberg and a detailed list of tapes (see photo essay fig. 2). The extensive checklist of videos for this Encuentro presents a stark contrast with that of the London event: whereas the London Encuentro focused on a small number of tapes by artists from Latin America, most of whom were associated with CAYC, the Paris list is strikingly international, including works from across the United States, Western and Eastern Europe, and Japan, providing insight into the connections and networks being established through CAYC's expansive mail network of letters and bulletins that included calls for submissions. The catalog stated that participants would be attending from Argentina, Austria, Belgium, Colombia, France, Germany, Holland, Hungary, Israel, Italy, the Philippines, Poland, Spain, Switzerland, the United States, and Yugoslavia.

The Espace Pierre Cardin was an arts complex consisting of a large theater, galleries, restaurant, and convening spaces located in the Jardins des Champs-Élysées. Formerly the café, théâtre, and restaurant des Ambassadeurs, the space was taken over by the couturier Pierre Cardin in 1970, who said of the endeavor: "It is my luxury, like keeping a ballerina."[56] The space had an eclectic program. In 1976, for instance, it hosted both a survey exhibition about the French actress Sarah Bernhardt and an installation of David Tudor's interactive sculptural and electronic music environment *Rain Forest IV*. A set of twenty-four images from the Encuentro published by CAYC shows Pierre Cardin in attendance, along with other figures such as the curators René Berger and Guy Brett, the

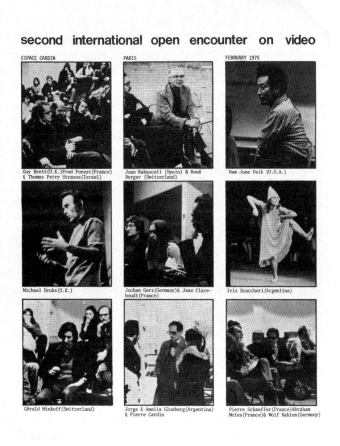

second international open encounter on video

ESPACE CARDIN PARIS FEBRUARY 1975

Guy Brett(U.K.)Fred Forest(France) & Thomas Petry Strauss(Israel)

Joan Rabascall (Spain) & René Berger (Switzerland)

Nam June Paik (U.S.A.)

Michael Druks(U.K.)

Jochen Gerz(Germany)& Jean Clare-boudt(France)

Iris Scaccheri(Argentina)

Gérald Minkoff(Switzerland)

Jorge & Amelia Glusberg(Argentina) & Pierre Cardin

Pierre Schaeffer(France)Abraham Moles(France)& Wolf Kahlen(Germany)

critic Pierre Restany,[57] and the artists Antonio Berni, David Medalla, and Nam June Paik (figs. 7, 8).[58] One can occasionally see stacks of videotapes sitting on a table in the background, but the photographs focus exclusively on the people attending the event. Nearly all of them are shown sitting in a circle on folding chairs, in a large room. One group shot shows that a video camera was set on a tripod in the middle of the room, and another shows a microphone on a tripod behind a group of participants.

From this we can assume that the sessions were recorded, though it is unknown whether these recordings still exist. Two small televisions are visible in the background of one image, suggesting that the equipment available for viewing videotapes may have been more on the scale of portable TVs designed for an individual viewer rather than larger equipment.

The Encuentro featured more than a dozen artists from Paris's growing video art scene.[59] Many of these artists were associated with the Centre National pour l'Animation Audiovisuelle and had just been featured in their seminal exhibition at the Musée d'Art Moderne de la Ville de Paris, *Art Vidéo Confrontation 74* (8 November–8 December 1974). There were also many Italians who would later take part in the Ferrara Encuentro, as well as numerous Germans and Belgians who had been previously involved with CAYC events. For artists associated with Latin America, the lineup remained fairly consistent with that of the London screening: the works of Jaime Davidovich, Felipe Ehrenberg, Raúl Marroquin, Marta Minujín, and the CAYC Group made a return, while the works of Roberto Altmann and Lea Lublin were added (both Altmann and Lublin were living in Paris). A significant number of notable North American, Eastern European, and Japanese artists joined the roster, some through institutional affiliations. For example, the FAVIT Centre for Film Audio Video Research in Ljubljana would sponsor portions of the Encuentros in exchange for technical training for their students by CAYC. (Works by Marina Abramović, Sanja Iveković, and other artists living at the time in the former Yugoslavia were presented at the Encuentro.) Other artists appeared as a result of chance encounters. For example, the Massachusetts artist Donald Burgy, who worked with CAYC to produce various art books in the early 1970s and began to send tapes to the Paris Encuentro, said he originally met Glusberg in a New York City bar, where they discussed trends in the conceptual art world and from that point on collaborated exclusively via mail for years.[60] The Paris Encuentro added tapes by major US-based artists, including Eleanor Antin, John Baldessari, Douglas Davis, Terry Fox, Allan Kaprow, Les Levine, Antoni Muntadas, Nam June Paik, Martha Rosler, and Allan Sekula. Many of these tapes would be included in future editions.

THE III INTERNATIONAL OPEN ENCOUNTER ON VIDEO, PALAZZO DEI DIAMANTE, FERRARA, 25–29 MAY 1975

The third Encuentro was hosted by the Galleria Civica d'Arte Moderna at the Palazzo dei Diamante in Ferrara, Italy, co-organized by Glusberg, the curator Lola Bonora, and the gallery director Franco Farina, with technical coordination by Carlo Ansaloni. The Galleria Civica d'Arte Moderna's video program had been established by Bonora and Ansaloni around 1972 and would eventually be known as the Centro Video Arte.[61] The Encuentro, which was sponsored by Furman S.P.A., Sony's distributors in

Italy, was inaugurated on 25 May 1974, and for five days, video screenings and round-table discussions were held on the new medium.[62] The cover of the Encuentro catalog prominently notes "ediciones tercermundo presenta" (Third World Editions presents) (see photo essay fig. 3). Though the catalog itself does not really mention ediciones tercermundo further,[63] a press release for the event notes that the Encuentro would also feature on 17 May a screening of films made by Latin American artists. The list of films in the press release includes several works that were credited in the London Encuentro catalog as being produced by "Third World Editions" Cooperative, with additional works listed by Analivia Cordeiro, Angelo de Aquino, and Narcisa Hirsch, among others.[64]

The co-organizer for the Encuentro, Lola Bonora, was a key figure in the success of the early Encuentros. A curator as well as a video practitioner at the Gallerie d'Arte Moderna in Ferrara, Bonora was introduced to Glusberg by the critic Pierre Restany, and she brought tapes by Claudio Cintoli and Fabrizio Plessi to the London Encuentro.[65] Bonora participated in all of the European Encuentros, brought numerous Italian art-world figures and videos to the Paris Encuentro, and then greatly expanded this lineup for the Ferrara edition. In addition to bringing her own tapes, Bonora connected CAYC to artists from key institutions throughout Italy.[66] Italy had been particularly active as a site of video production in the early 1970s, with figures such as Bonora and Carlo Ansaloni in Ferrara and Luciano Giaccari in Varese establishing centers that not only showed video art but also worked with video production. Giaccari's organization Video Studio 970/2, for instance, helped the Brazilian artist Antonio Dias produce his first video, *The Illustration of Art / o. video (Music Piece),* in 1971.

Art/tapes/22 in Florence, founded by Maria Gloria Bicocchi, was without doubt the most significant early production center in Italy, despite its short life span of three years (1973–76). Conceived as both a video art production center and a video distributor, art/tapes/22 sponsored artists from across Europe and the United States to produce new video works using its equipment, studio, and technical assistance. From 1974 to 1976, the center's video technician was the US American artist Bill Viola, who was just at the start of his career. Art/tapes/22 is particularly notable for the caliber of artists who produced work there, including major Italian artists such as Alighiero Boetti, Pier Paolo Calzolari, Giuseppe Chiari, Jannis Kounellis, and Giulio Paolini, other Europeans such as Marina Abramović, Joseph Beuys, Daniel Buren, Rebecca Horn, and Arnulf Rainer; and US artists such as Vito Acconci, Chris Burden, Simone Forti, Dan Graham, Joan Jonas, and Allan Kaprow.[67] Bicocchi was credited in the Paris Encuentro's catalog for assisting with the organization (although it is not clear what she did) and for attending the event. She is not mentioned in the catalog for the Ferrara Encuentro, though art/tapes/22 contributed approximately ten works to be screened for the Paris and Ferrara events.

Many of the Paris Encuentro participants returned for the Ferrara edition, and the tapes heavily overlapped with those screened in Paris. While Glusberg's essay in the Paris catalog focused on video and the ideological struggle of the individual in creating a revolutionary language, his essay for the Ferrara publication (which is all in English) reflects on the tool in relation to the commercial industry of television. "A television audience generally thinks of TV in terms of a spectacle and absorbs it as a solution to his leisure; very few people do regard it as a means of research into reality and free expression, nor is it usual to think of it as a language through which creators communicate their values, codify and transmit their ideology."[68]

Glusberg's subtle but important shift in thematic focus reflects the ideas that were actively circulating within the alternative video and video art communities in the 1970s. Producing an alternative to corporate or national television that allowed for greater personal expression, fluidity of ideas, and broader representation of diverse viewpoints was a commonly shared goal among not only artists but also educators, political activists, and community organizers. Within the specific context of the Ferrara Encuentro and Italy's experimental art circles during the mid-1970s, video as an artistic tool would be part of a larger political debate surrounding the State-owned Radiotelevisione italiana's monopoly of television, something the constitutional courts would put an end to in 1976 with the decision to allow private networks to broadcast locally.[69] Therefore, "the roots of the Centro Video Arte branched out politically and aesthetically from an idea of shared information and communication."[70] This platform would define the work produced by Centro Video Arte as it evolved and solidified as an institution and would be a primary theme for other artists throughout art centers in Italy. Footage of the Encuentro, taken by the staff at Galleria Civica, shows that the roundtable focused heavily on the themes mentioned above: video is discussed for its subversive potential, and the participants agree that artists need to "take possession of video, diverting it from normal and expected uses."[71]

Throughout the Paris and Ferrara Encuentros, Glusberg heavily promoted the upcoming Encuentro in Buenos Aires, to be hosted at CAYC. In this sense, the London, Paris, and Ferrara Encuentos could be considered important sites of research for the first Encuentro to be based in Latin America. Just as Glusberg was bringing notions of Latin America to Europe, he would then bring global video art back to Argentina.

THE IV INTERNATIONAL OPEN ENCOUNTER (ON VIDEO), CAYC, BUENOS AIRES, 31 OCTOBER–14 NOVEMBER 1975

The Buenos Aires Encuentro was a unique and important event for video art in Latin America (see photo essay fig. 4). Indeed, Glusberg had constantly promoted its occurrence and emphasized its scale and significance in the mailed invitations:

> This is the first such international event to take place in Buenos Aires, and we are counting on the participation of a substantial group of artists from Europe, the United States, and Canada who have notified us of their decision to colaborate [sic] in this festival. Our intentions are (well defined): we want to carry on a dialogue in spite of the distance; we want to learn from the experience; we want to make it possible for video-makers from other centers in Latin America to exhibit their works; we want to succeed with such encounters so that—once and forever—Latin American artists can establish permanent contacts with their counterparts around the world. The artists and specialists at CAYC are putting special emphasis on their attempts to set up a Latin American circuit.[72]

While the first three Encuentros had focused on promoting Argentine conceptualism in European cities with active video art scenes, Glusberg was now focused on bringing video art back to Latin America. Having established networks with some of video art's most prominent names, CAYC would bring these figures to Buenos Aires for the fourth iteration, and the structure of the Encuentros would broaden from roundtables to include workshops and training for local and foreign art collectives to learn more about video.

The July invitation stated that the Encuentro would run until 7 November, but by October the flyers show it had been extended by another week, with additional workshops running through 14 November. During this period, the title was also shifted slightly to bring a broader focus. Publicity flyers referred to the event as "IV International Open Encounter on Video," but for the catalog, the title became "Video Alternativo: Fourth International Open Encounter" and the event expanded to include the "Primer Coloquio Latinoamericano de la Comunicación" (First Latin American colloquium of communication).[73] The Encuentro included screened videotapes during the day and talks from notable international figures in the art world, such as Florent Bex, Wulf Herzogenrath, and Antoni Muntadas, while the roundtables and workshops of the colloquium looked at the intersections between communications and other fields such as psychoanalysis, music, and architecture. This year saw important new additions of work from numerous locations throughout the Americas, as well as new participants

from Spain (see the Barcelona Encuentro, discussed below). It was widely attended by participants from around the globe, causing quite a scene at the CAYC headquarters. As Margarita D'Amico describes:

> Like all encuentros and festivals—of all kinds—there was order and disorder; equipment that worked and others that didn't; people who were interested and people who were on a different plane; people who celebrated the encuentro with enthusiasm, who believe in video as a medium of communication and serious artistic expression, and people who, genuinely, didn't see this, nor can they perceive its possibilities.[74]

The Buenos Aires Encuentro happened just a few months before the Argentine coup d'état in March of 1976, in which the military over-threw President Isabel Perón, an event closely monitored by onlookers around the world. The tension and fear in the country was palpable. For example, in February of 1975, shortly before the coup, the Argentine government launched a military operation to quash the Ejército Revolucionario del Pueblo (People's Revolutionary Army) in the Tucumán Province, resulting in the deaths of hundreds of left-wing guerillas;[75] and that June, the country saw soaring inflation rates of up to 35 percent a month. Glusberg's essay for the Buenos Aires catalog focused on the issues circulating in Argentine society as it faced tumultuous inflation, political controversy, and social unrest:

> The question, "how much will a kilogram of meat cost next month?" would certainly be more appropriate at this moment than an attempt to understand artistic works. . . . As a result, these facts make us think about the context in which art is produced in Latin America. This catastrophic and "terrorist" inflation, these macabra [sic] revenges, are the results of political problems. And it is for that reason that Latinamerican [sic] art cannot avoid being political, or to be more precise, ideological.[76]

The tapes exhibited drew extensively from the previous Encuentro participants but with the addition of many more Latin American artists, most notably from Brazil.[77] CAYC had been connected to and involved with Brazilian artists through collaborative exhibitions as well as par-ticipation in the 11th and 14th São Paulo Bienales. The Buenos Aires Encuentro was timed to overlap with the dates of the XIII International Bienal, São Paulo (17 October–15 December 1975), presumably to attract greater international attendance at the Encuentro from people who were already traveling to South America to attend the Bienal.[78] This iteration of the Bienal included a particularly strong showing of video art from the United States, though the genesis of those inclusions is one of the stranger stories in the history of video art, and a story that would eventually intersect with that of the Encuentros.

In January 1975, Philadelphia's Institute of Contemporary Art (ICA) at the University of Pennsylvania would mount the exhibition *Video Art*, perhaps the most significant international survey exhibition of video art to have been presented in the United States at the time. Organized by the ICA's director, Suzanne Delehanty, the exhibition surveyed video from across the United States, Canada, Europe, Japan, and Brazil. Delehanty was particularly drawn to the portability of video, realizing that it could allow the ICA to mount a significant and broadly international project on a limited budget. Unable to travel to every country herself, Delehanty began reaching out to a network of international curators in 1973, asking them to help make an initial selection of tapes. The curators included (among many others) Barbara London and David Ross in the United States; Peggy Gale in Canada; René Block in Germany; Fujiko Nakaya in Japan; and Walter Zanini in Brazil. In the case of Brazil, Delehanty was not aware of any video artists, but she assumed they were there, given the importance of the São Paulo Bienal as a contemporary art event.[79] At the time Delehanty contacted him, Zanini, the director of the Museu de Arte Contemporânea da Universidade de São Paulo (MAC USP), was also not aware of any video artists in Brazil; however, he knew artists that he felt could produce good work if they had access to equipment. He contacted artists in São Paulo and Rio de Janeiro, and several artists in Rio (Sonia Andrade, Fernando Cocchiarale, Anna Bella Geiger, and Ivens Olinto Machado) were able to secure access to an American portapak camera in time to produce work for the ICA exhibition—work that would be some of the most significant early video art produced in Brazil.[80] Zanini would feature the works in 1974 at the eighth iteration of *Jovem Arte Contemporânea* (JAC; Young contemporary art) at MAC USP and also acquire the works, thus having MAC USP act as lender to the *Video Art* exhibition at the ICA. Work by the Brazilian artist Antonio Dias would be added to the ICA show through the participation of art/tapes/22 in Florence, which had produced or distributed eight works in the exhibition.

In 1975, *Video Art* traveled to the Contemporary Arts Center in Cincinnati (22 March–30 May), the Museum of Contemporary Art in Chicago (28 June–31 August), and the Wadsworth Atheneum in Hartford (17 September–2 November). Jack Boulton, the director of the Contemporary Arts Center, had also been appointed United States Commissioner for the 1975 São Paulo Bienal. Boulton had the idea to tour the exhibition to São Paulo, and under his direction the Canadian, European, Japanese, and Brazilian artists were all removed from the checklist. The show, rechristened as *Video Art USA*, was presented as the US contribution to the Bienal, along with a new Portuguese catalog with essays by Boulton and David Ross (and no essays carried over from the ICA exhibition) (fig. 9).[81] The exhibition was sponsored under the auspices of the United States Information Agency, the former public relations branch of the US government tasked with promoting positive

| Fig. 9. Cover of *Video Art USA: XIII São Paulo Bienal,* exh. cat. (São Paulo: n.p., 1975).

(often propagandistic) views of the United States both domestically and abroad. To manage logistics for the tour, a new nonprofit was founded in New York: Independent Curators International (ICI).[82] The artist Eleanor Antin recalls being instructed that no tapes featuring political commentary could travel to São Paulo.[83] Following the Bienal, the exhibition was retitled again as *Video arte;* a third catalog, in Spanish, was published;[84] and the exhibition continued traveling, as a survey of United States artists, to Santiago, Lima, and Bogotá throughout the spring and summer of 1976.

Given that the *Video Art* exhibition at the ICA Philadelphia had encouraged a group of Brazilian artists to begin experimenting with video, it seems particularly unfortunate that the Brazilian artists were removed from the US-only version of the show that traveled to Brazil for the Bienal and then throughout Latin America.[85] In many instances, this exhibition would be the first encounter that visitors had with video art.[86] The Philadelphia version of the show also serves as an instructive

case study when compared to the Encuentros. Both had a broadly shared goal of presenting video art as a global medium with multiple thriving artistic centers around the world. But, while the Encuentros accepted tapes through multiple avenues, including open submissions and direct contact from artists, the ICA exhibition used an international network of established curators to act as regional advisers, offering narrower lists of who they felt were the strongest artists. Today, the ICA exhibition appears particularly prescient in its checklist of artists who for the most part remain seen as the pioneers of video art around the world, whereas the Encuentro checklists can be particularly striking for their lists of artists and collectives that even specialists may have never encountered. Nonetheless, nearly 60 percent of the artists featured in the Philadelphia version of *Video Art* presented work in at least one Encuentro, and approximately 25 percent of them presented work in the Buenos Aires Encuentro, which overlapped by three days with the exhibition's presentation at the Wadsworth Atheneum and overlapped entirely with the presentation of *Video Art USA* at the Bienal.

Most importantly, the Buenos Aires Encuentro included a majority of the Brazilian video works that were created for the ICA Philadelphia exhibition, and a significant group of Brazilian artists are said to have attended.[87] The event also included talks and discussions from an impressive list of Argentine artists and cultural figures, including Antonio Berni, Jorge Luis Borges, Néstor García Canclini, Roberto Jacoby, and Rafael Viñoly. The artist Álvaro Barrios would provide insight from Colombia, and Margarita D'Amico would represent Venezuela. (In a review of the Encuentro, D'Amico confirms that the works from Álvaro Barrios, Fernando Cocchiarale, Juan Downey, Paulo Herkenhoff, Jonier Marin, Regina Vater, and Group Videamus and a showcase of four video-collages she had collected in Cuba were all screened successfully at the Encuentro.)[88] CAYC summaries of the Buenos Aires Encuentro also mention that artists from Peru and Mexico were present, though it doesn't give specific names.[89]

Canada, a significant player in the global expansion of video, had contributed tapes to the prior Encuentros—but at the Buenos Aires Encuentro, the country became a focus.[90] Three Canadian video artists were hosted at CAYC: Amerigo Marras, Terry McGlade, and Bill Vazan (fig. 10). In the catalog, Vazan is listed as giving a talk, "VIdeo in Canada"; however, it became instead a panel discussion among the three Canadian artists, Margarita D'Amico, and Antoni Muntadas.[91] Vazan recalled that in addition to having a solo exhibition opening at CAYC on 12 November 1975, he participated in an interview with D'Amico about his work and acted as a cameraman for an interview that D'Amico conducted with Jorge Luis Borges (fig. 11).[92]

As a corollary to the Canadian artists' panel, the German curator Wulf Herzogenrath presented a talk titled "Video in Europe." One of

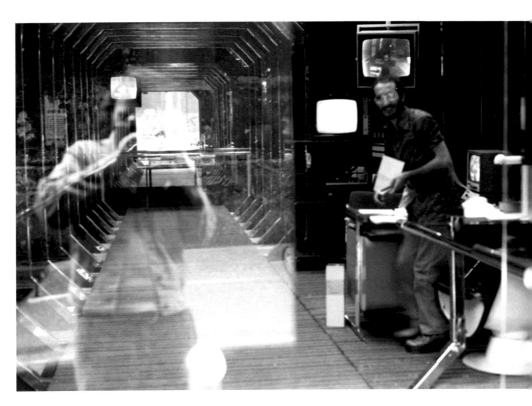

the most significant German curators to engage early on with video art, Herzogenrath was at the time the director of the Kölnischer Kunstverein. For *documenta 6* in 1977, Herzogenrath curated a section devoted entirely to video art, which was likely the most important and widely seen presentation of video art to have taken place in Europe up to that point. Herzogenrath was likely already at work on the *documenta* presentation when he traveled to Buenos Aires for the Encuentro. In addition to his talk, Herzogenrath contributed to the screenings a tape documenting projects at the Kölnischer Kunstverein by artists including Vito Acconci, Valie Export, Joan Jonas, and Ulrike Rosenbach. These tapes and presentations by international figures would give audiences in Buenos Aires key insight into how parallel institutions were functioning. It would also reveal crucial differences in the hemispheric privilege afforded North American and European artists. It is unclear what works Herzogenrath may have encountered in Buenos Aires. That said, *documenta 6* included about half of the US American and European artists featured in the ICA Philadelphia *Video Art* exhibition, but no artists from Brazil or Japan, which had been areas of focus both in Philadelphia and at the Encuentro.

THE V INTERNATIONAL OPEN ENCOUNTER ON VIDEO, THE INTERNATIONAAL CULTUREEL CENTRUM, ANTWERP, 16–22 FEBRUARY 1976

Throughout the Encuentros, Florent Bex, the director of the Internationaal Cultureel Centrum (ICC) in Antwerp, had been a frequent participant, both in providing tapes and as an attendee of the roundtables and presenter on certain panels. Glusberg often consulted with Bex on the expanding lists of European artists, curators, and critics that were invited to the Encuentros.[93] Bex had attended all of the Encuentros up to this point, including the Buenos Aires Encuentro, during which he held a panel, "Art and Video." The ICC had previously hosted the CAYC show *Kunstsystemen in Latijn-Amerika* in April to May of 1974, where a "pre-Encuentro" had been held during the exhibit's opening of Latin American Week. According to Bex, no catalog was published for the Encuentro, only leaflets and flyers.[94] These leaflets, which are similar in format to standard CAYC press mailings, initially listed more than two hundred "artists who have confirmed their participation." A more detailed list, likely distributed at the event, lists approximately 125 tapes by 66 artists, many repeated from prior Encuentros.[95] Bex recalls that for the Antwerp Encuentro "we installed viewing places with comfortable seats in different rooms, programming only a few artists on each monitor," also noting that each viewing program was approximately one hour long.[96] A special program on 20 February focused on video art from Poland, introduced by the artist Jan Świdziński. The schedule includes an introductory text and manifesto-like statement on "Contextual Art" from artists who had participated in

Fig. 10. Bill Vazan takes a picture of Amerigo Marras in the CAYC gallery space during the Buenos Aires Encuentro, 1975.

Fig. 11. Bill Vazan (Canadian, b. 1933). Images of the Buenos Aires Encuentro, contact sheet, 1975. The second line of film includes scenes from an interview Vazan shot with Borges; the fourth line depicts Glusberg driving; and the final two lines show images of the Encuentro.

Fig. 12. Panel discussion at the Antwerp Encuentro, 1976. Jorge Glusberg is on the left and Florent Bex is second from right.

Fig. 13. Panel discussion at the Antwerp Encuentro, 1976.

Fig. 14. An audience member asks a question during a panel at the Antwerp Encuentro, 1976.

the Workshop of Film Form based in Łódź, Poland.[97] CAYC had had a previous relationship with Poland beyond the Encuentros; most notably, El Grupo de los Trece had been inspired by a workshop at CAYC held by the Polish avant-garde director Jerzy Grotowski in November of 1971.[98]

A press release dated 31 January 1976 lists eight Belgian artists as having confirmed their participation in the Encuentro, but the screening lists for the Encuentro note only two: the architect Luc Deleu and the conceptual artist Jacques-Louis Nyst.[99] Working documents for the event also list a group of seven tapes to be lent by De Appel art center in Amsterdam (including works by Chris Burden, Nan Hoover, and Gina Pane), but it is unclear whether these works were screened. From Germany, Bex and Glusberg screened a recording of the musician Albrecht/d. and Joseph Beuys performing at the London ICA (1974),[100] Yürgen Oster's tape *Casablanca I*, and Wolf Vostell's *T.O.T. (Technological Oak Tree)* (1972). From Great Britain, there were returning works from COUM Transmissions and new ones from Reindeer Werk, Chris Sarrat, and Adiauvision TV Studio. Gerald Minkoff represented Switzerland; Brazil was represented by Letícia T. S. Parente's *Preparation II*, along with *Wireless Telephone*, a work produced by a group of artists led by Anna Bella Geiger who play the children's game of Telephone. Luis M. de Jesús represented Puerto Rico with *Pilea Sprucena*, which was also shown at the Belgium Conceptual Video Contest in 1977.[101]

Press coverage of the Antwerp Encuentro presented the event as among the seminal exhibitions initiating a video art scene in Belgium.[102] David Hall described the Antwerp Encuentro as "highly successful and well attended by video-makers from all over Europe," encouraging video art to thrive in Belgium amid institutional skepticism (figs. 12–14).[103] Following the Encuentro, Bex and Glusberg continued to collaborate on the Encuentros along with other various exhibitions: for example, CAYC and the ICC held *Contemporary Belgian Artists* at the Museo Genaro Pérez in Córdoba, Argentina, in April–May of 1976, which then traveled to the Museo Provincial de Bellas Artes Rose Galisteo de Rodríguez in Santa Fe, Argentina, in July 1976.

THE VI INTERNATIONAL OPEN ENCOUNTER ON VIDEO, MUSEO DE ARTE CONTEMPORÁNEO, CARACAS, 25–30 JANUARY 1977

In his essay for the Venezuela Encuentro catalog, Gerd Stern, a US American Beat poet turned entrepreneurial media exporter occasionally working in Caracas, comments on the remarkable flood of video submissions to the Encuentro:

> Tapes have been pouring into the Museo de Arte Contemporaneo, under whose auspices, Jorge Glusberg will stage his encounter in

Caracas. They arrive in brown paper bags, in bandaged boxes, in fancy containers from all over the world, like so many Christmas gifts. And very much like those offerings we receive every year, some of the tapes are useful, interesting, colorful, disgusting. Others are beautiful, unintelligible, disturbing, conceptual. The mass of tapes which still comes pouring in represents communications from aficionados in anthropology, philosophy, medicine, sociology, art, and journalism, etc.[104]

By the time of CAYC's Encuentro in Caracas, the city had already seen numerous large-scale exhibits of media arts and video, and it was a burgeoning site for experimental video and artistic theory. Venezuela's awareness of and participation in video art production and exhibition was promoted in Caracas particularly by Margarita D'Amico, a popular art theorist and historian and a professor at the School of Social Communication at the Universidad Central de Venezuela (who had attended the Buenos Aires Encuentro), and Sofía Imber, the director of the Museo de Arte Contemporáneo de Caracas (MACC), who would make numerous connections in the American video art world through various trips to New York City. (MACC already had a fairly impressive collection of video art from the United States and Canada.) While announcements for the event show that the date was originally set for September of 1976, the Caracas Encuentro actually took place several months later, in late January of 1977. The Encuentro was organized by Glusberg and Imber, and the catalog is titled *1977 Video: Encuentro Internacional de Video* (see photo essay fig. 5). Featuring essays by Glusberg, Imber, and Stern, it was the first (and only) edition with essays by someone other than Glusberg.

The catalog opens with an essay by Imber that reflects on the polarized reactions to video art during the exhibition *Arte de video* (fig. 15), which she had organized in Caracas in April of 1975:

> Almost fifty thousand people, mostly young, crowded into the halls of the museum, anxious to see what can be done with this new medium. . . . The reactions of those who usually write about art were hesitant, revealing that sometimes the public is much more advanced than the critics. Maybe not even sometimes. Maybe always. It is indeed probable that every revolution and every innovation in communication techniques, has been met with the same misunderstanding, or equal resistance on behalf of the "experts" in the previous forms, who each time will feel threatened in their habits and prestige. On the other hand, artists, who are the creators of something, eagerly explore everything that broadens their means of expression; and the public, if invited with intelligence and skill, delightedly discover the enrichment of these possibilities of perception.[105]

As Imber points out, multimedia exhibitions in Venezuela had up to this point been marked by both enthusiasm and controversy. Though using film rather than video, the "birth of multimedia installations" in Caracas is often considered *Imagen de Caracas*, a government-sponsored exposition that celebrated the quadricentennial anniversary of the city, realized in 1968.[106] Starting in 1966, officials in the city hired an important lineup of artists and intellectuals, including Jacobo Borges, Juan Pedro Posani, and Mario Robles, among many others, to transform the public space of

El Conde Park and tell the history of Caracas for the public. The giant exhibit was held within a metal structure that covered 10,000 square meters;[107] inside, the audience was presented with an impressive maze of ramps and paths that led to a group of eight large 35mm projectors that showed the committee's films recounting the history of Caracas. The footage, presented in a neorealist style, was particularly critical of colonialism. As can be imagined, this sparked intense controversy, and the structure was shut down by government officials after two months, when

| Fig. 15. Cover of *Arte de video*, exh. cat. (Caracas: Fundación Museo de Arte Contemporáneo de Caracas, 1975), signed by Charlotte Moorman for Margarita D'Amico.

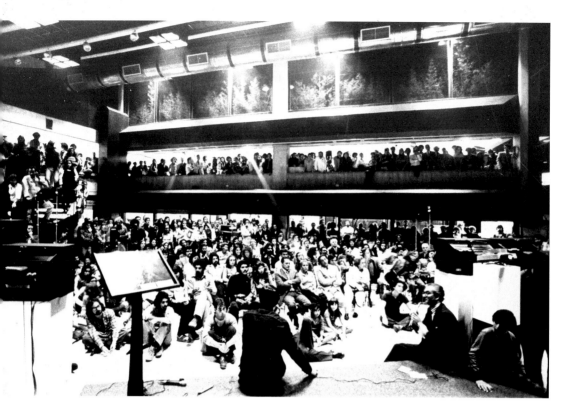

Fig. 16. Douglas Davis
talks with Carlos
Rangel at the *Arte de
video* symposium,
Caracas, 1975.

Fig. 17. Charlotte
Moorman performs
Yoko Ono's *Cut Piece*
(1964) at *Arte de
video,* Museo de Arte
Contemporáneo de
Caracas, 1975.

authorities claimed the cost of operation was too high to maintain. This poignant moment of commemorating four hundred years of Caracas's history and the controversy that ensued characterized many of the future discussions that would surround video and media installations in public spaces and institutions.

Gerd Stern was one of the founders of the media collective USCO (short for The Us Company, or The Company of Us), and by the early 1970s he had decided to try his hand at producing international multimedia art installations as a business. In 1971, while he was in the early stages of building that company (Intermedia Systems Corporation) and also teaching communications at the Harvard Graduate School of Communication, Stern was approached by José Ignacio, a representative of the Ministry of Public Works in Caracas, to produce a multimedia project in Venezuela.[108] As he spent increasingly more time traveling between Cambridge and Caracas, Stern became friends with Imber and other notable personalities from the Caracas art world. In 1972, Stern organized a seminar at MACC with the video artists Woody and Steina Vasulka, and in 1975 helped Imber plan the wildly popular *Arte de video* exhibition in Caracas. Numerous artists attended this exhibition to give performances and hold conversations, and Stern brought more than two dozen tapes to screen.[109] Douglas Davis put together an additional collection of his tapes and organized a symposium (fig. 16). Charlotte Moorman gave live performances of multiple artists' works, including Nam June Paik's *TV*

Bra for Living Sculpture (1969), Yoko Ono's *Cut Piece* (1964), John Cage's *26'1.1499 for a String Player* (1955), and Takehisa Kosugi's *Chamber Music* (1962), among others (fig. 17).[110] These performances from Moorman were very well received and led a Caracas newspaper to deem Moorman "La Juana de Arco de la nueva música" (the Joan of Arc of new music).[111] For the panel discussion, Jacobo Borges, Margarita D'Amico, and Régulo Pérez represented the Venezuelan perspective on alternative video.[112] Additionally, Stern tracked down posters of other global video art shows and collectives to display in galleries so that audiences could see what else was going on internationally. While Imber reported nearly 50,000 visitors to *Arte de video*, D'Amico reports that the exhibition had 57,000 attendees over the sixteen days it was open.[113]

The artist Les Levine, also in Caracas at that time, caused much controversy over *Arte de video* when he publicly commented that he thought the pieces Stern had provided to MACC were stereotypical and unoriginal. In an interview with *El Nacional* (14 May 1975), Teresa Alvarenga asked what Levine thought of *Arte de video*. He opined:

> It's the marijuana group. That is, people who are interested in translating the experience of drugs with electronic effects into video, and they represent the standard group of David Ross. . . . In my opinion, only four of these artists are worthwhile: Nam June Paik, Keith Sonnier, Allan Kaprow, and Peter Campus, and the

rest of these people aren't serious enough to be shown in such an exhibition.[114]

Two weeks later, Stern published a reply saying all of the artists were chosen because they were devoted to video exclusively and not "generalists" like Levine; that the "marijuana" label was a symptom of anti-Communist rhetoric and propaganda from the Cold War era; and that David Ross had nothing to do with the show.[115] This episode epitomizes the lack of consensus about quality that would circulate in conversations about video exhibitions in the 1970s. Nonetheless, the show made international waves. Grace Glueck cited the show in a *New York Times* article on the growing trend of video art festivals worldwide.[116]

In the catalog for the Caracas Encuentro, MACC includes a list of twenty-nine video artists who were in the collection of its videothek; this included many US artists who had participated in the previous *Arte de video* exhibition (Stephen Beck, Chris Burden, Shigeko Kubota, Charlotte Moorman, and Nam June Paik among them) as well as the Venezuelan artists Régulo Pérez and Pedro Terán. Though Stern was not in Venezuela at the time of the Encuentro (he and his wife were expecting their first child),[117] he was in steady contact with Imber and helped her plan the technical logistics of the event via written correspondence, recommending how to set up the schedule, galleries, and monitors. Stern's essay for the catalog, written in English, emphasizes the concept of the "Encuentro" and encourages viewers to keep an open mind. He also references Glusberg's controversial reputation in a fairly surprising way:

> Communication is, in the best sense an "experience" in which all human beings can participate and which they can make available to each other in sharing the "being" of humanity. The encouragement of this sharing is what I believe Jorge Glusberg is about. In certain circles of video "art" he has been criticized as being indiscriminate, undisciplined, naïve, political, polemic. He may be all of these things but for a number of years he has also been a Santa Claus . . . bringing us a range of gifts of "experience."[118]

However, when the essay was translated into Spanish, the comments about Glusberg were reworded to be about "video art" in general: "In certain circles, video art has been criticized as being indiscriminate . . . it is possible that video art is all these things but for a number of years it has also been a Santa Claus."[119]

Glusberg's essay in the catalog follows a pattern similar to that of his previous essays, stating that video is an extension of mass communications and emphasizing its radical potential in alternative uses. Echoing many of the artistic manifestos of the 1970s, the essay closes with a discussion of video as a tool for building the future and as a remedy for the present: "With the possibilities of the video, creators can choose between

different futures; elaborate and re-record desired futures. You can also go back, then return to the present, and from there correct behaviors to improve social relationships."[120] As the essays from Imber, Stern, and Glusberg discuss, this Encuentro was designed and shaped to emphasize the idea of using the museum gallery and public spaces to confront the public with new ideas in an open and unbiased way.

For this edition of the Encuentro, it is unclear exactly what tapes were screened. The catalog was printed in January—before the event—and includes a list of names organized by country that matches the lists of participants that were sent out on CAYC bulletins as promotional material.[121] The largest groups of names are from Belgium, Brazil, France, Germany, Italy, Japan, and especially the United States. Latin American countries besides Argentina and Brazil are also included, but only very marginally: Group Videamus and Jonier Marin represent Colombia; Sub-Secretaría de Radio Difusión and "Estudios Churubusco" represent Mexico; Francis Schwartz represents Puerto Rico; and Cine Video U.C.V. and Itamar Martinez represent Venezuela. Three panels were listed in the promotional flyer: "Communication and Literature," organized by Juan Liscano; "Communication and Art," coordinated by Jorge Glusberg; and "Communication and Architecture," coordinated by Rafael Viñoly.[122] The announcement also says that videotapes will be shown by "European, Canadian, Latin and North American, Australian, and Japanese artists."[123]

Perhaps already overshadowed by *Arte de video*, the Encuentro was followed by another highly popular and acclaimed exhibit, *Muestra de video del Primer Festival de Caracas* (Video show of the first festival of Caracas), held at the Biblioteca Central at the Universidad Central de Venezuela from 2 to 9 February 1979. The festival was overseen by Salvador Itriago, while the video portion was curated by D'Amico. Unlike its predecessors, this show almost *exclusively* focused on Latin American artists and is one of the earliest and most significant efforts of its kind. The list of those who submitted tapes and attended is extensive. According to the catalog, participation was solicited from the column El espacio y su memoria (Space and memory) in *El Nacional*, Caracas, in December of 1978.[124] The catalog gives a detailed look at the "video participants" as well as a very detailed chronology of video art activity in Venezuela up to that point, starting in May 1971 with the release of D'Amico's newspaper column Imágenes del futuro (Images of the future) in *El Nacional*, which covered international events in multimedia and video art, and ending with their current *Muestra de video* that February of 1979. The range of videos exhibited in the show covers those working in "education, industry, politics, and art," and D'Amico commented that this history and exhibition confirms that "even though there are very few people in our country dedicated to the study of new media, they do exist and have demonstrated that they prevail nonetheless."[125]

THE VII INTERNATIONAL OPEN ENCOUNTER (ON VIDEO), FUNDACIÓ JOAN MIRÓ, BARCELONA, 22–27 FEBRUARY 1977

Only a month after the Caracas edition, the seventh Encuentro opened at the Fundació Joan Miró in Barcelona (see photo essay fig. 6). The Fundació had opened to the public in June of 1975 as a space to exhibit Miró's work and to sponsor new experiments in contemporary art. Like the Buenos Aires edition, the Barcelona Encuentro consisted of extensive screening programs alongside a colloquium on communication, both of which coincided with the opening of the CAYC-organized exhibit *Amèrica Llatina '76* (22 February–27 March 1977), a modified version of *Art Systems in Latin America*. The catalog for this exhibition is in Catalan, while the Encuentro publication is in English. These events were co-coordinated by Francesc Vicens, the director of the Fundació between 1974 and 1981.[126] This would be the final Encuentro in Europe.

In the years leading up to and following the dictator Francisco Franco's death in November of 1975, the cultural landscape of Spain was going through dramatic transitions. Barcelona, which had been strongly anti-Franco and as a result horrendously oppressed by his regime, was at this point redefining and redeveloping its distinct voice on a domestic and global scale. This was evidenced by a flourishing scene of experimental Catalonian filmmakers who had their own festival at Fundació Miró the week before CAYC arrived.[127] The Encuentro would also very much fit into this greater process of regaining cultural visibility. As the Catalan language had been banned from the public realm under Franco, reclaiming it in institutional materials such as an exhibition catalog or brochure would unquestionably be a political act in itself.

The Colloquium on Communication accompanying the Encuentro ran from 23 to 25 February. Tapes were installed on sixteen monitors in one of the gallery rooms and available for public viewing from 22 to 27 February.[128] A brochure from Fundació Miró shows that a panel originally titled "Communication and Art"[129] was later changed to "Current Artistic Practice in Times of Change," while the other two panels remained the same: "Communication and Video" and "Communication and Architecture." For the discussions, the usual participants, listed as Florent Bex, Margarita D'Amico, Hervé Fischer, David Hall, Wulf Herzogenrath, Lea Lublin, Katsuhiro Yamaguchi, and the CAYC Group, among others, also met with key figures from Barcelona's art scene.[130]

In the CAYC catalog, Glusberg's essay "The Semiotics of Video-Art" steps back from emphasizing the Latin American struggle and focuses extensively on the notion of technological progress.[131] The social and political function of avant-garde art was a key issue that was discussed in the panels. Following the Encuentro, Glusberg wrote an extensive description of the events in *Leonardo* magazine, summarizing the main arguments of panelists such as Lola Bonora, Joan Costa, D'Amico, Gillo Dorfles,

Fischer, Daniel Giralt-Miracle, and Yamaguchi.[132] From Glusberg's review, it appears critics were either unconvinced or undecided as to whether video could connect the artist to a greater public, but the symposium overall produced fruitful dialogue on this contention. Though Glusberg doesn't offer an analysis of the discussions, he asserts that what he "obtained from the participants was that the Symposium was very useful to them and that similar exchanges of experiences and views should be arranged."[133]

While many of the Encuentros appeared in local papers as announcements (often written by Glusberg), critical reviews were more rare. However, for the Barcelona Encuentro, several pieces of written commentary on the event circulated in the wave of new art journals that had started publishing in the early to mid-1970s.[134] The Catalonian critic and art historian Giralt-Miracle (a participant in the "Communication and Video" panel), praises the show for making Barcelona the "World Capital of Alternative Video" by eliminating "censorship of any kind . . . thus enabling an international confluence of efforts difficult to achieve by any other procedure."[135] He also summarizes the major trends in video practice for readers: those that emphasize the aesthetic aspects of video; those that focus on the creative process and semantics of the medium; and those that prioritize political subversion through the dispersion of information. Together, these efforts aim to deconstruct the "hypnotizing power of mass media and offer real communication between sender and receiver."[136] Giralt-Miracle's review (as well as the one he published in *Guadalimar*[137]) reiterates the various projected focuses of the Encuentros and posits the event as thus highly successful. A review by J. Corredor-Matheos similarly praises the uncurated nature of the show, but his overall takeaway is less positive: "The results are still, altogether, rather poor . . . few of the pieces are interesting enough to hold one in front of the screen."[138]

While these reviews present the Encuentro in a comprehensive light, a review by Andreu Avel·lí Artís (under his pseudonym Sempronio) gives a more behind-the-scenes commentary. Sempronio says that Vicens told him, "You have no idea how many tapes we received! Incessantly they were coming from all over the world."[139] This caused problems, as there was no international standard for display, and so the gallery, which had sixteen monitors of all shapes and sizes,[140] ended up resembling a "TV sales room."[141] The chaotic gallery was maintained by young students, one of whom described his confusion: "I joined the tiny group of onlookers. The truth is that nobody knew what was going on."[142] Two reviews from *Zoom: Revista de la imágen*, however, hold nothing back. In his review, Eugenio Bonet wrote:

> The disappointing results of this Encuentro and the incorrect and false information that has been disseminated about it, requires that some points are clarified in light of the prestigious image that has been promoted. It is important to avoid the deformations and

manipulation of facts that lead to distant considerations and the creation of sterile gatherings surrounding this medium. The video meetings organized by CAYC are conceived as open and intimate shows . . . in which it is intended to condense in a week a huge, disproportionate, and indiscriminate amount of videotape. The show thus becomes a kind of avalanche of materials, without providing an effective body of information; this issue is more serious in our country given the scarcity of information and access to the medium. . . . 240 videos were announced, but there were only about 80 tapes, and it is interesting to note that even among the Spanish participants it was impossible to see more than one tape. . . . [O]f the nineteen people announced [for the panels], twelve attended, and only six participated in the panel along with some other speakers who improvised at the last moment.[143]

This review encapsulates the problematic nature not just of the Barcelona Encuentro but of all ten editions: the scope and ambition was simply beyond the technical means of almost any organization at that point, but for visitors this could be seen as more than a technological failure. Reflecting recently on this history, the artist Antoni Muntadas suggested that a common problem may have been that the Encuentros failed to adequately be in dialogue with or responsive to the local video communities in each city, thus broadcasting the existence of an international video art network to which local participants felt neither connected nor welcome.[144] Some viewers were able to gain an understanding of the various trends and discussions occurring around the medium if they already had some grasp of the field, but by no means would these Encuentros provide general audiences or even local practitioners with any coherent histories or narratives about alternative video. It was in all senses an "Encounter" and perhaps absolutely nothing more. Nevertheless, it is crucial to note that even in the Encuentros' failures, what was promised on paper sheds light on the networks of communication and exchange that Glusberg and his co-organizers were trying to establish; and that, despite the pandemonium, the Encuentros could also inspire new collaborations and connections.

The second review (author unknown) from *Zoom* demonstrates this. It is openly critical: "The VII Open Video Encounter, organized by the CAYC and held within the framework of the Miró Foundation, will remain in Barcelona's cultural memory as one of the most disappointing episodes."[145] However, the review then goes on to discuss how Margarita D'Amico and Manuel Manzano, disgruntled with the Encuentro, decided to hold their own seminar outside the Fundació Miró from 28 February to 6 March, using equipment donated by Antoni Muntadas and Mireia Sentias. Their seminar consisted of a week of daily training sessions that helped students make videos examining four neighborhoods in the city. From this training session, the Video-Nou Collective was formed.[146]

THE VIII INTERNATIONAL OPEN ENCOUNTER ON VIDEO, GALERÍA BANCO CONTINENTAL, LIMA, SEPTEMBER 1977[147]

The Encuentro in Lima served as both the eighth installment of the International Open Encounters on Video for CAYC and the first edition of the Nacional Encuentro de Video Arte for Peru (see photo essay fig. 7). It was held as a collaboration between CAYC, the Produciones Cinematográficas Nacionales (PROCINE), the American Embassy in Lima, Centro de Teleducación de la Pontificia Universidad Católica (CETUC), Metálicos Unión, and Telesud Peruana S.A.[148] The show opened on 16 September 1977 and was held at the Galería Banco Continental in conjunction with the opening of the CAYC-organized exhibition *La década de los 70s* (The seventies).[149] Glusberg co-organized both events with Alfonso Castrillón, then the director of the Galería Banco Continental. The catalog was printed locally in Lima and was written in English, with an essay by Glusberg titled "Alternative Video, Video Art" that combines and rearranges texts from his previous Encuentro contributions.[150] After Glusberg's essay, the catalog lists the participants and their tapes by country.

Prior to this Encuentro, the only Peruvian artist to regularly appear in the Encuentro catalogs was Rafael Hastings, who had been living in France since the 1960s. Hastings was one of the first Peruvian artists to experiment with video art, which he did while studying at the Agence Française de l'Image, Paris, in 1967.[151] Hastings began collaborating with CAYC in 1973, and he exhibited his work in the first three Encuentros as part of the Grupo CAYC tapes.[152]

Glusberg's co-organizer Castrillón was a prolific advocate of experimental arts in Peru. When the artist Francesco Mariotti returned to Peru from Europe in 1971, Castillón approached him about doing an exhibition organized around the kinetic and light-based sculptures he had produced for *documenta 4* and the X International Bienal, São Paulo.[153] Instead of a solo show, they created the Contacta-Festival de Arte Total, which celebrated multidisciplinary art that directly engaged with audiences.[154] Though the project did not include video, it was a predecessor in its embrace of conceptual art forms and interactive environments, including experimental cinema, theater, and performance (as well as poetry, yoga, and crafts).[155] Mariotti continued to work with electronic art forms in Lima, including the re-creation of the ambitious light and sound environment he had made for the São Paulo Bienal, *El movimiento circular de la luz* (The circular movement of light).[156]

The first exhibition of video art in Peru was almost certainly *Video arte*, the touring version of *Video Art USA* that had been presented at the XIII International Bienal, São Paulo, and that itself consisted of only the US-based artists from the international exhibition *Video Art* first presented at the ICA Philadelphia in 1975. In Lima, the Instituto de Arte Contemporáneo at the Museo de Arte Italiano hosted the show,

presenting thirty-two works of video in three "environments."[157] The show was free to the public and, according to the newspaper *La Prensa*, "three environments had been assembled to project the works in the exhibit: one was a special panel with a curved surface and made of highly reflective aluminum. The second, a kind of 'TV garden' where 24 devices simultaneously broadcast emissions with works by different artists. The third was a projection room, also with simultaneous broadcasts."[158] Unfortunately, further information on *what* was broadcast is lacking, but it was probably the same checklist of works that had first toured to São Paulo. Nam June Paik's *TV Garden* (1974) had been part of the exhibition since its first incarnation at the ICA Philadelphia, though it is highly unlikely that the work was presenting video by artists other than Paik.[159] At this moment, the term *video art* itself did not have a well-defined meaning in Peru. Around the time of the 1977 Encuentro, *La Prensa* made free use of the term, listing various public screenings of television shows as "Video Art." For example, in September of 1977, a BBC documentary series, *Spirit of the Age*, was screened as video art.[160] Such labels highlighted the newness of the medium in Lima during this period as well as the confusion surrounding what the term entailed.

Press for the 1977 Lima Encuentro listed tapes from Belgium, Brazil, Canada, Colombia, England, France, Japan, Spain, Switzerland, the United States, and Yugoslavia, and called the event a "dialogue between artists and local experts" during a panel on communication and video.[161] It also emphasized how the Encuentro was part of an effort to increase cultural exchange between Argentina and Peru. Enrique Ballón and Desiderio Blanco from the Universidad Nacional Mayor de San Marcos and the artist Rafael Hastings were identified by the press as representatives for Peru, while Argentina was represented by Glusberg (fig. 18) and the architects Horacio Antonacci and Carlos Sallaberry. Exhibited tapes included those by the Peruvian artists José María Eguren, Rafael Hastings, Roberto Lima, and Po-Chu Yi, and by CETUC.

At the same time as the Encuentro, the Pontificia Universidad Católica was holding its III Festival de Teleducación, Cine, Radio y Televisión from CETUC (also participants in the Encuentro, as noted above). This festival focused on educational video that was being produced for broadcasting purposes, not "alternative video" specifically.[162] As the video art historian Max Hernández Calvo points out, the 1976 *Video arte* exhibition did not include Peruvian artists, while the Lima Encuentro did, "therefore making [the Lima Encuentro] the first platform for showcasing Peruvian video works."[163] José-Carlos Mariátegui recounts that the Lima Encuentro was a resounding success, with a large turnout, and that the following international figures from the Latin American video art realm were present: Solange Farkas (who would go on to found Videobrasil), Néstor Olhagaray (a professor at the Escuela de Bellas Artes at the Universidad de Chile and the future director of the

Bienal de Artes Mediales in Chile), and Elias Levin Rojo (a video arts curator from Mexico City), among others.[164] Mariátegui also recalls that the galleries exhibited the works of Hervé Fischer, Nam June Paik, and Wolf Vostell and, unlike prior Encuentros, had "perfectly isolated rooms" for audiences to view the videos.[165] Additionally, the Encuentro was an important moment in Peru's larger history of electronic arts, as it demonstrated the public's curiosity about the new medium: "a massive turnout confirmed the interest generated by the expressions in art and technology."[166]

As mentioned above, the Lima Encuentro was also called the first Nacional Encuentro de Video Arte for Peru. Despite the Encuentro's success with the public in 1977, it was not until 1998 that the Galeria de Artes Visuales at the Universidad Ricardo Palma and the Alta Tecnología Andina (ATA) joined efforts to put on what they considered a continuation of the Lima Encuentro. Titled the Segundo Festival Internacional de Video Arte, the new event invited international guests (Glusberg, Farkas, and Olhagary would return) and aimed to showcase Peruvian artists alongside French artists from the Centro Internacional de Creación de Video Montbeliard-Belfort, France, which also sponsored the event and provided the festival with equipment. Therefore, while the Lima Encuentro did plant the seeds for forming a community around

the medium of video—which at that point was a mix of individuals who approached it as art, education, science, and/or cinema—access to the equipment remained limited for decades due to cost and availability. Since the restart in 1998, the festival has played an important role in developing and circulating video art in Lima.

THE IX INTERNATIONAL OPEN ENCOUNTER ON VIDEO, MUSEO DE ARTE CARRILLO GIL, MEXICO CITY, 14 NOVEMBER–2 DECEMBER 1977

The ninth Encuentro was held at the Museo de Arte Alvar y Carmen Carrillo Gil as a collaboration between that museum, CAYC, and the Colegio Nacional de la Comunicación (figs. 19–23). Like the Lima Encuentro, the Mexico City event was simultaneously called the ninth International Encuentro for CAYC and the I Nacional Encuentro de Video Arte for Mexico, and it would serve as one of the key early events in the advancement of Mexican video art. The announcements and invitations say that the artists John Baldessari, Felipe Ehrenberg, Allan Kaprow, Les Levine, Nam June Paik, and Roger Welch were among those invited to attend in person to give performances and screenings, while Raúl Lomelí (the director of the Colegio Nacional de la Comunicación and co-organizer of the Encuentro), Juan Acha, Margarita D'Amico, Néstor García Canclini, Leopoldo Maler, Amerigo Marras, and Carla Stellweg would all participate in the colloquium. The opening of the Encuentro was coordinated with the CAYC-organized exhibition *21 Artistas argentinos: Década del 70*, which was held at the Museo Universitario de Ciencias y Arte (MUCA) (fig. 24).[167] CAYC had previously collaborated with MUCA on the exhibition *Arte conceptual frente al problema latinoamericano* (Conceptual art facing the Latin American problem) in February of 1974. No catalog was produced for the Encuentro,[168] but the announcement for the event claims that after screening in Mexico City, the tapes would travel to Monterrey and Guadalajara.[169]

As Claudia Ferrer has noted, the Mexico City Encuentro was preceded by an exhibition titled *Video Art: Videocinta de vanguardia estética televisual* (Video Art: Videotapes of a new televisual aesthetic), which was held at the Galería de Exposiciones Temporales at the Museo de Arte Moderno en Chapultepec, from 12 July to 12 August 1973.[170] The exhibition was cosponsored by the Instituto Nacional de Bellas Artes y Literatura under the auspices of the US Embassy in Mexico City.[171] Whereas most of the early video exhibitions in Latin America had been strongly grounded in international strands of conceptual and performance art, *Video Art: Videocinta de vanguardia estética televisual* had a strong emphasis on work that used video synthesizers and other electronic manipulations of the video signal—an approach that would soon be pursued by the Mexican video artist Pola Weiss in 1974. Though no official documentation exists

From top, left to right:

| Fig. 19. Jorge Glusberg (left) in Mexico, 1977.

| Fig. 20. Attendees at the Mexico City Encuentro, 1977.

| Fig. 21. Panel discussion at the Mexico City Encuentro, 1977.

| Fig. 22. Jorge Glusberg (second from right) participating in a roundtable at the Mexico City Encuentro, 1977.

| Fig. 23. Audience at the Mexico City Encuentro, 1977.

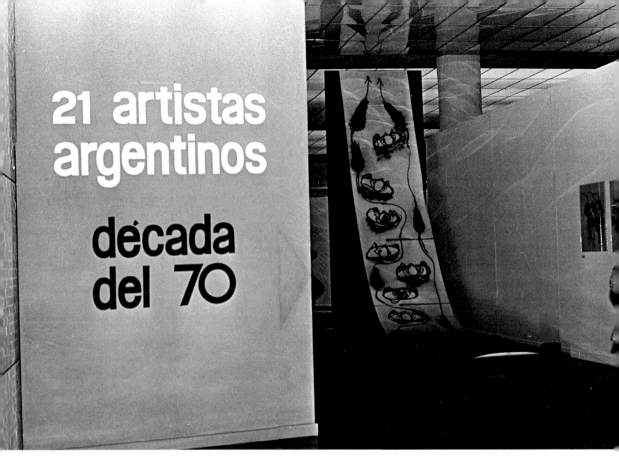

detailing how the exhibition influenced Weiss, Gabriela Aceves Sepúlveda states that "it is possible that through this exhibit she was introduced to the potential of image distortions and effects—such as chroma-keys, solarization, and audio/image interchangeability as well as experiments with choreography and sound."[172] Several artists in the show had worked at the National Center for Experiments in Television (NCET) in San Francisco and at other experimental programs residing in the major public television stations in the United States.[173] Curiously, the booklet for the *Video Art* exhibition also includes a translated version of Neil Hickey's essay "Notes from the Video Underground," which had been published in *TV Guide* in 1972.[174] In a review of the exhibition, Juan Acha laments the limited access to the technology, as it posed a promising alternative to the commercial TV industry.[175]

Outside of Mexico City, there was the Primer Encuentro Mundial de la Comunicación (First World Communication Conference), held in Acapulco on 20–26 October 1974, which was hosted by Televisa and drew an eclectic lineup of significant names in the field of communications, including Cantinflas, Umberto Eco, Jacques Fauvet, Sergio Leone, Robert Lindsay, Marshall McLuhan, Abraham Moles, Roman Polanski, Wilbur Schramm, and the music group the 5th Dimension.[176] The large number of international figures that attended was a significant sign to

the communications industry and art world alike that such gatherings for discussions on emerging technologies were highly popular.

Raúl Lomelí recalls that he met Glusberg in Caracas, and they decided to set the IX Encuentro in Mexico City. Lomelí acted as a curator of events and helped generate interest within the Mexico City art world. In an interview, Carla Stellweg, the editor of *Artes Visuales*, details that while not officially a co-organizer, she contributed to the Encuentro by inviting her network of New York artists (Levine, Paik, Kubota, etc.).[177] The tapes screened at this event were contributed from a wide array of individuals. Glusberg brought fifty-three tapes to the event for screening, many of which were his "staple" Encuentro works from Europe, Canada, the United States, Japan, and South America (Argentina and Brazil in particular), and Lomelí brought thirty videos that came from a broad spectrum of alternative video. Lomelí's contributions speak to his extensive knowledge of the international field at this point. Mexico was represented by Raúl Araiza, Ulises Carrión, Video Color, Juan Ruiz Healy, and Pola Weiss.[178] Tapes from ASCO artists Gronk and Harry Gamboa Jr. and from Marinus Boezem, Donald Lipsid, Una Maye, Mike Osterhout, Guillermo Pulido, Tomiyo Sasaki, Merle Spandorfer, and Selena Whitefeather were also included. As with all of the Encuentros, it is unclear which of the intended tapes actually made it to the screen, but the list of artists evidences the increasingly complex networks that were being constructed around the Encuentros.

One noteworthy Encuentro participant was Pola Weiss. Often considered the pioneer of Mexican video art alongside Sarah Minter, Weiss received her bachelor's degree in journalism and communication at the Universidad Nacional Autónoma de México (UNAM) in 1974 after presenting a video thesis titled "Diseño para una unidad de producción de material didáctico en video tape" (Design for unity of didactic material production on video tape). She traveled to New York in the mid-1970s, where she met Nam June Paik and Shigeko Kubota in 1976, and then founded arTV, a production company, in Mexico City. With arTV as her studio, Weiss created *Flor cósmica* (1977; Cosmic flower), *Autovideato* (1979), and other pieces that explored the theme of "videodanza."[179] In February of 1977, she had a highly popular show, *Video México*, curated by Kubota, at the Anthology Film Archives in New York City, establishing a measure of international visibility. At the IX Encuentro in Mexico City, Weiss presented *Flor cósmica*, and her image is used in advertisements for the event (figs. 25, 26).

Stellweg's journal *Artes Visuales* devoted its seventeenth volume exclusively to video art. It opens with a summary of the 1973 show *Video Art: Videocinta de vanguardia estética televisual* and a clear explanation of the discussion and trends in the field, including short quotes and statements from Douglas Davis, Downey, Ehrenberg, Levine, Maler, Marras, Silvia Naranjo, Paik, Weiss, and essays from Maria Gloria Bicocchi and

Fig. 25. Booklet for the Mexico City Encuentro publicizing Pola Weiss's performance at the Museo de Arte Carrillo Gil, 1977.

Fig. 26. Booklet for the Mexico City Encuentro publicizing Pola Weiss's performance at the Museo de Arte Carrillo Gil, 1977.

Hans Magnus Enzensberger, among others. There is also a scathing review of the Encuentro, and, like reviews of the previous editions, it remarks on how chaotic and dysfunctional it was, to the point of alienating the public. The reviewer, Sandra Shaul, notes that

> what was meant to be the first major exhibition of video art in Mexico may have taken place. It is difficult to know. Having spent five days in Mexico City from the Friday evening of the opening until the following Tuesday without having been able to see the installations completed, a definite programme of seminars, workshops, or even the exhibition dates, I, as well as several other curious onlookers, which included the artists invited to show their work and to participate in a conference programme, were left shaking our heads in wonderment.[180]

In addition to pointing out the technical problems, Shaul questions whether the Encuentro truly aimed to unite artists from North and South America in a productive discussion. Her perception, instead, is that the event was catering specifically to the high-profile figures who had come from the United States, such as Paik, Kubota, and Kaprow. She notes that the most valuable aspect of the Encuentro appeared to be the informal connections made over lunch or at the bar after the events, but even here it was impossible for anyone outside the exclusive circle of participants to get involved. Rather than presenting the public with video art "for the first time," it trended toward an elite art-world gathering.[181] Shaul concludes the review by writing:

> In a country such as Mexico where technological development is astonishingly poor, where poverty is so wide spread, and the wealth kept amongst a small group of people, video art, rather than being a potential mass art form, is more a luxurious slap in the face to the vast majority of the population. In spite of this, for a tiny group of people, there must be the satisfaction of knowing that due to them, Mexico is now a bit more "au courant."[182]

This criticism reveals a shift that had slowly been taking place in the Encuentros. The earliest Encuentros accompanied CAYC's exhibition *Art Systems in Latin America*, which featured a wide array of conceptual art from Latin America, much of it quite political. Likewise, Glusberg's essays in many of the early Encuentro catalogs highlighted the political potential for video, with the Ferrara catalog noting, for instance, that "video in the artists' hands is developing a new image culture challenging the triviality and cretinism proposed by the TV corporations (representing group interests) instead of serving people's needs." Indeed, rather than standing against corporate television, the ninth Encuentro's co-organizer Raúl Lomelí was closely connected to the Mexican television conglomerate Televisa, being their former deputy director of news and

| Fig. 27. The Sogetsu
Kaikan, where the
Tokyo Encuentro
was held in 1978.

| Fig. 28. Jorge Glusberg
(right) in Japan, 1978.

assistant to the executive vice president.[183] These relationships did not go unnoticed: writing to David Mayor about events in Mexico City, the artist Felipe Ehrenberg noted: "crazy jorge gluzber [*sic*] (CAYC ARGENTINE) was around, organized IX video festival, linked up with mexico's most reactionary forces . . . right wing art world, private television consortium, conservative press . . . etc . . . yek!"[184] Some of the same types of questionable alliances that sustained CAYC in Argentina were now plaguing the Encuentro. Caught in the paradox of corporate sponsorship, the need for prominent artists to gain notoriety, and a stated aim to politicize the public through video, the goal and impact of the Encuentros had grown increasingly muddled.

THE X INTERNATIONAL OPEN ENCOUNTER ON VIDEO, SOGETSU KAIKAN, TOKYO, 20–27 MAY 1978

The final Encuentro took place in Tokyo at the Sogetsu Kaikan on 20–27 May 1978 (fig. 27).[185] The project credits both a Tokyo-based "Steering Committee" and "Acting Committee" that included video artists such as Hakudo Kobayashi, Toshio Matsumoto, Fujiko Nakaya, and Keigo Yamamoto, as well as critics, professors, and arts professionals. The primary organization of the event, however, was handled by Glusberg (fig. 28) and the artist Katsuhiro Yamaguchi. The event was sponsored by Sony as well as the Asahi Newspaper Company.[186] The catalog for the program is primarily written in Japanese, though the symposium program, Glusberg's essay, and a timeline of Japanese video art are translated into English (see photo essay fig. 8). For his contribution, Glusberg reprinted his essay "The Semiotics of Video Art" from the Barcelona Encuentro

catalog, and the program lists Gerry Barteig, Michael Goldberg, Glusberg, Rebecca Horn, Paik, and Bill Viola as representing the Americas and Europe. Paik, Viola, and Horn gave performances that were followed by symposium panels. Though the announcements give a long list of tapes that were screened, the emphasis of the Encuentro was on the symposium and events.

A respected elder figure among the Japanese avant-garde, the Encuentro's co-organizer Katsuhiro Yamaguchi had been a founding member of Jikken Kōbō (Experimental workshop) in 1951, and by the early 1970s had become deeply involved with video art, becoming a founder of the group Video Hiroba in 1972. (Several members of this group were also part of the committees for the Tokyo Encuentro.)[187] While there are several origin stories for the birth of video art in Japan, none of them involve artists rushing to acquire the Sony Portapak when it appeared in the Japanese market in 1965.[188] A few artists, such as Toshio Matsumoto, Keigo Yamamoto, and Kohei Ando began experimenting with video at the

end of the 1960s. The Canadian artist Michael Goldberg is widely credited with introducing Western-style video art to Japan when he traveled to Tokyo for four months beginning in November 1971 and began lecturing and presenting video art from Canada.[189] Goldberg had initially arrived seeking to add contacts to his International Video Exchange Directory. In February 1972 he organized, with Yamaguchi and Fujiko Nakaya, *Video Communication DO IT YOURSELF KIT*, for which eighteen Japanese artists produced their first videos. These were exhibited at the Sony building in Ginza. (Goldberg worked with each artist directly to provide technical instruction.)[190] The Video Hiroba collective emerged from this endeavor.[191] Of the Video Hiroba artists, Fujiko Nakaya played the most significant role in the dissemination of Japanese video art internationally. Educated in the United States, Nakaya undertook significant collaborations with the US group Experiments in Art and Technology and worked with figures including John Cage, Merce Cunningham, and David Tudor in Japan. In 1979, Nakaya founded a video art distribution service, Processart Inc., both to distribute Japanese video art internationally and to circulate international video art within Japan (Processart, for instance, distributed tapes from Electronic Arts Intermix within Japan).

Japanese video featured prominently at every Encuentro beginning with the second Encuentro, in Paris. Artists associated with Video Hiroba (especially Hakudo Kobayashi, Toshio Matsumoto, Fujiko Nakaya, Katsuhiro Yamaguchi, and Keigo Yamamoto) were presented often, although the Encuentros also featured other significant Japanese artists, including Norio Imai, Duck Jun Kwak, Tsuneo Nakai, Ko Nakajima, and Morihiro Wada. Thus, it seems particularly strange that the detailed chronology of Japanese video art printed in the Tokyo Encuentro catalog hardly mentions the activities of CAYC, even though the chronology specifically mentions other international festivals that presented video works from Japan. The chronology does note that Yamaguchi attended the Buenos Aires Encuentro and spoke at the Encuentro in Barcelona.[192]

Michael Goldberg details the six-day event as opening with presentations from Glusberg (fig. 29), who discussed the semiotics of video, and Nam June Paik, who stressed the importance of video art but advised potential artists not to spend too much time watching others' works.[193] The space was constituted of ten monitors "competing with installation pieces by Katsuhiro Yamaguchi, Keigo Yamamoto, Fujiko Nakaya, Hakudo Kobayashi, and Nubohiro Kawanaka."[194] Like prior Encuentros, the event demonstrated a demand for video art despite the lack of resources:

> Noisy as it all was, the public came in droves and watched (mostly electronic pieces) with awe and some interest. Yusuke Nakahara, the respected critic, voiced the opinion shared by many, that such a presentation impedes communication with the viewer. Clearly there is an audience for video in Japan, but it is difficult to get

space and video companies' support for anything but large, flashy exhibitions. Japanese producers and groups are trying hard to solve the problems of showings, distribution, and survival. Certainly their work, done in spite of very limited access to hardware in a country overflowing with it, compared favourably with the best work from elsewhere.[195]

The month before the Tokyo Encuentro, in April 1978, CAYC presented *Japan Video Art Festival: 33 Artists at CAYC* at its space in Buenos Aires. Glusberg's lengthy essay for the catalog of this event returns frequently to the work of Yamaguchi; Yamaguchi may have also played a significant role in the selection of works, although this is unclear. Within

| Fig. 29. Jorge Glusberg (far right) presenting at the Tokyo Encuentro, 1978.

the history of the circulation of Japanese video art outside of Japan, CAYC's *Japan Video Art Festival* is notable particularly for its large checklist of thirty-three artists, many of whom had not presented work widely outside of Japan. For instance, the CAYC festival stands in contrast with Barbara London's highly influential and tightly curated MoMA survey *Video from Tokyo to Fukui and Kyoto* (1979), which presented work by thirteen artists, ten of whom overlapped with the CAYC festival. London's project ultimately traveled to twelve museums in the United States, Canada, Europe, and Japan, thus beginning to establish a canon of Japanese video artists internationally. The CAYC *Japan Video Art Festival* presented a much broader view of nearly two dozen additional artists, though the presentation was confined to its audience in Buenos Aires.[196]

Glusberg had a long-standing interest in promoting artistic exchange between Japan and Argentina. In 1969, his first exhibition at CAYC (at the time still named CEAC), *Arte y cibernética* (Art and cybernetic), prominently featured computer-drawing prints by eight Japanese artists associated with Computer Technique Group (CTG). Glusberg traveled to Tokyo in February of 1969 to meet with the group and learn more about the process of computer-generated imagery. A group of six Argentine artists then produced their own prints for the show using similar techniques.[197] Interestingly, the work of CTG is now seen as representing one point of origin for video art in Japan. In 1968, CTG wanted to produce computer animations, but the process exceeded the capabilities of the (quite powerful for the time) computer that they were working with. They solved this problem by producing a stop-motion animation on 16mm film: they produced a series of drawings on a computer screen, advancing the film one frame at a time with each new drawing. The resulting animation thus appears on a cathode-ray tube screen within a section of CTG's 1968 film *Computer Movie #1*, though the group was not represented in either the Tokyo Encuentro or the *Japan Video Art Festival*.[198]

Glusberg also wanted Latin American work to be presented in Japan. In 1977, CAYC had presented an exhibition, *18 Latin American Artists*, at Art Core gallery in Kyoto, a space that had also hosted several exhibitions of Japanese video art. Ultimately, however, it can be difficult to know who actually were the intended audiences for these projects. CAYC's *Japan Video Art Festival* was presented only in Buenos Aires, but the catalog for the project was printed solely in English. The catalog for the Tokyo Encuentro was printed mostly in Japanese and partly in English, but the extensive chronology focused only on the history of video art in Japan, whereas one might have expected that Glusberg would have been eager to disseminate the history of video art from *Latin America*. One might wonder if Sandra Shaul's criticism of the Mexico City Encuentro may also be applicable to Tokyo, that the important figures who traveled internationally to attend were the target audience for the event. Yet, even this may have had mixed results: when asked further about his experience with the Tokyo Encuentro, Michael Goldberg recalled that he had expected to serve as an aide in cataloging and organizing tapes (considering his extensive experience with Japanese and international video art) but was instead asked to work the coffee stand in the cloakroom by the entrance. As a result, Goldberg was not sure how many tapes were shown successfully.[199] At the same time, Barbara London recalls that "Bill Viola returned from Tokyo galvanized by the culture and by the artists he met while participating in a video exhibition and conference organized by Jorge Glusberg in 1976."[200]

CONCLUSION

The history of CAYC and the Encuentros presents a dilemma for scholars. The catalogs, flyers, and press releases that CAYC circulated to its vast mailing list present a picture of the Encuentros as among the most globally connected events devoted to video art during the 1970s. The screening checklists document an intriguing, and in many cases little-known, early history of video art from several countries throughout Latin America and suggest that this work was screened many times internationally. Yet, many of these tapes have proved impossible to track down; perhaps they were lost amid the chaos of the Encuentros themselves. Likewise, as many reviews reported, the events themselves rarely followed the printed schedule, and frequent technical problems likely prevented the full checklist of tapes from being shown at each event. We may never know which tapes were actually screened and who may have seen them, thus making it difficult to identify what impact, if any, the tapes that were sent to these events may have had on the visitors who attended. In many ways, the story of the Encuentros follows the same tropes of memory and forgetting so common to art from throughout Latin America in this era.

Often, the ideas presented by CAYC were not properly followed through. For instance, the earlier Encuentro catalogs suggest that CAYC, through its offshoot Ediciones Tercermundo, would be acting as a distributor for film and video works produced by the Grupo de los Trece and other Latin American artists within its orbit. But there is little evidence to support that it actively pursued this role beyond bringing these tapes to the Encuentros themselves. Flipping through the Encuentros catalogs, one notes the large percentage of works that are credited as being sent by video distributors and art galleries. CAYC's Encuentros would have been only one of many venues to which these distributors were sending work, as they devoted themselves to raising awareness and creating opportunities for the exhibition of their artists' works; it does not appear that CAYC pursued similar opportunities for its artists beyond the events that CAYC organized itself. In fact, it is largely CAYC's own videos from this period that have disappeared from circulation and that may no longer exist.

Glusberg's own conflicting roles within the organization likely hampered CAYC's influence. Glusberg was simultaneously the director and curator of CAYC, the organizer of the Encuentros, a video maker producing work included in the Encuentros, an art critic publishing reports about his own events, the publicist of those events, and the patron and funder of CAYC, through his company Modulor. As the reviewer of another CAYC project noted in the issue of *Artes Visuales* devoted to video art: "The Group of 13, which recently took honors at the São Paulo Biennial, Brasil + 11 guest artists joined in presenting *Propuestas argentinas*

actuales (*Present-day Proposals in Argentine Art*), well-organized, financed, and perhaps suffered almost entirely by Jorge Glusberg, the director of the Buenos Aires Art and Communication Center [CAYC]."[201] Looking at the great ambition embodied in the ten Encuentros that took place between December 1974 through May 1978, one could easily forget that these were just one part of a shockingly large group of exhibitions and events that Glusberg and CAYC were producing and circulating throughout the world (and likewise it is much easier to see how these events were so often careless in their execution). Glusberg's genius was to realize that all of the new communication tools celebrated by CAYC would lower the obstacles to creating an international network able to circulate new and dematerialized forms of art that could easily be mailed, wired, transmitted, reproduced, performed, or fabricated on-site to allow art from Latin America to be cheaply exhibited throughout the world. CAYC's projects capitalized on these new modes of conceptual art to produce projects for nearly any organization that would have them. Though Glusberg and CAYC had a strong, clear desire to raise the visibility of Latin American art internationally, and though they put great effort into producing a printed record of their activities and publicizing their projects, they often failed to follow through on other actions (distribution, dissemination, access) that may have transformed an initial "encounter" into more substantial networks of engagement and exchange.[202] This would be the task undertaken by the next generation of video organizers in the later 1970s and 1980s, and remains one of the primary struggles in preserving the history of video art in Latin America today.

Notes

1 Many thanks to Karl McCool at Electronic Arts Intermix for providing the "Open Circuits Schedule" from its internal archive. Jorge Glusberg is listed as participating in the panels "Global Trends in Experimental Television," chaired by the State University of New York (SUNY) at Buffalo media scholar and professor Gerald O'Grady; and "Video and the Museum," chaired by the US American scholar and filmmaker Willard Van Dyke (who was also at that time MoMA's director of the Department of Film).

2 The artists who were associated with and part of this group varied over time but included Jorge Glusberg, Jacques Bedel, Luis Benedit, Gregorio Dujovny, Carlos Ginzburg, Jorge González Mir, Victor Grippo, Vicente Marotta, Luis Pazos, Alberto Pellegrino, Alfredo Portillos, Juan Carlos Romero, and Julio Teich. Juan Bercetche, Mirtha Dermisache, Mercedes Esteves, Bernardo Krasniansky, Leopoldo Maler, Marta Minujín, Marie Orensanz, Osvaldo Romberg, Edgardo Vigo, and Horacio Zabala would also all be listed as part of the Grupo CAYC at various points throughout the Encuentros. See Graciela Sarti, "Grupo CAYC: Cronología; January 1974," *Centro Cultural Recoleta: Centro Virtual de Arte Argentina* (2013), http://cvaa.com.ar/02dossiers/cayc/07_crono_1974a.php. See also CAYC, "Alternative Video: Museum of Modern Art Study Conference, Open Circuits: The Future of Television," program, 19 January 1974, Getty Research Institute, Jean Brown papers, acc. no. 890164, box 72, which lists the titles *Homo Sapiens* (1970), *Experiences* (1971), *'We' Group Laboratory* (1971), *Road* (1972), *Mass*

Media in Argentina (1972), *Exercises on Oneself* (1972), *Anthologies* (1973), *Dialogue with Jorge Glusberg* (1973), and *The Group of the Thirteen* (1973).

3 "Mais la video peut bien aider a consolider et approfondir les effets d'un changement structurel. Elle y est pour corriger les deficits quantitatifs de l'audience, la basse qualité de l'information, et de developer les orientations adéquates des contenus éducatifs; pour collaborer finalement avec l'essai de réorganiser le déséquilibre global, propre d'un pays sous-développé." Jorge Glusberg, untitled text, *Recontre Internationale Ouverte de Vidéo* (Buenos Aires: Ediciones Argentinas, 1975), n.p. Unless otherwise indicated, all translations are by the authors.

4 Jorge Glusberg, "Video in Latin America," in *The New Television: A Public/Private Art, Essays, Statements, and Videotapes, based on "Open Circuits: An International Conference on the Future of Television,"* ed. Douglas Davis and Allison Simmons (Cambridge, MA: MIT Press, 1977), 205.

5 The dates given for all cities are for the video art portion of the Encuentros.

6 Participating countries included Argentina, Australia, Austria, Belgium, Brazil, Canada, Chile, Colombia, Cuba, Czechoslovakia, Denmark, England, Finland, France, Germany, Guatemala, Hungary, Ireland, Israel, Italy, Japan, Mexico, Netherlands, Peru, the Philippines, Poland, Portugal, Puerto Rico, Scotland, South Korea, Spain, Sweden, Switzerland, Uruguay, the United States, Venezuela, Wales, and Yugoslavia.

7 Several artists have noted in private conversations with the editors that they submitted their sole copy of a video to the Encuentros, only to have the copy never returned and be presumed lost.

8 Raúl Marroquin, "The Paris Performance," *Fandangos* 4 (1974).

9 Zanna Gilbert has noted that Glusberg's bulletins adopted many of the characteristics of mail art, especially because many of the participants were also regulars in the mail art network. Glusberg himself occasionally contributed to mail art open calls. However, rather than promote a more open system, Glusberg's bulletins were somewhat misused by incessantly promoting CAYC's favored groups of artists. See Susannah Gilbert, "Transgressive Networks: Mail Art, Circulation and Communication in and out of Latin America, 1960s–1980s" (PhD diss., University of Essex, 2012), 235–36.

10 Luis Camnitzer, *Conceptualism in Latin American Art: Didactics of Liberation* (Austin: University of Texas Press, 2007), 248–49. For a further discussion of CAYC's promotional activities, see also Daniel R. Quiles, "Network of Art and Communication" (lecture, Expanded Conceptualism conference, Tate Modern, London, 18–19 March 2011). Quiles highlights Camnitzer's criticism of CAYC and provides an excellent and in-depth examination of the paradoxical relationship that CAYC had with the development of conceptualism in Latin America.

11 This essay builds upon key critical and scholarly texts on the Encuentros by Rodrigo Alonso, *Elogio de la Low-Tech: Historia y estética de las artes electrónicas en América Latina* (Buenos Aires: Luna Editores, 2015); Laura Baigorri, ed., *Vídeo en Latinoamérica: Una historia crítica* (Madrid: Brumaria, 2008); José Emilio Burucúa, ed., *Nueva historia argentina: Arte, Sociedad, y política*, vol. 2 (Buenos Aires: Sudamericana, 1999); José-Carlos Mariátegui, "The Influx of a Video and Electronic Art Festival in Peru," in *El mañana fue hoy: 21 años de video-creación y arte electrónico en el Perú (1995–2016) = The Future Was Now: 21 Years of Video and Electronic Art in Peru (1995–2016)*, ed. Max Hernández Calvo, José-Carlos Mariátegui, and Jorge Villacorta (Lima: Alta Tecnología Andina, 2018), 330–39; Katarzyna Cytlak, "International Open Encounters on Video: The Role of the Art and Communication Center (CAYC) in Buenos Aires in International Video

Art Networks during the 1970s," in *Early Video Art and Experimental Film Networks: French-Speaking Switzerland in 1974, a Case-Study for "Minor History,"* ed. François Bovier (Lausanne: ECAL, 2017), 137–66; Claudia Ferrer, "Hacia una genealogía del videoarte en México: Decada de los 70" (master's thesis, Universidad Nacional Autónoma de México, 2017); and Quiles, "Network of Art and Communication."

12 See the New York University Archives, Angiola Churchill papers, MC.282, box 4, folder 10. The last record in this collection of Glusberg as cochair is from 1994. It is unclear in what capacity he continued after that date.

13 "A los doce años tenía ya en la terraza de su casa un museo de geología, con muestras de todas las piedras y de todos los huesitos de animalitos de la pampa; así que siempre fue un organizador." Leopoldo Maler, interview by Graciela Sarti, http://cvaa.com.ar/03biografias/glusberg_jorge.php.

14 See Asociación Argentina de Críticos de Arte, *Historia crítica del arte argentino* (Buenos Aires: Telecom, 1995); and María Isabel Baldasarre and Silvia Dolinko, eds., *Travesías de la imagen: Historias de las artes visuales en la Argentina*, vol. 2 (Buenos Aires: CAIA, 2012), especially the chapter by Mariana Marchesi and Teresa Riccardi, "MNBA/CAYC, 1969–1983: Dos alternativas institucionales en la promoción del arte argentino," 575–606, which has a detailed analysis of the rise of CAYC and other institutions during this time.

15 For an in-depth history and analysis of the role of the Instituto Torcuato Di Tella in Argentina, see John King, *El Di Tella y el desarrollo cultural argentino en la década del sesenta* (Buenos Aires: Gaglianone Establecimiento Gráfico, S.A., 1985). Also see Jorge Romero Brest, *Arte visual en el Di Tella: Aventura memorable en los años 60* (Buenos Aires: Emecé, 1992); Andrea Giunta, *Avant-garde, Internationalism, and Politics: Argentine Art in the Sixties* (Durham, NC: Duke University Press, 2007); Rodrigo Alonso, "Hacia una genealogía del videoarte argentino," in Baigorri, *Vídeo en Latinoamérica*, 13–26; and Alonso, *Elogio de la Low-Tech*.

16 For more on Minujín's role in the development of multimedia art in Argentina, see Jorge Glusberg, *Marta Minujín* (Buenos Aires: Ediciones de Arte Gaglianone, 1986); Victoria Noorthoorn, ed., *Marta Minujín: Obras 1959–1989*, exh. cat. (Buenos Aires: MALBA, 2010); Martín Lucas, ed., *Marta Minujín: Happenings, Performances* (Buenos Aires: Ministerio de Cultura, 2015); and Zanna Gilbert, "Mediating Menesundas: Marta Minujín from Informalismo to Media Art," in *Marta Minujín: Menesunda Reloaded*, ed. Helga Christoffersen and Massimiliano Gioni (New York: New Museum, 2019), 10–35.

17 The artist Antoni Muntadas also remembers seeing the employees of Modulor preparing CAYC flyers for mailing when he visited the offices in the 1970s. Antoni Muntadas, conversation with Glenn Phillips, 5 September 2019.

18 *Testigo*, no. 3 (July–September 1966): 67–71; *Testigo*, no. 4 (October–December 1966): 81–86; and *Testigo*, no. 5 (January–March 1970): 105–6.

19 See King, *El Di Tella y el desarrollo cultural*, 165; Romero Brest, *Arte visual en el Di Tella*, 201; and "Instituto Torcuato Di Tella: Conferencia de Prensa," 24 April 1970, typed manuscript, Archivos Di Tella, Universidad Torcuato Di Tella, Buenos Aires. Accessed through the International Center for the Arts of the Americas (ICAA), Museum of Fine Arts, Houston, record ID #762050.

20 Shifra M. Goldman, *Dimensions of the Americas: Art and Social Change in Latin America and the United States* (Chicago: University of Chicago Press, 1994), 11.

21 In addition to inheriting the Di Tella space, it appears CAYC also inherited its printers, as many of the catalogs match style and aesthetic. See Rubén Fontana and Zalma Jalluf, eds., *Historica gráfica del Di Tella* (Buenos Aires: Capital Intelectual, 2017).

22 Among these exhibitions were *Arte y cibernética* (Galería Bonino, Buenos Aires, August–September 1969; Comisión Nacional de Artes Plásticas,

Montevideo, June 1970; San Francisco, 1971; London, 1971); *From Figuration Art to Systems Art* (Museo Provincial de Bellas Artes E. Caraffa, Córdoba, Argentina, 1970; Camden Arts Centre, London, 1971); *Arte de sistemas* (Museo de Arte Moderno de Buenos Aires, July 1971; Internationaal Cultureel Centrum, Antwerp, April–May 1974; Palais des Beaux-Arts, Brussels, June–July 1974; Institute of Contemporary Arts, London, December 1973–January 1974; Espace Pierre Cardin, Paris, 19 February–11 March 1975; Palazzo dei Diamanti, Ferrara, 25 May–22 June 1975); *Hacia un perfil del arte latinoamericano* (3rd Bienal Coltejer, Medellín, Colombia, May 1972; Salón de la Independencia, Quito, May 1972; Pamplona, Spain, June–July 1972; CAYC, Buenos Aires, June–August 1972; Instituto de Arte Contemporáneo de Lima, July 1972; Museo Caraffa, Córdoba, October 1972; Galería Amadís, Madrid, February 1972; Wspóckzsna Gallery, Warsaw, September 1972); and *Homenaje a Salvador Allende* (CAYC, Buenos Aires, October 1973).

23 The title of each show was based on the approximate population of the presenting city.

24 Jorge Glusberg, "Vida y milagros del videoarte," in Museo Nacional de Bellas Artes, *Video Arte Internacional: Buenos Aires 1990*, exh. cat. (Buenos Aires: Talleres Gráficos Crear, 1990). Though Glusberg purchased the camera in 1969, Pedro Roth states that the Portapak was not used at first and was instead displayed at his factory for Modulor ("Lo tenía como adorno en su fábrica de luces, Modulor"); Pedro Roth, email to Sophia Serrano, 18 June 2019.

25 Cytlak, "International Open Encounters on Video," 141. Cytlak's essay does an excellent job tracing CAYC's early usage of video art and provides crucial framework for understanding the Encuentros' influence in Europe during this time.

26 Examples of projects that include CAYC-produced tapes include Festival para formatos no comerciales (CAYC, November–December 1973), followed by Projection of Films Made by Latin American Artists and Dialogue with Jorge Glusberg (Museum of Contemporary Art, Chicago, March 1974); Latin American Film and Videotape (Center for Media Study, SUNY Buffalo, New York, May–June 1974); Festival Cine Experimental (CAYC, June 1974); Latin American Week (Antwerp, June 1974); and Video Tapes: Toward a Future of Television (a series of four talks by Glusberg starting in June 1974). Materials about these events were found at the Getty Research Institute, Jean Brown papers, acc. no. 890164, box 72, folders 10–15, and box 73, folders 1–5.

27 See Cytlak, "International Open Encounters on Video," for an in-depth analysis of how these video events influenced Glusberg's Encuentros.

28 The talks were "History of Alternative Video," "Description of the Different Kinds of Video Equipment," "Artists and the Video Tape Tool," and "Alternative Video and the Future of TV."

29 In a conversation with Sophia Serrano, 25 April 2019, Stanislaus von Moos recalled that when he was working with Glusberg at the International Committee of Architectural Critics, he had asked Glusberg how they were able to voice criticism during that time. Glusberg responded that his visibility and international connections provided protection for them.

30 For full details on the events surrounding the shutdown of *Arte de sistemas*, see Graciela Sarti, "Grupo CAYC: Historia; Proyección internacional," *Centro Cultural Recoleta: Centro Virtual de Arte Argentina* (2013), http://cvaa.com.ar/02dossiers/cayc/04_histo_04.php.

31 "U.S. Decides Not to Take Part in Sao Paulo Bienal This Year," *New York Times*, 31 May 1971.

32 "U.S. Decides Not to Take Part in Sao Paulo Bienal This Year."

33 Raúl Marroquin, "CAYC," *Fandangos* ("Phandangos") 3 (1974).

34 Néstor García Canclini, "Cultural Reconversion," in *On Edge: The Crisis of Contemporary Latin American Culture* (Minneapolis: University of Minnesota Press, 1992), 29–44. The military coup, which took place on 24 March 1976, removed Isabel Perón from the presidency and put in power a three-man military junta. Jorge Rafael Videla became president of Argentina as the head of the military junta, which initially included General Orlando Ramón Agosti and Admiral Emilio Eduardo Massera.

35 "El auge de la empresa comenzó en el Mundial del 78 cuando iluminó todos los estadios, menos el de Vélez Sarfielfd. El planetario, el edificio de la naciente Argentina Televisora Color, las bajadas de las flamantes autopistas, el Aeroparque y el Aeropuerto de Ezeiza, varias cárceles, el Mercado Central y las escuelas de la gestión Cacciatore, fueron iluminados por la empresa de Jorge Glusberg." Authors' translation from the written dossier on the scandal detailing the aired news segment produced by the journalist Daniel Tognetti and later developments in the controversy surrounding Glusberg later in his life, found in "Los expedientes Glusberg," *Ramona: Artes Visuales Argentinas* 38 (March 2004): 58, http://70.32.114.117/gsdl/collect/revista/index/assoc/HASHa103/4325b069.dir/r38_11nota.pdf.

36 In the documentary, Glusberg is also accused of traveling with art instead of hiring a handler, charging artists exorbitant fees for exhibiting at the museum, refusing to publish catalogs unless his essays were included, having important paintings go missing under his tenure, and exhibiting falsified art. It claims that Modulor employees were mistreated and that the company's factory was moved out of Buenos Aires to evade financial issues brought against Glusberg's company.

37 See also Marta Traba's critique in *Art of Latin America, 1900–1980* (Washington, DC: Johns Hopkins University for the Inter-American Development Bank, 1994), esp. 141–48.

38 García Canclini, "Cultural Reconversion," 37.

39 Correspondence between Jorge Glusberg and Julie Lawson, 10 June 1974, Papers Relating to the Exhibition "Art Systems in Latin America," Tate Archives, folder TGA 955/7/2/106.

40 Rodrigo Alonso describes Kamien's dance film in collaboration with Marcelo Epstein, *Ana Kamien* (1970, 16mm, 32 min., B+W), as "not only one of the first examples of dance for the camera in Argentina: it is also one of the best." Rodrigo Alonso, "From Tango to Video Dance: Dance for the Camera in Argentina" (presentation at Dance for the Camera Symposium, University of Wisconsin, Madison, February 2000), accessed at http://www.roalonso.net/en/videoarte/tango.php.

41 Attendees included Michel Baudon, Florent Bex, Gillo Dorfles, Nicolás García Uriburu, Amelia de Glusberg, Bill Harpe, Dante Leonelli, Leopoldo Maler, Raúl Marroquin, Gérald Minkoff, Abraham Moles, Colin Naylor, Luis Pazos, Osvaldo Romberg, Caroline Tisdall, and Antonio Trotta.

42 *Latin American Week: International Open Encounter on Video* (Buenos Aires: Ediciones Argentinas, 1974).

43 Daniel R. Quiles and Jaime Davidovich, *Jaime Davidovich: In Conversation with Daniel R. Quiles* (New York: Fundación Cisneros, 2017), 85.

44 Edward Lucie-Smith, "Video in the United Kingdom," in Davis and Simmons, *The New Television*, 184. See also Stuart Marshall, "Video: From Art to Independence," *Screen* 26, no. 2 (1985): 66–72.

45 The ICA had planned to hold an exhibition called *Videosphere* starting in January 1971, but it was canceled and the show that preceded it was extended. See the complete archival list of ICA exhibitions at https://archive.ica.art/sites

/default/files/downloads/Complete%20ICA%20Exhibitions%20List%201948%20
-%20Present%20-%20July%202017/index.pdf.

46 This, of course, implies that another attempted goal of the Encuen-tros was to make copies of works that were presented or submitted at the events.

47 Correspondence between Lawson and Glusberg, 10 June 1974, Papers Relating to the Exhibition "Art Systems in Latin America," Tate Archives, folder TGA 955/7/2/106.

48 Flis Henwood, Nod Miller, Peter Senker, and Sally Wyatt, *Technology and In/equality: Questioning the Information Society* (London: Routledge, 2002), 52.

49 The proposed list included John Barth, Peter Brook, Anthony Bur-gess, Guillermo Cabrera Infante, Lawrence Olivier, John Osborne, Peter O'Toole, and Peter Weiss. Correspondence between Lawson and Glusberg, 2 September 1974, Papers Relating to the Exhibition "Art Systems in Latin America," Tate Archives, folder TGA 955/7/2/106.

50 Caroline Tisdall, "Wring Out the Old," *Guardian*, 11 December 1974.

51 Peter Fuller, "Art Systems in Latin America," *Arts Review*, 13 December 1974, 746.

52 Fuller, "Art Systems," 746.

53 *The Video Show: Festival of Independent Video at the Serpentine Gallery*, exh. cat. (London: Arts Council of Great Britain, 1975).

54 Raúl Marroquin, "The Paris Performance," *Fandangos* ("Fandadan-gos") 6 (1975).

55 Other people listed in the materials include Donald Forrests, "Madame Uriburu," and "Madame Debray." It is unclear what role these people played in the event.

56 "Mix Maxim's, Pierre Cardin and Voila!—A TV Dinner," *Los Angeles Times*, 14 September 1977, A6.

57 Restany, who had strong ties to Argentina, would then bring an exhi-bition surveying current French artists to CAYC in Buenos Aires the following August, sponsored by CAYC and the French Embassy in Argentina. See CAYC, "El Arte en Posicion Critica: Practica y Teoria," 8 August 1975, Stanford Univer-sity Special Collections, Felipe Ehrenberg papers, 1964–2000, box 17, folder 2.

58 CAYC, "Second International Open Encounter on Video," Getty Research Institute, Jean Brown papers, acc. no. 890164, box 73.

59 These artists included Bernard Amiard, Roland Baladi, Dominique Belloir, Alexandre Bonnier, Jean Clareboudt, Hervé Fischer, Fred Forest, Jochen Gerz, Françoise Janicot, Gina Pane, Jean Roualdes, Sacha Sosno, Bernard Teyssèdre, and Rainer Verbizh.

60 Donald Burgy, phone conversation with Sophia Serrano, 22 January 2019.

61 *Videoarte a Palazzo dei Diamante, 1973–1979: Reenactment*, exh. cat. (Fer-rara: Fondazione Ferrara Arte, 2015), regularly uses "Centro Video Arte" when discussing the early years, despite not yet being under that official title.

62 CAYC, "Third International Open Encounter on Video," invitation/announcement, 21 March 1975, Getty Research Institute, Jean Brown papers, acc. no. 890164, box 72.

63 Third World Editions is credited as a collaborator for videos listed under "The CAYC Group" in the catalog checklist, including videos by Angelo de Aquino and Rafael Hastings. CAYC, *Third International Open Encounter on Video*, exh. cat. (Buenos Aires: Ediciones Argentinas, 1975).

64 Press release for the third Encuentro, Getty Research Institute, Jean Brown papers, acc. no. 890164, box 73.

65 Lola Bonora, email to Pietro Rigolo, 17 September 2019. Many thanks

to Pietro Rigolo for reaching out to Bonora on behalf of the authors and for translating her replies.

66 In the catalog, tapes are listed as being presented by the Galleria del Cavallino in Venice, art/tapes/22 in Florence, Video Studio 970/2 in Varese, and the Grupo OBM and Environmedia group in Milan.

67 Bicocchi's memoir of art/tapes/22, published in the catalog for the 2008 survey exhibition *art/tapes/22: Video Tape Production*, goes into great detail about the network of artists and collaborators that were established during this time. Maria Gloria Bicocchi, "Between Florence and Santa Teresa: Behind the Scenes at art/tapes/22," in *Art/tapes/22: Video Tape Production*, ed. Alice Hutchison, exh. cat. (Long Beach: University Art Museum, California State University, Long Beach, 2009), 33–85.

68 Jorge Glusberg, "Alternative Video (against TV)," in CAYC, *Third International Open Encounter on Video*.

69 Carlo Ansaloni in "Lola Bonora e Carlo Ansaloni in conversazione con Cosetta G. Saba e Lisa Parolo," in *Videoarte a Palazzo dei Diamante, 1973–1979: Reenactment*, exh. cat. (Ferrara: Fondazione Ferrara Arte, 2015), 44. Approximately a month before the Ferrara Encuentro, Italian courts had transferred control of national television from the executive branch to Parliament, a step that itself was thought would diversify broadcasting simply by the need to represent the different political parties. For more information on the history of Radiotelevisione italiana and State control of Italian television, see *Television across Europe: Regulation, Policy, and Independence* (Budapest: Open Society Institute, 2005), 871–77.

70 Cosetta G. Saba, quoted in "Lola Bonora e Carlo Ansaloni in conversazione con Cosetta G. Saba e Lisa Parolo," 45.

71 Authors' translation of unattributed quote from the summary of the video "Third International Open Encounter on Video: Documentazione della tavola rotunda," in *Videoarte a Palazzo dei Diamante*, 90.

72 CAYC, "Fourth International Open Encounter (on Video), Buenos Aires," invitation/press release, 7 July 1975, Getty Research Institute, Jean Brown papers, acc. no. 890164, box 73.

73 See "Video y Comunicación: IV Encuentro Internacional y Coloquio Latinoamericano," *Mayoria: Espectáculos*, 2 November 1975, 17; and Margarita D'Amico, "Video Internacional en Buenos Aires," *El Nacional* (Caracas), 14 December 1975.

74 "Y como en todo los encuentros y festivales—de todo tipo—hubo orden y desorden; aparatos que funcionaron y otros que no; gente interesante y gente que estaba en otra onda, gente que celebró el encuentro con entusiasmo, que cree en el video como medio de comunicación y expresión artística válido, y gente que, sencillamente, no ve lo evidente, ni vislumbra lo posible." D'Amico, "Video Internacional en Buenos Aires."

75 Luis Camnitzer provides a poignant comparison between CAYC and the art collective Tucumán Arde, who would be active in raising awareness to the political revolt in the Tucumán region. See Luis Camnitzer, *Didáctica de la liberación: Arte conceptualista latinoamericano* (Montevideo: Casa Editorial HUM, 2008), 84–98. See also Ana Longoni, *Del Di Tella a "Tucumán arde": Vanguardia artística y política en el '68 argentino* (Buenos Aires: El cielo por asalto, 2000); and Ana Longoni, *Vanguardia y revolución: Arte e izquierdas en la Argentina de los sesenta-setenta* (Buenos Aires: Ariel, 2014).

76 Jorge Glusberg, "Alternative Video," in CAYC, *Video Alternativo: Fourth International Open Encounter*, exh. cat. (Buenos Aires: Ediciones Argentinas, 1975).

77 Tapes listed were from Sonia Andrade (Brazil), Fernando França

Cocchiarale (Brazil), Mario Cravo Neto (Brazil), Margarita D'Amico (Venezuela), Miriam Danowski (Brazil), Jaime Davidovich (Argentina-US), Angelo de Aquino (Brazil), Juan Downey (Chile-US), Felipe Ehrenberg (Mexico-England), Raúl Marroquin (Colombia-Netherlands), Anna Bella Geiger (Brazil), Group CAYC (Argentina), Group Videamus (Colombia), Paulo E. Herkenhoff (Brazil), Lea Lublin (Argentina-France), Leopoldo Maler (Argentina), Arturo Montagu (Argentina), and Letícia Parente (Brazil).

78 It should be noted that the Bienal was boycotted by many in the art world during the 1970s and thus had limited exposure, particularly among artists who opposed the dictatorship.

79 Suzanne Delehanty, conversations with Glenn Phillips, 16 January 2008 and 26 March 2014.

80 Walter Zanini, conversation with Glenn Phillips and Elena Shtromberg, 16 July 2004. See also Cacilda Teixeira da Costa, "Video Art at MAC," in *Made in Brasil: Três décadas do video brasileiro*, ed. Arlindo Machado (São Paulo: Itaú Cultural, 2003), 313–16.

81 Japan was also represented at the Bienal with a video exhibition, which featured work by Katsuhiro Yamaguchi and Keigo Yamamoto, both of whom had work in the Buenos Aires Encuentro. Yamaguchi traveled to Buenos Aires from Tokyo to attend the Encuentro.

82 Renaud Proch (currently the director of ICI), conversation with Glenn Phillips, 4 February 2010, based on Proch's research in the ICI archives. The organization was first founded as Independent Curators, Inc. The initial association with the US Information Agency is startling, given that ICI is known today in large part for its focus on independent viewpoints globally.

83 Antin switched her work from the mildly political *Ballerina and the Bum* (1974), which was included at the ICA, to *The King* (1972), a video in which she applies hair to her face to create the image of a bearded man. She was later told that some visitors to the Bienal took the piece to be a subversive political statement expressing support for Fidel Castro. Eleanor Antin, conversation with Glenn Phillips, 28 September 2006. An edited version of this conversation appears in Glenn Phillips, ed. *California Video: Artists and Histories* (Los Angeles: Getty Publications, 2008), 23–25. The unedited interview can be found in the Institutional Archives of the Getty Research Institute.

84 *Video arte*, exh. cat. (Bogotá: Centro Colombo Americano, 1976).

85 The *Video Art USA* and *Video arte* exhibitions were credited solely to Jack Boulton as curator.

86 The *Video arte* exhibition is widely regarded to be the first exhibition of video art to appear in Peru, and artists in Bogotá such as Gilles Charalambos and Omaira Abadía also refer to this exhibition as their first exposure to video art.

87 Teixeira da Costa, "Video Art at MAC," 313.

88 D'Amico, "Video Internacional en Buenos Aires."

89 CAYC, "V International Open Encounter on Video," 1 December 1975, Getty Research Institute, Jean Brown papers, acc. no. 890164, box 73.

90 Véhicule Art Inc., a nonprofit exhibition and educational space based in Montreal, sent tapes by ten artists, and other tapes were sent by Video Dub in Montreal/New York, Video Inn and Western Front in Vancouver, and several other groups and individual artists from across Canada. Since the early 1970s, Canada had been particularly active in establishing international networks for video art, and the Canada Council for the Arts was involved in supporting video art. Starting in 1971, Michael Goldberg, the founder of Video Inn, initiated the International Video Exchange Directory, which compiled the names

of independent video producers worldwide and fostered global video networks via mail. In 1973, the VIVO Media Arts Center in Vancouver hosted 160 international delegates from Europe, Japan, the United States, and Canada for an event they called MATRIX. From this event, they formed the Satellite Video Exchange Society. Glusberg did not attend this conference, but CAYC did appear in the International Video Exchange Directories. See *International Video Exchange Directory*, no. 4 (1976). Next to its contact information, the directory notes that CAYC has the following equipment: ½" Toshiba Ampex Color, ½" Sony Portapak, ½" Sanyo Portapak, ½" B&W Cassette, ¾" Sony U-Matic, and two color Toshiba IK-83a cameras.

91 Bill Vazan, phone interview with Sophia Serrano, 17 June 2019.

92 Vazan, phone interview.

93 Florent Bex, email to Glenn Phillips, 10 September 2019.

94 Sophia Serrano, email correspondence with the Bibliotheek M HKA, 23 May 2018.

95 The archives at the Museum of Contemporary Art, Antwerp (M HKA) hold the list of tapes that served as internal documents used by Bex and Glusberg for tracking purposes; the archives at the Stedjelijk Museum, Amsterdam, had portions of the thin leaflet circulated to attendees.

96 Bex, email.

97 The text notes that "contextual artists oppose the whole notion of conceptual art, regarding it as an art which cannot be the answer to the problems of modern civilization. They also oppose all modifications of contemporary Modernism as being a stylistic version of art of the past. Artists present contextual art as a model of art of the modern civilization with quick changes which the relativistic models of art and science of the first half of the 20th century were not able to describe." ICC-CAYC, "5th International Encounter on Video / 5e Internationale videodagen," 14–22 February 1976, Stichting Stedelijk Museum Amsterdam, Special Collections. The text's authors include Kazimierz Bendkowski, Wojciech Bruszewski, Paweł Kwiek, Józef Robakowski, Jan Świdziński, and Ryszard Waśko. Further information about this group can be found in "An Outline History of Polish Video Art," *Culture.Pl*, 13 April 2005.

98 Graciela Sarti, "Grupo CAYC: Historia; La formación del Grupo de los Trece," *Centro Cultural Recoleta: Centro Virtual de Arte Argentina* (2013), http://cvaa.com.ar/02dossiers/cayc/04_histo_02.php.

99 See "ICC 5th International Encounter on Video," press release, 3 February 1976, Getty Research Institute, Jean Brown papers, acc. no. 890164, box 73; and "ICC-CAYC: 5th International Encounter on Video: Lijst Videotapes," Stichting Stedelijk Museum Amsterdam, Special Collections.

100 For an analysis on the circulation of ideas between Joseph Beuys and artists in Latin America, see Katarzyna Cytlak, "La rivoluzione siamo noi: Latin American Artists in Critical Dialogue with Joseph Beuys," *Third Text* 30, nos. 5–6 (2016): 346–67.

101 A student of John Balossi and Luis Hernández Cruz, de Jesús was a psychologist and artist at the Universidad de Puerto Rico, Río Piedras campus, who would experiment with video in the 1970s. See Luis M. de Jesús, "Biographical Profile," http://luismdejesus.com/biography.

102 Cf. Jan Debbaut, "Some Notes on Video Art in Belgium," *Studio International* 191, no. 981 (1976): 273.

103 David Hall, "Video," *Studio International* 192, no. 982 (1976): 77.

104 See Gerd Stern, "Encuentro de Video," in CAYC and MACC, *1977 Video: Encuentro Internacional de Video*, exh. cat. (Caracas: Ediciones Amon, 1977). Stern's essay was originally sent to Sofía Imber in English for inclusion in the

catalog, which is the translation used in this essay; see Stanford University, Gerd Stern papers (1938–2012), acc. nos. 2013-098, 2013-121, and 2013-122, box 35, folders 3–4.

105 CAYC and MACC, *1977 Video*.

106 For a full history of *Imagen de Caracas*, see Benjamín Villares Presas, "Videoarte en Venezuela: Cuatro generaciones de arte audiovisual," in Baigorri, *Vídeo en Latinoamérica*, 231–38; Gabriela Rangel, "Imagen de Caracas: Art as Action," in *Contesting Modernity: Informalism in Venezuela, 1955–1975*, ed. Mari Carmen Ramírez and Tahía Rivero (Houston: Museum of Fine Arts, 2018), 167–81; and Gabriela Rangel, "Imagen de Caracas: Contradidáctica para la Integración del las artes," *Colección Cisneros*, 7 November 2016, https://www.coleccioncisneros.org/es/editorial/statements/imagen-de-caracas-contradid%C3%A1ctica-para-la-integraci%C3%B3n-de-las-artes.

107 More than 100,000 square feet.

108 Ignacio had seen some of Stern's work in a magazine and wanted his help in providing equipment for a World Bank project called *Col de Sur*. After this project, Stern then helped produce a multimedia installation for a group of Czechoslovakian artists at the battlefield of Carabobo. See Gerd Stern, "From Beat Scene Poet to Psychedelic Multimedia Artist in San Francisco and Beyond, 1948–1978," an oral history conducted in 1996 by Victoria Morris Byerly, University of California, Berkeley, Bancroft Library, Regional Oral History Office.

109 Artists included Peter Campus, Frank and Laura Cavestani (Space Video and Video New York), David Cort, Peter Crown, Douglas Davis, Juan Downey, Ed Emshwiller, Bill and Louise Etra, John Godfrey, William Gwin, Ian Hugo, Shigeko Kubota, the National Center for Experiments in Television in San Francisco (Stephen Beck, David Dowe, and Jerry Hunt), Phill Niblock, Nam June Paik, Willard Rosenquist, Lillian Schwartz, Woody and Steina Vasulka, WGBH-TV Boston (Ron Hays), WNET's TV Lab (Allan Kaprow, Otto Piene, James Seawright, Thomas Tadlock, and Aldo Tambellini), and Jud Yalkut. See Stanford University, Gerd Stern papers (1938–2012), acc. nos. 2013-098, 2013-121, and 2013-122, box 35, folder 3.

110 See Stanford University, Gerd Stern papers (1938–2012), acc. nos. 2013-098, 2013-121, and 2013-122, box 35, folders 3–4.

111 Simón Silva, "La Juana de Arco de la nueva música," *Farandula*, 4 April 1975.

112 Villares Presas, "Videoarte en Venezuela," 232.

113 For a slideshow of images from *Arte de video*, see Margarita D'Amico's digital archive, managed by Humberto Valdivieso, "La bohemia hipermediática: La Imagen—Arte de Video 1975," http://labohemiahipermediatica.weebly.com/festival-de-videoarte.html.

114 Teresa Alvarenga, "Es imposible borrar de la mente las experiencias que ofrece el arte conceptual," *El Nacional* (Caracas), 14 May 1975.

115 Gerd Stern, "La polémica sobre el video-arte: Comenzada en Caracas toma vuelo internacional," *El Nacional* (Caracas), 3 June 1975.

116 Grace Glueck, "Videotape Replaces Canvas for Artists Who Use TV Technology in New Way," *New York Times*, 14 April 1975.

117 See Stanford University, Gerd Stern papers (1938–2012), acc. nos. 2013-098, 2013-121, and 2013-122, box 35, folders 3–4.

118 Letter from Gerd Stern to Sofía Imber, n.d, Stanford University, Gerd Stern papers (1938–2012), acc. nos. 2013-098, 2013-121, and 2013-122, box 35, folders 3–4.

119 Stern, "Encuentro de Video."

120 Jorge Glusberg, untitled essay, CAYC and MACC, *1977 Video*.

121 See CAYC and MACC, *1977 Video,* [11–19]; and CAYC, "VI International Open Encounter on Video: Museum of Contemporary Art Caracas," flyer, 12 December 1976, 1, Getty Research Institute, Jean Brown papers, acc. no. 890164, box 73.

122 CAYC, "VI International Open Encounter on Video," 4.

123 On the final page of the catalog, there is a list titled "OFVIDEOS" [*sic*], where the following are listed: Wolf Vostell (Germany), the CAYC Group (Argentina), Nam June Paik (Museo de Arte Contemporáneo), Daniel Sicard (France), Cardena-Warming Up, Etc. Etc. Etc. Co. (Holland), Richard Chapman (England), Emilio Vedova (Italy), Keigo Yamamoto (Japan), Colonia Country Club—"Estudios Churubusco" (Mexico), Marek Konieczny (Poland), L'Etoile du Nord (Sweden), Heinz Brand (Switzerland), and Cine Video UCV (Venezuela). Cf. CAYC, "VI International Open Encounter on Video," 23.

124 Universidad Central de Venezuela, *Muestra de Video del Primer Festival de Caracas,* exh. cat. (Caracas: UCV, 1979).

125 Universidad Central de Venezuela, *Muestra de Video.*

126 Vicens later entered politics and took positions in the Catalonian Parliament and General Courts.

127 Fundació Joan Miró, *Programa d'activitats: Febrer 1977* (Barcelona: La Poligrafa, S.A., 1977).

128 Fundació Joan Miró, *Programa d'activitats.*

129 CAYC and Fundació Joan Miró, brochure, "VII Encuentro Internacional de Video," n.d., Getty Research Institute, Jean Brown papers, acc. no. 890164, box 73.

130 The video panel lists a number of prominent Catalonian artists and critics from that time: Eugenio Bonet, Joan Costa, Joaquim Dols Rusiñol, Daniel Giralt-Miracle, Joan Enric Lahosa, Toya Nogales, Sergi Schaaff, and Manel Valls. *Note:* the CAYC Encuentro catalog has the names and dates of the "Architecture and Communication" (24 February) and "Video and Communication" (25 February) panels incorrectly swapped, so the video panel lists the architecture panel participants and vice versa. The Fundació Miró brochure lists everything correctly, and otherwise the names of participants match.

131 CAYC and Fundació Joan Miró, *Seventh Open International Encounter, Barcelona,* exh. cat. (Buenos Aires: Ediciones Argentinas, 1977).

132 Jorge Glusberg, "1977 Symposium on Video and Communication, Barcelona, Spain," *Leonardo* 11 (1978): 46.

133 Glusberg, "1977 Symposium on Video and Communication," 46.

134 *Batik* began in 1973, *Guadalimar* in 1975, and *Zoom: Revista de la imágen* in 1976.

135 Daniel Giralt-Miracle, "Barcelona, Capital del Video Alternativo," *Batik* 32 (March 1977).

136 Giralt-Miracle, "Barcelona."

137 Daniel Giralt-Miracle, "VII Festival Internacional de Video," *Guadalimar* 2, no. 21 (March 1977). Many thanks to the Fundació Joan Miró for providing these reviews.

138 J. Corredor-Matheos, "Festival Internacional de Video," *Destino,* no. 2057 (3–9 March 1977).

139 Sempronio, "¡Hola, video-arte!," *Tele/eXpres,* 28 February 1977, 6.

140 Corredor-Matheos, "Festival Internacional de Video."

141 Sempronio, "¡Hola, video-arte!," 6.

142 Sempronio, "¡Hola, video-arte!," 6.

143 Eugenio Bonet, "El VII Encuentro Internacional de Video en la Fundación Miró," *Zoom: Revista de la imágen* 5 (1977).

144 Muntadas, conversation.

145 "Video Social en Barcelona," *Zoom: Revista de la imágen* 5 (1977).

146 For a history of Video-Nou, see especially Teresa Grandas, "Grup de Treball and Vídeo-Nou: Two Collective Projects in 1970s Spain," in *L'Internationale: Post-War Avant-Gardes between 1957 and 1986*, ed. Bart de Baere and Christian Höller (Zurich: JRP/Ringier, 2013), 227–33.

147 The starting date of this Encuentro was 16 September, but the actual closing date is unclear.

148 CAYC, *Video Arte: 8th International Video Art Festival*, exh. cat. (Lima: n.p., 1977).

149 "Encuentro de Video Arte," *La Prensa, Lima*, 11 September 1977, 18.

150 CAYC, *Video Arte*.

151 The next significant example of video art from Peru was Teresa Burga's closed-circuit experiments, made while she was studying at the Art Institute of Chicago on a Fulbright Scholarship in 1969. For a full chronology, see José-Carlos Mariátegui, "Cronología del video en el Perú," *Alta Tecnología Andina*, http://ata.org.pe/cronologias. For a complete background on television and electronic arts in Peru, see José-Carlos Mariátegui, "Background: The Beginnings of Video and Electronic Media in Peru," in Hernández Calvo, Mariátegui, and Villacorta, *El mañana fue hoy*, 308–15.

152 Hastings says that all of these works were lost, after never being returned from the Encuentros. Rafael Hastings, conversation with Glenn Phillips and Elena Shtromberg, 28 July 2014.

153 Mariotti was born in Bern, Switzerland, but his family moved to Lima when he was nine years old. He then returned to Europe for his studies in 1965.

154 Mariátegui, "Cronología del video en el Perú."

155 Program for Contacta 71, https://www.mariotti.ch/media/uploads /libros/Contacta_71_pdf.pdf.

156 Willy Rotzler, "Kreislauf des Lichts: eine Kinetische Meditations- skulptur von Francesco Mariotti," *Du* (June 1972): 432–41. Mariotti returned to Switzerland in 1981 and directed the video art festival in Locarno from 1982 to 1987.

157 "En 24 televisores proyectan muestra 'video arte,'" *La Prensa, Lima*, 27 August 1976.

158 "En 24 televisores proyectan muestra 'video arte.'"

159 The monitors in this work display Paik's 1973 video *Global Groove*.

160 "Video arte," *La Prensa, Lima*, 10 September 1977.

161 "Encuentro de Video Arte harán en Banco Continental," *La Prensa, Lima*, 6 September 1977.

162 "Tercer Festival de Teleducación realizará la Universidad Católica," *La Prensa, Lima*, 18 September 1977.

163 Max Hernández Calvo, "Towards a Video Art Scene in Peru," in Hernández Calvo, Mariátegui, and Villacorta, *El mañana fue hoy*, 316–27.

164 José-Carlos Mariátegui, "The Influx of a Video and Electronic Art Festival in Peru," in Hernández Calvo, Mariátegui, and Villacorta, *El mañana fue hoy*, 333.

165 Mariátegui, "Influx of a Video and Electronic Art Festival," 330.

166 Mariátegui, "Influx of a Video and Electronic Art Festival," 330.

167 CAYC, "The Seventies," invitation/announcement, 11 November 1977, Getty Research Institute, Jean Brown papers, acc. no. 890164, box 73, folder 4.

168 This discussion of the IX Encuentro is deeply indebted to Claudia Ferrer, whose excellent master's thesis examines the early years of video art in

Mexico through meticulous research and interviews, and also reproduces some of the internal documents used by Glusberg and Lomelí to plan the event. See Ferrer, "Hacia una genealogía del videoarte en México." We are grateful to Ferrer for sharing her thesis with us.

169 CAYC, "IX International Encounter (1st National) on Video—Mexico," event announcement, undated, Getty Research Institute, Jean Brown papers, acc. no. 890164, box 73, folder 4.

170 Ferrer, "Hacia una genealogía del videoarte en México," 11.

171 *Video Art: Videocinta de vanguardia estética televisual,* exh. cat. (N.p., 1973).

172 Gabriela Aceves Sepúlveda, *Women Made Visible: Feminist Art and Media in Post-1968 Mexico City* (Lincoln: University of Nebraska Press, 2019), 278.

173 The show featured tapes by Stephen Beck, Stephen Beck and Warner Jepson, Peter Campus, David Dowe, Ed Emshwiller, Bill and Louise Etra, John Godfrey, Don Hallock, Jerry Hunt, Willard Rosenquist, David Silver and Jonathan Price, and Robert N. Zagone and Richard Feliciano, and photographs of video artists taken by Margaret D'Hamer. For more information about NCET and the strands of video production supported there, see Steve Seid and Maria Troy, eds., *Videospace: The National Center for Experiments in Television, 1967–1975* (Berkeley: Berkeley Art Museum and Pacific Film Archive, 2001).

174 *Video Art: Videocinta de vanguardia estética televisual,* n.p. Originally published in *TV Guide,* 9–15 December 1972, 6–10, and 16–22 December 1972, 34–40. This two-part essay, which describes the alternative video movement as "a minirevolution aspiring to become a maxirevolution," presents a concise panorama of many strands of video activity in the United States, from fine art to guerrilla television, and includes a discussion of the experimental activities at centers like NCET.

175 Juan Acha, "El arte del video tape encontra de la T.V.," *Excelsior,* n.d., cited in Aceves Sepúlveda, *Women Made Visible,* 71.

176 Miguel Sabido, "Umberto Eco: El Banquete de Acapulco," *El Universal: Confabulario—Suplemento Cultural,* 27 February 2016.

177 Interview between Claudia Ferrer and Raúl Lomelí, in Ferrer, "Hacia una genealogía del videoarte en México," 42–43.

178 Further thanks to Claudia Ferrer for these documents. Reproductions from untitled folder at the Museo de Arte Alvar y Carmen Carrillo Gil in Ferrer, "Hacia una genealogía del videoarte en México," 54–64.

179 See Ana Sedeño, "Revisión General Sobre la Videocreación en México," *Razón y Palabra,* https://www.redalyc.org/articulo.oa?id=199520330087.

180 Sandra Shaul, "Video-Art," *Artes visuales,* no. 17 (Spring 1978): 47. (The Spanish-language original, titled "Video Arte," is on 23.)

181 Shaul, "Video-Art," 47 (Spanish-language original, 23).

182 Shaul, "Video-Art," 48 (Spanish-language original, 24).

183 Fausto Popoca, "Refuerza Televisa a su equipo de impugnación del reglamento," *Proceso,* 28 July 1979.

184 Felipe Ehrenberg, letter to David Mayor, 1 January 1978, Tate Archives, Correspondence between David Mayor and Felipe Ehrenberg, folder TGA 815/1/1/5. Thanks to Zanna Gilbert for bringing this letter to our attention.

185 This section of the essay was greatly aided by interviews that Glenn Phillips and Rika Iezumi Hiro conducted with the artists Hakudo Kobayashi, Masao Komura, Ko Nakajima, Fujiko Nakaya, Morihiro Wada, and Keigo Yamamoto in October 2006.

186 *Video Art 1978: X International Open Encounter on Video,* exh. cat. (Buenos Aires: CAYC, 1978); and "Japan National Video Committee Tokyo, CAYC,

Buenos Aires," Stanford University Special Collections, Felipe Ehrenberg papers, 1964–2000, box 17, folder 3.

187 For more information on avant-garde movements in Japan in the 1950s and 1960s, see Charles Merewether with Rika Iezumi Hiro, eds., *Art Anti-Art Non-Art: Experimentations in the Public Sphere in Postwar Japan, 1950–1970* (Los Angeles: Getty Research Institute, 2007).

188 What are now acknowledged as some of the first video artworks in Japan were 16mm films that presented television or computer monitors as their central image, featuring video feedback and other electronic manipulations of the screen. Experimentations like this began around 1968; there are scattered instances of artists incorporating video into live performances around the same time. For more information on the history of video in Japan, see Ann Adachi, Rebecca Cleman, and Lori Zippay, eds., *Vital Signals: Early Japanese Video Art* (New York: Electronic Arts Intermix, 2010).

189 There are certainly earlier instances of international artists presenting video work in Japan, including works by Takahiko Iimura that were presented in Japan after he had moved to New York. The video artist Shigeko Kubota (a curator at Anthology Film Archives in New York and the wife of Nam June Paik) was also a crucial source of exchange between Japan and artists internationally.

190 Fujiko Nakaya, "Japan: Video Hiroba," *artscanada* 30, no. 4 (1973): 52.

191 The original members of the collective were Sakumi Hagiwara, Nobuhiro Kawanaka, Hakudo Kobayashi, Masao Komura, Toshio Matsumoto, Shoko Matsushita, Tetsuo Matsushita, Rikuro Miyai, Michitaka Nakahara, Fujiko Nakaya, Yoshiaki Tono, Katsuhiro Yamaguchi, and Keigo Yamamoto; *Video Art 1978*, 47.

192 *Video Art 1978*, 47–50.

193 Michael Goldberg, "Japan Video Encounter," *Video Guide* (Summer 1978): 6.

194 Goldberg, "Japan Video Encounter," 6.

195 Goldberg, "Japan Video Encounter," 6.

196 It was this contrast between the checklists for London's and Glusberg's projects that inspired the Getty Research Institute's 2007 screening series *Radical Communication: Japanese Video Art 1968–1988.*

197 *Arte y cibernética*, Buenos Aires, Centro de Estudios de Arte y Comunicación, 1969.

198 Computer Technique Group disbanded in 1969.

199 Michael Goldberg, email to Sophia Serrano, 18 August 2018.

200 "Between the Lines: 1970s Video in Japan," in Adachi, Cleman, and Zippay, *Vital Signals,* 38. London likely means the Tokyo Encuentro in 1978, as Glusberg did not organize an event in Tokyo in 1976, and Bill Viola did not participate in any other event with Glusberg.

201 "Marathon," *Artes visuales* 17 (Spring 1978): 50. (The Spanish-language original, titled "Maraton," is on 28.)

202 Outside of the Encuentros and other video events, CAYC did a better job at disseminating art from Latin America in traveling exhibitions and projects, though we see that these projects typically rely on a smaller group of mostly Argentine artists as the representation of "Latin America," with very little attention to, for instance, Central America and the Caribbean. Here, too, the rhetoric of openness and expansiveness far exceeds the actual promotion of artists beyond a small core circle.

Photo Essay

| Photo essay fig. 1.
Cover of ICA and
CAYC, *I International
Open Encounter on
Video* [London],
exh. cat. (Buenos
Aires: Ediciones
Argentinas, 1974).

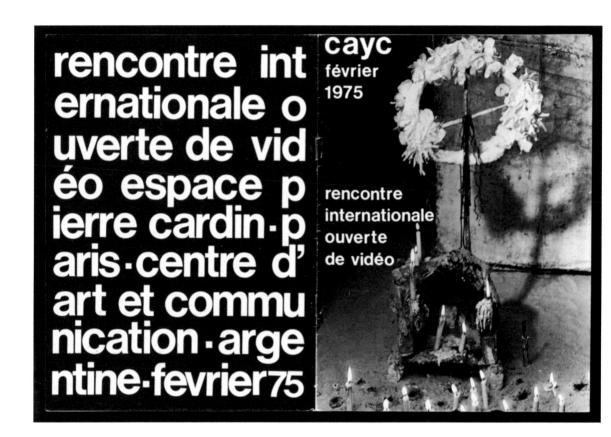

| Photo essay fig. 2.
Cover of CAYC, *Recontre
international ouverte
de video: 20–25 février,
1975* [Paris], exh. cat.
(Buenos Aires: Artes
Gráficas Delgado, 1975).

| Photo essay fig. 3.
Cover of CAYC,
*Third International
Open Encounter on
Video* [Ferrara],
exh. cat. (Buenos
Aires: Ediciones
Argentinas, 1975).

ENCUENTRO INTERNACIONAL DE VIDEO
1977 VIDEO

| Photo essay fig. 4.
Cover of CAYC, *Video
Alternativo: Fourth
International Open
Encounter; Buenos
Aires,* exh. cat. (Buenos
Aires: Ediciones
Argentinas, 1975).

| Photo essay fig. 5.
Cover of CAYC and
MACC, *1977 Video:
Encuentro Internacional
de Video* [Caracas],
exh. cat. (Caracas:
Ediciones Amon, 1977).

seventh intern ational open e ncounter on vi deo - barcelon a - spain - fund ació joan miró and center of a rt and commu nication - 1977

fundació joan miró

cayc

seventh international

open encounter

barcelona

| Photo essay fig. 6. Cover of CAYC and Fundació Joan Miró, *Seventh International Open Encounter: Barcelona,* exh. cat. (Barcelona: The Foundation, 1977).

| Photo essay fig. 7. Cover of CAYC, *Video Arte: 8th International Video Art Festival* [Lima], exh. cat. (Lima: n.p., 1977).

| Photo essay fig. 8. Cover of CAYC, *Video Art 1978: X International Open Encounter on Video* [Tokyo], exh. cat. (Buenos Aires: CAYC, 1978).

video arte

SECTION 2
NETWORKS AND ARCHIVES

José-Carlos Mariátegui

Imagined Video Archives: Strategies and Conditions of Video Art Collections in Latin America

For Néstor Olhagaray, in memoriam

In Latin America, video artworks have circulated broadly and achieved significant visibility in recent decades, and they are now part of private and museum collections.[1] More than four decades of festivals, exhibitions at museums and cultural centers, and creative laboratories played a key role in the proliferation of video production and the dissemination of works throughout the region. As the Brazilian curator and researcher Ana Pato has argued, this proliferation and diffusion made it necessary to preserve those works, resulting in the creation of small audiovisual collections outside of museums.[2] The initial lack of interest in acquiring those works from all but a handful of museums, as well as the urgent need to organize the materials and prevent them from becoming technologically obsolete, led to the first video art archives in Latin America being established by independent festivals and initiatives. There were also programs that promoted the creation and dissemination of new works and helped cultivate networks of artists and communities at different levels: locally, regionally, and globally. In many cases, video art archives have now achieved a certain degree of institutionalization, making it possible to develop original narratives and propose new histories. Recovering and recognizing the value of audiovisual materials that were often abandoned, in a precarious state of conservation, or unidentified has been crucial to the study of video art in Latin America. Those investigations, which inevitably involved digitization as well as methods to organize the information and catalog the material gathered, produced critical essays[3] and publications that incorporate historical studies linked to the work of video artists,[4] demonstrating just how imperative it is to have local video art archives.

Studying the history of audiovisual archives in Latin America requires a broad perspective so that one can identify the wide range of administrative and preservation strategies. Many of these video art archives have dissonant and fascinating approaches to protecting a legacy that is now hanging in the balance, due to rapid technological degradation and a systemic lack of institutional support. In numerous cases, personal initiatives—carried out in a self-directed manner—fill the role that should be played by more established public and private cultural institutions. These audiovisual archives protect local histories and memories that are embedded in social contexts and also inextricably tied to the technical characteristics of their medium, their forms of representation, and their institutional dimension. As Jorge La Ferla and Ramiro Díaz explain, "the origin and the narrative of the archive over time suggest that it has value as a cultural and political memory, the meaning of which has shifted according to the history of different media, their uses and formats in the museum environment. . . . [I]t may now be necessary to think about the use of technologies in terms of exhibitions, archival conservation, and dialogue with the public at galleries and museums, reflecting the diversity of approaches within the institutions."[5]

Beyond the specific characteristics inherent to the local region, one must also consider the nature of video itself, a medium and technique that poses two significant challenges. First, the conservation of magnetic and digital formats has certain requirements that differentiate them from film; there are dozens of formats and codecs, which make them more fragile as the years pass. Second, audiovisual works are difficult to organize because archival systems were originally designed to catalog museum collections that primarily contained still images. Video thus inhabits spaces and problems that bring it closer to other audiovisual practices, such as experimental cinema and short films.

These are some of the basic assumptions underpinning our research, which attempts to establish a preliminary mapping of the institutions, organizations, and personal initiatives associated with the preservation, cataloging, and dissemination of video art works in Latin America. One of the greatest challenges was obtaining information from different sources and analyzing it with the goal of producing a systematic and comprehensive study of the various strategies developed in the region, which would in turn contribute to better knowledge of artists and their works, the preservation status, and data on the cataloging and management of those archives. This involved in-depth interviews, email correspondence, and surveys.[6] Based on the results obtained, we have identified four models that demonstrate the key organizational practices and strategies for preserving and disseminating video artworks in Latin America: video art festivals, museums and institutions, personal initiatives, and exhibitions based on archival research.

THE ARCHIVE AS NECESSITY AND NARRATIVE:
VIDEO ART FESTIVALS

During the 18 Festival de Arte Contemporânea Sesc_Videobrasil 2013, one audiovisual installation had an especially prominent place. Screens displayed excerpts from works in competition, artist interviews, performance documentation, and oral histories of invited guests, all gathered over the course of more than thirty years. This sustained and extensive collection of video-related content has made Videobrasil a reference institution in Latin America.[7] The Videobrasil festival was founded in 1983 by the Brazilian curator Solange Farkas. It has a collection of 14,000 magnetic tapes (90 percent of the physical material in the collection corresponds to recordings and copies), of which 1,400 are works of video art—1,100 by Latin American artists. Videobrasil's digitized collection, which contains twelve terabytes of data, includes the collections of renowned Brazilian artists such as Marina Abs, Rafael França, Rosângela Rennó, and Eder Santos. Ana Pato, who worked as a researcher in Videobrasil's collection and has carried out extensive research, notes that "[the Videobrasil archive] was organized and a database was created, with a classification system, a controlled vocabulary, designed for the collection itself. At that time, . . . it was and continues to be a collection originating in the festival. Every database was designed with that in mind . . . and so what was missing in that project . . . [was] to include the artworks within the classification system for our data . . . [and] to do more work on them in a broader . . . artistic context."[8]

Pato identifies three stages in the history of the Videobrasil archive. The first corresponds to the archive's creation in 1983 until 2001, decades during which it received a large amount of material as a result of the works submitted to the festival, making necessary a preservation plan for the works that had been collected. The second stage, between 2002 and 2007, involved the professional digitization and classification of the material, which led to the creation of Videobrasil online, a pioneering project with a complex information system for works, documentation (including installation documentation of time-based media works), photographs, institutions, people (artists and curators), texts, essays, and publications.[9] In the third stage, the collection was disseminated through exhibitions, with the aim of developing new narratives via discussions and curatorial approaches, as a strategy to promote memory practices. The first exhibition was *Memórias inapagáveis: Um olhar histórico no Acervo Videobrasil* (2014; Unerasable memories: A historic look at the Videobrasil Collection), curated by Agustín Pérez Rubio.[10] A critique of the limitations of archival classification was the impetus for the 2017 exhibition *AGORA SOMOS TODXS NEGRXS?* (Are we all Blxck now?), which brought together the different generations of Black artists in the collection.[11] The Videobrasil archive does not have a category that identifies skin color

or race, which led the exhibition's curator, Daniel Lima, to carry out an investigation that revealed the small number of artists of African descent represented in the collection.

Another video art festival of note, the Festival Franco Latino Americano de Video Arte—first held as the Festival Franco-Chileno de Video Arte in Santiago (1981–92)—played an essential role in the region as a space for freedom of expression during the military dictatorship of Augusto Pinochet (1973–90), expanding first to Buenos Aires and then to Montevideo and Bogotá, until it ended in 1996. In 2015, thanks to Pascal-Emmanuel Gallet (at the time, the head of the Cultural Activities Office of the General Directorate for Cultural and Scientific Relations of the French Ministry of Foreign Affairs), and alongside a study and a number of interviews conducted by the Argentine artist and curator Gabriela Golder on the connections around video in Argentina and France, the French government was able to donate digital copies of the works shown at the festival to the Museo Nacional de Bellas Artes in Santiago[12] and the Universidad Nacional de Tres de Febrero (UNTREF) in Buenos Aires, creating a valuable regional historical archive. Those institutions are affiliated with two important events: the Bienal de Artes Mediales (BAM) in Santiago and the Bienal de la Imagen en Movimiento (BIM) in Buenos Aires, which have also begun working on their own archives.

Following the end of the Festival Franco-Chileno de Video Arte, the Chilean artist and academic Néstor Olhagaray founded the Corporación Chilena de Vídeo y Artes Electrónicas (CChV),[13] which established the Bienal de Video y Artes Mediales—now BAM—in 1993. CChV began collecting works when the biennial was created and now has around five hundred works in both magnetic tape and digital formats, of which four hundred are by Latin American artists. The Archivo Audiovisual de la CChV (AAV_CChV) has historical works from the early 1980s to 2007, as well as pieces submitted to the Concurso Internacional Juan Downey (a video art competition) and a collection of expanded cinema works, which are essential to understanding the history and context of audiovisual art in Chile. CChV has also established the Mediateca Libre, an archive and content repository for digital culture.[14]

BIM in Buenos Aires occupies a space between a festival and an exhibition, pushing the aesthetic possibilities of film and experimental video in new directions in both technical and formal aspects.[15] It was founded in 2012 by the filmmakers, curators, and scholars Gabriela Golder and Andrés Denegri—the directors of the organization CONTINENTE—and is produced by UNTREF. It has also established an archive called VER (See), which has 215 digitized works.

In Central America, unlike what occurred in South America, there has been a unifying phenomenon among the countries in the region, allowing the landscape of Central American audiovisual production to be concentrated in a small number of representative institutions. Arguably

the most significant is the Museo de Arte y Diseño Contemporáneo (MADC)[16] in San José, Costa Rica, which has eighty-five videos as part of its collection. The museum's Centro Regional de Documentación e Investigación (CRDIA) houses a video library that has been collecting materials since 1994. Many of the works were awarded prizes or honorable mentions in the *Inquieta imagen* (Restless image) competition and exhibition, which was conceived to encourage experimentation and to broaden knowledge about digital art production and video creation in Central America (fig. 1). As Fiorella Resenterra, the former director of MADC, explains: "For the MADC, Inquieta Imagen was the language of contemporaneity, and it is now an essential record and archive for understanding the present."[17]

THE ARCHIVE IN CONVERSATION: MUSEUMS AND INSTITUTIONS

Video was a vitally important medium for maintaining a critical and optimistic spirit in Latin America, particularly during the military dictatorships of the 1970s, when video served as an experimental instrument for liberation and memory and as a vehicle for international dissemination at a time when many artists were living in political exile. During those years, despite the complex political and social situation, some museums

and institutions sought to promote the use of video through exhibitions and creative spaces. Nonetheless, videos were not all considered works of art under the museums' own conservation and cataloging systems. As a result, some materials were lost and others were transferred to the libraries and media libraries of those institutions.

In the 1970s, the Museu de Arte Contemporânea da Universidade de São Paulo (MAC USP) carried out a groundbreaking project in the region, initiated by its director, the Brazilian curator and art historian Walter Zanini. MAC USP facilitated an openness to new experimentation in the midst of the military dictatorship, which was a crucial factor in the creation of an audiovisual critical memory and the emergence of the first video works by Brazilian artists including Roberto Evangelista, Paulo Herkenhoff, and Letícia Parente. Zanini supported the idea of the museum as an open laboratory, and in 1976, he created "Espaço B," which contained the Núcleo de Video Tape and made video equipment available for experimentation in new languages and technologies.[18] MAC USP is now building a digital preservation laboratory; since 2014, it has been digitizing and cataloging this important audiovisual collection, which is a landmark in the history of video creation in the region.

The Pinacoteca do Estado de São Paulo also began collecting video works in 2006. Its archive includes nineteen works by Brazilian creators, the oldest from 1973 and the most recent from 2018. The Pinacoteca acquired most of the works with funding from the Programa de Patronos da Arte Contemporânea da Pinacoteca. It has also held workshops addressing different aspects of the conservation, cataloging, and exhibition of time-based media and video works.

By the end of the 1960s, Buenos Aires was a key city for video and new media production. The Instituto Torcuato Di Tella; artists such as Marta Minujín; and the work of the art critic and businessman Jorge Glusberg, through the Centro de Arte y Comunicación (CAYC), developed an interdisciplinary, experimental, and international art that explored the relationship between art and technology, with an emphasis on audiovisual creation. Glusberg promoted video art through the International Open Encounters on Video (1974–78), which contributed significantly to the international circulation of work by a new generation of Latin American artists, although many of those materials are now lost.[19]

The first institutional collections of audiovisual works in Buenos Aires did not appear until the late 1980s: in 1989, the Instituto de Cooperación Iberoamericana (ICI) organized the exhibition *Buenos Aires Vídeo I*, curated by Carlos Trilnick. The ICI became the most significant institution for the dissemination and conservation of video art in Buenos Aires. As the artist and curator Graciela Taquini notes, the ICI became identified with a generation of young creators,[20] establishing prizes, a number of screening series, and a video library as well as publishing a book about the period.[21]

The ICI was followed by the Museo de Arte Moderno de Buenos Aires, which, under the direction of Laura Buccelato (1997–2013), had a video collection that was developed by Taquini, based on the works that had been presented in that space and were donated by the artists. In 2010, the materials were cataloged; they now form the museum's audiovisual archive. Between 2017 and 2018, Gabriel Boschi and Valeria Orsi carried out research, reorganizing the audiovisual works and their associated documents and discovering new data about their provenance. This archive is primarily composed of the works that were selected for the different editions of the Premio Arte y Nuevas Tecnologías MAMbA—Fundación Telefónica or included in the museum's exhibitions and screenings. Some initiatives were halted upon the departure of their administrators, which set a precedent in terms of institutional sustainability and the inability to develop a consistent long-term project. This is also the case at the Museo Nacional de Bellas Artes (MNBA) in Buenos Aires, which in the 1990s, under the direction of Jorge Glusberg and the coordination of Rubén Guzmán, began acquiring video art for the collection; however, many of the works have not been yet cataloged.[22]

Two exemplary cases have emerged in the city of Rosario, Argentina, where audiovisual collections have achieved a remarkable degree of institutionalization. In 2000, the Museo Castagnino + Macro began a collection that now has sixty-five works, through an acquisitions program for contemporary Argentine art.[23] The museum is currently working on migrating the archives to a digital format, cataloging and researching the archive, and planning future acquisitions. Rosario also hosts the emblematic Festival Latinoamericano de Video de Rosario—now the Festival de Cine Latinoamericano Rosario[24]—which began in 1993. In the wake of that event, the city's first public video library was created in 1995: the Centro Audiovisual Rosario (CAR), a public cultural space for audiovisual events that has more than ten thousand Latin American audiovisual works, making it one of the largest collections in the region.[25]

Among Mexican museums, the Museo de Arte Carrillo Gil in Mexico City has one of the longest traditions in Latin America of collecting and exhibiting video and video installations. The museum has three hundred audiovisual works, of which approximately fifty are by Latin American artists. It also has historical works related to video, as well as recent ones, many by artists who have participated in the museum's exhibitions or activities.

In Uruguay, the Centro Cultural de España (CCE) in Montevideo has an important archive of Ibero-American video art, which was begun in 1988 by the artist and curator Patricia Betancur and now has three hundred works. The video works were produced for exhibitions and activities at CCE, many through its Centro de Recursos Audiovisuales (CRAS), a space dedicated to the development, creation, and dissemination of new media projects. CCE has also worked on restoring audiovisual material, as

in the exhibition *La condición video: 25 años de videoarte en el Uruguay* (The video condition: 25 years of video art in Uruguay)[26] and more recently *Intersticios: Cuerpos políticos, estrategias conceptualistas y experimentalismos cinematográficos* (Interstices: Political bodies, conceptualist strategies, and cinematographic experimentalism),[27] the latter of which will be examined in more detail later.

In Santiago, the Centro de Documentación Artes Visuales at the Centro Cultural La Moneda (CCLM) has three hundred audiovisual recordings, both video art and performance, as well as television programs about the visual arts. The Archivo Digital of the Cineteca Nacional at CCLM supplements these works with other historical recordings and even feature films, many of which are available online.[28] CCLM seeks to restore, preserve, and disseminate the cinematographic and audiovisual heritage of Chile and to promote knowledge about it. The online archive[29] allows access to the first cinematographic footage shot in Chile in 1903, as well as the latest films that have been released. Of particular note is a complete chronology of Chilean feature films, numbering more than 460. This is an important example of an archive being successfully disseminated, promoting both its circulation and free public access to the collection, through digital means.

In Central America, TEOR/éTica in San José, Costa Rica—founded in 1999 by the artist, curator, and researcher Virginia Pérez-Ratton—has a collection of works by Central American and other artists who have exhibited at the institution or provided material for viewing or donation.[30] TEOR/éTica's collection of three thousand items includes recordings of performances and interventions, video art, and documentation related to exhibitions and artists from Central America and abroad.

In Peru, Alta Tecnología Andina (ATA) and the Museo de Arte de Lima (MALI) have been developing the espacio-Plataforma de Preservación Audiovisual (ePPA), which seeks to preserve and disseminate the Peruvian audiovisual collections preserved and studied at both institutions by incorporating them into a unified single database.[31] The project will create a space within MALI for viewing audiovisual material, which will be supplemented by an online platform for searching its contents. The MALI and ATA collections have more than two hundred works: most of the works at MALI arrived through its acquisition program, while the works at ATA come from coproduction and creative projects carried out over more than two decades. The ePPA also studies and preserves materials from the audiovisual movement in 1970s and 1980s Peru.

Finally, in Bolivia, the Cinemateca Boliviana seeks to preserve and disseminate the Archivo Nacional de Imágenes en Movimiento de Bolivia.[32] The archive's work is motivated by the increasing importance of moving images as essential documents for the preservation of collective historical memory, the construction of national identities, and the shaping of social imaginaries. In addition, Nicobis—Archivo Audiovisual de los

Pueblos Indígenas is a center for communication in film, video, television, radio, and publishing. Founded in 1981, the Archivo was the first video production company in the city of La Paz, and it has operated continuously for more than thirty-six years, developing more than one hundred and fifty audiovisual productions, including documentaries, feature films, and cartoons. Nicobis is primarily focused on Indigenous peoples and the environment and on children and adolescents. Another institution in Bolivia, the Centro de Documentación de Artes y Literaturas (CEDOAL) at the Espacio Simón I. Patiño, preserves and facilitates the public consultation of its collection of Bolivian video art through its online catalog,[33] the outcome of rigorous research by the Bolivian artist Narda Fabiola Alvarado, who documented the history of video art in her country.[34]

SUSTAINED AND UNSUSTAINABLE INITIATIVES: THE PERSONAL ARCHIVE

The two models examined in the previous sections show that an important impetus for the creation of video art collections comes directly from individuals who have led or established organizations to promote the creation and dissemination of video and experimental media art. In the cases presented in this section, the individual takes on a central role, through small personal endeavors that—in response to a lack of institutional support—assume responsibility for conservation, cataloging, and dissemination. Such endeavors become intertwined with the professional and artistic lives of the people behind the initiatives.

The Museo Centroamericano de Videoarte (MUCEVI) is a project by Antonieta Sibaja in San José, Costa Rica, which seeks to create a new form of visibility for video and sound artists in the Central American and Caribbean regions. MUCEVI was founded in 2010 and now has almost four hundred works in digital formats dating back to the 1990s, when the production of video art began increasing in Central America. Along the same lines, the Argentine filmmaker Mariela Cantú founded Arca Video Argentino, an online archive and database that aims to highlight the work of artists and promote the conservation, dissemination, and exhibition of Argentine video art, facilitating public access to a valuable collection of artistic production. In 2019, Cantú received a creative grant from the Fondo Nacional de las Artes of the Ministry of Culture in Argentina to update the current platform and create an archive of Argentine experimental video, using a participatory approach. Although MUCEVI and Arca seek to promote the study and conservation of their video art archives through workshops and screenings, both projects are facing issues common among independent archives. As Cantú explains, "what happened to Arca is what happens to a lot of projects: the problem of sustainability. The database still exists, the research still exists, all that is fine. The problem was maintaining not only the website . . . but also

[dealing with] issues related to coding, which has to be updated, as well as having a team of people who can upload new information over time."[35] Cantú believes that it is important to develop participatory archive projects, allowing the members of a community to make decisions about the cataloging criteria that are most appropriate for them, therefore nurturing a bottom-up sustainability.

The Asociación Archivo Nuevos Medios Ecuador (AANME),[36] established by María Belén Moncayo, is an example of an independent collection pursuing an institutional path. AANME was created in 2002, initially out of a closet in Moncayo's home in Quito. Today, it has an online catalog with 318 works by 121 artists. AANME published a book on the archive, titled *Ecuador 1929–2011: 100 artistas del audiovisual experimental* (2011; Ecuador 1929–2011: 100 experimental audiovisual artists).[37] The collection also holds the experimental film work of the painter and playwright Eduardo Solá Franco and two hundred works on loan from international artists. Throughout its existence, AANME has received international support to enable its sustainability over time.

Led by the filmmakers Ángela López Ruiz and Guillermo Zabaleta, the Laboratorio de Cine FAC (Fundación de Arte Contemporáneo) in Montevideo has been operating since 1999 as an artists' collective and a laboratory. Through workshops and exhibitions, López Ruiz and Zabaleta have been able to coalesce the interests of artists, archivists, curators, and researchers who have collaborated on mapping and restoring audiovisual works throughout the region. The collection includes one hundred and fifty works of Uruguayan experimental cinema since 1951 in both digital and film formats, developed through the Laboratorio de Cine FAC's efforts to restore the material.

The last individual archivist to be discussed in this section, the French-Colombian artist and academic Gilles Charalambos, has approximately three hundred works of video art by Latin American creators; he is also the creator of a landmark website, *Historia del videoarte en Colombia*.[38] Charalambos began preserving and collecting audiovisual works in 1976 and now has pieces in magnetic, digital, and film formats (16mm, 35mm, Super 8, etc.). This archive is the result of both his intense personal labor and, in part, his activities organizing video festivals. Charalambos used the archive to develop the publication *Aproximaciones a una historia del videoarte en Colombia 1976–2000* (Approaches to a history of video art in Colombia 1976–2000)[39] and the exhibition *Retro Visión Espectral: Aproximaciones a una historia del videoarte en Colombia* (2018; Spectral retro vision: Approaches to a history of video art in Colombia), to be discussed in the following section.

These "archivists"—Antonieta Sibaja, Mariela Cantú, María Belén Moncayo, Ángela López Ruiz and Guillermo Zabaleta, and Gilles Charalambos—challenge institutional models. They serve as caretakers of a scattered cultural heritage, preserving it and giving it visibility, as well

as supplementing that activity with initiatives such as workshops and spaces. In addition, while discussing those who have built independent collections, it is important to mention two artists who have established indispensable archives: Paulo Bruscky and Ximena Cuevas. In these cases, one might say that the archives themselves are fundamental elements of the artists' creative practice.

Paulo Bruscky has played a key role in bringing major international art movements—including Fluxus, Gutai, mail art, performance art, and conceptual art—to Brazil. Bruscky's studio is also his archive. There he collects valuable material, including a collection of Super 8 films that are crucial to understanding his rich and prolific career, which spans more than four decades at the intersection of art, life, and communication.[40]

Ximena Cuevas is one of the most prominent Mexican video artists working today and is an essential reference in Latin America. Her archive contains fifteen hundred works (a vast majority are Mexican, with seventy being from elsewhere in Latin America) and was created based on a passion for the language of the moving image. Cuevas was able to catalog and digitize this archive with a grant from the Sistema Nacional de Creadores; doing so allowed her to develop new narratives and organize an original historical timeline of Mexican video art: "The timeline of Mexican video art is unique within Mexico. No one has cataloged it this way, and it is very interesting when . . . you begin to see the relationships and dialogues over time. . . . I create archives as a provisional arrangement, [which] opens up more interesting readings."[41]

As mentioned above, since these are personal projects, often without enough funding or other support, they run the risk of being unsustainable in the long term. Moreover, the arduous work required to organize and catalog such archives often competes with an artist's own creative practice. As Cuevas says: "I feel a bit like I am drowning in the archives because they do become an ocean, so I periodically try to review them and put them back in order, because—of course—archives without a structure are a meaningless ocean."[42]

EXHIBITIONS AS INVESTIGATION: THE EXPANDED ARCHIVE

The final model, which is becoming increasingly common for the establishment of audiovisual archives, is retrospective or historical exhibitions based on research and investigations into video materials that were widely dispersed or inaccessible. Four recent cases demonstrate this trend.

To commemorate the twenty-year anniversary of ATA, a research project was carried out in its archives, which made it possible to collect, analyze, and catalog materials for the exhibition *metadATA: 20 años de Cultura, Arte y Tecnología* (2016; metadATA: 20 years of culture, art, and technology)—cocurated by Jorge Villacorta, José-Carlos Mariátegui,

| Fig. 2. Installation
view of the *metadATA:
20 años de Cultura,
Arte y Tecnología*
exhibition at the
Centro Cultural Ricardo
Palma, Lima, 2016.

| Fig. 3. Installation
view of the *Retro
Visión Espectral:
Aproximaciones
a una historia del
videoarte en Colombia*
exhibition at the
Museo de Antioquia,
Medellín, 2019.

Nataly Montes, and Reina Isabel Jara—at the Centro Cultural Ricardo
Palma in the Miraflores district of Lima (fig. 2). The exhibition included
audiovisual material from the early years of ATA, the Festivales
Internacionales de Video/Arte/Electrónica, the project Escuelab, and
selected projects and collaborations with organizations and individuals.
A video-on-demand (VoD) system was also installed in a gallery, making
nearly two hundred titles available to the visiting public. Following this
exhibition, public and private funds were obtained to produce a bilingual
volume of original essays titled *El mañana fue hoy: 21 años de videocreación y
arte electrónico en el Perú (1995–2016) = The Future Was Now: 21 Years of Video
and Electronic Art in Peru (1995–2016)*.

The exhibition *Retro Visión Espectral: Aproximaciones a una historia
del videoarte en Colombia*—curated by Gilles Charalambos and held at
the Museo Monumento a los Héroes in Bogotá (2018) and the Museo
de Antioquia[43] in Medellín (2019)—featured the most representative
pieces by Colombian artists from 1973 to 2000 in the context of sound,
electronic, and conceptual experimentation. The artists included
Andrés Burbano, Clemencia Echeverry, José Alejandro Restrepo, and
Charalambos himself. The forty-two works in the exhibition, presented
on household television sets from the 1980s and 1990s to evoke the
atmosphere of the period when the works were created (fig. 3), were the
result of research by Andrés García-La Rota of the Instituto Distrital
de las Artes (Idartes) in Bogotá. García-La Rota's investigation required
exhaustive archival research, including the acquisition, digitization, and

restoration of a number of videos that represented important findings for
the history of Colombian video art. For the exhibition, the four galleries
in the Museo de Antioquia were divided by decade (1970, 1980, 1990, and
2000, respectively); in addition, a space showed interviews and a selec-
tion of one-minute excerpts from several of the videos. *Aproximaciones a
una historia del videoarte en Colombia 1976–2000* was published as part of
the project.[44]

Under the coordination of Guillermo Zabaleta, the CCE in
Montevideo presented the 2019 exhibition *Intersticios*, a visual-arts
platform focused on the restoration, preservation, and exhibition of
archives, documents, and research on artistic works and practices
centered on the experimentalism of the 1950s, conceptualist poetics,
and the rise of new media in the mid-1980s (fig. 4). In the exhibition,

the archive is displayed in the gallery as a large installation along three curatorial axes: *Cuerpos políticos: Mujeres artistas uruguayas de los sesenta* (Political bodies: Uruguayan women artists of the 1960s), curated by Elisa Pérez Buchelli; *Estrategias conceptualistas: Los grupos Octaedro, Los Otros, y Axioma* (Conceptualist strategies: Octaedro, Los Otros, and Axioma), curated by May Puchet; and *Disruptivo, directo, militante, experimental: El cine desde Uruguay hacia América Latina* (Disruptive, direct, militant, experimental: Cinema from Uruguay to Latin America), curated by Ángela López Ruiz.

Finally, since the material resulting from research for audiovisual exhibitions is often far more extensive than what is actually shown, it is important to mention the work of the Centro de Documentación Príamo Lozada (CDPL) at the Laboratorio Arte Alameda (LAA) in Mexico City. CDPL does not have a collection of works, but it preserves the material resulting from each exhibition at the LAA. The center also contains a library as well as the archive of the new-media curator Príamo Lozada, the director and founder of the LAA. The exhibition *(Ready) Media: Hacia una arqueología de los medios y la invención en México* (2010; [Ready] media: Toward an archaeology of media and invention in Mexico) was the product of a critical and interdisciplinary reading of the LAA archive, which yielded both an audiovisual series of more than two hundred works on six DVDs and a publication, now an essential reference on the history of art, technology, and new media in Mexico.[45]

CONCLUSIONS

These four models allow us to identify several recurrent situations as well as working practices and occupational cultures in video archives in Latin America. One of the main findings is that many video art archives are still scattered; in addition, important preservation and dissemination initiatives operate under administrative models with precarious sustainability. Although video art has—perhaps belatedly—been incorporated into museum collections, there is still much work to be done in terms of recovering works and creators that have been abandoned, particularly those that emerged in the region in the final decades of the twentieth century. Institutional initiatives are still few and far between and have serious economic constraints that do not permit the much-needed organization and dissemination of the materials. Inadequate cataloging and a lack of access (particularly online) limit the possibilities for studying and circulating this valuable material. From a technical standpoint, there are good cataloging practices and record-keeping techniques in archives that contain a broader range of audiovisual works, such as the Cinemateca Nacional of the Centro Costarricense de Producción Cinematográfica or the Cinedata repository in Uruguay.[46] Nonetheless, conservation policies in Latin American countries where there are film archives or preservation initiatives do not necessarily include video art collections or recognize them within the standards they use for audiovisual conservation and cataloging. The lack of defined cataloging procedures leaves the preservation of video art collections in an institutional limbo.

From a personal perspective, and based on the work carried out at ATA since 1995, I can assert that taking on the multiple responsibilities involved in archiving video art is a complex task. First, there is physical preservation and technical maintenance, which requires the format of the works to be updated regularly to prevent them from becoming technologically obsolete. Second, it is necessary to rigorously respect and protect the copyright of the material and to demand fair payment for artists when it is exhibited, a practice that is ignored in many institutions in Latin America, particularly in Peru. These two aspects complicate the proper preservation and dissemination of the works. On the positive side, since 2018, the Peruvian Ministry of Culture has organized the Concurso Nacional de Proyectos de Preservación, which offers financial support to preserve Peru's audiovisual heritage. ATA, in partnership with MALI, won a grant to develop the ePPA (as mentioned above) as part of this competition. Nonetheless, the public funding models do not make a long-term commitment, nor is there a national film and video archive to preserve this legacy for future generations. It is disappointing to see that there are few cultural heritage institutions in Peru with policies to protect the country's audiovisual legacy and the collective creative memory of the nation and its people.

Systematic work with audiovisual collections allows us to develop critical readings and identify the limitations of cataloging and its levels of visibility. The archive is no longer the exclusive concern of professionals in the information sciences but rather a transversal axis for critical reflection.[47] As mentioned above, Videobrasil has carried out research and curatorial work that has revealed the problematic power relations of rigid cataloging structures. Ana Pato says that "I was extremely impressed . . . because I was able to see the relationship between power and memory . . . the role of archivists in the sense of a person's opinion."[48] This is echoed by Mariela Cantú, who calls for collaborative or open archival parameters: "There is space for a very significant exercise of power by the archivist, which can be somewhat problematic when you think about more open forms of archiving, and so there is this whole movement of participatory archives. . . . if we are going to think about a community archive, for example, the community itself should catalog it, with criteria that are appropriate."[49]

A reflection on the abundance of alternative narratives that can be offered by video art archives is embedded in the independent efforts and initiatives that seek to collect and study the history of Latin American video art. These parainstitutional initiatives pursue alternative administrative models—grounded in collaboration—which make it possible to explore flexible classifications and cataloging models, encouraging speculation on potential new readings and histories. The existence of this type of initiative confirms the importance of and need for access to audiovisual archives and underscores the commitment of individuals to preserving their country's audiovisual memory. The precarious sustainability of many of these initiatives is a characteristic of our incipient democracies, which we see portrayed in Latin American audiovisual history and which affect the critical development of audiences and publics in times when content fragmentation is encouraged and there is fierce competition for attention from multiple screens and mediums.

Notes

This essay was translated from the Spanish by Audrey Young.

1 This work is a preliminary survey and thus does not claim to be exhaustive or conclusive. The objective is to propose several paths for more systematic study and discussion in the future, which should include greater detail on the artists and their works, the preservation status thereof, and a critical understanding of their cataloging, as well as the visibility of the works and creators that compose Latin American video art collections. It is also important to note that this study represents only a portion of the existing archives; other archives are still invisible and widely scattered.

The author and the project team would like to thank the following people for their valuable support: Tania Aedo, Rodrigo Alonso, Narda Alvarado, Priscila Arantes, Elisa Arca, José Balado, Patricia Bentancur, Valeria Boggino, Andrés Burbano, Gilles Charalambos, Fernanda D'Agostino, Eduardo de Jesús, Alejandrina D'Elia, Gonzalo Egurza, Solange Farkas, Paloma Ferrero, Paola Gallardo,

Fabiana Gallegos, Andrés García-La Rota, Gabriela Golder, Laura Guitron, Silvia Hirao, Ángela López Ruiz, William Miranda, Verónica Moll, María Belén Moncayo, María José Monge, Mario Opazo, Valeria Orsi, Kevin Pérez, Georgina Ricci, Enrique Rivera, Gustavo Romano, Lucía Sanromán, Ivonne Sheen, Antonieta Sibaja, Daniel Soto Morúa, and Guillermo Zabaleta. The author is particularly grateful to Almendra Otta, a research assistant at ATA, who actively collaborated with us during the second stage of the project, from the second half of 2019 to early 2020.

2 Ana Pato, "Digital Archives: The Experience of Videobrasil," in *Futuros possíveis: Arte, museus e arquivos digitais = Possible futures: Art, Museums, and Digital Archives*, ed. Giselle Beiguelman and Ana Gonçalves Magalhães (São Paulo: Peirópolis and EDUSP, 2014), 84–95.

3 Luis Camnitzer, María Clara Bernal Bermúdez, and Juan Felipe González Espinosa, *Antología de textos críticos 1979–2006: ArtNexus / Arte en Colombia* (Bogotá: Universidad de los Andes, 2007); Laura Baigorri, ed., *Vídeo en Latinoamérica: Una historia crítica* (Madrid: Brumaria, 2008); Jorge La Ferla, ed., *Historia crítica del video argentino* (Buenos Aires: MALBA-Fundación Eduardo F. Costantini and Fundación Telefónica, 2008); Clara Garavelli, *Video experimental argentino contemporáneo: Una cartografía crítica* (Buenos Aires: Editorial Universidad Nacional de Tres de Febrero, 2014); Rodrigo Alonso, *Elogio de la Low-Tech: Historia y estética de las artes electrónicas en América Latina* (Buenos Aires: Luna Editores, 2015); Max Hernández Calvo, José-Carlos Mariátegui, and Jorge Villacorta, eds., *El mañana fue hoy: 21 años de videocreación y arte electrónico en el Perú (1995–2016) = The Future Was Now: 21 Years of Video and Electronic Art in Peru (1995–2016)* (Lima: Alta Tecnología Andina, 2018).

4 José-Carlos Mariátegui and Jorge Villacorta, *Videografías (in)visibles: Una selección de videoarte latinoamericano 2000–2005*, exh. cat. (Valladolid: Museo Patio Herreriano, 2006); Enrique Aguerre and Fernando Álvarez Cozzi, *La condición video: 25 años de videoarte en el Uruguay* (Montevideo: Centro Cultural de España en Montevideo, 2007); Jorge La Ferla and Mariela Cantú, *Video argentino. Ensayos sobre cuatro autores: Carlos Trilnick, Arteproteico, Marcello Mercado, Iván Marino* (Buenos Aires: Nueva Librería, 2007); Arlindo Machado, *Made in Brasil: Três décadas do vídeo brasileiro* (São Paulo: Itaú Cultural, 2003); Narda Alvarado, ed., *El videoarte en Bolivia: Aproximaciones teóricas y videografía* (La Paz: Gobierno Autónomo Municipal de La Paz, 2010); María Belén Moncayo, ed., *Ecuador 1929–2011: 100 artistas del audiovisual experimental* (Quito: Asociación Archivo Nuevos Medios Ecuador, 2011); Clara Garavelli, *Video experimental argentino contemporáneo: Una cartografía crítica* (Buenos Aires: Editorial Universidad Nacional de Tres de Febrero, 2014); Teté Martinho and Solange Oliveira Farkas, eds., *Videobrasil: Três décadas de vídeo, arte, encontros e transformações* (São Paulo: Associação Cultural Videobrasil, 2015); Claudia Aravena and Iván Pinto, eds., *Visiones laterales: Cine y video experimental en Chile (1957–2017)* (Santiago: Ediciones Pesados Metales, 2018); Gilles Charalambos, *Aproximaciones a una historia del videoarte en Colombia 1976–2000* (Bogotá: Instituto Distrital de las Artes-Idartes, 2019); and Gilles Charalambos, *Historia del videoarte en Colombia*, https://www.bitio.net/vac.

5 Jorge La Ferla and Ramiro Díaz, "Repositorios Midiáticos," in *IV Seminário serviços de informação em museus: Informação digital como patrimônio cultural / 4th Seminar on Museum Information Services: Digital Information as Cultural Heritage*, ed. Cristina Ayres da Silva Maringelli (São Paulo: Pinacoteca de São Paulo and SESC, 2017), 322–23.

6 The information used to produce the essay was based on personal conversations, interviews, and data provided by the organizers of many of these projects, beginning in early 2019. In-depth interviews were conducted with

Mariela Cantú, Ximena Cuevas, Jorge La Ferla, Ruy Luduvice, and Ana Pato. Eighteen responses were received to a survey that sought to gather basic information on different collections. In total, more than forty professionals were contacted and have contributed valuable information during the process, through correspondence and their survey responses.

7 See La Ferla and Díaz, "Repositorios Midiáticos."

8 Ana Pato, interview by the author, 10 May 2019.

9 See the Videobrasil collection online at http://site.videobrasil.org.br /acervo.

10 See Associação Cultural Videobrasil, "Unerasable Memories: A Historic Look at the Videobrasil Collection," http://site.videobrasil.org.br /publicacoes/livrosexposicoes/memorias.

11 See Associação Cultural Videobrasil, *Agora somos todxs negrxs?*, http:// site.videobrasil.org.br/exposicoes/galpaovb/agorasomostodxsnegrxs.

12 See biobiochile.cl, "Donarán archivos de los Festivales Franco Chilenos de Video Arte 1983–1994 al Bellas Artes," 7 October 2015, https://www .biobiochile.cl/noticias/2015/10/07/donaran-archivos-de-los-festivales-franco -chilenos-de-video-arte-1983–1994-al-bellas-artes.shtml.

13 See Corporación Chilena de Video y Artes Electrónicas, http:// www.cchv.cl.

14 See Mediateca Libre, http://mediatecalibre.cl.

15 See Bienal de la Imagen en Movimiento, http://bim.com.ar.

16 See Museo de Arte y Diseño Contemporáneo, http://madc.cr.

17 Fiorella Resenterra, "Del sosiego a la invención," in *Inquieta Imagen 2017: Ultra_contaminados* (San José, Costa Rica: Museo de Arte y Diseño Contemporáneo, 2018), 5.

18 Cristina Freire, "Alternative Nets," in *Subversive Praktiken, practices Kunst unter Bedingungen politischer Repression; 6oer–8oer/Südamerika/Europa = Subversive Practices: Art under Conditions of Political Repression; 60s–80s/South America/ Europe*, ed. Hans D. Christ and Iris Dressler, exh. cat. (Ostfildern, Germany: Hatje Cantz, 2010), 245–89; and Walter Zanini, *Walter Zanini: Vanguardas, desmaterialização, tecnologias na arte*, ed. Eduardo de Jesus (São Paulo: Editora WMF Martins Fontes, 2018).

19 Rodrigo Alonso, "Hacia una genealogía del videoarte argentino," in Baigorri, *Vídeo en Latinoamérica;* and Katarzyna Cytlak, "International Open Encounters on Video: The Role of the Art and Communication Center (CAYC) in Buenos Aires in International Video Art Networks during the 1970s," in *Early Video Art and Experimental Film Networks: French-Speaking Switzerland in 1974, a Case-Study for "Minor History,"* ed. François Bovier (Lausanne: ECAL, 2017), 137–66.

20 Graciela Taquini, "Una crónica del videoarte en la Argentina: De la transición a la era digital," in Baigorri, *Vídeo en Latinoamérica*, 27–36.

21 Rodrigo Alonso and Graciela Taquini, *Buenos Aires Video X: Diez años de video en Buenos Aires* (Buenos Aires: ICI, Centro Cultural de España, 1999).

22 The museum's digital collection is available online and has more than 2,500 works, but it was not possible to identify any video works; searching by categories and keywords yields no results.

23 See Castagnino + Macro, https://castagninomacro.org.

24 See Festival de Cine Latinoamericano Rosario, http://www .festivalcinerosario.gob.ar.

25 See Centro Audiovisual Rosario, http://www.centroaudiovisual.gob.ar.

26 Enrique Aguerre and Fernando Álvarez Cozzi, *La condición video: 25 años de videoarte en el Uruguay*, exh. cat. (Montevideo: Centro Cultural de España en Montevideo, 2007), https://issuu.com/facozzi/docs/condicionvideo.

27 See Centro Cultural de España, *Intersticios: Cuerpos políticos, estrategias conceptualistas y experimentalismos cinematográficos*, http://cce.org.uy/evento /intersticios-cuerpos-politicos-estrategias-conceptualistas-y-experimentalismos -cinematograficos.

28 See Centro Cultural La Moneda, https://www.cclm.cl/cineteca -nacional-de-chile.

29 The original website for the digital archive of the Cineteca Nacional at CCLM, https://www.ccplm.cl/sitio/archivo-digital, is no longer active.

30 See TEOR/éTica, https://teoretica.org/?lang=en.

31 See Alta Tecnología Andina, ePPA (espacio-Plataforma de Preservación Audiovisual), http://ata.org.pe/2019/03/26/eppa-espacio-plataforma-de -preservacion-audiovisual.

32 See Cinemateca Boliviana, http://www.cinematecaboliviana.net.

33 The website for the Centro de Documentación de Artes y Literaturas at the Espacio Simón I Patiño, http://espacio.fundacionpatino.org/cedoal, is no longer active.

34 Alvarado, *El videoarte en Bolivia*.

35 Mariela Cantú, interview by the author, 8 May 2019.

36 See Asociación Archivo Nuevos Medios Ecuador (AANME), https:// www.archivo.aanmecuador.com.

37 Moncayo, *Ecuador 1929–2011*.

38 See Charalambos, *Historia del videoarte en Colombia*, http://bitio.net/vac.

39 Charalambos, *Aproximaciones a una historia del videoarte*.

40 Paulo Bruscky, *Arte e multimeios = Art and Multimedia = Arte y multimedios*, ed. Cristiana Tejo (Recife, Brazil: Zolu, 2010).

41 Ximena Cuevas, interview by the author, 29 April 2019.

42 Cuevas, interview.

43 The original website for the exhibition *Retro Visión Espectral*, https:// www.museodeantioquia.co/exposicion/retro-vision-espectral, is no longer active.

44 Charalambos, *Aproximaciones a una historia del videoarte*.

45 *(Ready) media: Hacia una arqueología de los medios y la invención en México* (Mexico City: Conaculta, 2010), set of 6 DVDs.

46 See Centro de Cine, https://www.centrodecine.go.cr; and Cinedata.uy, https://www.cinedata.uy.

47 Andrés Maximiliano Tello, *Anarchivismo: Tecnologías políticas del archivo* (Adorgué, Argentina: La Cebra, 2018).

48 Pato, interview.

49 Cantú, interview.

Gabriela Aceves Sepúlveda

La portapak en Latinoamérica: The Gendering of Video Art in Argentina, Brazil, Chile, Colombia, and Mexico

The introduction of the portable video camera recorder—most commonly
known as a portapak—occurred alongside the international reappearance
of feminism(s) both as political movements and in public discourse in the
early 1970s. This convergence made video one of the most sought-after
means of expression for women artists who had been marginalized by
dominant modes of media and political representation and by the patriar-
chal structures of the art world. The portable video camera facilitated the
exploration of the intimate and domestic, while the videotape provided
a wide range of options for independent distribution and circulation of
video-based projects that gave women artists a greater voice and presence
in the visual arts and mass media. Video's immediacy and confrontational
nature empowered these artists to challenge media representations of the
female body, female sexuality, and cultural stereotypes—thus potentially
transforming fixed notions of class, gender, and ethnicity.[1] Furthermore,
the medium's newness and resulting lack of history afforded women
artists more agency to determine the terms of use and relationship to
video technology, which in turn allowed many to develop and theorize an
embodied relation with their portapaks that challenged dominant percep-
tions about the gendering of technology.[2]

Across Latin America, the convergence of feminist discourse and
the introduction of video technology is not as visible as in Canada, the
United States, and Western Europe. This invisibility is due in part to the
uneven introduction of video technology to the region and the complex
ways that distinct feminist discourses have been defined and theorized
in relation to local politics and the visual arts.[3] Feminist activism across
Latin America has a long and rich history that has been in constant
dialogue with international feminists' discourses and local Indigenous
practices. In particular, the reemergence of feminisms in Latin America

110

in the 1970s spoke to international trends, as many feminist activists traveled abroad, were in exile, or were engaged with feminists around the world through diverse networks. In the wake of the celebration of the first United Nations World Conference of the International Women's Year (IWY), held in Mexico City in 1975, several magazines, film collectives, art exhibitions, and radio and television programs were established all over the region, with many sharply critiquing the dominant intellectual and cultural spheres as sites of patriarchal power and meaning-production.[4]

In this chapter, I seek to make visible the pivotal role that women in Latin America played as agents of video technology by focusing on some of the first (1960s–70s) and second (1980s) generation of video artists in the region. Specifically, I look at how Latin American women became not only producers but also enablers of video technology in various capacities and how, in doing so, they transformed and challenged media representations in art and the gendering of technology. I elaborate two loose clusters of affinities between women artists working in Latin America with electronic images. The first cluster focuses on three artists: the Argentine Marta Minujín, the Mexican Pola Weiss, and the Colombian Sandra Llano-Mejía, each of whom developed unique engagements between self and technology and challenged dominant perceptions about the gendering of technology. This group of artists transitioned from traditional artistic formats to experiments with performance, Happenings, installations, closed-circuit television, computers, and electronic images, leading to some of the most experimental engagements with videography in the region. The second cluster focuses on Anna Bella Geiger, Letícia Parente, and Sonia Andrade from Brazil; and Lotty Rosenfeld, Diamela Eltit, and Gloria Camiruaga from Chile, all of whom are discussed as artists who developed an audiovisual language to challenge stereotypical gender representations in media while simultaneously reinscribing the female body as both a site of violence and political articulation in response to military dictatorships.[5]

Women artists working in film, video, and television in the 1970s verged toward an exploration of the objectification of the female body in media and art by blurring the boundaries between the subject and the object of representation. Above all, they proposed a messier and more embodied model of perception to reconfigure normative relations between the viewer and the object of representation, between the screen and the body. As Amelia Jones argues, US-born artists such as Joan Jonas present "complex psychodynamic relations in their art which reconfigure normative relations between 'the televisual flesh' and 'the flesh of the body' into a new techno phenomenology of experience that combats alienation."[6] Japanese-born and US-based Shigeko Kubota took this further by developing an embodied relationship with the technology itself. As I have argued elsewhere, Kubota conceptualized her camera as

an extension of her body, a prosthetic for a mother-daughter relation, a substitute for a sexual partner, and a means to claim self-sufficiency.[7] In an excerpt from a poem that complemented her video installation *Behind the Video Door* (1969–76), Kubota affirmed that

> I travel alone with my Portapak on my back, as Vietnamese women do with their babies. I like video, because it is heavy. Portapak and I traveled over Europe, Navajo land, and Japan without male accompany. Portapak tears down my shoulder, backbone and waist. I feel like a Soviet woman, working on the Siberian Railway.[8]

Using video's intermedial capacities, Kubota also fused a range of artistic genres and developed her own categories to understand her media explorations (as in her creation of *video-sculptures* and *video-diaries*).[9]

In parallel and at times earlier than Kubota and Jonas, Minujín, Weiss, and Llano-Mejía explored electronic and audiovisual technology to address new and expand normative gender relations of perception and spectatorship by proposing a corporeal relation between self and technology. Similarly, artists working in Brazil and Chile used video technology as early as 1973 to record performances and actions in which their female bodies were subjected to different forms of repetitive violence as metaphors of gendered and military oppression.

In the 1970s, video technology in Latin America was scarce and expensive. Only artists with economic means and the right connections could afford to experiment with such technology. While many portapaks were brought to the region via individual artists, in some areas the broadcast industry, which was increasingly adopting video technology in live broadcasts, played a crucial role in providing access to video technology for artistic experimentation.[10] At the same time, the encroachment of television in everyday life was progressively apparent, as was its role in influencing public discourse and consumer behavior and in circulating stereotypical gendered roles and unrealistic representations of the female body. By the end of the 1960s, most households in the capital cities and urban centers of the region owned a TV set. Televisa in Mexico and TV Globo in Brazil would become two of the largest broadcasting companies in the region, wielding significant political power.[11]

A noteworthy response to the influence of the broadcasting industry is one of the resolutions of the IWY conference, which demanded a transformation in the way media representations reinforced traditional gendered behavior and called for the increased participation of women in media broadcasting.[12] In the visual arts, experimentation with emergent televisual broadcasting technologies (closed-circuit television, live feedback, time delays, and so on) became a sought-after platform to question the art establishment while also commenting on the impingement of mass media in the public domain. Poignant examples of these practices were developed at the Instituto Torcuato Di Tella in

Buenos Aires, where as early as 1966 Roberto Jacoby popularized the concept of "mass media art" in the Argentine art milieu.[13] However, the novelty of televisual technologies and its affordances has yet to be fully understood in relation to a feminist sensibility that simultaneously reemerged at this moment of experimentation. Characterized for making the personal political, for demanding the recognition of reproductive labor, for questioning the objectification and mediatization of the female body and the gendering of spectatorship, and for challenging the patriarchal structures that defined the sensible and the knowable, this feminist sensibility was at play in the early experiments with televisual and electronic-imaging technologies.

In what follows, I provide another account of the development of video art narrated through a lens that, rather than examining feminist political affiliations or activisms, looks at affinities among artists who questioned the dominance of masculinity as a symbol of authority and the monopoly that patriarchy had on language, media, meaning, and culture. More broadly, this essay provides an overview of the complex ways in which video technology and critiques of traditional gender roles and representation intersected in the work of Latin American women artists, thus providing a more nuanced understanding of the global convergence of feminism(s), video art, and technology.

EMBODYING THE TELEVISUAL AND BREAKING THE MEDIA BORDER

In the 1960s, Marta Minujín burst onto the Argentine art scene after a sojourn in Europe. Supported by the Instituto Torcuato Di Tella and various national and international fellowships that allowed her to freely traverse and influence dominant international networks of the postwar avant-garde, Minujín produced innovative works, experimenting with all kinds of artistic formats, including closed-circuit television and telematics. As one of the few Latin American women artists to embrace televisual technology as an art medium in the mid-1960s, Minujín challenged both the national and international art milieu. For instance, she described her experiences with Billy Klüver's Experiments in Art and Technology (E.A.T.) in 1967 as "very sexist" and out of the ordinary: "it was very strange for a woman, and all the more a South American one, to get involved with art and technology."[14]

After producing a series of immersive sculptures and actions with multicolor mattresses that proposed a tactile, affective, and sexual relationship with the television screen, Minujín began to experiment with closed-circuit television.[15] Minujín's engagement with televisual technology went beyond reversing the subject/object binary; she developed complex environments that proposed an intersubjective interaction between the viewer and the object of representation that

led her to reconfigure normative relations of spectatorship and insist on an affective and embodied connection between viewer and screen. She directed her interest to how subjects were exposed to mass media and to the dichotomies between mediation and liveness produced by broadcasting technology. This interest in producing excessively sensorial and emotional collective experiences spoke to a feminist sensibility that sought to make the intimate public and to break with the media border that separated the real from the mediated experience. For instance, using a closed-circuit television system in *La Menesunda* (Mayhem), Minujín and her collaborator Rubén Santantonín transgressed the subject-object relationship by allowing the viewer to see and be seen. Exhibited at the Instituto Torcuato Di Tella in May of 1965, *La Menesunda* was a site-specific installation consisting of sixteen stations that replicated the perceptual, tactile, and olfactory experiences of three commercial avenues in Buenos Aires. The installation incorporated the viewers and put them on display for others through the closed-circuit television system and a peephole through which participants could see other female participants getting beauty treatments. By encouraging this act of voyeurism, *La Menesunda* engaged with a feminist sensibility that, as Nadja Rottner has argued, raised questions "on spectatorship and how our perception of art is affected by sex and gender."[16] Similar preoccupations on the gendered dimensions of visual art, media spectatorship, and representation were brought to the fore internationally through the widely distributed work by John Berger (1972) and Laura Mulvey (1975). In Argentina, several feminist collectives established between the military coups of 1966 and 1976, as well as the feminist films by María Luisa Bemberg, contributed to the development of a public more attuned to feminist sensibilities. Specifically, Bemberg's short films *El mundo de la mujer* (1972; Women's world) and *Juguetes* (1978; Toys) presented a sharp criticism of the liberating aspects of the process of modernization, which reduced women and girls to submissive and gendered stereotypes through consumer culture spread by television.[17] These two short films resonated with Minujín's interest in revealing the gendered and sexual dimensions of media spectatorship and representation.

Following *La Menesunda*, Minujín created *Simultaneidad en simultaneidad* (Simultaneity in simultaneity), the first transcontinental Happening and the initial marker of the history of video in Argentina. Minujín produced *Simultaneidad en simultaneidad* at Buenos Aires's Instituto Torcuato Di Tella in 1966, in collaboration with Allan Kaprow (based in New York) and Wolf Vostell (based in Berlin). The Happening took place on two different days and seven days apart to explore the emission and transmission of information between the three cities simultaneously through video, radio broadcasting, photography, telegrams, and telephones (fig. 1).[18]

All of these works already spoke to the affordances of video technology that artists would continue to explore in the 1970s (for example,

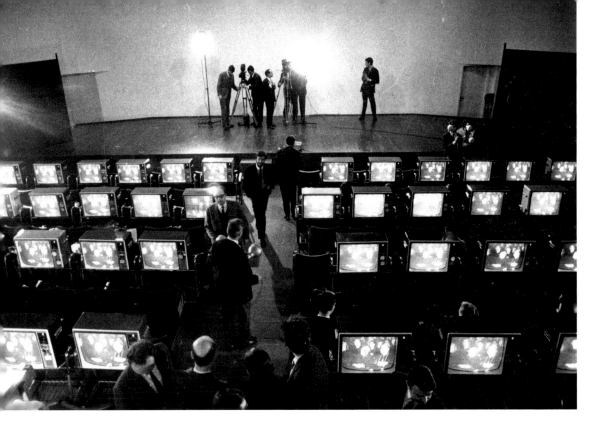

live feedback loops that blurred the circuits of emission and transmission of information to break with the viewer's passive role and the spectator's alienation). But it is perhaps through the creation of *Minuphone* (1967), an immersive and interactive phone booth where viewers can watch themselves on a television screen as they make a phone call, and *Minucode* (1968), a social environment consisting of the filming of separately held parties, through which Minujín begins to blur the line between self and technology.[19] Through the development of an artist trademark that combined her last name with the words *phone* and *code*, Minujín moved to intimately link herself to her work. As Inés Katzenstein observes, this move speaks to Minujín's awareness of the effects resulting from the circulation of her image and name as a brand.[20]

Here I turn to Pola Weiss to explore the affinities between her work and that of Minujín and Kubota, with the goal of understanding how Minujín's pioneering engagement with art and technology could be seen as both empowering and transgressive in its questioning of technology as an exclusively masculine field of engagement. Much like Minujín's move to combine herself with her work and Kubota's development of genres and intimate relations with her camera, Weiss proposed different fusions of self and other through experimentations across distinct narrative genres. This led her to develop hybrid forms and categories that resisted any established framework and proclaimed her independence as a video producer. In Mexico, Weiss began to collaborate with both state and private television in 1974 and soon after declared herself to be a *teleasta—*

| **Fig. 1. Marta Minujín (Argentine, b. 1943).** *Simultaneidad en simultaneidad* (Simultaneity in simultaneity), 1966. Media environment at the Instituto Torcuato Di Tella, Buenos Aires. Minujín collaborated with Allan Kaprow and Wolf Vostell on the work.

a producer of televisual images. At a moment when Mexican intellectuals and politicians were debating the content of television programming and the management of broadcasting, Weiss advocated for video as a tool to explore audiovisual production as a valid form of intellectual activity. Weiss established arTV, her own production company, in 1978, and until she took her own life in 1990, she produced a series of television programs and videos to develop an alternative to commercial television and to foster active and critical viewers.[21]

Combining the predominant articulation of video art as a medium of self-knowledge with a concern for exploring video's relation to television broadcasting and the medium's aesthetic and technical qualities, Weiss incorporated live feedback and experimented with multiple cameras and mirrors to break the media border, thus creating alternate televisual realities where pairings of self and other shifted and alternated. For example, in her *videodanzas* (video-dance performances)—live events in public spaces in which she combined performance and video—Weiss transformed her video camera into an eye or a limb as she danced with it in her hand, filming her movements as they effectively converted her portapak into a prosthetic through which to explore and push the limits of bodily experiences (fig. 2). During these *videodanzas*, Weiss's camera broadcast her movements through video signals transmitted to monitors and reflected through mirrors. By merging her body with that of the spectator, Weiss not only reformulated the subject/object relation in the

matrix of representation but also produced an alternate televisual reality in which couplings of self and other fluctuate and switch.

Like Kubota, Weiss took her embodied relation with her camera and video practice to an extreme by intimately fusing herself to her practice. She conceptualized the creation of each of her videos as an act of giving birth (*alumbramiento*). By naming her camera as her *escuincla* (from the Náhuatl word for daughter) and her vagina as the site of video production, Weiss metaphorically transformed her creative process into an act of incestuous copulation with her *escuincla*.[22] In doing so, Weiss not only declared her self-sufficiency as a female video producer taking ownership of being both the inspiration and the author of all stages of production but also gendered all aspects of video production as female. Additionally, through playful neologisms and metaphors, Weiss extended her position to take an active role in the process of breaking down the viewer's alienation. She conceived of herself as an audiovisual guide—a *Venusina* (a goddess from Venus) whose mission was to *extraPOLAr* (extrapolate), or make the viewer see images; *interPOLAr* (interpolate), or interrupt the viewer to disrupt the narrative; and *POLArizar* (polarize), or invite the viewer to reflect on what he or she saw.[23] Like Minujín, Weiss was aware of the value that the circulation of images could bring to her name, and she fused her name with both her artwork and her own production company, arTV, thus giving it a utopian goal. For Weiss, arTV was a tool that would shape a new man, a "cosmic man" in touch with his feelings, and the portable video camera would allow everyone to become a producer.[24] Weiss believed that in the near future, everyone would own personal libraries and collections of self/video recordings.

While Weiss did not have the same international recognition as Minujín, she built relationships with various artists and networks of artists internationally, most notably Kubota. Weiss authored the first thesis produced in video in Mexico; in addition, as a university professor, she became a mentor and role model for the second generation of video artists who would continue to push the boundaries of the media border and the relationship between self and technology.[25]

Similarly, the Colombian-born artist Sandra Llano-Mejía produced pioneering work in Mexico and the United States during the 1970s and 1980s and, despite her inclusion in international collections, is just beginning to receive attention. Llano-Mejía's work speaks to an interest in an embodied relation to technology, through an exploration of different modes of perception and cognition based on the registers of biofeedback technology and video. In the early 1970s, Llano-Mejía moved to Mexico City from Colombia to study visual arts at the Escuela Nacional de Artes Plásticas (ENAP). As a student, she began to produce an innovative series of graphics using electrocardiograms (ECGs) and electroencephalograms (EEGs) to translate the pulsations and biological registers of her body (heart rate, breath, movement, brain waves). These experiments formed

the basis of her thesis to obtain her degree in visual arts and were later part of an exhibition titled *De la energía vital y otras emociones—1976–7: Los registros eléctricos de la muerte* (Of life energy and other emotions—1976–7: Electrical registers of life and death).[26]

Influenced by texts on cybernetics, logic, and psychoanalysis and by exposure to international and national trends of conceptual art, Llano-Mejía believed that the world had entered a time of machines and that neither drawing nor painting was an expression of the current reality.[27] Thus, Llano-Mejía did not focus on developing hand-eye-pencil coordination in her drawing classes; rather, with these series of ECG-EEG graphics, Llano-Mejía demonstrated the possibility of producing aesthetically pleasing images by manipulating her heart, breath, and brain waves and visually translating them into vital energy and the emotions that drove her desire to create using the tools of her time.[28] These interests in perception, vital energy, and technology continued to drive Llano-Mejía's artistic production and would lead her to further experiments with video, sound, and performance. Between 1978 and 1979, she participated in collaborative events that showcased a series of video installations and Happenings in Casa del Lago and Galería Chapultepec in Mexico City.[29] In *Vidarte: Un suceso* (1979; Video-life: An event), organized in collaboration with Humberto Jardón, the gestures and movements of the gallery visitors were videorecorded and transmitted through a closed-circuit television as those visitors traverse a wall-environment constructed with mirrors. At the end of the journey, the mirrors were shattered, fracturing the images of the visitors as those images were transmitted live through the monitors (figs. 3a, 3b).[30]

| Fig. 3a. Sandra Llano-Mejía (Colombian, b. 1951) and Humberto R. Jardón (Mexican, b. 1953). *Vidarte: Un suceso* (Video-life: An event), 1979. Video installation and Happening at the Galería Casa del Lago in Mexico City.

| Fig. 3b. Sandra Llano-Mejía (Colombian, b. 1951) and Humberto R. Jardón (Mexican, b. 1953). *Vidarte: Un suceso* (Video-life: An event), 1979. Video installation and Happening at the Galería Casa del Lago, Mexico City.

Echoing Weiss's and Minujín's interest in incorporating the viewer as an active participant and formulating a critique of the alienation produced by the televisual image, in *Vidarte* the shattering of mirrors could be read as a literal gesture toward the destruction of the mediated image. But beyond this, Llano-Mejía and Jardón describe the event not as an artwork but as "a study of the viewer's personality through images, in which the viewers are transformed into models for the artists so they can record their gestures and attitudes in order to capture correlations between images and the personality of the models could be captured."[31]

With this work, Llano-Mejía and Jardón were in dialogue with a sociological approach to art, which was increasingly in vogue in Mexico, as elsewhere.[32] For example, in 1978 Mónica Mayer had installed the iconic *El tendedero* (The clothesline) based on the responses given by Mexican women to her inquiry about their experiences of sexual harassment in the city. And earlier, Minujín had pioneered the recruitment of participants through the use of computers in *Circuit* (1967) and later in *Minucode* (1968). However, Llano-Mejía and Jardón's interests went beyond the sociological as well. They were also driven by Llano-Mejía's readings of psychoanalytical texts on character analysis and statistical information on the human body.[33] Rather than using surveys or computers to recruit participants, Llano-Mejía and Jardón were interested in creating environments to observe participants. This scientific approach would continue to be a constant in Llano-Mejía's provocative melding of science, art, and technology, and it led her to be a pioneer in the use of biofeedback technology.[34]

In 1977, Llano-Mejía's exhibition of ECG and EEG graphics at the Universidad del Valle in the city of Cali, Colombia, had already caused a stir in the local art scene, but it was likely the installation of *In-Pulso* (1978; In-Pulse) at the Museo de Arte Moderno in Bogotá that has garnered her the recognition of being one of the first artists to use video art in Colombia (fig. 4).[35] Based on Llano-Mejía's earlier ECG graphics, *In-Pulso* is a participatory installation in which the artist records the heartbeats of museum visitors on an electrocardiogram. In Bogotá, the installation also included a video recording of the artist producing her own ECG

| Fig. 4. Sandra Llano-Mejía (Colombian, b. 1951). *In-Pulso* (In-Pulse), 1978. Installation (video and ECG) at the Museo de Arte Moderno, Bogotá.

graphics in a physics lab at Universidad Autónoma Metropolitana (UAM) in Mexico City. The video *In-Pulso* became part of the collection of the Museum of Modern Art in New York in 1981.

In the 1980s, Llano-Mejía's appointment as a professor of philosophy at UAM and her connections with the medical imaging and video industries allowed her to continue to produce elaborate performances with video and biofeedback technology. Throughout the decade, she

collaborated with Jardón and with the composer Rafael Mejía (her partner) on the creation of performances that incorporated biofeedback registers, video, and sound. In *Piano experimental* (1985; Experimental piano), Llano-Mejía unfolds printouts of her EEGs and displays them as musical notations for Mejía to interpret in real time on the piano. In *Música imitada* (1986; Imitated music), a live *video-acción* staged at the Museo de Arte Moderno in Mexico City, Llano-Mejía, Mejía, and Jardón use TV monitors to display prerecorded videos showing overhead views with sequences of an interpreter playing variations of a forty-five-minute piano composition. Four of the five monitors are installed around a grand piano facing the audience. The fifth monitor is placed on top of the grand piano, taking the place of music notations. Mejía interprets (or imitates) live one of the variations following the video sequence displayed in the fifth monitor. Over the course of the forty-five minutes, the five monitors and Mejía's interpretation begin to play at counterpoint, producing a cacophony of six pianos—five prerecorded pianos shown on the monitors and one live (figs. 5a, 5b). As in *Piano experimental*, here Llano-Mejía, Jardón, and Mejía use the affordances of video to explore different conventions of time and performance and propose a more experimental connection between music and visual arts that speaks to the international trends in conceptual art at that time.[36]

| Fig. 5a. Sandra Llano-Mejía (Colombian, b. 1951), Humberto R. Jardón (Mexican, b. 1953), and Rafael Mejía (Mexican, dates unknown). *Música imitada* (Imitated music), 1986. Performance at the Museo de Arte Moderno, Mexico City.

| Fig. 5b. Sandra Llano-Mejía (Colombian, b. 1951), Humberto R. Jardón (Mexican, b. 1953), and Rafael Mejía (Mexican, dates unknown). *Música imitada* (Imitated music), 1986. Performance at the Museo de Arte Moderno, Mexico City.

As with Weiss and Minujín, video technology for Llano-Mejía was a tool that allowed her to experiment with new languages. Like them, through her practice Llano-Mejía also theorized and speculated about new relations of self and technology and transformations of modes of perception and cognition. This is evident in *Video Book* (1989), an installation with two television monitors without casings that lay adjacent to each other like two pages of an open book (fig. 6). The monitors showed video recordings of close-up portraits of the artist and a series of layered images (including poems written by the artist) distorted with visual effects and

| Fig. 6. Sandra Llano-
Mejía (Colombian,
b. 1951). *Video Book*,
1989. Installation
at the Instituto de
Visión, Bogotá.

accompanied by sounds of nature and self-reflective monologues by the artist. This work reflects Llano-Mejía's interests in books and her own conjectures on what an audiovisual book could look like in the future.

Just like in her early explorations with EEC and ECG technology in *Video Book* and other works, Llano-Mejía continued to experiment with electronic media as a translator of body impulses. She speculated on how new audiovisual technology has transformed our ways of knowing and sensing the world, speaking of a feminist sensibility in search of new relations between self and technology. Llano-Mejía's explorations with video are part of the wide range of media that she experimented with, and in doing so, her work articulates an interest in the intersections of science, technology, and art.

PERFORMING AND INSCRIBING CORPOREAL GESTURES ON THE SCREEN

In "Rhetoric of the Body," the Chilean critic Nelly Richard contextualizes the recurrent use of the body as a vehicle of expression in the work of avant-garde Chilean artists working under the military dictatorship of

Augusto Pinochet (1973–90). Richard claims that "under circumstances where censorship is applied to vast areas of meaning in language, any superfluous discourse or unspoken pressure which escapes or undermines the syntax of the permitted can only surface as bodily gestures."[37] The body, as the site where the personal and public meet, hence emerges as the most immediate way to expose the suppression of meaning and dismantle the power that official discourse has over its production. In what remains of this chapter, I discuss how artists in Brazil and Chile used the video camera to record intimate performances that employed exaggerated gestures, impossible actions, and self-inflicted violence to voice the excessive use of violence by the military dictatorship and to challenge normative media representations of femininity.

In Brazil, Anna Bella Geiger, an artist mostly known for her cartographic forms that "interrogated gender, racial, national and continental identity,"[38] was pivotal in fostering a network of video artists locally and internationally between the 1970s and 1980s. In 1970, Geiger returned to Brazil from a limited teaching position at Columbia University and subsequently dedicated most of her career to teaching art at various institutions in Brazil.[39] At that point, Geiger's Rio de Janeiro studio became an important meeting place for the first generation of artists that experimented with video technology.

For example, sharing one portapak camera brought to Brazil by Jom Azulay, Geiger's group (which also included Letícia Parente and Sonia Andrade, among others) produced videos for the international video art exhibit at the Institute of Contemporary Art in Philadelphia in 1975.[40] Geiger, Parente, and Andrade used the video camera to record a series of repetitive actions that documented their responses to the hostile environment in Brazil at the time.

In *Passagens* (1974; Passages), Geiger slowly climbs different stairways in Rio de Janeiro (fig. 7). Through different framings and camera angles, viewers see how Geiger's slow climb up requires more effort as the video progresses from an indoor staircase toward one outdoors and subsequently onto a monumental staircase of a public building. In performing such repetitive action, Geiger constructs a progressive narrative from the intimate to the public that is suggestive of the tedious nature of women's reproductive labor but also reflective of the slow progression of women's fight to gain more visibility in the public sphere—a demand that circulated across the country as elsewhere in Latin America as second-wave feminist activisms gained visibility during the 1970s. Indeed, in Brazil, small feminist consciousness-raising groups emerged in São Paolo and Rio de Janeiro in 1973, and by the end of the seventies, they had spread to the northeastern, midwestern, and southern parts of the country.[41] Left-leaning feminist newspapers *Brasil Mulher* (1975–80) and *Nos Mulheres* (1976–78) promoted women's rights and resistance to the military dictatorship.[42]

| Fig. 7. Anna Bella
Geiger (Brazilian,
b. 1933). Video still
from *Passagens*
(Passages), 1974.

In a tactic reminiscent of Geiger's suggestive adherence to the feminist call for making the personal political, Letícia Parente famously stitched the words "Made in Brasil" on the sole of her bare foot in front of a video camera for her work *Marca registrada* (1975; Trademark) (fig. 8). By deliberately and repetitively puncturing the sole of her foot with a needle, Parente produces a startling image that evokes an act of self-inflicted suffering. Through repetition, this act becomes normalized and, as Elena Shtromberg argues, directly alludes to the torture practices of the Brazilian dictatorship.[43]

However, this allusion to torture is specially committed to a female body—thus, through this self-inflicted violence in *Marca registrada*, Parente adds a gender dimension to what has been discussed as a critique of the convergence of Brazil's export economy, nationalism, and consumer culture as signs of the country's progress and modernity.[44] In addition, by using a video camera to record what is normally understood as feminized manual labor, Parente's intimate act of sewing is in stark contrast to the mass reach of consumer culture spread by television. As Shtromberg describes, television was the ideal vehicle for promoting an illusion of

Fig. 8. Letícia Parente (Brazilian, 1930–91). Video still from *Marca registrada* (Trademark), 1975.

consumerism, of "spreading a shared desire for products that many could not afford to buy."[45] Unlike Minujín's and Weiss's approach to video technology and indulgent integration of their identity with their work, here Parente makes a move in the opposite direction. Through her video performance, Parente uses branding to turn the political into the personal by showing how the burden of Brazilian history and consumer culture is inscribed onto a female body. But what does it mean to be a female Brazilian body for export? How does a South American female body carry the effects of capitalism under a military dictatorship? These questions were taken to an extreme by Sonia Andrade, who, like Parente, became an artist later in life.

In a series of eight video vignettes produced between 1974 and 1977, Andrade questions the way the televisual image serves to dominate daily life and prescribe models of acceptable gender behavior—and, more significantly, she transgresses limits of the female body through performances of self-inflicted violence.[46] By performing intimate actions in domestic settings—such as pretending to cut her pubic and facial hair, putting her body in impossible situations by attempting to move it after

forcing her limbs into different cages, and wrapping her face with a tight wire—Andrade implicates herself as a subject of violence, showing her female body defying consumer culture standards and rituals of female beauty as it stands in for widespread pain inflicted by the military regime. As Richard notes, "voluntary pain simply legitimates one's incorporation into the community of those who have been harmed in some way."[47] In performing these series of actions, Andrade not only bonds herself to the harmed community but also involves viewers as witnesses. The performance scholar Diana Taylor states that performing violence in public makes both the resulting personal pain and a mode of resistant citizenship visible to the structures of power that refuse to see them.[48] Moreover, performing trauma in public reveals obscured forms of violence and potentially has the power to promote the participation of more people in demanding justice through practices of remembrance that are in themselves powerful means of demanding accountability, thus leading to the development of a participatory citizenship.

Andrade brought to light how the media censored everyday violence and military torture, and, by making viewers into witnesses, she complicated the distinction between passive and active viewers. She experimented with this complication in *Untitled, Desligue a televisão* (1974,

| Fig. 9. Sonia Andrade (Brazilian, b. 1935). Video still from *Untitled, Desligue a televisão* (Turn off the television), 1974, 1977.

1977; Turn off the television), also part of this series, in which Andrade stands in front of a series of TV monitors stacked on top of one another (fig. 9). After turning the monitors off, Andrade faces the screen and tells the viewers to do the same by continually repeating "Desligue a televisão" (Turn off the television).[49] Unlike Weiss's, Llano-Mejía's, and Minujín's use of feedback, visual effects, complex environments, and hyperbolic

fusions with technology to interpellate embodied and active viewers, here Andrade, arguably emboldened by the authority of her visibly exhausted female middle-age body, addresses the viewer in a direct and confrontational manner.[50]

In Chile, Lotty Rosenfeld and Diamela Eltit began to experiment with video as part of the actions staged by Grupo CADA (Colectivo Acciones de Arte, 1979–83) that sought to disrupt Pinochet's military rule. Individually, both Rosenfeld and Eltit produced performances for the video camera. In *Una milla de cruces sobre el pavimento* (1979; A mile of crosses on the pavement), Rosenfeld paints white lines over the dividing lines of Avenida Manquehue in Santiago. Hours later, Rosenfeld screens her actions at the same site. By introducing the screen on the site, Rosenfeld investigates video's potential as an intervening agent rather than just as a recording device. In *Zona de dolor I* (1980; Zone of pain I), Eltit cuts and burns herself before going to a brothel; there she videorecords herself reading parts of her novel and washing the floor as images of herself are projected onto the walls. Like Andrade, Eltit resorts to pain as a way to "approach the borderline between the individual and the collective."[51] Eltit would extend her tactic of self-inflicted pain into an act of communal love with others in her subsequent videos in which she records herself kissing a homeless man.

By the 1980s, the production of video art in Chile was marked by the extensive participation of women, many of whom also worked in documentary film and literature. As Richard has mentioned, the hostile military environment that destroyed all institutions paradoxically "opened up a space for the marginal," and both women and queer artists found more space for expression.[52] In 1987, Rosenfeld, Eltit, and Richard curated an exhibition of multimedia works by Chilean women titled *Women, Art and the Periphery*, at The Floating Gallery, part of the Women in Focus Society in Vancouver, during their visit to Canada as foreign artists (fig. 10).[53]

As one of the earliest all-Chilean-women shows exhibited internationally that included a unique program of video art, *Women, Art and the Periphery* was crucial in making visible the practices of women video artists and reframing such practices outside the Argentine-Brazilian axis (which had already gained some international recognition). The program of screenings included videos by Sybil Brintrup, Gloria Camiruaga, Eltit, Soledad Fariña, Tatiana Gaviola, Magali Meneses, Patricia Navarro, Sandra Quilaqueo, Rosenfeld, and Marcela Serrano. In the interest of space, I will not elaborate on the video productions of all the artists included in the exhibition—but, broadly speaking, the productions addressed the toll that Chile's hostile environment took on female bodies and also transgressed the boundaries of normative female desire. For instance, in *El padre mio* (1985; My father), Eltit and Rosenfeld reflect on

RECENT VIDEO ART BY CHILEAN WOMEN

LA COMIDA
The Supper
Sybil Brintrup/Magali Meneses
12 min., Chile, 1983

EL PAN NUESTRO
Our Daily Bread
Gloria Camiruaga
8 min., Chile, 1987

DIAMELA ELTIT
10 min., Chile, 1986

POPSICLES
Gloria Camiruaga
5 min., USA/Chile, 1982/84

CONFIDENCIAS
Confidences
Soledad Fariña
6 min., Chile, 1985

TOPOLOGIA I
Topology I
Soledad Fariña
7 min., Chile, 1983

LA GALLINITA CIEGA
The Blind Chicken
Patricia Navarro
10 min., Chile, 1987

YO NO LE TENGO MIEDO A NADA
I Am Not Afraid of Anything
Tatiana Gaviola
5 min., Chile, 1984

EL PADRE MIO
My Father
Diamela Eltit/Lotty Rosenfeld
10 min., Chile, 1985

FRAGIL
Fragile
Magali Meneses
3 min., Chile, 1985

700 PLANOS PARA KAFKA
700 Planes For Kafka
Sandra Quilaqueo
24 min., Chile, 1985

AUTOCRITICAS
Self-Critics
Marcela Serrano
15 min., Chile, 1980

November
Curators **DIAMELA ELTIT, NELLY**

21 & 22
RICHARD and LOTTY ROSENFELD

the effects of the military regime on the everyday lives of poor Chilean families. In the video, viewers see superimposed images taken from a Chilean TV program of Pinochet commemorating the military coup mixed with images and speeches of a community from the periphery of Santiago during a gathering. One of these images includes the testimony of an eight-year-old girl, Marisol Díaz, who reads the story of her life in front of the video camera. Telling the viewer how her father physically abuses her mother and sister, she ponders the nature of her father's violent behavior toward women. Viewers also see images of a woman speaking about the effects of economic and political measures established since 1973: the erosion of women's access to health, education, and jobs. In contrast to this documentary style, an experimental video by Camiruaga, *Popsicles* (1982–84), also included in the screening, presents tight shots of Camiruaga's daughters licking and enjoying popsicles that encase toy soldiers while they recite the Hail Mary. As the video progresses, a narrative full of seductive and sexual innuendo that speaks to female sexuality and desire emerges through the juxtaposition of images. In the words of Camiruaga, this work "is an interaction of the space, the symbols and the historical context in which I live as a woman on this side of the continent. It is a rosary of alarm, eternal and circular; the alarm of a woman who desires life, light, truth, and solidarity, but who instead sees and receives death and fear. It is a rejection of all that is destruction, and death, yet is depicted almost attractively as innocence."[54]

| **Fig. 10.** *Recent Video Art by Chilean Women.* From *Video Guide: Women, Art and the Periphery* 9, no. 42 (1987).

After an experimental phase, Camiruaga, who studied philosophy at the Universidad de Chile (graduating in 1971) and video art at the San Francisco Art Institute (1981), went on to produce important documentaries about the social conditions of women in Chile such as *La venda* (1999–2000; Blindfolded) composed of testimonies of women who had been sexually tortured while detained during Pinochet's dictatorship.[55] As one of the pioneers of video art in Chile, Camiruaga made a point of using video to give voice to those who had not been sufficiently heard.

Through different aesthetic approaches, Camiruaga, Eltit, and Rosenfeld used their video cameras to capture the effects of the dictatorship on the next generation of Chilean women.

CONCLUSION

The two clusters of affinities between female artists working in Latin America that I have discussed constitute some of the many examples of explorations with video technology by women in the region. Each of the artists developed and crisscrossed networks of relations with known and lesser-known artists both nationally and internationally, producing compelling cross-pollinations that spoke to their own realities. And each of them influenced others as much as they were influenced by collaborators and fellow artists, as demonstrated by Minujín's involvement with E.A.T., Kaprow, and Vostell; Weiss's relationship with Kubota; Geiger's networks in the United States; Chilean artists' shows in Canada; and Llano-Mejía's early interventions in Mexico and Colombia. Even though many artists experimented with video because it did not have the same history of domination by male artists that other media had—and, indeed, the use of new technology allowed these and other women artists to express their own voice on their own terms—they still engaged in contexts where all intellectual fields were predominantly masculine spheres of action. Moreover, by participating in both local and international art environments that have historically disregarded the work of Latin American women artists, the artists discussed here became agents who challenged dominant perceptions about who could make art, experiment, and create with video technology. Some of these women were simultaneously artists, teachers, mothers, and wives; others trailblazed in the field as single professional women; still others defied heterosexual roles; but all challenged the masculine order in terms of representation and content, expressed both in the hierarchical structures that define art and technology and in the patriarchal mechanisms of authority and social control. For example, Minujín confronted the sexist art environment that couldn't fathom the existence of a South American woman making experimental art using computers, video, and branding and creating her own technology, as in *Minuphone*. In Mexico, Weiss and Llano-Mejía were two of the first artists to experiment with and have access to

video technology in the country. Llano-Mejía was the twelfth woman to graduate with a degree from ENAP and, although she is not interested in discussing her work in gendered terms, she fully recognizes how her position as an immigrant woman experimenting with technology affected the recognition of her work in the Mexican art milieu.[56] Similarly, Weiss's non-Hispanic last name and her female, middle-class white body facilitated her access to technology to some extent, but she was shunned from the art world due to her eccentric personality and approach to art. In Chile and Brazil, video became a means to confront and make visible the connection between authoritarian regimes and its mechanism of social control with violence against women.

The affordances of video technology allowed all of these artists to voice a fractured and embodied subjectivity always in the process of becoming that destabilized any fixed notion of self. This is most clearly seen in Weiss's attempts to break with the subject/object position through the use of live feedback and monitors, in Minujín's experiments with telematics, and in Llano-Mejía's attempts at visualizing vital energy and emotion through biofeedback technology and closed-circuit television. Hence, whether proposing alternative relationships to technology, imagining potential future uses, or disrupting how the female body was represented in the media by turning it into a site of self-inflicted violence and political potential, these artists imagined an embodied perception and saw in new technology the potential to express it. In doing so, they speak to a feminist sensibility that questioned those who had the power to define the knowable and the sensible. Through their practices, tacitly or actively, they opened up spaces for other women artists to produce videos and experiment with new technology; in addition, they likely inspired those who followed. By proposing diverse relations between self and technology and producing alternative representations of the female body, the artists discussed here constructed new audiovisual languages and practices through which other ways of being could be imagined in their local contexts and abroad.

Notes

1 Amelia Jones, *Self/Image: Technology, Representation, and the Contemporary Subject* (New York: Routledge, 2006).

2 Gabriela Aceves Sepúlveda, *Women Made Visible: Feminist Art and Media in Post-1968 Mexico City* (Lincoln: University of Nebraska Press, 2019); Gabriela Aceves Sepúlveda and Sarah Shamash, "Feminizing Oswald De Andrade's 'Manifesto Antropófago' and Vasconcelos' *Raza Cosmica*: The Videos of Sonia Andrade and Pola Weiss," in "Mestizo Technology: Art, Design, and Technoscience in Latin America," ed. Paula Gaetano Adi and Gustavo Crembil, special issue, *Media-N: Journal of the New Media Caucus* 12, no. 1 (2016): 12–19; and Gabriela Aceves Sepúlveda, "Imagining the Cyborg in Náhuatl: Reading the Videos of Pola Weiss through Haraway's Manifesto for Cyborgs," *Platform: Journal of New Media and Communication* 6, no. 2 (2015): 46–60.

3 On the uneven introduction of video to Latin America, see Elena Shtromberg and Glenn Phillips, "Video Art in Latin America," in *Pacific Standard Time: LA/LA,* exh. brochure (Los Angeles: Getty Foundation, 2017); and for an overview of 1970s feminisms in the region, see Sonia E. Alvarez, Patricia Chuchryk, Marysa Navarro-Aranguren, and Nancy Saporta Sternbach, "Feminisms in Latin America: From Bogotá to San Bernardo," *Signs* 17, no. 2 (1992): 393–434. For a discussion on feminist art, see *Radical Women: Latin American Art, 1960–1985,* ed. Cecilia Fajardo-Hill and Andrea Giunta, exh. cat. (Los Angeles: Hammer Museum, 2017).

4 The literature on this topic is extensive. On 1970s feminist activism in Brazil, see Lia Zanotta Machado, "Feminismos brasileiros nas relações como estado: Contextos e incertezas," *Cadernos Pagu* 47 (2016), https://doi.org/10.1590 /18094449201600470001. On activism in Argentina, see Catalina Trebisacce, "Historias feministas desde la lente de María Luisa Bemberg," *Nomadías* 18 (2013): 19–41; and Alejandra Vassallo, "'Las mujeres dicen basta': Feminismo, movilización, y política de los setenta," in *Historia, género y política en los '70,* ed. Andrea Andújar et al. (Buenos Aires: Feminaria, 2005), 61–88. On activism in Chile, see Susan Franceschet, "Explaining Social Movement Outcomes: Collective Action Frames and Strategic Choices in First- and Second-Wave Feminism in Chile," *Comparative Political Studies* 37, no. 5 (2004): 499–530.

5 Listed here are the artists and their life dates: Marta Minujín (b. 1943), Pola Weiss (1947–90), Sandra Llano-Mejía (b. 1951), Anna Bella Geiger (b. 1933), Letícia Parente (1930–91), Sonia Andrade (b. 1935), Lotty Rosenfeld (b. 1943), Diamela Eltit (b. 1949), and Gloria Camiruaga (1940–2006).

6 Jones, *Self/Image,* 139, cited in Nadja Rottner, "Marta Minujín and the Performance of Softness," *Journal of Art History* 83, no. 2 (2014): 120.

7 Aceves Sepúlveda, *Women Made Visible,* 260–73.

8 Shigeko Kubota, "Video Poem" (1968–76) excerpt, cited in Aceves Sepúlveda, *Women Made Visible,* 263.

9 For more on the work of Kubota, see Midori Yoshimoto, *Into Performance: Japanese Women Artists in New York* (New Brunswick, NJ: Rutgers University Press, 2005).

10 In Mexico and Chile, private and public broadcasters opened their doors to artists, allowing those artists to experiment with video equipment. In Argentina, the Instituto Torcuato Di Tella, via the Centro de Experimentación Audiovisual (established in 1963), offered state-of-the-art equipment to artists. For Chile, see Gaspar Galaz and Milan Ivelic, "El video arte en Chile (Un nuevo soporte artístico)," *Aisthesis* 19 (1986): 5–21. For Argentina, see Daniel R. Quiles, "Double Binds: Technology and Communication in Argentine Art, 1965–1977," in *Latin American Modernisms and Technology,* ed. María Fernández (Trenton, NJ: Africa World Press, 2018), 235–64; and Inés Katzenstein, "Marta Minujín's *Minucode* Code and Context," in *Marta Minujín: Minucodes,* ed. Gabriela Rangel (New York: Americas Society, 2015), 30–41. On television broadcasting and video art in Mexico, see Aceves Sepúlveda, *Women Made Visible,* 57–82 and 249–90. On video art and television broadcasting in Brazil, see Elena Shtromberg, *Art Systems: Brazil and the 1970s* (Austin: University of Texas Press, 2016), 91–122. For one of the first overviews on the histories of video art in Latin America, see Laura Baigorri, ed., *Vídeo en Latinoamérica: Una historia crítica* (Madrid: Brumaria, 2008).

11 For an overview of the history of television in Mexico, see Aceves Sepúlveda, *Women Made Visible,* 61–82; for the history in Brazil, see Shtromberg, *Art Systems,* 91–122; in Argentina, see Katzenstein, "Marta Minujín's *Minucode* Code"; and in Chile, see Galaz and Ivelic, "El video arte en Chile."

12 "Resolution 181 Actions Taken by the Conference, Women and Media," in "Plans of Action," *Report of the World Conference of the International Women's Year, Mexico City, 19 June–2 July 1975* (New York: United Nations, 1976), 34, https://undocs.org/E/CONF.66/34.

13 Quiles, "Double Binds," 238.

14 Cited in Catherine Spencer, "Performing Pop: Marta Minujín and the 'Argentine Image-Makers,'" *Tate Papers*, no. 24 (2015), https://www.tate.org.uk /research/publications/tate-papers/24/performing-pop-marta-minujin-and-the -argentine-image-makers.

15 For a discussion of these early works, see Rottner, "Marta Minujín and the Performance of Softness," 110–28.

16 Rottner, "Marta Minujín and the Performance of Softness," 126.

17 In the following decades, Bemberg went on to produce full-length feminist films, including *Momentos* (1981), *Señora de nadie* (1982; Nobody's wife), *Camila* (1984), and *Yo, la peor de todas* (1990; I, the worst of all). For more on Bemberg's films, see Trebisacce, "Historias feministas," 19–41.

18 Rodrigo Alonso, "Art and Technology in Argentina: The Early Years," in *Latin American Modernisms and Technology*, ed. María Fernández (Trenton, NJ: Africa World Press, 2018), 229.

19 Both of these projects were installed and produced in New York. *Minuphone* developed as part of Minujín's participation with E.A.T. *Minucode* was installed in the Center for Inter-American Relations (CIAR) in New York. Ira Schneider, who by 1970 would be coeditor of the influential magazine *Radical Software*, shot the documentaries for *Minucode*. See Gabriela Rangel, "May 1968 á la Minujín," in Rangel, *Marta Minujín*, 7–19.

20 Katzenstein, "Marta Minujín's *Minucode* Code," 35.

21 Gabriela Aceves Sepúlveda, "The Utopian Impulse in the Videos of Pola Weiss," in *Performing Utopias in Contemporary Americas*, ed. Alessandra Santos and Kim Beauchesne (New York: Palgrave Macmillan, 2017), 283–300.

22 Aceves Sepúlveda, "The Utopian Impulse," 284.

23 Pola Weiss, "Antología de videos y performance," triptych/invitation, Galería Chapultepec, Mexico City, 1982. Fondo Pola Weiss. Arkheia, Museo Universitario Arte Contemporáneo, Universidad Nacional Autónoma de México.

24 Aceves Sepúlveda, "The Utopian Impulse," 284–85.

25 Sarah Minter, "A vuelo de pájaro, el video en México: Sus inicios y su contexto," in Baigorri, *Vídeo en Latinoamérica*, 159–68.

26 See Sandra Llano-Mejía, *De la energía vital y otras emociones*, http:// sandrallano-mejia.com/1977-de-la-energ%C3%ADa-vital.html.

27 Miguel González, "De la energía vital y otras emociones," *El País* (Cali), 2 July 1977, 3.

28 Sandra Llano-Mejía, interview by the author, 24 May 2019.

29 In 1978, Llano-Mejía collaborated with Andrea Di Castro, Humberto Jardón, Humberto Bravo, Fernando Castro, Fernando Caballero, Carlos Cacciatore, and Cecilio Baltazar in *Intervalo ritual*, a series of three Happenings, video projections, lasers, and live music at Casa del Lago in Mexico City. See *Intervalo ritual*, exh. cat. (Mexico City: Casa del Lago, 1979), courtesy of Sandra Llano-Mejía; and Erandy Vergara, "Electronic Traces: Archaeological Perspectives of Media Art in Mexico," *archée: Revue d'art en ligne; Arts médiatiques & cyberculture*, http://archee.qc.ca/archives/sommaire_2013_03.php.

30 See Sandra Llano-Mejía and Humberto Jardón, *Vidarte: Un suceso*, invitation and press release (Mexico City: Instituto Nacional de Bellas Artes and SEP, 1979), courtesy of Sandra Llano-Mejía.

31 Llano-Mejía and Jardón, *Vidarte*. Unless otherwise noted, translations from the Spanish are mine.

32 Other artists experimenting with the sociological approach during this period include Teresa Burga, whose *Perfil de la mujer peruna* (1980; Profile of the Peruvian woman) consisted of an exhibition of sculptures, objects, and images based on a survey conducted with more than two hundred women in Lima.

33 In particular, Llano-Mejía mentions the work on character analysis by Wilhelm Reich. Llano-Mejía, interview.

34 Other female artists experimenting with biofeedback technology at the time included the New York–based artist Nina Sobell, who in 1973 produced *Brain Wave Drawing* using an ECG system and closed-circuit television. For an overview of the use of brain-computer interfaces in contemporary art, see Mirjana Prpa and Philippe Pasquier, "Brain-Computer Interfaces in Contemporary Art: A State of the Art and Taxonomy," in *Brain Art: Brain-Computer Interfaces for Artistic Expression*, ed. Anton Nijholt (n.p.: Springer, 2019), 65–115.

35 For a discussion on the reception of *In-Pulso* in Colombia, see Gilles Charalambos and Nasly Boude Figueredo, "Aproximación a una historia del videoarte en Colombia," http://www.bitio.net/vac/contenido/historia/index.html. On the reception of the exhibition in Cali, see González, "De la energía vital y otras emociones."

36 As the art critic Juan Acha explains, in its treatment of time, technology, and live performance, *Música imitada* was in dialogue with the work of John Cage and constituted an innovative event for Mexican audiences at the time. "Juan Acha, *Música Imitada*," Museo de Arte Moderno, Mexico City, press release, September 1986, from the personal archive of Sandra Llano-Mejía.

37 Nelly Richard, "Rhetoric of the Body," in *Margins and Institutions: Art in Chile since 1973* (Melbourne: Art & Text, 1986), 72.

38 Shtromberg, *Art Systems*, 142.

39 "Anna Bella Geiger," *Encyclopédia Itaú Cultural*, http://enciclopedia.itaucultural.org.br/pessoa296/anna-bella-geiger.

40 Arlindo Machado, "El arte del video en Brasil," in Baigorri, *Vídeo en Latinoamérica*, 53–60; and Shtromberg, *Art Systems*, 106.

41 Zanotta Machado, "Feminismos brasileiros."

42 Zanotta Machado, "Feminismos brasileiros"; and Leslie Marsh, *Brazilian Women's Filmmaking: From Dictatorship to Democracy* (Urbana: University of Illinois Press, 2012), 50.

43 Shtromberg, *Art Systems*, 110–19.

44 Shtromberg, *Art Systems*, 110–19.

45 Shtromberg, *Art Systems*, 110.

46 Shtromberg, *Art Systems*, 114.

47 Richard, "Rhetoric of the Body," 68.

48 Diana Taylor, "'You Are Here': The DNA of Performance," *Drama Review* 46, no. 1 (2002): 149–69.

49 Shtromberg, *Art Systems*, 118.

50 At the time, a study on women and broadcasting indicated that viewers seemed to like female anchors because they appeared to be motherly, and this made certain news content easier to deliver. However, if there was something negative to report, female anchors could also appear to be scolding the audience. Aceves Sepúlveda, *Women Made Visible*, 62.

51 Richard, "Rhetoric of the Body," 66.

52 Diamela Eltit and Nelly Richard, "Art after the Coup: Interventions by Chilean Women," interview by Sara Diamond, *Fuse* 11, no. 5 (1988): 19.

53 The artists were invited by Sara Diamond and Karen Knights from Video In (now VIVO Media Arts). Besides the exhibition and video screenings, Rosenfeld designed an installation, performed an action at Vancouver's Public Courthouse, and produced new work at the Western Front, an artist-run center in Vancouver. A few years earlier, in 1983, an exhibition in which all artists were Chilean women, including women in exile, was shown in Berlin. For the exhibition in Berlin, see Andrea Giunta, "Poetics of Resistance," in Fajardo-Hill and Giunta, *Radical Women*, 251–60; and for the Vancouver program of activities, see *Women, Art and the Periphery*, in SVES Fonds, the Crista Dahl Media Library & Archive (CDMLA), VIVO Media Arts, Vancouver, BC.

54 *Popsicles* can be seen at https://www.vivomediaarts.com/programming /digitization/popsicles-1984-gloria-camiruaga (with requested access) and at https://vimeo.com/221821919.

55 Camiruaga is also known for the videos she produced as registers of the work of other artists, including Pedro Lemebel, Diamela Eltit, and Nicanor Parra. For more on Camiruaga, see Carlos Trilnick, "Gloria Camiruaga," *IDIS* (21 July 1982), https://proyectoidis.org/gloria-camiruaga.

56 Llano-Mejía, interview.

Interview with Ximena Cuevas

Video: A Laboratory for Experimentation

Ximena Cuevas (Mexican, b. 1963) works primarily with video, film, and performance. Based in Mexico City, Cuevas has presented her work internationally at museums including the Museum of Modern Art (MoMA) in New York, the Guggenheim Museum in New York, the Museo Universitario de Arte Contemporáneo (MUAC) in Mexico City, the Centre Pompidou in Paris, the Guggenheim Museum in Bilbao, and the Museum of Contemporary Art in San Diego. She has participated in the Sundance Film Festival, the Berlinale, the Montreal International Film Festival, and the New York Film Festival, to name a few. Cuevas has also received awards from institutions such as the Fondo Nacional para la Cultura y las Artes and the Rockefeller Foundation. After studying film at the New School for Social Research and at Columbia University, both in New York, Cuevas began to experiment with video starting in the 1990s. Her work centers on exploring the blurred realities of everyday life and its intersection with national identity, gender, and mass media. Alongside her prolific work as an artist, Cuevas is a collector and archivist of historical works of video art. She has amassed more than fifteen hundred pieces, which she has compiled into various series, including Cronología de video arte en México, 1977–2009 (Chronology of video art in Mexico, 1977–2009).

ELENA SHTROMBERG We wanted to start by learning more about your history. Your father is the artist José Luis Cuevas, so you were born into the art world. Can you talk about your beginnings?

XIMENA CUEVAS Yes, I was born an artist's daughter, and growing up, there were no boundaries between art and life; it was all part of the everyday. When I was a little girl, my dad would draw little faces on

my elbows that would talk when I moved them. This was really the first moving image for me: the drawings on my body would come to life, and in a way this was my introduction to art and the moving image. I also remember that I would stand at his side at his drawing table and see how the blank sheet would become filled with worlds, which is also a sort of moving image. His drawings almost always contained a window. I remember asking what that meant, and he said that in the window was the drawing he would make the following day.

I remember noticing the difference between our lives and people who had "normal" jobs—people who had set schedules. My friends' parents would be home for meals and then go back out to work. But my father was an artist from the moment he woke up to the moment he went to sleep. Living in that atmosphere, experiencing the world with him, was to be in a world of creativity and fantasy. For example, we'd walk through the streets, collecting phrases that we overheard from the people we'd pass, and we'd make up these impossible dialogues and memorize them. It was great for the memory, we'd repeat these phrases over and over, and at the end of the walk we'd have a whole conversation with them. It was very much about capturing life for the sake of playing games. For me, art has always had this same sense of playfulness to it. As an artist, there's no waste in life; all that you are living through is part of your art. I could never see a drawing as just the finished piece; the magic of it was the process of arriving at that place. I would go with my father to lithography studios, and I thought the lithography stones were magic. When they'd lift the paper off the stone it was like a theater curtain, and new worlds appeared like magic. So, between magic and games, these were my first introductions to the world, and it was a great privilege to be a child born into this artistic perspective. I also grew up with many people visiting our house, the most marvelous people. I was good friends with Luis Buñuel growing up [fig. 1].

ES Really?

XC Yes! Of course, today he would be in the "Me Too" movement. [*Laughs.*] I was twelve years old and he was eighty, and he would ask me to marry him. Although of course he also was already married! [*Laughs.*] But when I started to grow interested in studying cinema, Buñuel taught me an idea that seems useful for all the arts. He said: "You are on the road. On one side, a car drops off a man. On the other side, a woman and her dog are being dropped off. At this moment, a scene like this one is happening in various places. But where do you put the camera?" For me, this is the essence of

art. What is your vantage point? To make something absolutely original does not exist; we are limited as human beings, and the question is: where do you put the camera? These ideas shaped me greatly as a person and as the artist that I am today.

ES Did you think you wanted to be a filmmaker at that time?

XC No, I was thinking of pursuing drawing or painting like my father, but luckily I didn't. It's better to have your own voice, and I found cinema to be so incredible because it's both private and public. I remember the first time I saw a film set. I was neighbors with Rita Macedo and Carlos Fuentes, and I went to see their daughter Cecilia. There were a bunch of trucks and equipment. I was maybe ten years old. There were all these people, mostly men, looking in one direction. They were filming a sex scene.

ES In the street?

XC No, inside the house, but there it was. For the first time, I saw two people kissing and undressing, but as a public act. Everyone was

watching, and I felt a strange excitement. I remember standing between other people, watching them filming a sex scene. That was the first time I saw filmmaking in my life. I'm not sure what film it was, but it left a lasting impression on me. We went often to the cineteca[1] when I was a girl, especially to see silent films, like those by Murnau,[2] and to see Buster Keaton. Cinema was in my

Fig. 2. Ximena Cuevas operating a Bolex camera, 1982.

blood [fig. 2]. So it made sense that I would go on to work for the Cineteca Nacional preparing films for projection. This was in 1979, when I was sixteen years old. Sometimes I was repairing films, but more realistically what I was doing was censoring them for the government. Movies would arrive in Mexico and the well-to-do ladies, all dressed up with fancy hairdos, would come on behalf of the government to look and say, "Flag that!" For example, in the movie *Cabaret*, by Bob Fosse, I had to cut out all the scenes related to abortion, so at the end you couldn't understand the sudden split of characters coming from the happy scenes cheering: "For you and the baby!"

ES So you had a list of things you had to edit out?

XC Yes. We'd mark the films with pencil and then cut them. But the job was also to repair them when needed. I'd use a Moviola,[3] and sometimes they'd just give me the first and last reels to take out the technical cards. I'd see the first and last five or ten minutes of the movie, and when I went home I'd fantasize about what happened in the middle. This played an important role in forming my cinema of

appropriation. It's almost like creating something that only exists in your mind. That, coupled with the censorship, [meant] I was basically an editor of experiences.

ES How did this affect your approach to editing video?

XC It was crucial. From the moment I started making videos I was using found footage, and what is not included from the scenes is what creates the discourse. Does that make sense? In a work of appropriation, it's about what's absent. And a particular narrative is woven through this approach. I worked in the Cineteca for a few months, and this mental exercise of thinking about these nonexistent relationships made me focus on giving a form to the invisible in my work.

ES That's really interesting, and it helps me understand your work. You always have elements that create mystery. There's always a scene created by what's not there, like someone being followed, or some menace that you never see, but it's the main structure of the narrative.

XC Yes. When I was about eighteen years old, I began to work in the film industry. I worked on about twenty feature films, like *Missing* [1982], by Costa-Gavras, in the art department; *Under the Volcano* [1984], by John Huston, as an apprentice to the script supervisor checking continuity, which was really fun [fig. 3]; I also worked on *The Falcon and the Snowman* [1985], by John Schlesinger. There were

| Fig. 3. Ximena Cuevas with John Huston (left).

many different jobs, and I was fascinated by the atmosphere of big movies, all the people working there, and each movie had a totally different feel even though the crew remained the same. But I am also of the generation of hardcore cinephiles, like Alfonso Cuarón, Guillermo del Toro, Emmanuel Lubezki. I worked with them on some films, and I noticed that, while I'm very much part of that generation, I don't have that talent of asking for money to carry out my dreams, or at least the expensive ones.

ES [*Laughs.*]

XC And in areas where you need to have not just a vision and passion but other talents like public relations, there tend to be very few women. There is Marcela Fernández Violante, Marisa Sistach, Maria Novaro, but overall it's a very male-dominated world that I didn't fit into. So when I turned thirty, I started feeling very anxious that I didn't have the skills for this aspect of filmmaking, for all the bureaucracy it entailed. But with every director I learned so much, and there's no waste in these experiences. Like with John Huston, I learned that you have to have a point of view and precision in filming, so that if you died no one could edit or change anything without you. He had an auteur's control on the vision. Arturo Ripstein—I worked as an editor on one of his movies—is a director for whom every single element of his movies has a reason for being there.

ES But did you want to be a big filmmaker, was that your goal?

XC Yes, of course. But I also knew I didn't have what it took to self-promote in that way. And I was also inspired by the notion of artmaking as a daily practice, so I bought a small Sony or Canon Video 8 camera that I could use like a sketchbook to record my thoughts and ideas.

ES When did you get that first camera?

XC I got my first video camera around 1990, but I got a Super 8 camera in 1983 or 1984. I was working a lot with Ricardo Nicolayevsky. We would make Super 8 films, and we would develop and edit everything in a day. He's a musician, and he'd play music with his piano over the projections in his apartment. My generation was very affected by the AIDS crisis in the 1980s. So many people were dying of AIDS, many of our friends—like out of ten friends, six or eight had died. This is in the beginning of the 1980s, and it really gave us a different relationship to art. We didn't have a name for

what we were doing. Even Ricardo—who made one of the masterpieces of the 1980s, the Super 8 portraits of people from our generation—didn't have a name or greater ambition. There was no ambition for the future, because we were dying. Everything was just in a rush, and I think everything you leave behind is part of who you are as an artist and a person.

ES Had you seen much video art before you started making videos?

XC It's strange, because I don't think I'd seen video art before, but the media itself gives you certain connections with other artists from video's history. Once you have this tool that records in real time, you start trending toward certain aspects of the medium, like using it for confessions or using it as an extension of the body. The first video art I remember seeing was much later, when I saw a piece by Sadie Benning, and it was so obvious I had an immediate connection with the work. It was universal: if you gave this tool to someone in Africa, Latin America, the United States, Europe, Asia, or wherever, it would provoke the same type of narrative.

ES The creativity is structured by the medium.

XC Exactly. But when I got the video camera, all my friends in the film industry were saying that video doesn't have the same depth as film. You'd never put my little camera on a dolly. But it had other traits that cinematic productions didn't—intimacy, spontaneity, capturing the everyday, much like we do now with social media and our phones. So I would say we were inventing a language.

ES Did you know other people in Mexico who were making video art?

XC No, that happened later. It wasn't a community, we were just islands of solitary people, of weirdos. We didn't have many connections between us, just connections in terms of how we used the media. But once I started traveling I grew more aware of video. Around the same time I encountered Sadie Benning's work, I went to a conference in New York where I saw *Columbus on Trial* [1992] by Lourdes Portillo, and *Technology/Transformation: Wonder Woman* [1978], by Dara Birnbaum, and I attended a panel with B. Ruby Rich and Sally Berger (then at MoMA), so those were my first experiences. After the panel I approached B. Ruby Rich and asked to show her my work. She was super nice, and in a way she's my fairy godmother. I also really liked *Alma Punk* [1991–92] by Sarah Minter, which influenced me a lot. She used a very compact camera that allowed a lot of mobility and subjectivity, which blew my mind.

Then in the mid-nineties I was on the jury for Jovenes Creadores [Young Creators] (FONCA),[4] and that was very important because it gave me more access to Mexican artists, with contemporaries who were using video, like Eduardo Abaroa, Sofía Táboas, Damián Ortega, Teresa Margolles, and others.

ES Did you know Pola Weiss?

XC Pola Weiss, it's funny you mention her. She was a friend of my father's and she would come by the house a lot. I remember her coming in dressed like a complete hippie—actually she dressed a lot like how I'm dressed now!! [*Laughs.*] My father had a postcard in his studio of her with a video camera, but I had no idea. I just thought she was some hippie who'd come by the house. I got my first video camera in 1990, right after she passed away, but I wasn't aware of her work at all. But in terms of naming a pioneer for me, that's difficult because there were many little "weirdos" making videos on their own islands. Video Dos were disciples of Pola Weiss. But there are others like Domenico Capello. He would make these tiny videos of like thirty seconds. They were like just a little breath, or a sigh. Or Hector Pacheco, who I always felt was parallel to me, but we weren't a community or movement at all.

ES Was your father interested in video art?

XC Yes, he was, because I think it resonated a lot with drawing. The camera is like a pencil, it gives you an immediacy similar to making a drawing, with a rapid linearity that you can finish in a day. This is an interesting connection we had, because he would never leave his drawing table without finishing a drawing, since he was terrified that he would die and it would go unfinished. I think this is an important trait that I inherited from my father: my works are very centered on immediacy, which is related to his approach to drawing and painting.

GLENN PHILLIPS When did you begin seeing video art at spaces in Mexico City, and where was that work coming from?

XC It was later in the 1990s, and of course like everything in Mexico it came more from the United States than anywhere else. Even today it's sad how hard it is to see things by other artists from Latin America, although right now at Museo Universitario del Chopo there is an exhibition of Super 8 works by Latin American women, many names I've never heard of before. When the museums here started showing film and video art it was mostly the classics, like

Chris Burden. My work is more narrative, and that is always a challenge to present in an exhibition space, to find the right setting for it. What tended to be shown in the museums here were more performative works, like Richard Serra's *Hand Catching Lead* [1968], which is about the obsession with capturing.

ES What museums were these?

XC Museo de Arte Carrillo Gil was where I saw Nam June Paik and works by other Fluxus artists. I don't distinguish between film or video, I just focus on the small format—but at Carrillo Gil I also saw works by Yoko Ono and Andy Warhol. And then there was the biennial, which was promoted by Rafael Corkidi, the cinematographer for Alejandro Jodorowsky. He then went to Puebla and established the first school of video art. This was the first community movement of video art in Mexico, along with the one in Guadalajara established by Bruno Varela. Jesse Lerner and Rita Gonzalez's *Mexperimental Cinema* [1998] was very important too: that was the first book or screening series I saw on the topic, although that project came from the United States.

ES Did you always want to teach, and where have you taught in the past?

XC I have always taught and love teaching. I've done workshops at MUAC, as well as ones in Brazil, Costa Rica, which is interesting because of the lack of contact we have with these countries. It's tremendously interesting to me because Latin America is and has been since the mid-twentieth century a site of many profound expressions, both of passion and pain. But they are disconnected from one another. I think my work has a lot to do with this idea too, of reflecting on this sense of claustrophobia, of this expression without a foundation or direct reference to a broader history and location. The foundation is the camera, or the freedom to express these things. Even in Mexico there are many artists who are basically unknown. Susana Quiroz and Inés Morales, who do work similar to that of Sarah Minter, focusing on slums and impoverished areas (though they are actually from there), give a voice to those living in terrible urban conditions. For me, their work is among the most significant of the 1990s, because the medium gives you a profound insight. With video, you don't need to play by the rules, you don't have to be educated a certain way, nothing. You have the tool and you do what you can with it. Today, if you look at cell-phone video, it's amazing what's developed with that platform.

| Fig. 4. Tapes in the collection of Ximena Cuevas.

ES The other aspect of your work we'd like to discuss deals with the notion of archives and networks. We'd like to know more about the archive of video that you've collected, and how you circulate this work [fig. 4].

XC I started a collection of video art while traveling to the US to show my art. Wherever I'd go, I'd want to watch whatever was available. So I started collecting VHS tapes, because there was basically no way to get them in Mexico. I used to do exchanges with Kate Horsfield at Video Data Bank in Chicago. This was very important. They were distributing my work, and whenever I'd go to Video Data Bank, Kate would give me a ton of tapes. Then I'd come back home to Mexico and hold viewing sessions at my house.

GP Who would come for the viewings?

XC Well, many of my friends, of course Ricardo Nicolayevsky, Domenico Capello, Hector Pacheco, Carolina Esparragoza. I'd give workshops, and then I started making a collection based on different ways of using the camera. The Subjective Camera, for instance, which contains *Joe DiMaggio 1, 2, 3* [1991] by Anne McGuire. That piece kills me with joy, it's fabulous. It's just McGuire with her little

camera following old Joe DiMaggio. It's like a performative musical of her seeing the legend of Joe DiMaggio completely deconstructed, because now he's this old hunched-over man walking on the street. It strips away all the glamour of cinema and Hollywood, similar to my piece *Las tres muertes de Lupe* [1984; The three deaths of Lupe], and it's a commentary on the representation of women in cinema. I'd also collect tapes from Maria-Christina Villaseñor, who was a curator at the Guggenheim then. We were really good friends and I'd go to her place in New York to watch stuff. She did a wonderful program called *Drama Queens* that was based on melodrama, using old films like those by Ida Lupino mixed with video art; she was a super interesting curator. Sally Berger at MoMA also did a program with video art called *Mexican Video: Thorn of the Mountain* [1997]. Jesse Lerner showed me the beautiful masterpiece *Magueyes* [1962] by Rubén Gámez. At the time it was really nice because you could visit friends and copy tapes. It was much more free with VHS tapes; there weren't the same issues surrounding rights. The beauty of the medium was how easily you could reproduce and share and circulate work. For me, it has always been the medium of freedom in all ways. Another artist that really blew my mind was Miranda July—her early work like *Love Diamond* [1998], which was one of the most wonderful things I saw in my life. Women became such a strong part of video art. I don't think this is a coincidence—given the relation between women and diaries (people like Sor Juana, Virginia Woolf, or Anne Frank)—that women are using video this way, as if screaming out personal secrets. I think it's the freedom of the tool that pushes us into a powerful role in performance and video art.

ES Can you describe further how you structured your collection into a compilation about the history of video art?

XC My compilation is in two different parts. There is one called Anatomía del videoarte [Anatomy of video art], which examines the language of video. This includes the subjective camera, the wandering camera, the use of sound, different ideas that make up the grammar of the moving image. And the other archive is the Cronología de video arte en México, 1977–2009, which doesn't exist anywhere else in this country [fig. 5]. The idea was that this would be a sketch or skeleton of an archive that I'd like to fill out with the help of others. I've asked various artists to donate their collections, because while I do have a lot, I'm still missing many important works. For instance, I don't have enough of the work of Paulina del Paso, who is wonderful. My collection is as partial as memory is, it is just what came to my studio. It's very interesting, though, that

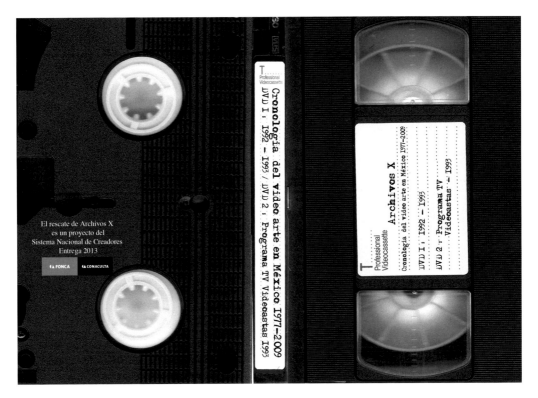

El rescate de Archivos X
es un proyecto del
Sistema Nacional de Creadores
Entrega 2013

FONCA CONACULTA

Cronología del video arte en México 1971-2009
DVD 1: 1992 - 1993 / DVD 2: Programa TV Videoastas 1993

Archivos X
Cronología del video arte en México 1971-2009
DVD 1: 1992 - 1993
DVD 2: Programa TV
Videoastas - 1993

when you look at the collection based on dates, you start to see dialogues and similarities between the artists even though we didn't know one another at the time. In other words, we are in a certain context and history where the reality provokes certain themes from people. For example, at a certain point Hector Pacheco and I were both connected by a resistance to the neoliberalism of Salinas Gortari, a Mexicanness exemplified in *Corazón sangrante* [1993], which shows a response to living in this neoliberal era.

ES Was the goal of this compilation for your own use, or for a museum, or . . .

XC These were for my own use as well as for workshops. I needed to have the archives organized in a way so that I could share them at workshops, because an archive without order is not an archive—it's more like a mass graveyard.

GP The series you've made are like a portable archive, and I think it's important that they are not too overwhelming in size. Elena and I were able to watch the whole *Cronología de video arte en México* as part of our research, which is something we could not do when we walked into other collections of a thousand tapes that weren't organized. It may not be comprehensive, but it's structured: it's put

Fig. 5. Videotape titled *Archivos X: Cronología de video arte en México, 1977–2009* (Archives X: Chronology of video art in Mexico, 1977–2009), from Ximena Cuevas's collection.

into categories, and it's almost like a course that the viewer can follow along.

ES Can you explain more about how you worked on it and organized it?

XC Yes, when I first got the VHS tapes, they were organized alphabetically and they are all still just here at my house; there are many tapes. And I've been working on it more or less continuously for over twenty years. The big problem is the shift in technology and formats: the problem I have with my archive is that all my hard drives will eventually die, which is a saga because there's no end to it. I went to a conference for archivists and a speaker asked: "Who here has lost complete archives just because of a faulty cable?" I got very nervous, because transferring the video art from physical storage on drives and discs is a task that is endless. In Mexico there is little interest or resources for archives. I think many institutions here in Mexico have struggled with producing a concrete or accurate history, because history here has to do with moments of power and who holds the pen to rewrite history. I don't think the lack of interest in shaping memories is a coincidence; it can be for political reasons or even personal ones to highlight friends.

ES Right, you erase and start anew. You keep erasing history, because whoever's the one in power keeps narrating the history and telling the story.

XC Yes. I just approached Sol Henaro at MUAC and I gave her my chronology of Mexican video art, because there are certain artists who are very important, like Sarah Minter, but it's really hard to say someone is the "one" or the pioneer, because no one is really "the first." There are many isolated events. But we are entering a complex and disturbing subject; even our personal memory is selective. I don't even have the same memories as my sister even though we grew up together in exactly the same time and place. I asked my uncle, who is over ninety, why do we need to remember, and he said it is our reference for life; it is what give us continuity and a sequence, of what we are as human beings.

ES That's why we're calling the book *Encounters*, because there wasn't one history; there were different versions everywhere, and they intersect through multiple networks, never one, always mapped out and reaching different places. In our experience, traveling in Latin America—even in one city, within one time frame, there's never one story. There are all these different stories that depend on who's telling them.

Notes

This interview was conducted in Mexico City on 19 December 2018. It was translated from the Spanish by Sophia Serrano.

1 This is the Cineteca Nacional de México.
2 Cuevas is referring to the German director F. W. Murnau.
3 A Moviola is a device used for editing film.
4 FONCA is the Fondo Nacional para la Cultura y las Artes.

SECTION 3

MEMORY AND CRISIS

Elena Shtromberg

Memory and Forgetting in Video Art from Latin America

The commitment to presenting the distortions and gaps in historical memory is one that is shared by video artists from Latin America working across different regions and time periods. In the relatively brief, roughly fifty-year history of video art, artists have deployed its technology, summoning at first its analogical and later digital specificities, to confront traumatic political and social pasts, particularly in opposition to the spectacularization of historical events in the mass media. Artist videos, unlike traditional documentary film and television, allow for a layering of temporalities with moments of reality and fiction, reconciling memory and forgetting in a fragmented, at times ephemeral, visual document more suited to representing a multiplicity of perspectives. Freed from journalistic conventions and strict adherence to historical veracity, artist videos propose something much more impressionistic, more adept at transmitting the complexity of trauma. The role of artist videos in configuring new modes of remembering and reflecting on historical disasters positions them alongside memorials. However, unlike state-sponsored monuments celebrating strategic national ideals, artist videos incorporate more nuanced representations and critiques of historical violence, inaugurating new ways of reconciling the past and the present.

By examining artists from different generations and their experimentation with video's unique features as a means to reflect on the past, this text will position video production from Latin America in dialogue with the interdisciplinary body of scholarship emerging out of memory studies. In his seminal text on the phenomenon of memory, Andreas Huyssen captures the contemporary impulse to turn to the past, a tendency that he identifies as "in stark contrast to the privileging of the future so characteristic of earlier decades of twentieth-century modernity."[1] For artists working within this "turn," video technologies

have presented a unique opportunity for capturing the complexities of memory, particularly with regard to its erasures. For Huyssen contends that "memory is always transitory, notoriously unreliable, and haunted by forgetting."[2] This understanding is no doubt influenced by studies into the psychology of memory and in particular the blurring between fact and fiction that takes place when recalling trauma.[3] What is particularly salient about the medium of video is its capacity for layering lived and imagined realities to accommodate what psychoanalysts have called the "fragmented visual percepts" of traumatic pasts.[4]

What then can artist videos tell us about memory and its erasures? Decades before Huyssen, the media scholar Vilém Flusser acutely foresaw that video enacted a different kind of memory through what he identified as a posthistorical gesture, which "aims not only to commemorate the event (a historical engagement) but also to compose alternative events (posthistorical engagement)."[5] When video was first widely used during the 1970s and 1980s, artists, the majority of whom came to video from other media such as painting and sculpture, were oscillating between embracing the immediacy that video equipment then offered them and critiquing what one scholar called the "electronic instantaneity" of commercial television.[6] The shape of this critique was wide and varied, but one thing that *can* be said is that it involved a consideration of the medium's capacity not only to document but also to reflect on the longer historical impact of political and social violence, leaving and circulating an alternative record. Further, as Ina Blom describes in a more recent study on the medium, early analog video functioned "as a machine whose ability to contract and distribute temporal materials in an unfolding present [that] resembles the working of human memory."[7] Leaning on the medium's capacity to record and layer moments of remembering with strategic erasures, or forgetting, artist videos introduce a unique way to reckon with the past.

With Flusser and Blom in mind, this essay proposes three case studies that act as posthistorical gestures in which video performs and embodies multiple approaches to memory. My objective is not to identify video as a register or a definitive response to traumatic political events but rather to position it as a technological intermediary, negotiating the visual record as hovering, sometimes uncomfortably, between remembering and forgetting. James Young, a scholar of the Holocaust, wrote that for artists, the best "engagement with Holocaust memory in Germany may actually lie in its perpetual irresolution" and that "only an unfinished memorial process can guarantee the life of memory."[8] It is this facet of irresolution that I seek to probe further in the work of three artists who represent different generations and distinct regions in Latin America: Oscar Muñoz (b. 1951) from Colombia, Clemente Padín (b. 1939) from Uruguay, and Ernesto Salmerón (b. 1977) from Nicaragua. All three artists deploy different features of video to address specific historical moments

in their countries but do so in a way that does not restrict the interpretation of their work to solely a historical lens. Instead, their work sheds light on the layered ways in which video functions to capture and express the complexity and ungraspable nature of deeply traumatic political pasts.

OSCAR MUÑOZ

There is no artwork that more acutely visualizes the mechanisms and limitations of memory and its representation as well as Oscar Muñoz's *Re/trato* from 2004 (fig. 1). Muñoz, whose artistic reflections are included in this volume, is a well-established artist from Cali, Colombia, and is perhaps best known for his photographic work.[9] Though born in Popayán, during the 1970s he grew up in Cali, where he graduated from the Escuela de Bellas Artes. Perhaps equally important to Muñoz's artistic career was the community of innovative filmmakers working in Cali in the 1970s, which introduced him to the possibilities of cinematic experimentation. Throughout his oeuvre, Muñoz has constantly questioned the process of image making, challenging how the medium of photography works to produce the images that become part of the popular and historical imagination, an inquiry he also brings to his video work. In *Re/trato*, Muñoz paints his self-portrait on a warm concrete surface using a paintbrush dipped in water. Just as the sketch is realized, the water instantaneously evaporates, prompting the artist to keep repainting his likeness in a Sisyphean undertaking that can never be fully realized. The action is looped in a cycle that lasts just under thirty minutes, replaying the ritual of creating the portraits that then quickly evaporate, always lingering somewhere between remembering and forgetting. The title, *Re/trato*, has multiple meanings. In an art context, perhaps most immediately it means a portrait or the pictorial representation of a person. The slash following "*Re*" suggests a brief pause so that the title can also mean *I try again*, a possible reference to the repeated attempts to capture the elusive portrait. And a third variant on the title can signify "to retreat," performed by the retreating image that continually evades getting anchored onto the surface.

What then can we say about this portrait that denies the basic principle of portraiture and its capacity to record and represent its subject? How is this failed attempt, witnessed and rehearsed over and over again during the twenty-eight-minute duration of the video, a reflection on history and its erasures? Muñoz's video and its lack of a cohesive subject becomes a sort of antimemorial, reminding the viewer instead of the ephemerality of the gesture that is normally used to document history and its most notable figures. There are multiple interpretations of such a gesture and its relationship to Colombia's history. In fact, in the many instances that this work has been exhibited, it has commonly been referenced as a reflection on the country's violent political context, particularly of those disappeared during Colombia's decades-long armed

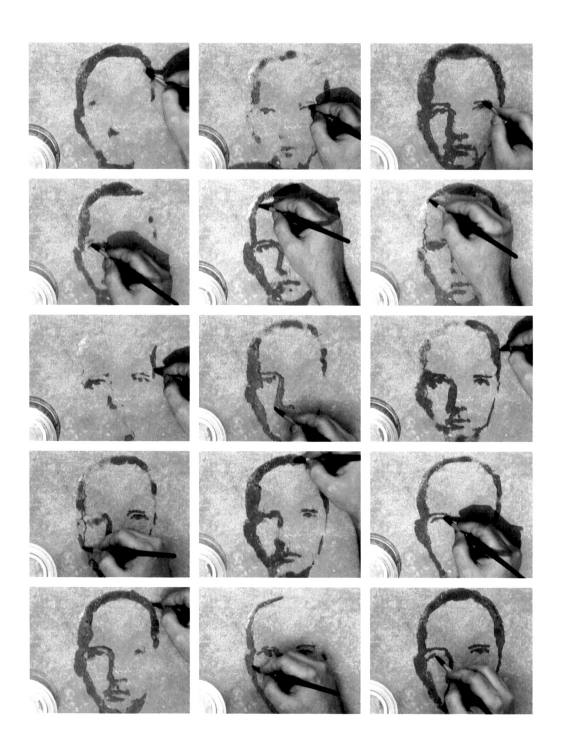

| Fig. 1. Oscar Muñoz
(Colombian, b. 1951).
Video stills from
Re/trato, 2004.

conflict between the government, paramilitary groups, and leftist rebels. The memory of thousands of victims (millions by some accounts), many violently disappeared and still missing, continues to haunt the very recent peace process.[10] To reckon with this past, Colombia established the Centro Nacional de Memoria Histórica through a national decree in 2011.[11] This multipronged entity is dedicated to recuperating and identifying those affected by the conflict and involves a searchable online archive of photos, letters, and other relevant documents that could help someone looking for a victim, for example.[12]

But artworks are not so pointedly targeted at or inscribed with a specific social or political agenda. In fact, while *Re/trato* is historically linked to Colombia's internal conflict, it is also intimately tied to the centuries-long history of portraiture. The impossibility of a portrait to ever fully capture someone's semblance exists alongside the impossibility of portraying all the disappeared and accounting for their memories. *Re/trato* poetically conjures the universal ambiguity of the conflicting oscillation between remembering and forgetting. The repeated gestures that lead to the erasures of the self foreground not only the instantaneity of forgetting but also the critical importance of trying to remember in the present. Muñoz refuses to allow for the clean slate afforded by forgetting at the same time that he highlights the persistence of historical voids— and it is the medium of video, with its temporal unfolding, that allows this process to be experienced by the viewer. As we witness the imprecise but methodical outlines depicting the subject take shape on the screen and then slowly disintegrate, we become suspect about the processes of representation.

There is no shortage of spectacularized portrayals of the Colombian conflict in mass-media outlets, including newspapers, books, and films; some attempt to impose a "truthful" version of the events as they took place. In contrast to the purported documentary nature of such media accounts, Muñoz proposes a nuanced, lyrical alternative. Through the repeated creation and disappearance of images played out in *Re/trato*, the artist relies on the medium of video to generate a diversity of narratives that the viewer must herself give shape to, narratives that are not limited to one specific or contextual interpretation. On the one hand, this work is inevitably and inextricably linked to the context of Colombia's history and its media representation, but on the other, the artist's gestures destabilize and even point to a crisis in representation in contemporary art more generally. The disappearing image thus becomes a viable metaphor for the functioning of memory and its many lacunae. Leaning on the idea espoused by Flusser in his reflection on video, Muñoz's contours become posthistorical gestures that go beyond solely being commemorations of the disappeared, as a memorial might be; they also serve as prompts for a multiplicity of reflections.

CLEMENTE PADÍN

Like Muñoz, the Uruguayan artist Clemente Padín also addresses the erasures of memory, specifically in his work *Missings Miss* from 1993. Padín is a multimedia artist, although he is best known as a visual poet who was and continues to be a prominent name in mail and performance art. He bought his first video camera in 1980 and began to produce videos consistently from then on. Many of Padín's artist videos, along with his other works from this time, deal with the human rights violations committed during the Uruguayan military dictatorship (1973–85), when thousands suspected of politically motivated crimes were unjustly imprisoned, tortured, and disappeared. The artist himself was detained in 1977 and imprisoned for seven years, two and a half of which he spent in prison, with the remaining years spent as a captive in his home. *Missings Miss*, a work whose title is characteristic of the playful and elastic verbal strategies that the artist often employs in his poetry, references, among

other issues, the many Uruguayans who were disappeared by the regime and never identified. The use of English in the title allows for this linguistic play while also establishing the work as a manipulated text and an artistic statement rather than footage of an actual event. For the piece, Padín first videotaped a street protest in Montevideo where people were holding up banners featuring photos of the missing and demanding justice for the disappeared (fig. 2). During the nearly six-minute duration of the video, the image of the protest begins to deteriorate slowly as the banners depicting the missing fade into unrecognizable and unintelligible visual noise on the screen (figs. 3–6). Such degradation of the image is a unique quality of analog VHS tapes, which, unlike digital videos, slowly deteriorate in quality after repeated playback. In *Missings Miss*, Padín manipulates this technical attribute of the medium: he played the original tape hundreds of times and painstakingly documented its slow degradation into static. Through intentional repeated playback and duplication, he methodically erases all traces of the disappeared depicted on the banners, replacing them with the visual noise resulting from their erasures. This deliberate dissolution of the video image technically restages and performs the disappearances that took place during the military regime, leaving a visual document that poses more questions than provides answers. The artist explained that it took him six months to complete the video using a technique known as rewind, pause, and copy, where for each successive copy he made, he had to line up the images to the exact second in order to achieve the final version in which the images transition smoothly toward their own disintegration.[13] Curiously, the visual degradation of VHS tapes resulting from repeated playback is called generation loss (*perdida por generación* in Spanish), a technique that numerous video artists deliberately included in their work to achieve a certain grit and graininess that distinguished video images from those on television.[14] In Padín's work, however, the technique becomes an uncanny reference to the generation lost to violence and the wave of repression incurred during this political moment in Uruguay and in the neighboring countries of Argentina, Brazil, and Chile, also under military dictatorships.

Similar to Muñoz, Padín investigates the instability of representation, in this case by exploiting the instability of the medium of analog video. The missing are not celebrated with a memorial but invoked through a poetic and performative reflection. Again, though the work is intimately tied to the political context of Uruguay, it is, like *Re/trato*, a commentary on repressive state violence, understood both in the country where it was produced and by the victims and those living with authoritarian violence worldwide. Outside of its political interpretations, the video stands as testimony to the impossibility of remembering, portraying memory, like the image, as something that degrades so that it is no longer recognizable. And yet, it is by capturing the process of deterioration that video also stands to remember.

ERNESTO SALMERÓN

My final case study is the *Documentos* series, completed between 2002 and 2003 by Ernesto Salmerón, an artist from Nicaragua and the youngest of the three artists discussed in this essay. Salmerón's works are a slight departure from the aesthetic continuity between *Re/trato* and *Missings Miss*, but *Documentos* expands equally on video's unique attributes vis-á-vis memory, making it worthwhile to consider in tandem with the others. Comprising three short video pieces titled *Documento 1/29*, *Documento 2/29*, and *Documento 3/29*, the series reflects on media spectacle and archival footage documenting the Sandinista Revolution.[15] Salmerón went to the Universidad del Valle in Cali, Colombia, where he met Oscar Muñoz and helped him with his videos, no doubt a formative experience.[16] Much of Salmerón's work deals with the legacy of the Sandinista Revolution, which took place in Nicaragua between 1979 and 1990, and, more specifically, with its postrevolutionary aftermath. Like Muñoz and Padín, Salmerón interrogates historical and cultural memory; however, he focuses more pointedly on its manipulated restaging in mass media, particularly with regard to political violence. In an interview, Salmerón describes the *Documentos* videos as Post-Post-Post Revideolución, stating that "3 times Post means that the revolution is something from a very very very distant past, not chronologically but psychologically . . . the dimension of trauma, of the suffering of the minds who were in the war, who sacrificed for an ideal and were later betrayed. . . . History as trauma."[17] For him, the platform of video, one that closely resembles but is also ideologically opposed to that of mass-media channels, brings to light and confronts the failures of the revolution as well as its official representation. Video, he explains, is not only "a substitute for film" but also a way "to democratize and amplify the production of messages," thus identifying his interest in the medium's capacity to communicate with a broader population.[18] Salmerón's constructed term *revideolución* foregrounds the (revolutionary) importance

and appeal of video for his research "as an easier means to say things and less expensive."[19]

The title of the series, *Documentos*, references the role and importance of documentation as historical record, also reinforced by the institutional numeration *1/29*, *2/29*, and so on, often used for organizational and archival purposes. In one interview, Salmerón stated that he used the word *Documento* because it sounded important, even if video's capacity to act as document is implicit at best.[20] The creation of a historical record is especially crucial in Nicaragua, where, according to Salmerón, there "are sectors of the dominant class that want to erase history, . . . from the right as much as the left." The notion of historical erasures is thus a part of Salmerón's visual investigations as much as it is in Muñoz's and Padín's works. The number 29 in the series references the twenty-nine men who followed Augusto Calderón Sandino, the revolutionary leader who led an uprising against the United States between 1927 and 1933 and subsequently became the hero for whom the Sandinista Revolution was named.[21] The small but victorious revolutionary army of twenty-nine soldiers who accompanied Sandino was known as the EDSN (Ejército Defensor de la Soberanía Nacional de Nicaragua), and Salmerón sought to pay homage to the soldiers by dedicating one video to each of them (although he stopped the series after *Documento 3/29*). All three short vignettes feature found film footage from INCINE (Instituto Nicaragüense de Cine), a cultural propaganda organ for the revolution during the 1980s. INCINE opened on the day that the Sandinista army arrived, victorious, at the center of Managua in 1979, and it closed in 1990, after electoral defeat, which also shuttered access to the film archives. Although the film footage has been suppressed from the public, Salmerón was able to obtain some of the damaged film reels through a personal contact he had, later working fragments into his videos.[22] The artist's impulse to expose these fragments from the missing archival collections in his videos echoes the focus on acknowledging the missing in Muñoz's and Padín's works. All three present the victims of violent political and social transformations, and the importance of recuperating, even if only ever partially, the traces the missing left behind.

In *Documentos*, Salmerón pays particular attention to sound, an often underexamined facet of video production, despite the fact that video as a medium originates in audio-recording devices. The audio in the works functions to shape the narrative surrounding the archival footage, reinforcing the artist's deployment of repetition and dissonance as aesthetic strategies. *Documento 1/29* (2002), the longest of the three at three and a half minutes, is the most exemplary of the series. It begins with a synthesizer-generated sound, providing a strident soundtrack to the images that unfold. The text on the screen, "La gloria no es la que enseñan los textos de historia," is a quote from the poet, Catholic priest, and politician Ernesto Cardenal.[23] Cardenal was a member of the Sandinistas

and served as minister of culture from 1979 to 1990; later, he left the party, disillusioned with its authoritarianism.[24] The inclusion of Cardenal's text at the start and toward the end of the video instills a persistent skepticism in official histories and a discontent in political discourse that linger throughout the video. This moment is then followed by the faded clips of revolutionary rhetoric, which the artist repeatedly rewinds and replays, and which serves as the background to images of soldiers, bare-chested young men, who perform a series of synchronized exercises interspersed with images of the dictator General Anastasio Somoza, who was overthrown by the Sandinistas in 1979 (figs. 7–9). The intentional audio distortions interrupting the empty but celebratory revolutionary clichés (such as "the defense of democracy") are recorded onto the bodies of soldiers, exposing

their performance of futile physical disciplinary tactics. The frequent inclusion of images of soldiers and the presence of rifles, circling military planes, and other ominous symbols such as skull tattoos, interspersed with the staccato rhythms of the soundtrack, suggests the constant presence of a threat. The sense of heightened alert reinforces the friction posed by menacing violence, one that continues into present-day Nicaragua.

The cinematic footage that Salmerón recuperated and included in *Documentos* belonged to films originally dedicated to celebrating the ideals and recognized personalities of the Sandinista Revolution, once part of a national cultural legacy housed at the film archives of INCINE.[25] After the institute's abrupt closure just over a decade later, the films that were housed there were no longer accessible, creating historical gaps in the visual documentation of this era. Salmerón's deliberate manipulation of the film fragments, already in a state of deterioration, layered with audio and visual noise not only repositions but also rewrites the narratives of the original films, complicating their accounts of the revolution.

In comparison to *Documento 1/29*, *Documento 2/29* (2003) is significantly shorter at roughly twenty-five seconds. It features a black screen pulsating with splotches caused by the aging film as white text scrolls across it. The video begins with the sound of drums interrupted by shrill noises that become the background to a short text by Ernesto Cardenal, the same poet whose text makes an appearance in *Documento 1/29*. The brief text, drawn from Cardenal's epic book of poetry from 1989, *Cántico Cósmico* (*Cosmic Canticle*), stresses that youth is more adventurous and interested in the new but as a result is also more vulnerable to death.[26] While innocuous on its own, the verse takes on a cautionary note on the heels of the first *Documento*, in which youthful soldiers are the frontline of the revolution, eager for change despite the high cost.

Like the preceding two documents, *Documento 3/29* (2003) begins with the dissonant sounds of drumming pierced by a high-pitched noise. At about a minute long, the video combines text with fragments of film footage. One of the first shots is of a signboard for FSLN, an abbreviation for the Frente Sandinista de Liberación Nacional, intercut with the sound of a woman stating, "Trabajando porque no podemos dejar que la sangre de nuestros mártires sea pisoteada."[27] That statement is repeated several times as Salmerón rewinds and replays the footage, honing in on the word *trabajando* (working), repeated throughout the rest of the video while a young peasant woman with a basket on her head continually walks over to a large cross, seemingly a grave. The FSLN sign, once proclaiming the Sandinistas' triumphant rise to power, becomes equated with the grave. The replayed shots of the woman walking and the emphasis on labor in the frequent reiteration of the word *trabajando* suggest that the revolution did not do much for the plight of the peasants.

All three *Documentos* are visually united through the incorporation of the sequestered black-and-white film footage, Cardenal's poetic texts,

and the discordant audio soundtrack constantly interrupting any attempt at a cohesive, and even less so triumphant, historical narrative. Indeed, Salmerón's videos disrupt the objective of the original documentary footage, at times forcefully, through the incorporation of multiple layers of visual and audio interference that emphasizes the poetics of his aesthetic strategies. The resulting works demonstrate a complex and fragmented web of reactions that are liberated from representing the ideals of the revolution and are more in tune with its contemporary and challenging lived reality. Historical memory in the *Documentos*, despite the ironic title, is represented as unstable and in a constant process of precarious reconstruction. As in Padín's and Muñoz's work, the *Documentos* series oscillates disconcertingly between forgetting and remembering.

VIDEO'S MEMORY

In her essay "The Politics of Video Memory," Marita Sturken makes the claim that video belongs to a field of cultural memory "that contests and intervenes with official history."[28] She describes independent video as generating "databanks of alternative images and accruing an alternative visual history to the nationalist history produced by broadcast television," a statement that recalls Flusser's assessment of video as a posthistorical gesture, addressed earlier in the present essay. The alternative histories enacted in *Re/trato* (Muñoz), *Missings Miss* (Padín), and the *Documentos* series (Salmerón) do not attempt to promote a specific or truthful vision of past political events. Rather, they provoke reflection on the variability of historical narratives and their representation at large, particularly in mass media. The lack of a singular focal point in these works complicates a singular mode of viewing and understanding and instead elicits diverse modes of interpretation that suspend resolution. All three artists came to video after having worked with different media—and in video they found a distinctive means to recollect and integrate the fragments of traumatic pasts into layered visual narratives that prompt viewer engagement. Moving images in video allow for the artists' reflection on historical memory to be renewed with each viewing, exhibiting a version of history that is constantly in process. By considering these three works alongside each other, I sought not only to draw on the parallels across geographic and generational divides but also to signal what I identify as a broader tendency among artists—particularly, although not limited to, those in or from Latin America—to use video to present history as something residing between memory and forgetting.

Notes

1 Andreas Huyssen, *Present Pasts: Urban Palimpsests and the Politics of Memory* (Stanford: Stanford University Press, 2003), 28.

2 Huyssen, *Present Pasts*, 28.

3 See, for example, Dori Laub and Nanette C. Auerhahn, "Knowing and Not Knowing Massive Psychic Trauma: Forms of Traumatic Memory," *International Journal of Psychoanalysis* 74 (1993): 288.

4 Laub and Auerhahn, "Knowing and Not Knowing," 288.

5 Vilém Flusser, "Gestures of Video," in *Gestures*, trans. Nancy Ann Roth (Minneapolis: University of Minnesota, 2014), 145. Originally published in German as Vilém Flusser, *Gesten: Versuch einer Phänomenologie* (Braunschweig: Bollmann, 1991).

6 William Kaizen, *Against Immediacy: Video Art and Media Populism* (Hanover, NH: Dartmouth College Press, 2016), 9.

7 Ina Blom, *The Autobiography of Video: The Life and Times of a Memory Technology* (Berlin: Sternberg, 2018), 16–17.

8 James E. Young, "At Memory's Edge: After-Images of the Holocaust in Contemporary Art and Architecture," in *The Collective Memory Reader*, ed. Jeffrey K. Olick, Vered Vinitzky-Seroussi, and Daniel Levy (Oxford: Oxford University Press, 2011), 371.

9 Muñoz was awarded the Hasselblad prize in 2018 in recognition of the excellence of his photography.

10 The peace agreement to end Colombia's conflict, signed in 2016, was a years-long process between the revolutionary armed forces of Colombia (FARC) and the government, then headed by President Juan Manuel Santos, who ruled for two terms from 2010 to 2018.

11 See Centro Nacional de Memoria Histórica, "Contexto," https://centrodememoriahistorica.gov.co/contexto.

12 See Archivo Virtuale de los Dereches Humanos, Memoria Histórica y Conflicto Armado, El Centro Nacional de Memoria Histórica, http://www.archivodelosddhh.gov.co/saia_release1/ws_client_oim/menu_usuario.php.

13 Clemente Padín, correspondence with the author, January 2019.

14 Surprisingly, when Padín attempted to send this work to video festivals, it was rejected because the jurors could not see the images clearly and thus deemed the file damaged or corrupt. The video's first public exhibition was on YouTube after a friend helped Padín upload it, and it is still there today. Clemente Padín, correspondence with the author, 16 April 2019. See "Missing Miss: Clemente Padín," YouTube video, posted 15 July 2015, https://www.youtube.com/watch?v=kqlupCfAfds.

15 The first of this series, *Documento 1/29*, was codirected with Mauricio Prieto, an artist and friend of Salmerón's from college in Cali. These videos are related to Salmerón's project, *Auras de guerra* (Auras of war), which he began while in college in 1996 and which lasted around a decade.

16 At the Universidad del Valle, Salmerón studied social communication and had the opportunity to experiment with multiple media, leaning heavily on photography. While there, he took an experimental video class whose theme was violence, which led to the creation of his first video, *JHS: The Salvation*, in 2001. The video was made with Mauricio Prieto y Edward Goyeneche for the Taller de Video Experimental taught by Oscar Campo. Eduardo de Jesus, "Ernesto Salmerón: Interview," *Videobrasil* (December 2004), http://site.videobrasil.org.br/dossier/textos/542048/1777211.

17 De Jesus, "Ernesto Salmerón."

18 De Jesus, "Ernesto Salmerón."

19 De Jesus, "Ernesto Salmerón."

20 De Jesus, "Ernesto Salmerón."

21 Sandino later adopted César as his middle name.

22 The artist got the archive on VHS tapes in the late 1990s, before YouTube made the INCINE works available. Ernesto Salmerón, email to author, 19 August 2019.

23 The text translates as "Glory is not what is taught in history books."

24 Carla Macchiavello identifies the poem as coming from "Hora 0" (Zero hour), an epic poem relating the counterrevolutionary ways of humanity and the brutal heroism of the revolutionaries; the phrases of the poem also ennoble and praise new heroes, replacing those of the past. See Carla Macchiavello, "The Power of Pink: Performing the Archive in the Works of Ernesto Salmerón," *Emisférica: After Truth* 7, no. 2 (2010), https://hemisphericinstitute.org/en/emisferica-72/7-2-essays/the-power-of-pink-performing-the-archive-in-the-works-of-ernesto-salmeron-51427855.html.

25 INCINE was launched in order to support films glorifying the revolution at its height during the 1980s and then closed only about a decade later, remaining closed throughout the 1990s.

26 The full text is: "En todas las especies los más jovenes son más aventurados que los viejos, más dispuestos a cambio y lo nuevo, y por tanto más propensos a la muerte."

27 The text translates as "We are working because we can't let the blood of our martyrs be stepped on."

28 Marita Sturken, "The Politics of Video Memory: Electronic Erasures and Inscriptions," in *Resolutions: Contemporary Video Practices*, ed. Michael Renov and Erika Suderburg (Minneapolis: University of Minnesota Press, 1996), 2.

Sebastián Vidal Valenzuela

Festival Franco-Chileno de Video Arte: A Space of Resistance under Dictatorship and Expansion in Democracy

There is no question that one of the most significant cultural events related to video art produced during Augusto Pinochet's dictatorship in Chile (1973–90) was the Festival Franco-Chileno de Video Arte (fig. 1).[1] Established in 1980 as part of the French foreign cultural policy, the festival was promoted by the cultural section of the French embassy in Chile as a space for exchange and collaboration between artists from both countries, founded under the direction of Pascal-Emmanuel Gallet (the head of the Cultural Activities Office of the General Directorate for Cultural and Scientific Relations of the French Ministry of Foreign Affairs). The festival was initially called the Encuentro Franco-Chileno de Video Arte (1981–85) and was held annually at the Instituto Chileno Francés de Cultura in Santiago. Each year, the program ran for a little more than a week and included works by French and Chilean video artists, as well as conversations and discussions about the technological mechanisms for artistic production in video and about video's limitations and dialogues with other disciplines; it also provided space for political reflections on visuality and artistic forms.

 Why do I believe that it is vital to resurrect the importance of this festival within the history of Latin American video? To provide some context: based on the theory proposed by the Argentine video art scholar Rodrigo Alonso in his essay "Zona de turbulencia: Video arte de Latinoamérica" (Turbulence zone: Video art from Latin America), the genre's emergence in the region would be historically intertwined with at least three variables: political and cultural precarity, a lack of access to technologies, and the struggle to find a foothold in the cultural landscape. Alonso argues:

| Fig. 1. Cover of the
*Catálogo Sexto Festival
Franco-Chileno de
Video Arte,* 1986.

Fig. 1. Cover of the *Catálogo Sexto Festival Franco-Chileno de Video Arte,* 1986.

Yet when we examine the conditions of its [Latin America's] video production, the same problems seem to recur time and again: a lack of official support, technological obsolescence, an absence of spaces for reflection, marginalization, a lack of production systems and financial support, the indifference of the commercial sector—cinema, television, multimedia—to the fate of experimental electronic production. We might say, without too much irony, that if there is one thing that unites Latin America, it is the persistence of its obstacles and difficulties.[2]

As in the rest of Latin America, the earliest video art scene in Chile experienced these three conditions to a certain extent. Nonetheless, one element that may differentiate Chile from other countries in the region is the festival: it generated both a distinctive model and a unique space for political and cultural openness, making it possible to create spaces for reflection and discussion, establish small-scale grant funding systems, and expand the art world into other areas of the audiovisual industry. As the festival developed, key political and cultural issues that existed during those years were actively interrogated, transforming the event into a countercultural space, even though it could not be declared as such.

One must also consider the argument of the Argentine art historian Andrea Giunta, who has suggested that the evolutionary model of the historiographic canon of international neo-avant-garde movements should be suspended in the Latin American context in order to reexamine their impact, since those movements have often downplayed and obscured the significance of works and actions created in analogous periods.[3] To

open up the possibility of historical simultaneity, the field of video art would have to revise its own systems of development, particularly in terms of the canonical art spaces. The festival can thus establish a crucial link between an avant-garde scene recognized around the world, as in France, and radical experimentalism in a peripheral region under dictatorship and in the transition to democracy, as in Latin America—and, in this specific case, in Chile.

As with most countries in the region, video art in Chile originated in performance practices. Works by Carlos Altamirano, Juan Downey, Carlos Leppe, Gonzalo Mezza, Lotty Rosenfeld, and Colectivo Acciones de Arte (CADA) envisioned video as a form of experimentation and documentation. Some artists, such as Altamirano, Downey, Leppe, and Mezza, used installation devices that transformed their works into complex pieces far removed from traditional practices like painting or sculpture. It is important to note that the dictatorial context surrounding the Festival Franco-Chileno de Video Arte was one of severe censorship and control over the media. As in many countries in the Southern Cone, there was intense cultural suppression in Chile during the Pinochet years: murals by the Brigada Ramona Parra had been painted over,[4] books deemed suspicious were burned, postage stamps were redesigned, and, of course, television was manipulated. A large part of the project to control and censor audiovisual media was carried out via the Dirección Nacional de Comunicación Social (DINACOS), which monitored all the material presented to the public.[5] This stringent oversight also ensured that the earliest video artists were confined to a small number of independent and private spaces. The regime's systematic dismantling of dissident voices meant that the critical contemporary art scene operated in a fragmented manner, often without any shared interaction.

Furthermore, the lack of a film industry and the regime's introduction of neoliberal economic policies served as fertile ground for television, and particularly advertising, to flourish in Chile in the 1980s. During that decade, television was a critical means of communication for many Chileans—and the regime recognized this. Through DINACOS, Pinochet used television as a tool to promote economic progress through official news reports about the regime and light programming, omitting the serious human rights abuses that were being committed at the time. As neoliberal policies were introduced in the country, there was a decisive focus on economic revitalization through foreign investment and consumer credit, leading to a boom in advertising. Consequently, many advertising agencies were established during those years, creating jobs for artists, videographers, and filmmakers who regarded their artistic work in those spaces as a means of survival. In turn, the work of emerging video artists was often driven by their access to the latest technologies through their advertising work. As the video artist Juan Forch explains,

Many of us who worked in and explored the pathways of video art in the 1980s, and video in general, were working in advertising. Just as video was a kind of cultural resistance, I think that because we had worked in advertising, video was our great escape and our way of resisting what advertising was inflicting upon each of us. . . . Every video that surfaced was a subversion of the regime.[6]

Against this backdrop of precarious technological access, television and advertising made it possible for artists to spend their free time working with technical tools such as cameras and editing equipment, which at the time were very expensive and not readily accessible. In the late 1970s and early 1980s, video art arrived in Chile through the documentation of performances and art actions. One exception to this rule was artists who lived abroad—either in exile or by their own choice—and were part of a scene of international video artists, as was the case with Juan Downey in New York and Gonzalo Mezza in Barcelona. Coincidentally, when video art began to take its initial steps in Chile, the Festival Franco-Chileno de Video Arte emerged as a space for the circulation and dissemination of audiovisual works. It thus became a central location for Chilean video artists to begin exhibiting their earliest works in this new format. As time passed, and with the continued support of the French government and local critics, the festival became a singular space in the country and in Latin America. The support of the French embassy acted as a kind of political umbrella for exhibiting pieces that occasionally contained covert statements against the regime.[7] Some of those pieces document body art actions, which, as Nelly Richard argues, invite the viewer to see the body as a painful mirror of society, as in works by Eugenio Dittborn, Diamela Eltit, Carlos Leppe, and Lotty Rosenfeld, among others.[8] Other works documenting actions in public spaces, such as those of Carlos Altamirano, Alfredo Jaar, Eltit, CADA, and Colectivo Al Margen (Collective on the Margin), enabled a critical reading of the social and political problems of those years. In many of these works, one can clearly see the idea of recognition concealed in the representation of the political discourse. The festival's continuity over time led to the development of an emergent—but sustained—scene of artists creating and reflecting on video and experiments with electronic moving images, which also symbolically became a powerful space of political and cultural resistance under the dictatorship.

Although there were independent spaces during the 1980s that exhibited video art in Chile—mainly in Santiago, such as the galleries Bucci, Cal, Cromo, Época, and Sur, and the Instituto de Arte Contemporáneo—the circulation of those early works was sporadic. In contrast, from the beginning, the festival was an important space because many audiovisual works were made specifically to be presented there, in a format open to the public. As the years passed, the festival became the central gathering place for audiovisualism in Chile during that period, as

well as a space for dialogue between local proposals—which had never been shown or had only appeared in independent exhibitions—and their French counterparts. The selection committee members for the French pieces worked at the production company Grand Canal, while the Chilean committee was made up of a group of artists and theorists that rotated every year. Ignacio Aliaga, Carlos Flores, Justo Pastor Mellado, and Néstor Olhagaray, to name only a few on the jury, appeared most frequently. As is widely known, censorship and the Chilean cultural blackout meant that video art made in Chile rarely circulated internationally. A binational conference such as the Encuentro Franco-Chileno de Video Arte thus helped to foster international contact between works, artists, and theorists, which in this early period was focused exclusively on France and Chile.

As part of the festival's programming, filmmakers, documentary makers, and others connected with the audiovisual landscape presented pieces that were not necessarily circumscribed by the specific universe of video art. Given the lack of local production, as well as the vague boundaries of a disciplinary field that was only beginning to develop in Chile, the diverse programming positioned video as an exercise in experimentation, advocating for an alternative language in order to place pressure on the commercial television industry. In this context, the festival also showed pieces made for television, music videos, and short films on video. The decision to include those type of works is related primarily to the use of the video format. Considering the blurred boundaries of the artistic work associated with these productions, there was a general feeling that works with an artistic element could be included in the programming, regardless of whether they were, for example, documentaries or music videos. Since the festival also served as a refuge for a community of artists linked to video, discussions initially focused on the education, exhibition, circulation, and dissemination of this new genre, as well as on censoring the media outlets for independent video in the country.

A crucial debate within the festival arose from the misgivings of a significant number of video artists who viewed the inclusion of hybrid formats associated with the media industry and culture—such as, for example, music videos—as evidence that the programming was focused more on the video format than on exploring the language of video art. That became one of the main discussions in the festival's early years. The video artists defended the autonomy of video art as a marginal and innovative genre within exhibition spaces, the media, and art criticism, while the audiovisual artists—many of whom made documentaries or music videos—defended their presence in the festival, pointing to the lack of other spaces for exhibiting video. The researcher Germán Liñero explains that

> given its dual role—operating as a space for disseminating French video art (which was the work that the officials in the Embassy's

Cultural Section were appointed to do) but also serving as a space for encounters and discussions around the national audiovisualism—there is a growing tension between the visual artists, the audiovisual artists, and the filmmakers (documentary makers and feature film directors who made videos because it was impossible to make films).[9]

Those were difficult times, when venues for dissemination such as the festival were unique and everyone wanted to have a place within it. For his part, the critic Justo Pastor Mellado, a member of the selection committee for several editions of the festival, notes that the discussion was also heavily focused on the language of video art:

> I think it was about specificity. Following the critique by the filmmakers, by the film semioticians, it was about responding to the specificity of video . . . and every year the discussion changed. One year, the discussion might be related to denarrativization, another year, it was the idea of an abbreviated narrative, a minimal narrative, so it was either between practices of denarrativization or the compression of minimal narratives.[10]

This tension may lead us to see the festival as an important nucleus for the development of video art in the Southern Cone. The technical precarity and lack of artistic or theoretical references to the language of video art, the pervasiveness of fields that grew out of television or experimental cinema, and the restrictions or censorship imposed by the dictatorships initially formed a terrain where—at least in the case of Chile—the space for encounters, exhibitions, and discussions was the Festival Franco-Chileno de Video Arte.

| **Fig. 2. Dominique Belloir (French, b. 1948).** Video still from *Paris mis à nu* (Paris laid bare), 1981.

The French works that were shown demonstrated a sophisticated knowledge and mastery of the techniques and language of video art. Year after year, works by artists including Dominique Belloir, Patric Bousquet, Colette Deblé, Jean-Paul Fargier, Michel Jaffrennou, Hervé Nisic, François Pain, Patrick Prado, and Philippe Truffault, among others, appeared again and again (fig. 2).

On the Chilean side, a significant number of the selected works in the earliest editions focused on the connection between body art, performance, and documentation of actions in public spaces, on the documentation of political protests, and on videos of theatrical performances. Those tendencies were apparent from the very first edition, which included artists such as Altamirano, CADA, Dittborn, Eltit, Flores, Jaar, Leppe, Mezza,[11] and Teatro ICTUS, with its project ICTUS TV.[12]

Among the Chilean works selected for the inaugural festival, Altamirano's performance *Panorama de Santiago* (1981), one of the first video performances in the history of Chile, is particularly noteworthy (fig. 3). In the video, the artist—in a subjective shot—runs through the streets of Santiago without stopping, carrying a heavy portapak video camera. His journey, which lasts almost seven minutes, takes him from the Biblioteca Nacional to the Museo Nacional de Bellas Artes, and as he runs he repeats over and over again, like a mantra: "Altamirano,

| Fig. 3. Carlos Altamirano (Chilean, b. 1954). Video stills from *Panorama de Santiago*, 1981.

artista chileno" (Altamirano, Chilean artist). Altamirano presented this video—the only one he made in his career—as both a reference to the history of Chilean art (since the work alluded to a painting of the same name made circa 1915 by the Chilean painter Juan Francisco González) and a potential metaphor for the pursuit and justification of the artistic gesture as a form of resistance. Juan Francisco González is widely recognized in Chile as one of the pioneers of the pictorial revolution in the late nineteenth century. The reference to the local painting tradition therefore also implies Altamirano's own movement as a pioneer into new territories. Self-trained in painting and engraving, video allowed him to experience the condition of political persecution as well as the pressure of referencing the fine-arts tradition. As the artist runs and tirelessly repeats "Altamirano, artista chileno," he is recognizing that the action belongs to the space of art. In other words, the action is reaffirmed as part of a new code that belongs to art, within which the reference is embedded, but it is also disengaged from the original medium of the reference: painting. Furthermore, Altamirano's act of running frantically with a camera on his shoulder through the streets of a heavily controlled city—as Santiago was in those years—would prove to be suspicious, at the very least. And finally, the fact that part of his journey includes two cultural axes that had been manipulated by the military during the dictatorship—the Biblioteca Nacional and the Museo Nacional de Bellas Artes—indicates that Altamirano is using running as a disruptive, cynegetic gesture, carrying out a critical action against institutional censorship and the country's cultural tradition.

That same year, Carlos Leppe performed *Cuerpo correccional* (1981; Correctional body), an action in which the artist plastered his feet and legs into the shell of a television set (fig. 4).[13] In the video, sitting on a glowing chair in the proscenium of the Instituto Chileno Francés de Cultura, facing another television set that was switched on but not displaying an image, Leppe begins his performance, as his video *Las cantatrices* (The opera singers) plays on three monitors alongside the action.[14] These monitors show Leppe's torso completely encased in plaster, with three holes, two on his chest and one on his abdomen. The performer also wears heavy makeup on his lips and eyes. Each television set displays a similar action against three different colored backgrounds: white, blue, and red, mirroring the colors of the Chilean flag. As Leppe's thick body moves, opera music can be heard, and he lip-synchs along with the singer. What is particularly striking in the action is that Leppe's mouth is being held open by obstetric forceps,[15] which distress him and prevent him from singing correctly (fig. 5). The action, in which he is visibly constrained by the plaster and the obstetric tool, symbolically represents the oppression of a social body; moreover, by portraying the opera singer in a male body, the action criticizes the heteronormative repression of that body. Next to the monitors showing *Las cantatrices,*

Leppe placed another television set showing a reading by his mother about the difficulties of childbirth. He then takes a hammer, shatters the shell of the television set and the plaster, and frees himself. When his performance was complete, Leppe discarded the internal components of this television set—screen, cables, transistors, and so on—in a wooden box on the street outside the building.

During the second edition, in 1982, Eugenio Dittborn presented *Lo que vimos en la cumbre del Corona* (1981; What we saw at the summit of Corona) and *Pieta II* (1982). The following year, Dittborn showed those

two pieces and *La historia de la física* (1982; The history of physics). These three works are part of a series that portrays specific dialogic exercises between formats and languages borrowed from mass culture, such as radio drama (in *Lo que vimos en la cumbre del Corona*) and television (in *Pieta II* and *La historia de la física*). In the former, Dittborn invited the actress Maruja Cifuentes to the Filmocentro studio to read aloud—in front of a fixed video camera—the story of a survivor of an airplane crash on Cerro Corona in 1965, in a single sixteen-minute take. The actress's performativity in front of a camera creates an eloquence that is in stark contrast to the lack of corporeality inherent to radio. *Pieta II* is an audiovisual proposal in which an image of the sculpture by Michelangelo is alternated with images of a foul in a match played by the Chilean soccer team during the qualifiers for the 1982 World Cup.[16] The idea of a fall, or death, which is painful for athletes, was a recurrent trope in Dittborn's work for many years and is linked to the classical representation of the fallen body in the Renaissance artist's famous sculpture. In 1982, Dittborn made his renowned video *La historia de la física* (fig. 6), in which he once again alternates images that appeared for a specific number of seconds based on the Fibonacci sequence: fragments of television programs with footage of musicians and athletes, as well as images of the birth of his daughter Margarita and of a performance from 1980 (with the video artist and filmmaker Carlos Flores serving as cameraman) in which Dittborn spilled 120 liters of burned oil out of a drum onto the ground in the Atacama Desert.[17]

| Fig. 6. Eugenio Dittborn (Chilean, b. 1943). Video still from *La historia de la física* (The history of physics), 1982/2008.

These three actions by Altamirano, Leppe, and Dittborn led Nelly Richard to write the following in the catalog for the festival's sixth edition:

> The repeated presence of an ordinary television set showing regular broadcast programming in the video installations (in particular those of Leppe and Altamirano), as well as the references to television programs (Dittborn), are evidence of the attention that those artists have paid—from the outset—to the relationship between video and television: the presence of the television set alludes—in many of the installations—to its status as a domestic symbol-object and an emblem of mass media consumption.[18]

Indeed, all three artists employ television as a way to subvert codes imposed by the dictatorship's censorship; they also criticize mass media through the use of the artist's body itself.

In addition to the works by Altamirano, Leppe, and Dittborn, many other performative works, such as those by Alfredo Jaar, Gonzalo Mezza, and CADA, were included in the festival's early editions.[19] This corroborates the hypothesis in Rosalind Krauss's famous essay of 1976, "Video: The Aesthetics of Narcissism," in which she suggests that "most of the work produced over the very short span of video art's existence has used the human body as its central instrument."[20] In those early years, until at least the mid-1980s, the central axis of much of the production linked to artistic experimentation focused on the use of the body and on public spaces. From the very beginning, the festival was an important showcase for performative works on video in Chile. This began to change over time, as production expanded to more diverse terrains, where formal experimentation with technology also began to have a larger presence.

Women video artists also had a vital presence at the festival. Gloria Camiruaga, Diamela Eltit (fig. 7), Magali Meneses, Lotty Rosenfeld, and Marcela Serrano, among others, brought proposals that engaged in the alteration of symbols, as a way of condemning the dictatorship. One interesting case is represented by the video artist and documentary maker Camiruaga. After obtaining a degree in philosophy from the Universidad de Chile, advised by Juan Downey, Camiruaga moved to the United States in 1980 to study video performance at the San Francisco Art Institute. She returned to Chile in 1982, a year after the festival began, and soon was participating through her video and documentary work. In the fifth edition, Camiruaga presented a video called *Popsicles* (1982–84), in which she captures her daughters licking popsicles as they loudly recite the Ave Maria in a chorus. As the popsicles melt, small plastic toy soldiers begin to appear; the soldiers are later placed on top of a Chilean flag. Having her daughters be part of the act of thawing the soldiers can be read as a mechanism for expunging sins through prayer. By not using a public space or her body as a prop and instead offering up her own daughters (another religious nod, as in Dittborn's *Pieta II;* or a reiteration of a mantra, as in

Altamirano's *Panorama de Santiago*)—Camiruaga subverts her intimate (family) space in order to condemn the crimes committed during the dictatorship.

The subjects addressed by these women artists are also considered in Richard's theoretical discussions in "Contra el pensamiento-teorema" (Against the thought-theorem):

> The fact that video art is produced in scenes that are completely alternative to both commercial distribution networks and institutional commissions also has an influence, in the sense that it offers women a freer space for proposals and deconstructions: a more autonomous space, from which it is possible to invert the signs of aptitude, which portray technology as a domain of masculine superiority.[21]

As the years passed, new names such as Victor Hugo Codocedo and Juan Forch began to appear at the festival. For those earliest editions, the organization produced a simple catalog/program typed on office paper and bound using brackets, containing the descriptions and technical data of the pieces shown. In November 1984, when the fourth edition of the event was already underway, Michele Goldstein arrived in Chile. She served as the French cultural attaché from 1984 to 1988 and continued to provide strong support and fresh momentum for the event. That same year, there was a new element: the presence of the

Chilean artist Juan Downey, an international figure in the field of video art, who presented two emblematic works: *Shifters* (1984) and *Satelitenis* (1982–84). The latter, a collaborative work, can be considered unique both within the festival's program and within the origins of video art in Chile. *Satelitenis* combined video art and mail art to create a video postcard between Santiago and New York (fig. 8). It included the work of Downey, who was based in New York; and Dittborn and Flores, who lived and worked in Chile. The artists sent one another videos as an exercise in audiovisual provocation and response.[22]

At the fifth edition of the festival (1985), there was another milestone: the Diario de Viaje (Travelogue).[23] With the goal of broadening the horizons of knowledge about video, the award offered a residency in France to a Chilean video artist and a residency in Chile to a French video artist. The artists were asked to create a video piece as a portrait of that experience, which was intended to expand the debate between those presenting work at the festival and their audience. Some of the French artists who participated in this initiative were Robert Cahen, Jean-Paul Fargier, Michel Jaffrennou, Jean-Louis Le Tacon, and Hervé Nisic. On the Chilean side, the winner of the first edition was the video artist Magali Meneses (*Diario de viaje* [1985; Travelogue]), who was followed by Juan Forch (*Torre Eiffel* [1985; Eiffel Tower]), Francisco Arévalo (*Muerte al rey*

Fig. 8. Juan Downey (Chilean, 1940–93), Eugenio Dittborn (Chilean, b. 1943), and Carlos Flores (Chilean, b. 1944). Video still from *Satelitenis,* 1982–84.

[1989; Death to the king]), and Francisco Fabrega (*La memoria del cielo* [1990; The memory of heaven]), among others.[24] Beginning in 1986, the Encuentro was renamed the Festival Franco-Chileno, the title by which it is known today. This edition also had a better catalog than the previous ones—a color hardcover, bound at the spine—which was maintained until the final edition.

Beginning with the fifth edition, the festival's catalogs had a greater number of theoretical texts, both French and Chilean. There was a strong presence by the French video artist and video art theoretician Jean-Paul Fargier, who played an important role: in addition to being one of the most prominent names in international video art, he wrote about video in specialized publications including *Art Press* and *Les Cahiers du Cinéma*. This broad experience and knowledge not only encouraged important discussions in Chile but also served to bring the latest developments in international video art to the country. The Chilean theorists in those years were also crucial, as they cultivated and facilitated an in-depth analysis of the conditions of video, the media, and institutionality under dictatorship, as well as participating as members of the organizing committee in different years.[25] In subsequent editions, the festival's proposal became increasingly established and, in 1998, a new initiative called Bolsa de Productores (producer grant) appeared, which was a system of financial support for Chilean audiovisual projects in the form of a competition.[26]

As the transition to democracy began to take shape, the festival entered a phase of appraisal. The arrival of democracy in 1990 also led to new institutional spaces such as the Museo Nacional de Bellas Artes, where many of the French video artists from the first phase gathered together for a video project conceived by Pascal-Emmanuel Gallet called Guirnalda (Garland), which included the creation of short videos to celebrate a decade of the festival and the country's new democratic era. Although the festival had initially been established as part of the policy of cultural support for Chile, it now began to expand its horizons. In 1992, the organizers of the Festival Franco-Chileno launched the Festival Franco-Latinoamericano de Video Arte, based primarily in Colombia, Argentina, and Uruguay. That was, strictly speaking, the final edition of the Franco-Chileno, as it would also become the Festival Franco-Latinoamericano. This series of changes revealed that a significant part of the festival's mission was defined by political and cultural support for artists during the Chilean dictatorship. With the transition to democracy underway, video artists and local actors decided to continue the legacy of the Franco-Chileno through the Bienal de Video y Artes Electrónicas, which began in 1993 and endures today as the Bienal de Artes Mediales.

The Festival Franco-Latinoamericano continued until 1996, ultimately inviting Brazilian artists to participate, reflecting the work that was being created during those years by local video scenes in their

respective countries.[27] This included the visual and theoretical work of key figures in the development of Latin American video art, such as Claudio Caldini, Sara Fried, Jorge La Ferla, and Graciela Taquini in Argentina; Gilles Charalambos, Santiago Echeverry, José Alejandro Restrepo, and Ricardo Restrepo in Colombia; and Fernando Álvarez Cozzi, Eduardo Casanova, and Guillermo Casanova in Uruguay. The festival was held at different venues, including the Biblioteca Luis Ángel Arango in Bogotá, the Centro Cultural Ricardo Rojas in Buenos Aires, the Museo de Artes Visuales in Montevideo, and the Museo Nacional de Bellas Artes in Santiago,[28] with the enthusiastic participation of renowned artists from each country and the most recent generations of video artists. As expected, a significant part of the festival's objective was to promote encounters between Latin American artists. These encounters were centered on audiovisual artists exchanging ideas about sociopolitical and technological changes and, in particular, discussing the new languages of video and its relationship to television. The Argentine artist, curator, and scholar Jorge La Ferla argues that

> the flow of television is increasingly constant, uniform, and continuous in our countries, almost entirely absorbing the capacity for consuming the electronic image. Video has not yet found its own place, and we repeat that this Festival is one of the few opportunities to see retrospective screenings from each of our countries alongside one another.[29]

Gilles Charalambos, a French-Colombian video artist and scholar who was on the festival's selection committee for the Colombian works, mentions in his *Aproximación a una historia del videoarte en Colombia* (Approaches to a history of video art in Colombia) that, as the years passed, the festival attracted increasing attention and enthusiasm from the art scene and the media.[30] Technological advances also led discussions toward the audiovisual potential of computers and art in the digital era. The Festival Franco-Latinoamericano, much like its predecessor, was funded by French state cultural foreign policy and the diplomatic impulse of Gallet with support from the institutions where it was held. In the case of Colombia, according to Charalambos, the festival became the most important event of its kind, attending to the legacy of the leading pioneers of Colombian video art as well as the younger generations, both dialoguing with key French and Latin American artists. As Charalambos explains:

> The IV Festival Franco-Latinoamericano de Video Arte had continuity, and thus took on an increasingly significant importance in the Latin American landscape. This edition also included a substantial number of Brazilian artists. That year, it showed more than fifty works, and it was the comparative showcase for the exchange of perspectives that Colombian video art needed. For the audience

and the artists, the festival's continued presence demonstrated the existence of Latin American works, which received recognition and appreciation in shared contexts. With newly acquired analytical insights, many of those who were part of this educated audience were able to identify the recurrent themes and styles of their creators.[31]

There was a high degree of receptivity in the video art scenes in different parts of the continent. In the early 1990s, the festival had a certain openness to the Colombian public and the media, which could, incidentally, be contrasted with what took place in Chile: the gradual dismantling of the festival and the adoption of a new model, with the launch of the Bienal de Video y Artes Electrónicas in 1993 (continuing today as the Bienal de Artes Mediales, as noted above). As in the Festival Franco-Chileno, the Festival Franco-Latinoamericano invited a European artist or theorist every year as a member of the international jury, offering conversation and debate. The guests included Florent Aziosmanoff (an artist and theorist), Jean-Paul Fargier (a video artist and theorist), Michaël Gaumnitz (a filmmaker and multimedia artist), and Jean-François Guiton (a video artist). The Latin American editions also published an annual catalog that was used for all the festival venues (Bogotá, Buenos Aires, and Santiago). For five years (1992–96), the festival presented the Latin American video art landscape, facilitating encounters and proposing a collective video art scene. Although the festival had developed with independent effort and determination in most of the countries, it was now seen from the perspective of international cooperation.

Studying the sixteen years of the festival has granted a view into the audiovisual memory of Chile and Latin America in a context of trauma and democratic expansion. Its programming offers a clear panorama of the paths and explorations in video art. As mentioned above, a significant portion—perhaps almost the entirety—of the Chilean video art scene during the period was part of the Festival Franco-Chileno. That festival's success as a model for exhibition, encounters, and discussion in the region allowed its borders to be opened up to artists from other countries, exporting the Festival Franco-Latinoamericano.

With the end of Pinochet's dictatorship in 1990, the Festival Franco-Chileno had fulfilled its objective and its role as a space of resistance—and it changed its perspective toward a global circulation and technology expansion mode, which symbolically ended with a satellite transmission to the entire continent in 1996. In addition, despite the quality of the works shown, the festival began to lose momentum following the changes that occurred in video art in the mid-1990s, due in part to the emergence of other technologies and modes of circulation in the Internet era. But the rich and compelling history of the festivals has played a huge part in video art in Latin America, and there is more to study in more depth.

Notes

This essay was translated from the Spanish by Audrey Young.

1 See also Sebastián Vidal Valenzuela, "Festival Franco-Chileno de Video Arte," http://centronacionaldearte.cl/glosario/festival-franco-chileno-de-video-arte.

2 Rodrigo Alonso, "Zona de turbulencia: Video arte de Latinoamérica," http://www.roalonso.net/es/videoarte/turbulencia.php#.

3 See Andrea Giunta, ¿Cuándo empieza el arte contemporáneo? (Buenos Aires: arteBA, 2014).

4 The Brigada Ramona Parra is a group of mural artists that was politically linked to the Partido Comunista de Chile. Founded in 1968, the Brigada was named after the militant Communist Ramona Parra, who was killed by the police during a protest march in 1946. Members played an active role in Salvador Allende's presidential campaign and later in the resistance to Pinochet's dictatorship.

5 Under the supervision of DINACOS, television channels—primarily university and government stations—were encouraged to focus on comedies, comedy shows, contests, and variety shows, which were used as a smokescreen to conceal human rights abuses, misinform the community, and prevent any kind of social engagement. This approach also proved to be a method for steering public opinion, which in this case reinforced the idea of order and economic progress. The Consejo de Calificación Cinematográfica censored 556 films during the dictatorship. See Gonzalo Leiva and Luis Hernán Errázuriz, El golpe estético: Dictadura militar en Chile, 1973–1989 (Santiago: Ocho Libros, 2012), 130.

6 Juan Forch, panelist on "Archivo Abierto: Videoarte, vacíos y documentos" (Coloquio Video Arte, Centro de documentación de las artes, Santiago, November 2006), https://www.youtube.com/watch?v=X-T870_Pb_c (1:01:12).

7 Some examples of these types of pieces are represented by the audiovisual works of CADA and their interventions in public spaces, such as Para no morir de hambre en el arte (1979; So as not to die of hunger in art) and Estudios para la felicidad (1979–81; Studies on happiness) by Alfredo Jaar; and Popsicles (1982–84) by Gloria Camiruaga.

8 Nelly Richard, "Contra el pensamiento-teorema: Una defensa del video-arte en Chile," in Catálogo Sexto Festival Franco-Chileno de Video Arte, exh. cat. (Santiago: Servicio Cultural de la Embajada de Francia/Instituto Chileno Francés de Cultura, 1986).

9 Germán Liñero, Apuntes para una historia del video en Chile (Santiago: Ocho Libros, 2010), 136.

10 Justo Pastor Mellado, "Espacios en disputa: Conversación con Justo Pastor Mellado," in Visiones laterales: Cine y video experimental en Chile (1957–2017) (Santiago: Ediciones Metales Pesados, 2018), 154–55.

11 CADA was an interdisciplinary group formed by the artists Lotty Rosenfeld and Juan Castillo, the poet Raúl Zurita, the writer Diamela Eltit, and the sociologist Fernando Balcells. This artistic collective created works and actions from 1979 to 1985.

12 In 1978, the Compañía de Teatro ICTUS (founded in 1955) developed its independent television project ICTUS TV, in which it recorded cultural programs with counterinformation on the dictatorship, to be shown at schools, neighborhood councils, unions, and independent art spaces. See Antonio Traverso and Germán Liñero, "Chilean Political Documentary Video of the 1980s," in New Documentaries in Latin America, ed. Vinicius Navarro and Juan Carlos Rodríguez (New York: Palgrave Macmillan, 2014), 167–84.

13 For more information on this performance, visit Leppe, "1981 / Cuerpo Correccional (acción corporal)," http://carlosleppe.cl/1981-cuerpo-correccional.

14 *Las cantatrices* (1980) had been previously shown as part of the exhibition *Sala de espera* (Waiting room) a year prior to the festival, at Galería Sur.

15 Obstetric forceps were medical instruments used to aid women in giving birth and were commonly used until several decades ago.

16 A final version of *Pieta*, the no. IV, was made in 1986. During 2008 and 2009, these videos, as well as *Cinco bocetos preliminares para la historia de la música* (1986; Five preparatory sketches for the history of music) and *El Crusoe* (1990; The Crusoe), were reedited by Dittborn and the documentary filmmaker Guillermo González. They were exhibited at the Museo de Artes Visuales in Santiago in September 2010.

17 The book *Chile, arte actual* provides a detailed description of this video; Milan Ivelic and Gaspar Galaz, *Chile, arte actual* (Valparaíso: Ediciones Universitarias de Valparaíso, 1988), 226–28.

18 Richard, "Contra el pensamiento-teorema," 20.

19 CADA participated frequently in the festival in the early years. Its members also participated individually.

20 Rosalind Krauss, "Video: The Aesthetics of Narcissism," *October* 1 (1976): 52. Translated into Spanish as Rosalind Krauss, "Videoarte: La estética del narcisismo," trans. Antonio García Álvarez, in *Primera generación: Arte e imagen en movimiento, 1963–1986*, ed. Berta Sichel, exh. cat. (Madrid: Museo Nacional Centro de Arte Reina Sofía, 2006), 45.

21 Richard, "Contra el pensamiento-teorema," 20.

22 Further analysis of *Satelitenis* can be found in Sebastián Vidal, *En el principio: Arte, archivos y tecnologías durante la dictadura en Chile* (Santiago: Ediciones Metales Pesados, 2012), 109–36.

23 The Diario de Viaje was conceived by the founder of the Festival Pascal-Emmanuel Gallet as Jorneaux du Voyage, a poetic way to portrait the other country (France or Chile, respectively) on video.

24 Initially, some of the artists who won the Diario de Viaje also received a residency at the CICV, such as Juan Forch, who won at the second edition and made a video called *Un (se) jour a Montbeliard*. The final Diario de Viaje, *El puente* (The bridge), was created in 2015 by Sophie-Catherine Gallet.

25 These theorists include Justo Pastor Mellado, Néstor Olhagaray, and Nelly Richard.

26 Another significant event from that edition was the creation of the Sociedad Chilena del Video, which was established by a group of Chilean creators and theorists who worked closely with the festival. It was a way to support the development of video in the country.

27 In 1996, the Festival Franco Latinoamericano was transmitted to the entire continent by satellite.

28 In the case of Chile, it was simultaneously the first Festival Franco Latinoamericano and the twelfth edition of the Festival Franco-Chileno.

29 Jorge La Ferla, "Aproximaciones a una selección de la producción videográfica argentina," *I Festival Franco Latinoamericano de Video Arte, XII Festival Franco Chileno de Video Arte*, exh. cat. (Santiago: Museo Nacional de Bellas Artes, 1992), 51.

30 Gilles Charalambos, *Aproximaciones a una historia del videoarte en Colombia 1976–2000* (Bogotá: Instituto Distrital de las Artes-Idartes, 2019).

31 Charalambos, *Aproximaciones a una historia del videoarte*, 75.

Oscar Muñoz

A Threshold of Suspension

Editors' note: The following brief interview was part of a conversation with Oscar Muñoz about the early context of his work. We have included it here to provide some background for the essay that follows.

ELENA SHTROMBERG Before your work in video, you were involved with the Experimental Cinema Group in the 1970s. Could you tell us a little about this time? What is the relationship between this group and your early work?

OSCAR MUÑOZ I think that during those years in the small artistic scene of Cali, there was an interdisciplinary connection that revolved, above all, around a few institutions such as La Tertulia, the Teatro Experimental de Cali, Bellas Artes, Ciudad Solar, etc. Pedro Alcantara formed a group dedicated to graphic art, which I was a part of and which was important for my proximity to this practice when I began. I had some work relationship with all these institutions.

I was also friends with the experimental filmmakers in Cali at a time during which the connection between visual artists and filmmakers was especially prosperous and rich.

There were some instances in which I collaborated with them; I remember I made the poster for Carlos Mayolo's film *Carne de tu carne* [1983; Flesh of your flesh]. I'm also in some of Oscar Campo's documentaries, and in some of [Luis] Ospina's documentaries as well. However, I distinguish my experimentation in video from that of my friends in the film group in some specific points. Even though cinema is a big influence for me, my work comes from

my practice with graphics, with drawing and photography—from the static image rather than cinematic image. While both moving images tell stories, I consider video to be very different from film, and unlike screening a movie in a theater, a video is exhibited so that you can pass by, stop to look at it for a bit, then continue on.

ES How do you see your work in relation to other art from Latin America, particularly with respect to systemic violence?

OM With regard to the extended and rich production of video in Colombia and even more so in Latin America, I find it difficult to have one defined and clear idea. In Colombia and Latin America as a whole, one commonality is that there is a broad spectrum of approaches to the implications of systemic violence, a problem that has affected all of us. In both film and video, there are artists who have widely used material produced by mass media; José Alejandro Restrepo often works in this way. Gilles Charalambos's work was one of the first examples of video art that I remember seeing. Additionally, I see new artists who work with video from an intimate and often autobiographical perspective, for example Laura Huertas. For my part, I believe that my work can be characterized as perhaps paradoxical: it seeks an approach but from a certain distance of reflection with poetic or philosophical intentions.

ES Do you remember what camera you used to make your first video, and where you first exhibited it?

OM I haven't considered myself an active operator of photographic or video cameras (instead I have attempted to take them apart so as to understand them better) and because of this I have asked for help with my photographs and videos from people who understand them better. Maybe this has been the reason that my work is done in my studio, with the camera fixed, registering an action and simply attempting to occupy my place, that of my point of view.

For the first two videos that I remember making, *Narciso* and *La mirada del cíclope* [2000/2001; The Cyclops's gaze], I used a Hi8 camera that belonged to my friend Eduardo Carvajal, and he acted as cameraman for the piece and then Ernesto Salmerón taped my work *Re/trato* [2004]. Later, I had a MiniDV that I used to make other videos, always with the help of my assistant.

The first time I exhibited my video work was during my first solo exhibition at the Sicardi Gallery in Houston, and simultaneously in 2002 at the LA Freewaves, a festival of films made in several Latin American countries held in Los Angeles. This edition of Freewaves was the inaugural exhibition we had at Lugar a Dudas

(our independent space and artistic laboratory in Cali), with four simultaneous monitors and a projection. Video exhibitions were not very common in Cali at that time, and Lugar a Dudas was just starting to evolve, so not many people attended. As a result of this exhibition, we began to discuss new ways of having the works interact with the public at Lugar a Dudas. These reflections resulted in having the vitrine, a space that is open to the street, which since then has exhibited video works and projections to pedestrians and passersby.

ES How do you determine which medium is most suitable for a piece? Do you pick a theme and then develop it through a specific medium?

OM Each of my works starts with an idea that I try to explore and understand, and each medium gives me a means to empower them, charge them with intensity, and at the same time simplify them. I have always thought that, in the process of understanding the work, the materials and the process of materialization intervene a lot. The manipulation and mode of a work allows one to approach it more closely from different angles; if you don't get there, at least you get closer to what you are attempting. For example, since more than a year ago, I have been working with dust as a leading material in two parallel works: a video and an installation. Even though I have been working with carbon dust for a while now, in this case it is linked to the movement of the image and to time as layers of dust physically accumulated on surfaces and in a video made frame by frame. I address this in my text for this book; I take my fascination with what I call the "threshold of suspension" and examine how it emerges throughout various works. While they are not all video pieces, you can understand more clearly if you see how this idea resonates across media, how it is shaped and formed in different ways.

ES Thank you, Oscar!

––––––––

I look at this scale not to see whether the pointer will presently dip down again, or even come to a moment of absolute rest. I look at it instead to see, within the miracle of that hesitant immobility, the slight, inappreciable tremor that indicates life.[1]

It has always been difficult for me to discuss my own work. However, today I will try to, so that the reader can accompany me on a brief tour of some of my works, keeping in mind that this perspective doesn't exhaust—or at least I hope it doesn't—other possible angles of approach.

This journey has an order, which I propose is motivated more by the connections that I find between the works than chronology; I will refer to works from different periods and different mediums, including pieces in process, prints, photographs, and videos. The connection I'd like to concentrate on, which subtly ties them together like a thread, frayed at times, aims to give a better idea of the image in time: of the strangeness of perceiving "inappreciable tremors" and of the transformations suffered by an image that has been designed to remain, fixed or printed, over time. This connection is about the different tensions that result from these images' instability; when their permanence is put in crisis, they are put into what I call *a threshold of suspension:* they are neither in full motion nor completely fixed. It recalls the suspense of an interrupted film, flickering before the imminent danger of being burned, which I remember happening many times back when the film would accidentally freeze during projection. In other words, I've always wanted to focus my attention toward the critical moment of the fixation of the image—be it chemical, physical, or metaphorical—in which it faces the dilemma of being consolidated and of creating a memory, or of dissolving and being buried by forgetfulness.

Therefore I have decided to group the discussed works in two sets. The first is composed of pieces/objects that, although "fixed" (note the inadequacy of this adjective), have a materiality that makes them react in a procedural manner to the flow of time. For this reason, they enclose within them the possibility of oscillating, transforming, and changing, but also the possibility of being lost, of no longer being an image: *Ante la imagen* (2009; Before the image), *Narcisos en proceso* (1995–2011; Narcissi in progress), and *Aliento* (1995; Breath). The second group includes works that I have recorded on video; in these, the moving images confront the tension of a latent detainment, suffering from the danger of being fixed, or, as mentioned with the previous works, of also disappearing as an image: *Narciso* (2001; Narcissus), *Línea del destino* (2006; Line of destiny), *Re/trato* (2004), and *Fundido a blanco* (2009; Fading to white).

THE OBJECT BECOMING THE SUBJECT

> The images that constitute our memory tend incessantly to rigidify
> into specters over the course of their (collective and individual)
> historical transmission: the task is hence to bring them back
> to life.[2]

Both material and chemical properties determine the sensitivity of the
photographic image. Without both, its development, its fixation and
permanence, its way of capturing the moment, would be impossible. The
photographic image has been celebrated for its ability to be the perma-
nent imprint of that which for an instant was, but will never be again.

In 2010, I came across the story of Robert Cornelius (1809–93), a
chemistry enthusiast with knowledge of metallurgy who worked in a lamp
factory that belonged to his family in Philadelphia. In 1839, just a few
months after the invention of the daguerreotype and Louis Daguerre's
famous shot of the Boulevard du Temple, Cornelius had made a real
breakthrough in his quest for a photographic image: after testing various
compounds, he found a way to create a faster reaction with an emulsion
of bromine salts on a copper plate with silver halides. Using this process,
he captured what could be considered the first self-portrait in the history
of photography. According to most accounts of this event, Cornelius
was immobile for between five and fifteen minutes in order to record his
image on the plate. This would be the unprecedented record of the efforts
of a subject to become a photographic object, to be embalmed forever on
a daguerreotype plate.

My own work *Ante la imagen*, which was commissioned by José
Roca for Philagrafika 2010, returns to Cornelius's self-portrait, but in
etching the image on the back of a mirror, the emulsion acts simulta-
neously on the layer that protects against corrosion as well as on the
reflective side of the mirror, leaving the engraved image at the mercy of
contact with the air. Thus it creates, also chemically, a reversal of the
achievement of Cornelius by unfixing the image, which clings to this
supposed immobility, as it is left exposed to the air and the corrosion of
time. Due to the physical and chemical reactions that occur on the mirror
when it comes into contact with the humidity of the environment, there
is a kind of disturbing mobility that, although imperceptible, is constant.
In Roca's words, the image "frees it and returns it to time, gives it an
existential condition and returns it to the state of flux, vulnerable to
deterioration, like life itself."[3]

THE LATENT IMAGE

> Finally, the image burns for memory, that is to say, it still burns, even when it is more than ash, a way of claiming its essential vocation for survival, in spite of it all. But, to know, to feel it, you have to dare, you have to put your face to the ash. And blow gently so that the embers underneath re-emit their heat, their radiance, their danger.[4]

In the mirrors of the *Aliento* series, the impression of the silicone screen print on the stainless-steel mirror only becomes visible when it is dampened: when you humidify it with your breath, you can see what is printed (fig. 1). These fleeting instances, when the mirror is cloudy and then cleared, also permit one to see the flash of the image, simultaneously allowing the engraved portrait to return the gaze.

For years, I have been selecting and cutting out piles of small portraits that families publish, usually for only one day, in the obituary section of the papers to share the loss of their loved ones. The impressions in *Aliento*—impressions that may or may not be visible, depending on the action of the observer—come from this collection. We are all relentless collectors of images that our memories keep in a certain state of latency, and therefore are accessible for their resurgence when a breath or an instant revives them. The moment my image in the mirror disappears, due to the fogging, is the same moment in which another is made visible.

A MEDIUM FOR THE FLEETING

In the series *Narcisos en proceso*, I lined up a group of acrylic trays full of water, and in each I "printed" a self-portrait that floats on the surface. (*Print* is another difficult word, since in this series the printing is also a problematic action: it is an application, not by contact as in screen printing but by depositing carbon dust on the surface of the water.) Over time, as the water in the container evaporates, the image sinks until it rests at the bottom of the tray.

The fragile image is softened and shaped by time. Time governs its lengthy journey from the initial event that deposits it on the surface of the water until, through eventual transformations, it lays fixed at the bottom, dry and motionless. There is imperceptible movement in this process, similar to that of the continents; the image is at the mercy of the process and the rhythm of the water's evaporation.

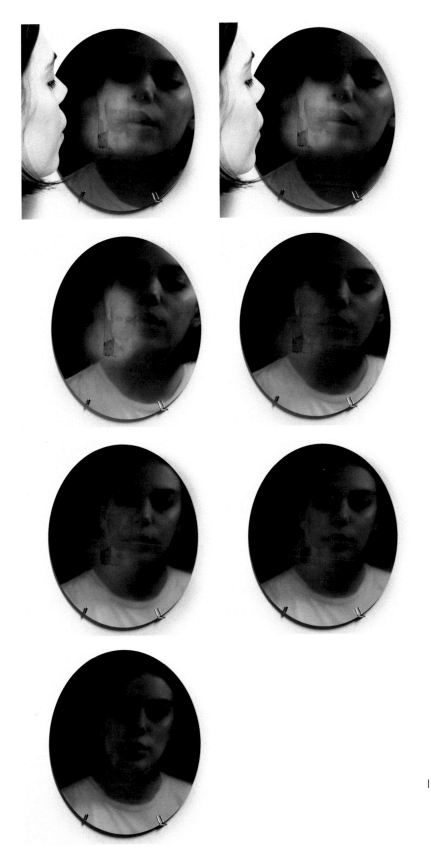

| Fig. 1. Oscar Muñoz
(Colombian, b. 1951).
Video stills from *Aliento*
(Breath) series, 1995.

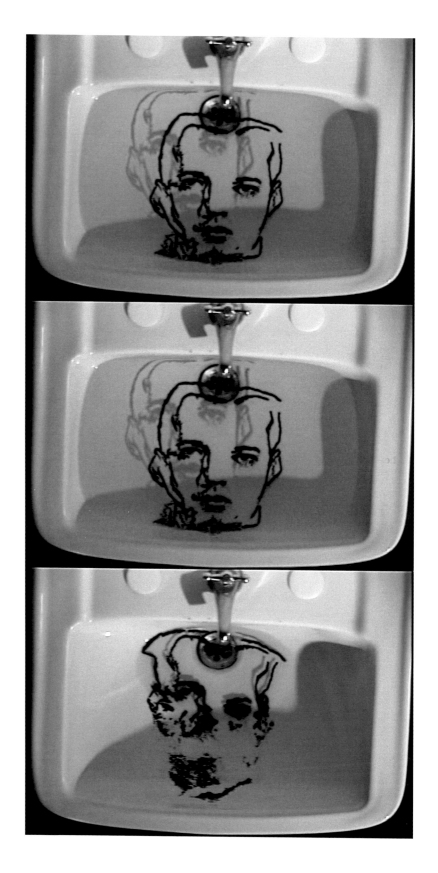

| Fig. 2. Oscar
Muñoz (Colombian,
b. 1951). Video
stills from *Narciso*
(Narcissus), 2001.

THE LINE AND ITS SHADOW

I have observed that all of my video work involves an attempt to make a portrait that almost always remains in a state of suspension. With a static camera I try to record simple actions that tend to explore critical moments of unrest, of impermanence, or of eventual disappearance. In 2001, I made a video of the same self-portrait from *Narcisos en proceso*, but this time in a sink, which reminds me of a TV screen, filled with water that the image rests on (fig. 2). The video shows how the carbon-dust image, once deposited on the water, slowly drains and is lost through the pipe.

This precarious image is like a line drawing that unravels as the water drains. The shadow of the dust pattern that floats on the surface also produces another portrait on the porcelain background. The image and its shadow, separated at the beginning, come closer and are dissolved once the water that distanced it diminishes.

FLICKERING MOVEMENTS

Línea del destino documents the action of cupping a little bit of water in my hand while simultaneously trying to steady the trembling of that hand in order to figure out what the water's reflection creates (fig. 3). But the shaking doesn't stop. The video ends up being a frustrated attempt to capture a reflection that is just that: a light reflected in a mirror of water that can't be contained.

This illusion of the immateriality of the image as pure reflected light is also present in other, recent video installations such as *Editor solitario* (2011; Solitary editor) and *El coleccionista* (2014–16; The collector). In *Editor solitario*, the projection shows a man's hands continuously arranging, regrouping, and reorganizing a series of portraits on a table. In *El coleccionista*, an almost transparent character, with his back to the observer and facing a wall, arranges a horizontal line of portraits. In each work, a person engrossed in their activity as editor, organizer, and exhibitor selects, groups, and shows an endless archive of portraits of people of different origins—from those who are part of their family, their personal circle, or national life, to characters from mythology and the world of art.

| Fig. 3. Oscar Muñoz (Colombian, b. 1951). Video stills from *Línea del destino* (Line of destiny), 2006.

These portraits are projected onto piles of white paper that act like screens. The images pass fleetingly over the paper, which accommodates them for a moment without allowing them to adhere or cement.

MAKING FOR UNMAKING

> From the tapestry of Penelope, what you see (during the day) is because it has been undone (during the night), and what can be undone (during the night), is only what was woven during the day.[5]

Re/trato is the video documentation of a repeating action—of the drive to record and preserve in the face of imminent fading—in which a hand with a brush struggles to finish a self-portrait. Here water acts as an ink that evaporates on a cement slab (the base for the drawing), which is warmed by the sun. This action is as insistent as it is unfruitful: while the hand is finishing the line on one end of the drawing, the other end is already disappearing, not allowing a permanent and static image to be fixed. The ink doesn't permeate—the foundation rejects it.

This is how the image is made and unmade like Penelope's tapestry: I draw new lines over those that were recently erased, trying to repeat the movements but never achieving them in the same way. In this incessant exercise of construction, in which the drawn line disappears without leaving marks or traces, the image is constantly in movement, perhaps making it difficult to perceive. But—more than the evaporation or the inadvertent fading of the line—isn't the important thing the fleeting gaze that follows the movement of the brush on the slab? The gaze follows the point of the line, which would be equivalent to the ephemeral *Now* of the moving image—where that image attempts to signal the place dividing the past that has vanished from the future that has not yet arrived. It is the continual creation of an image, interlaced with its disappearance,[6] that evokes the perception of movement on our retina. Would this not give us a good reason to be suspicious of the materiality of the moving image, or, better put, of its phantasmagoric immateriality?

THE SUBJECT BECOMING AN OBJECT

> The Photograph (the one I *intend*) represents that very subtle moment when, to tell the truth, I am neither subject nor object but a subject who feels he is becoming an object: I then experience a micro-version of death (of parenthesis): I am truly becoming a specter.[7]

In 2009, I started to record the video *Fundido a blanco*, an intimate portrait of my father, Gerardo, who was then ninety-six years old (fig. 4). He passed away one year later.

I remember that back then I was using a Canon camera that had the ability to make videos—that is, a device that appeared to be a photographic camera, not a video camera. I wanted the camera on the windowsill so that the source of light came from outside and would be reflected in my subject's pupils. After doing several takes of my dad sitting with his gaze fixed on the camera, trying futilely to stay upright and awake, I realized that he was posing, as still as possible, as if posing for a photo. It was likely that he was also waiting for the clicking sound of the camera, but it never arrived. We repeated this action a few times, which, in retrospect, was a mission that was perhaps unclear to him: Was this destined to be a short "take" on video or a photographic capture?

With this action I was trying above all to understand the process of prolonging the experience of those instants before a photograph is taken, which calls to mind two passages I read in this regard—one by Benjamin

| Fig. 4. Oscar Muñoz (Colombian, b. 1951). Video stills from *Fundido a blanco* (Fading to white), 2009.

and one by Barthes—that complement (or oppose?) each other. I'll start with the quote from "A Short History of Photography":

> "The synthesis of expression brought about by the length of time that a model has to stand still," says Orlik of early photography, "is the main reason why these pictures, apart from their simplicity, resemble well-drawn or painted portraits and have a more penetrating and lasting effect on the spectator than more recent photography." The procedure itself taught the models to live inside rather than outside the moment. During the long duration of these shots they grew as it were into the picture and in this way presented an extreme opposite to the figures on a snapshot.[8]

And here follows the description Barthes gives for the "micro-version of death":

> In order to take the first portraits (around 1840) the subject had to assume long poses under a glass roof in bright sunlight; to become an object made one suffer as much as surgical operation; then a device was invented, a kind of prosthesis invisible to the lens, which supported and maintained the body in its passage to immobility: this headrest was the pedestal of the statue I would become, the corset of my imaginary essence.[9]

In *Fundido a blanco*, the camera rests on the sill, positioned so that the window curtain can sway into the field of view—a signifier of inside or outside, an unstable, interposed layer that threatens the disappearing or appearing of what is being photographed. This interferes as well with the waking and sleeping of Gerardo as he continuously nods off; the instant wavers and is prolonged between his fixed gaze and the flickering; it wavers and lingers on the threshold of the detained and moving image, on the inhale and exhale of his breath. That tension remains in a loop; there is no end.

Notes

This text was translated from the Spanish by Sophia Serrano.

1 Henri Focillon, *The Life of Forms in Art*, trans. George Kubler (New York: Zone, 1989), 55.

2 Giorgio Agamben, "Nymphs," in *Releasing the Image: From Literature to New Media*, ed. Jacques Khalip and Robert Mitchell (Stanford: Stanford University Press, 2011), 66.

3 José Roca, *Oscar Muñoz: Protografías*, exh. cat. (Bogotá: Museo de Arte del Banco de la República, 2011), 30.

4 Georges Didi-Huberman, "Cuando las imágenes tocan lo real," in *Cuando las imágenes tocan lo real* (Madrid: Círculo de Bellas Artes, 2018), 52.

5 Jorge Santos Hernández, "El artear del arte; entre lo real, el acontecimiento, la resistencia y lo erótico (y en citando, en más de una, a Žižek)," in *Žižek Reloaded: Políticas de lo radical*, ed. Ricardo Espinoza Lolas and Óscar Barroso Fernández (Madrid: Ediciones Akal, 2018), 48.

6 This analogous mechanism suggests to me that the system of retransmission of images that replaced the flickering at twenty-four frames per second can be called the *interlaced scanning,* in which the images create the sensation of movement via the flow of the interlaced horizontal lines of a screen; there the odd lines are an image and the even lines are another. With a momentary delay between them, the interlacing divides them into even and odd lines and then updates them at thirty frames per second. The short delay between the updates of an odd and even line creates a distortion. This happens only because half of the lines follow the moving image while the other half wait to be updated.

7 Roland Barthes, *Camera Lucida: Reflections on Photography,* trans. Richard Howard (New York: Hill & Wang, 1981), 14.

8 Walter Benjamin, "A Short History of Photography," trans. Stanley Mitchell, *Screen* 13, no. 1 (1972): 8.

9 Barthes, *Camera Lucida,* 13.

SECTION 4

INDIGENOUS PERSPECTIVES

Francisco Huichaqueo in collaboration with Juan Juenan

The Image before the Image

What the soul is to the body
so is the artist to his people[1]

Much has been said about us—or almost nothing. It may be quite a lot, if
we consider the historiography and stereotypes that have been used to
describe us, to incorporate us into or exclude us from the official narra-
tive, for the sake of great economic, territorial, or government projects.
Perhaps very little, if we consider the scar that they adamantly tug open
time and again in this corner of Latin America known as Chile, where the
promise of modernity always seems to turn its back on any genuine possi-
bility of communication; an impossibility that began at Reinohuelén—the
first battle between the Spanish and the Mapuche—and has continued
to the present day, with the recent assassination of the young Mapuche
Camilo Catrillanca.

In any case, at this point along the journey, it seems as though the
attempts to locate a language that would finally allow us to reflect on
ourselves, understand one another, feel tenderness for the other, have
been insufficient. I believe that the pursuit of these languages, which
are ultimately platforms of convergence, is a political task that must be
undertaken within the different structures that make up society. They
should not solely focus on venerating the past as a static texture but
also help us resolve the questions of our flight into that complex but
no less certain future. In this sense, art as a spirit of our culture is vital
not only to condemning the violent logic that Chile and Argentina have
upheld with the Mapuche world but also to revealing who we were, are,
and will be.

Since an early age, I have moved between two cultural spaces:
that of tradition, spirituality, and territorial demands; and the place of

the other, the *winka*, the Chilean, where I also live, which has shaped me and developed me professionally. Perhaps for that reason, as an artist, I am interested in the construction of symbolic geographies, refuges where Mapuche and Chileans alike are moved by the narrative of their turbulent history; they recognize one another. But can a Mapuche work of art create this space of intimacy and healing? I believe it can, as long as spirituality is its primary source, and the dream or revelation—*pewma*—is the channel through which this wisdom is received. I direct my aesthetic reflections toward the creative possibilities of this knowledge. The works that I examine in this text are the result of this honest search, a mixture of chance, history, conversations, life, territory, humanity, and dreams.

MENCER: ÑI PEWMA

Mencer: Ñi pewma[2] is a film from 2011, which was a complex year for Chilean-Mapuche relations, as there was a significant wave of repression that ended with the imprisonment of many Mapuche people living in communities. While it is true that this persecution had been ongoing, 2011 was the year that the idea of the Mapuche political prisoner was introduced, as many of the most important community leaders were systematically detained. Chilean leaders began to call us terrorists and to develop an ad hoc legal framework that would allow us to be judged based on that presumption. It was a time of confrontations and demonstrations in both the city and the rural areas.

 Mencer attempts to articulate three dimensions that I believe are necessary to mention: the fact that repression is a government policy; the social impulse at that moment, expressed both in support of and against our demands; and my dreams, as a potential subjective method for interpreting this context. What is seemingly so formal takes on a life of its own in the making of the film, but a life that is somewhat saturated, with dense atmospheres, laden with symbolism and aesthetic elements. One example is the fascist woman who appears: with a Nazi aesthetic, a military cap, and a weapon in her hand, moving through different dimly lit areas, insulting the Mapuche along with everything that is "different" from her. This woman, who is young and physically beautiful but also embodies the most violent aspects of society, ends up weeping bitterly in what seems to be her own spiritual, healing pilgrimage. This woman, so powerful in the narrative of the film, appeared in my dream: there she was. I do not ask myself many questions about the "whys" of these visions. Perhaps the visions are not very important, except for the possibility of tying them to this creative experience, which dialogues with other languages and other quotidian experiences.

 The selection of the soundtrack and other technical features supports this oneiric experience and reinforces this sensorial coherence. I would define that experience as a progression, without a setting, that

imbues it with something dirty, coarse. The narrative is harsh, as if you were rubbing sandpaper on your face, or on your soul, and I inhabit that dark atmosphere of police confrontations, that nocturnal image, which is real, documented: a document that becomes nondocumentary. In the background, I use police frequencies, sounds of gunfire, protest marches, crying, and so on as a kind of soundtrack, which also recites the names of political prisoners and Mapuche killed in their communities. Like the audio, the visual elements are rough and harsh—the filters end up being consistent with the sandpaper texture mentioned above and with the social thermometer of our people. There are those textures like that of Super 8 film, which is grainy, like an oil painting on a moving canvas. Pictorially, I projected the film on a painting (hence the high contrasts), a technique that renders it expressionistic, dramatic.

Some have said that my work is documentary, since it documents a time, a contingent reality that exists in our country, an essence. I once asked a filmmaker, my professor, about the audiovisual genre of *Mencer*. He said that it was a film, because it has a narrative, a beginning, an end, a climax, people who suffer and are redeemed, it has a dramatic thrust, aesthetic parameters for the creation of the image. But, of course, the film does not end there: there are expressionist cartoons, images of a *machi* (shaman) looking for herbs, or a bird, for example, on Super 8 film. Despite the mixture, it has an aesthetic sense, a unity, a visual rhythm that results in . . . an expressionist film? Yes, of course, but more importantly, a filmic hybrid (expressionist film, Mapuche film, documentary, poem). This work grapples with desires that are bound up in the social landscape I observe.

I am faithful to my ethics and my aesthetics. I am faithful to the accurate translation of what I perceive as a problem, in which expensive equipment is entirely unnecessary. A cheap camera and a roll of Super 8 color film are enough to create the appropriate atmosphere for this work, which is not precious and is trying to come up somewhere for air. There is an effort to translate the mysterious—moving in another dimension—with the technical tools I possess and my training as an artist, which ranges from drawing to film.

On a conceptual level, the work is also full of things: for example, the names of prisoners and the name of Alex Lemún, who was murdered, are written with eucalyptus leaves floating on the allegory of a river. That same eucalyptus, and its use within the extractive forest industry—so contested by our culture—ultimately provoked repression and murder. Those names are floating in the water, like spirits, suspended, a kind of Ophelia with her symbolic weight, dialoguing in her singing, in her floating; an indeterminacy between life and death, with the performative and its representation. I believe that what is fundamental here is the levity, the suspension between materiality and the different symbolic threads we touch. A kind of slow motion—isn't it?—that floats, that is present. And

the film ends with a man, a simile or a nod, if you will, to Lautaro, the Mapuche warrior leader, albeit closer to someone practicing parkour, as he performs a balancing act. I allow these foreign, contemporary cultural influences to enter and to assume a weight in the narrative of the film.

Mencer begins with a chase of sorts through a forest of eucalyptus and pine trees, with a poem that speaks of those trees, underneath the sound of an engine, old audio files, and voices of grandparents dying alone. I would call it a filmic painting, which means that the film itself says what it needs for its continuity, color, characters, and soundscape—with me, of course, directing it. From a technical standpoint, a professional created the score, but beyond that, I knew the accents it should have, the aging, the silences, the moments when it made me shudder. I would say that I distance myself from a conceptual or intellectual plan. I believe that this approach generates multiple interpretations, which are also produced through the temporality. The film lasts thirty-two minutes, but the time has a different aperture, it connects you with certain fragments and experiences, and brushes up against other realities. The reversed flag waving in front of the Palacio de la Moneda—the Chilean government building—gives the story a strength, a visible depth, a dense, weighted atmosphere.

| Fig. 1. Video still from *Mencer: Ñi pewma,* dir. Francisco Huichaqueo, **2010.** 32 min.

The title of the film is *Mencer,* a neologism I saw written on a wall of my home (fig. 1). This image came to me in a dream, a revelation.

KALÜL TRAWÜN/REUNIÓN DEL CUERPO (REUNION OF THE BODY)

Creating space for Mapuche art within institutions and their infrastructure is a complex topic, one that can be uncomfortable at times, since many of our representations are memory, history—and also chance, which has a real weight within the Chilean social map. There is an undeniable political aspect, and a responsibility, to creating these spaces, insofar as they are opportunities to make our problems visible and to demonstrate that these expressions are dynamic and alive, and that they evade that exotic idea to which we are so often reduced. Within this context, Patricio Muñoz Zárate, a curator at the Museo Nacional de Bellas Artes in Santiago, invited me to organize an exhibition. I accepted but was careful not to reveal all the details I had in mind, foreseeing the suspicion that might be caused by an exhibition with those characteristics.

After making several adjustments to the dates, Muñoz Zárate and I agreed that it would take place between December 2011 and January 2012. Why? The exhibition would be held at a Museo Nacional de Bellas Artes gallery that was located inside a shopping center, and, given the many crowds during these months, it was thus a great opportunity to observe reactions in times and spaces that were symbolic and—at least in appearance—in stark contrast with Mapuche aesthetics. I am referring to

| Fig. 2. Video still from *Kalül Trawün/ Reunión del cuerpo*, dir. Francisco Huichaqueo, **2011.** 28 min.

the names of our political prisoners written with pieces of fabric on the walls, the names of the dead *weichafes* (warriors) written with eucalyptus leaves in trays of red water, a barbed-wire fence where—in a performative act and with help from the family of the poet David Añiñir—we dialogued with the image of the nineteenth-century human zoo (fig. 2). These are

very explicit images of one element of our relationship with Western cultures. Despite this dense and vivid message, the people who passed by in the hustle and bustle of shopping stopped to observe what was taking place as part of this proposal. They entered the space and, once they were inside, would participate with us in the performance. I recorded this interaction. When I watched the footage later, I saw a number of people who came in as visitors and ended up becoming part of the work as circumstantial, improvised actors, deeply moved by what they saw. Shots of them standing next to the replica of a Mapuche home and the barbed-wire fence, for example, are evidence of this rich experience. In addition, Añiñir, the poet, made several references to the creation of an *ülcantún*, a Mapuche song, outside the gallery, to which people reacted with enthusiasm and—not infrequently—by insulting "the shitty Indian" playing the kultrun (a ceremonial drum) and chanting in that space so symbolic of neoliberal culture. Using this performative lure, where most of the audience only belatedly realized that what they were witnessing was an artistic experience under the auspices of the Museo Nacional de Bellas Artes, we were able to access a collective psyche of sorts, in all its complex nuances: violent, indifferent, insulting, fearful, but also emotional, tender, and open to dialogue. There, memory, like an antique piece of jewelry, regained its luster for a moment when older people, many of them Mapuche who had migrated to cities years ago, seeing their dances and listening to their ancestral language, also let their mother tongue pour out amid tears, captured between the bars of a hostile environment. There was something warm, something healing in all of this, and suddenly, the human zoo was outside the glass: it was the people who were passing by indifferently or who looked inside without daring to enter. The zoo was those who did not embrace the challenge of language, communication, and community, which—despite everything—we had re-created in that place. Three thousand and one people visited the exhibition over the course of the month, during which I also conducted interviews, recorded footage, reviewed the press, and researched music as alternatives for the soundtrack, in order to have content for the film. In short, I can say that the script for *Kalül Trawün/Reunión del cuerpo* is the experience, the filmic experience. Both *Mencer* and this work represent a continuity that the public was also able to witness, since *Mencer*, which was an earlier film, was screened as part of the exhibition.

From a formal standpoint, I can say that we created scenarios for the dramatic action and were able to document it, making an experiential and experimental film in which there were no scripts other than headlines and articles in the press, which took the social pulse regarding the repressive situation against our people. The theme: us. Although this creation may seem chaotic due to its different layers, and particularly because I try to be faithful to that spiritual plane—the dream as a germ of the idea—there are thematic connections and dialogues with works

by other artists, such as Jean Rouch and his direct cinema, and the early work of Lars von Trier and his Dogme movement, both of which, through a very simple camera and a microphone, could turn an encounter into a film. In the case of *Mencer*, David Lynch's work was very important for me in terms of—for example—*The Unified Field* (2014–15). In *Mencer*, the unified field descends toward the Minche Mapu, "the underworld," where everything can exist, everything happens. The work thus revolves around those parallel spaces so typical of Mapuche culture, temporalities that intersect and are juxtaposed. The *pewma* (dream or revelation) makes that possible and creates a reality that connects me with the aesthetics I mentioned above. Consequently, in the symbolic, *Mencer* connects the Indigenous with Lynch; there are those deep meditations, cultural immersions, where the oneiric resource is vital, and in the film it finds a space, a language to communicate on this plane. The film is subjective, as I am not interested in seeking definitive answers—rather, I am proposing states of contemplation that produce vivid readings in the viewer. *Kalül Trawün/Reunión del cuerpo* is much more in tune with the aesthetics of Lars von Trier, his direct cinema. The theme is us, the Mapuche world, and the government. The script is provided by everyday issues, Sunday afternoon conversations, the media, and so on; inasmuch as the treatment has little to nothing formal or academic about it, that is my dialogue with von Trier.

From that perspective, some intersections—which are possibilities—can be perceived between avant-garde aesthetics such as surrealism and certain creative aspects of the Mapuche world. In both cases, the oneiric plane is a vital material from which images, fragments, words, and faces freely emerge and are able to be interpreted in this space of reality. Most of the time, however, they are channels that run in parallel, where the intersections result from more spontaneous situations or, in my case, personal pursuits. I would not dare to claim that this dialogue is a characteristic of contemporary Indigenous art—and maybe, now that I think about it, this is one reason I might say my work has no references to international Indigenous cinema. Why? I will dare to offer an answer: perhaps it is because I do not clearly see this aesthetic argument in any space in either Chile or Latin America. Indeed, at least in the Chilean landscape, I believe that there is little awareness of the possibilities of these intersections with other creative experiences and their historical and aesthetic contexts. Whether that is due in part to the local educational institutions not being the most adequate or current in audiovisual matters; to ignorance; or to other reasons is unknown, but whatever the case, that was my situation when I decided to dialogue with an artist. Perhaps it is more evident in the field of theatrical performance, as a more recent phenomenon beginning three or four years ago. In literature, this investigation is more advanced and even precedes some of the more contemporary audiovisual arguments.

But this apparent delay is—of course—not entirely the fault of Indigenous creators. As creators undergo this process of discovery via the possibilities of language (poetry, painting, theater, music, film, etc.), cultural institutions, and the academic world, the industry—in short, power and its neocolonial vision—also constrains intuitions and their potential works by demanding the exotic as a sign of "the Indigenous." I once attended an anthropology conference in southern Chile where someone argued that if the Mapuche used a camera, they were losing their culture; that it was not a cultural gesture that belonged to them, as if that which is Indigenous was irremediably tied to a condition of immobility, to a museum, and to recurrent political themes, uprooting, and pain. But the Indigenous world is more than that atavistic wound, and within my work I try to explore those silences, many of which are also healing and allow our culture to continue traveling along its path.

Spirituality as a communicative bridge between the past and the future is an element still seldom explored in our cinema, and this leads to the reiteration of certain places where creation occurs, such as chance—

Fig. 3. Video still from *Adentu/Retrato,* dir. Francisco Huichaqueo, **2015.** 4 min. Pictured, from left, are Teresa Montoya Levinao, Luis Melinao Melinao, and Huenulef Melinao Montoya.

which is real and important but is not the only raw material. Happiness, flight, love, beauty, and more also belong to our world, and if we want to speak about a living culture, we must observe these elements as singular and undeniable evidence (fig. 3). Eroticism is another aspect that has rarely been explored within the Mapuche visual arts, and I ask myself: Do we have the right to a Mapuche erotic art, or is it a privilege of other societies? I believe we *do* have the right, but not by inventing a reality. The reality of eroticism has always existed in our culture; there are rituals that include it, songs, and so on. I have explored these aspects within my work, and they have caused controversy. I have even been told that what I make is not Mapuche art because it romanticizes ideas and aesthetics without

seeing the dangerous immobility in this. Mobility, new proposals—
I would like to point out—are also political. In the end, I believe that
immobility is due to the lack of observational ability, in its practical and
spiritual aspect. Observation allows us to consider new alternatives,
paths, languages.

Sequence shooting is a method that fascinates me. I admire it and
am interested in it, and during a trip to Brazil, I learned that sequence
shooting done by Indigenous people is different than anything we have
seen before: it is purity, with no techniques, where the film camera
intervenes in a space and captures an unrepeatable moment in life, one
where no one knows when it will end. A shot with a hand-held camera
showing an Indigenous woman giving birth in the jungle can last twenty-
five minutes; the academic world would say that is a very long shot, but
we might ask: What is a long time?

The silences present in my work, they are observation, resistance,
communication. The classical narrative has a beginning, a climax, and
a denouement in the Aristotelian sense, as it were, and although those
elements are present in my work, I also question this formula when I
make films or documentaries. Is it truly necessary to show a conflict? Is
it not possible to show aesthetics and spaces from the world without obvi-
ous reasons? I think it is good to ask ourselves this question and, when

| Fig. 4. Video still from
*Ilwen: La tierra tiene
olor a padre* (The earth
smells like father), dir.
**Francisco Huichaqueo,
2013.** 32 min.

we are rehearsing the answers, to perhaps redirect our gaze. Distancing
ourselves from the academic world can sometimes be positive, as it makes
it possible to invent a poetic system, a pictorial line, a camera shot of our
own (fig. 4). Chilean Indigenous cinema is often criticized for being slow
and boring, but only because it is being compared to Hollywood cinema,
where everything explodes within a single minute. This is the dominant

imaginary in Latin America, in the audience; another form of domination, our mental blemish. It is complex to make changes to Hollywood cinema, a constant battle, but we have something dominant cinema does not, and it is the territory of our spirituality: powerful images, which—when they are handled properly in a film—people settle in and watch anyway. The image of a flag flying in front of the Palacio de la Moneda is something many have seen, but when the image is reversed, the temporal space is given a different density; I do not know why, but it is seared on the retina. It is essential to have instinct, sensitivity, and observation; I believe that this is the origin of a Mapuche cinema as such.

In today's Indigenous cinema, few directors have achieved acclaim. Some examples are Indigenous films from Canada, Brazil, and Mexico and from the Maori in New Zealand. I see that the academic world continues to exert a strong influence on those works, but they endeavor to have a signature and time of their own. I am interested in that territory, in the temporal dislocations and centripetal forces that act on the unconscious, a concept that I take from the Chilean filmmaker Raúl Ruiz. That is where I believe the path of my own creativity as a director leads, as I gather our desires, joys, icons, symbolisms, memories, territories; I transfer those elements to this plane, without manipulation or extortion caused by ideologies, or even the origin of the ancestral family name and bloodline. Creators must believe in what they observe, and there are few things more absurd in art than the pretension of purity.

I believe that both *Mencer* and *Kalül Trawün/Reunión del cuerpo* are moving in that direction and are contributing to constructing a Mapuche cinema, an Indigenous cinema.

WENU PELÓN

I spoke above about the filmic process in my work, looking at two or three films. Now I would like to discuss how the representation of video and film appears in the installation of my work, looking at the permanent exhibition *Wenu Pelón* (fig. 5).[3]

The Museo Arqueológico de Santiago invited me to develop a curatorial project for the renovation of its archaeological gallery, focusing on Mapuche objects in particular (fig. 6). This was a special commission, primarily because it was the first time the museum had invited a Mapuche artist to participate in the curatorial process; that invitation had never been extended before and now it was a possibility. I initially declined, as I had no experience and had not formally been trained for it. Over time, and given the museum's insistence, I said that I would only accept the responsibility if I could seek the support, advice, and counsel of Mapuche who were more knowledgeable about Mapuche archaeological objects than I was, such as Juana Paillalef, the director of the Museo Mapuche in southern Chile. My resulting conversation with Juana was crucial to my

| Fig. 5. Installation view of the *Wenu Pelón* exhibition at the Museo Arqueológico de Santiago, 2015–20.

| Fig. 6. Installation view of the *Wenu Pelón* exhibition at the Museo Arqueológico de Santiago, 2015–20.

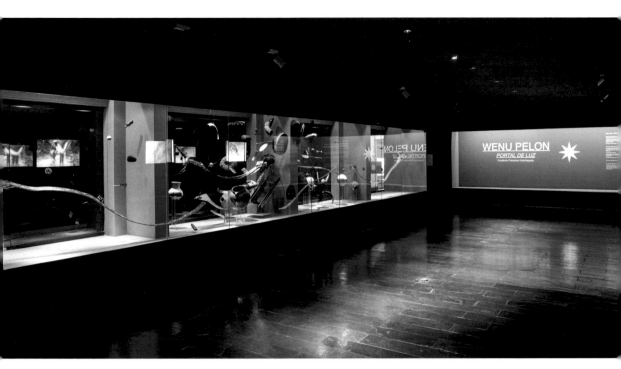

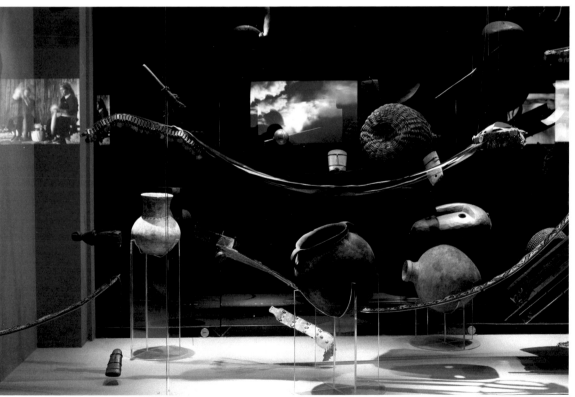

final proposal. Based on her own experience, Juana recommended restructuring the traditional physical space of the museum and its Western logic, which was oriented toward immobility and distance from the observer. Instead, the proposal would preserve the relationship between the community and the pieces on display, all of which have great historical and spiritual value. This shift from Western logic is not accidental, as the museum conserves pieces with enormous spiritual power, such as the ceremonial drum and stones of power like command icons; their arrangement, their "place" within that space also had to be considered through a spiritual guidance that only a *machi* can provide. I then contacted Machi Silvia Calfuman to receive guidance on how to proceed with this spiritual mission, which was no longer an artistic project, as the latter idea is more of a Western category and the connotations are very different. I discussed this experience with the curator and told her that I needed to integrate the *machi* into the team: she would look at the pieces in the museum vaults and would have the final say on whether or not this mission was feasible. Within a short period of time, the *machi* gave her approval, but she requested that a rogation be held for the objects that were going to travel from one museum to another for the installation. Her request created a certain distrust among the experts in charge of conserving the pieces, which is not strange if we consider that a Mapuche had never been part of those teams. The museum people were certainly not prepared. I must admit that there was a culture shock when the *machi* questioned why the pieces were there and not in the rural areas, and when she stated that the underlying reasons making this possible were the war itself, the selling of pieces to collectors, the theft of many other pieces, poverty, deception, and so on.

The time came when I had to present a proposal, a drawing, that would indicate the arrangement of the objects in the space. The *machi*'s recommendation was to request that guidance through a *pewma*, and so I did. I asked for the dream and it came. At the final meeting, before the installation process began, I told the museum team about this revelation, about how the exhibition should be organized, and I began to draw a picture that was consistent with my dream. This mission is a dream, I told them.

We began the installation, looking at the technical aspects that would allow us to replicate the exhibition in the gallery as faithfully as possible. It was a complex challenge for all of us, as there was no precedent for this way of working or for the logic that made it a reality. I believe, however—as both the *machi* and Juana Paillalef previously indicated to me—that the spiritual sequence we followed, which involved collaboration, was responsible for the exhibition still being up more than five years later, constantly serving as an opportunity for communication and exchange between different cultural actors in the country. I can say that this exhibition transcended the mere archaeological concept, and there are several reasons for this distinction. The pieces do not have

Fig. 7. Installation view of the *Wenu Pelón* exhibition at the Museo Arqueológico de Santiago, 2015–20.

a title or provenance and the concept of temporality does not refer to the chronology of the Western world; rather, through this cultural and spiritual protocol, they take on a living dimension, where our Mapuche culture continues to manifest itself through its diverse expressions. The valuable material that found space in this exhibition—the filmic portrait of the *werkén* (vocalist) Daniel Melinao following his first prison sentence; the poetry of Eliana Pulquillanca dancing as she recites her verses; the portraits of the grandparents of the Lonco (chief) Pascual Pichún projected inside a five-hundred-year-old vessel (fig. 7); the dreams that Machi Silvia entrusted to me during the preparation of the exhibition and that I transferred to black-and-white and color film footage; the Mapuche brother Héctor Mariano, who, in the Mapuche mountains, sings a song to me that he composed for his grandmother when she died—testifies to profound tenderness and humanity. The great number of visitors that continued to visit this exhibition year after year seems to confirm what I am saying, in contrast to previous exhibitions. According to these objective parameters, it would be fair to ask: What energy is in this work, this small territory that we have re-created, which allows this constant encounter? For me, the answer is related to its spiritual dimension, to the path that dreams give us, to the image before the image.

I would like to share my revelation with you, the dream that led to the creation of *Wenu Pelón/Portal de luz*, as a gesture that invites you to follow this intimate, genuine dialogue.

And in time, the image came.
I was silent
in the darkness of a spacious room
and as I turn my eyes I see
Mapuche objects
everyday
spiritual
Mapuche objects of every kind
suspended in the air
outside glass cases
despondent, upright
the Mapuche objects were
suspended in the air.
And there were ancient vessels.
I see the ancient jars
and within them, images.
Black-and-white images
of people I know
projected like a film
in the ancient silence of that hollow.

Notes

The essay and poem were translated from the Spanish by Audrey Young.

1 This text appears on Gabriela Mistral's tombstone. The original Spanish is: "Lo que el alma / Hace por su cuerpo / Es lo que el artista / Hace por su pueblo."

2 This title translates to "Mencer, mi sueño" (Mencer, my dream).

3 This title translates to "Portal de luz" (Portal of light).

Benjamin O. Murphy

Handing Over the Camera: Two Episodes in Video Art and Anthropology

In an influential essay from 1993, titled "Goodbye to *Tristes Tropiques*," the prominent American anthropologist Marshall Sahlins offered a provocative description of Indigenous peoples. Countering the popular view that such groups were doomed to vanish as they faced the ceaseless march of modern technologies and globalized capital, he argued that Indigenous groups around the world had long engaged in conscious and strategic assimilations of nonnative products and practices. Such assimilations, Sahlins asserted, had been mobilized precisely for the purposes of cultural survival, and he went on to offer various recent examples, such as Jeep-driving Austronesian artisans, Polynesian ecological activists, and, in a particularly noteworthy aside, an "Amazonian chief who turns a camcorder on the representative of the Brazilian Indian Service."[1] Sahlins's brief mention of the video-wielding chief was meant as a riposte to Claude Lévi-Strauss, whose foundational 1955 text *Triste Tropiques* narrated the French anthropologist's own encounters with various Amazonian chiefs during his travels in Brazil, episodes that Lévi-Strauss offered as a melancholy portrait of the entropic decay of Amazonian society as it faced the encroaching structures and products of Western "civilization." Sahlins's image of the camera-toting chief clearly rejected Lévi-Strauss's elegiac mode, a mode Sahlins characterized disapprovingly as a type of "nostalgic calling . . . , inspired by theoretical conceits of progress that turned perceptions of others into glimpses of past time—provided the others were not 'acculturated.'"[2] Yet, if Sahlins's image of precisely such an "acculturated" other was directed at Lévi-Strauss, it also had a more immediate, though unacknowledged and perhaps unintended, reference. The same year that Sahlins published his essay, the Brazilian organization Vídeo nas Aldeias (VNA; Video in the Villages) produced *Eu já fui seu irmão* (official English title: *We Gather as a Family*), which was composed

of various tapes recorded during an encounter between the Gavião (also
known as the Parkatêjê) and the Krahô peoples, Indigenous groups from
the neighboring states of Pará and Tocantins in the Amazonian region
of Brazil. The two groups had seen videos of each other's rituals within
the context of VNA's traveling video workshops and screenings, and they
subsequently expressed a desire to meet. About five minutes into the
tape that records the encounter, an unidentified Indigenous man appears
holding a video camera that he points first at a group of men who run
past him before turning the device to point directly at the viewer of the
screen image on which he himself appears (figs. 1, 2). He thus produces
precisely that situation Sahlins had invoked, in which an Indigenous
individual becomes the subject behind the camera rather than simply the
object in front of it.

Yet, the example of VNA's tape also complicates Sahlins's invo-
cation. In the anthropologist's account, the video camera serves as the
rhetorical device for a simple, albeit powerful, reversal of regimes of vision

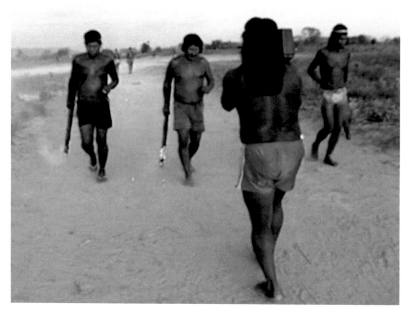

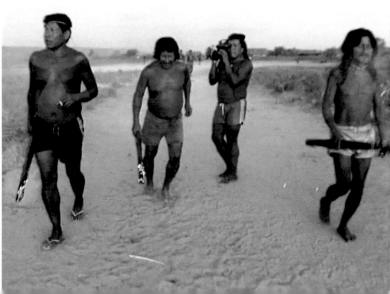

wherein an Indigenous subject would become the controlling agent of a technologized gaze. However, the sightlines coordinated by the camera in VNA's tape are not so simple. Indeed, the Indigenous individual seen wielding a camera himself also appears recorded by another camera while he records yet other Indigenous individuals, a situation suggesting not binary reversals but rather an extensive web of shifting positions between the subjects, objects, and makers of screen images. And in this, *Eu já fui seu irmão* bears a striking resemblance to another, unacknowledged forebear: the Chilean video artist Juan Downey's *Video Trans Americas* (*VTA*) project of 1973 to 1976, which had produced a similarly complex web of video viewers and makers through the experiments the artist undertook with various Indigenous groups. The *VTA* and VNA projects both staked their interventions on video technology's unique capacity for easy transport and immediate screening, properties they employed to allow Indigenous subjects to actively participate in the production of images about themselves. And in doing so, the two projects also reconfigured the relationship of anthropology to technology. In Sahlins's anecdote, technology remains a trope; it remains a rhetorical device at the disposal of the anthropologist that facilitates a more general description of the native, a metaphorical gauge of the native's participation in processes of "civilization," modernization, acculturation, and the like. In *Video Trans Americas* and *Vídeo nas Aldeias*, by contrast, video technology ceases to be a metaphor for native society's relation to modernity and instead becomes a description of anthropology itself. Its structure and processes become a model for the anthropological project as such, a project that those processes radically transform. By tracking these two attempts at video-based anthropology, the present essay will situate them within the broader landscape of anthropology's development over the twentieth and twenty-first centuries, suggesting how they offer a unique intervention within it.

———

Downey based *Video Trans Americas* on a simple observation. As he wrote in an early manifesto for the project in 1973, "many of America's cultures exist today in total isolation, unaware of their overall variety and of commonly shared myths."[3] The artist sought to redress this isolation through an expansive, transcontinental road trip that would structure its itinerary on the basic operations of videotaping and video screening so that Indigenous and other marginalized groups throughout the American continents could interact with other such groups. The initiative, Downey specified, would consist of three components: "playing back a culture in the context of another, the culture itself in its own context, and, finally, editing all the interactions of time, space and context into one work of art." By the time he formulated this project, the Chilean artist had been living in the United States for nearly ten years, the last four of which

he had spent in New York, a city that would serve as his home for the rest of his life. During his first years there, Downey had become closely involved with various members of the Raindance Foundation, a group of New York–based video makers, artists, and activists who appropriated the interdisciplinary structure of the Cold War research think tank as a forum from which to develop radical uses of video that could offer alternatives to the top-down, unidirectional dissemination of information that oriented commercial television.[4] In its official publication *Radical Software*, which had served as the original venue for Downey's manifesto, the group privileged the concept of feedback, the procedure unique to video technology wherein the camera, through the process of closed-circuit instant screening, records its own recording in looped transmission.[5] Because it broke down the boundaries between viewer and viewed by enabling video users to appear on both sides of the TV screen at once, feedback for many Raindance members offered the potential for participatory and collective models of media production based on a critical awareness of the apparatus through which information was recorded and delivered. Downey engaged feedback's basic procedure when he specified in his tripartite schema that the videos from his journey would be played back in the cultural contexts in which they were recorded, creating the possibility for the cultural actors thus recorded to view themselves on tape. Yet he critically altered the procedure as well by insisting that the same recordings be played back in the contexts of other cultures. The paradigmatic instance of feedback, the experience of viewing oneself on-screen, would be accompanied in Downey's formulation by the simultaneous experience of viewing a cultural other on-screen, a dynamic that effectively opened feedback onto a process of geographic transformations involving multiple parties in always shifting relations to camera and screen and, by extension, to each other. Within this process, Downey writes, the artist himself would thus figure as a "cultural communicant, as an activating aesthetic anthropologist with visual means of expression: video-tape."[6]

During the two years following his manifesto, Downey put this communicative framework into practice on a series of road trips, first through the southern United States, across the entire extension of Mexico, and into Guatemala in the summer of 1973; then on a second trip in the Andean highlands of Bolivia and Peru during the winter of 1973 to 1974; and finally, in July of 1974, on an exceptional trip to the artist's home country of Chile, whose situation under the military dictatorship of Augusto Pinochet the artist commented on bitterly in his travelogues from the journey.[7] Accompanied by his family and often by different members of the Raindance community, Downey carried out in these various locations the procedure he had described in his manifesto, taping different communities while also showing to those same communities videos he had taped with other groups on previous legs of his trips, thus creating a situation in which each set of his various interlocutors would figure as

both the objects and viewers of screen images within a transcontinental system of video transmission. From the extensive footage recorded during these experiences, Downey ultimately created fourteen edited videos that, while shown in different combinations in various group and solo shows and performances from 1973 onward, would not be shown together as a comprehensive whole until 1976, when the artist presented them in a complex installation under the project's original title, *Video Trans Americas*, at the Long Beach Museum of Art, the Contemporary Arts Museum Houston, and the Whitney Museum of American Art in New York. The installations of the *VTA* project varied in how they were presented at the three respective institutions over the course of that year, yet in each instance the artist relied on a series of two-channel configurations, showing pairs of videos side by side in different spatial arrangements meant to suggest the geographic itinerary of the trips that had produced the tapes themselves and that could further suggest the involvement of the installation's viewers in that same itinerary. In the installation at Houston, which would become the model for subsequent installations of *VTA*, the artist screened his two-channel videos on pairs of monitors situated at different points on a large, outlined map of the American continents placed on the floor, thus re-creating the geographic scope of the project at the level of the individual viewer's experience. The artist would carry this integration of viewers further in the project's unique installation at the Whitney, where he included a live, closed-circuit video camera that transmitted images of those viewers onto one of the four pairs of monitors arranged within the space.[8]

The same year as his presentation of *Video Trans Americas*, Downey embarked on another, separate project, inspired by the same principle of communicative anthropology that had oriented *VTA* but was distinct from that earlier project in important aspects. For this new project, the artist spent several months between 1976 and 1977 in southern Venezuela, where he lived with his family among the Yanomami people, an isolated Indigenous group whose territory spans portions of the Amazon rainforest of southern Venezuela and northwestern Brazil. The works the artist produced with the Yanomami depart significantly from *VTA*'s transcontinental ambitions in both method and format: Downey did not screen videos taped with other communities from other parts of the Americas for the Yanomami, and the videos he produced with the material he recorded with the Amazonian society were largely standard, single-channel edited tapes rather than double-channel configurations destined for complex spatial installation. Yet the Yanomami tapes also radicalized *VTA*'s collaborative and communicative dimensions, because an important part of the artist's practice with the group consisted in teaching Yanomami individuals to use video technology themselves.

In many ways, Downey's *VTA* and Yanomami projects are the results of the artist's own deep engagement with anthropology, and

specifically with the structuralism of Claude Lévi-Strauss and the generation of French ethnographers of Amazonian society that came after him, authors whom Downey read carefully.[9] Indeed, such a reference point is made clear in the artist's 1979 video *The Laughing Alligator*, the last and most complex of the tapes Downey produced with his Amazonian material, in which he pairs a voiceover of himself reciting a passage from *Tristes Tropiques* with alternating shots of himself wearing a suit in a modern office space and a Yanomami individual cutting wood.[10] Yet, Downey's citation of *Tristes Tropiques* in this case should be understood as a critical one, for the artist's notion of the "activating" role played by the anthropologist as "cultural communicant" is in fact antithetical to the view of communication Lévi-Strauss had offered in his classic text. While Lévi-Strauss had embraced the concept of communication as a useful model for explaining a large range of cultural phenomena that constitute the traditional objects of anthropological study, he would lament its effects when applied to the relation between the anthropologist and those objects.[11] There was a dynamic of mutual exclusion, Lévi-Strauss argued, between cultural difference and the cultural interaction necessary to perceive that difference. As he wrote with despair in *Tristes Tropiques* regarding his own anthropological endeavor, "I am caught within a circle from which there is no escape: the less human societies were able to communicate with each other and therefore to corrupt each other through contact, the less their respective emissaries were able to perceive the wealth and significance of their diversity."[12] If the paradigm of communication modeled such basic processes as language, kinship, and economy within distinct cultures, according to Lévi-Strauss, then communication *between* cultures tended to corrupt the distinctiveness of those processes.

In positioning his Indigenous interlocutors as participating agents in a communicative process both with himself and, in the case of *VTA*, with other Indigenous groups, Downey thus forcefully countered such a view, and in doing so he also anticipated many prominent critiques of Lévi-Strauss that would arise in the years following his own projects within his adopted US context. Indeed, as James Clifford would write in a highly influential analysis of *Tristes Tropiques* and several other key anthropological texts, the preoccupation with the corruption of Indigenous purity palpable in these documents signaled what he called a salvage paradigm, a stance that, though it declared the value of Indigenous societies, also tended to reproduce the paternalism of the colonial enterprise that had wreaked such havoc upon them. As Clifford wrote of that paradigm, it "assume[s] that the other society is weak and 'needs' to be represented by an outsider (and that what matters in its life is its past, not present or future). The recorder and the interpreter of fragile custom is custodian of an essence, unimpeachable witness to an authenticity."[13] The many photographs of Yanomami individuals holding video cameras that resulted from Downey's time in the Amazon offer perhaps the most striking

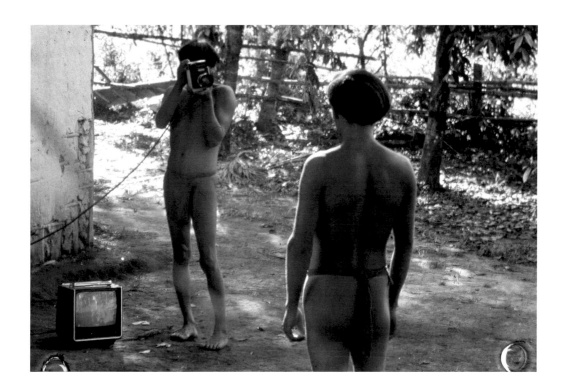

Fig. 3. Juan Downey
(Chilean, 1940–93).
Untitled, ca. 1976–77,
photograph.

example of the artist's break with this salvage paradigm, whose basic tenet
situated Indigenous peoples as always the objects, and never the agents,
of the camera's representations (fig. 3). In fact, the artist's photographs
concretely anticipate the camcorder-toting Amazonian chief that Sahlins
would imagine two decades later in his own response to Lévi-Strauss.
Along these same lines, they also presage the types of interventions that
would emerge within anthropology in subsequent years with the concept
of Indigenous media, an alternative paradigm that turned to a new object
of ethnographic interest: the use *by* Indigenous peoples of various elec-
tronic media. As Faye Ginsburg would argue in a prominent early articu-
lation of this position, such a paradigm served not only to greatly expand
anthropology's repertoire of objects but also to critically reformulate the
discipline's relation to these objects by problematizing anthropology's
apparent monopoly on their representation. That Indigenous people
themselves make and watch films and videos about their own societies,
Ginsburg put forth, requires a configuration that would treat "both
ethnographic and indigenous films as representations of culture *and* as
objects that are themselves implicated in cultural processes."[14] Ginsburg
characterized the effects of this configuration as a type of parallax, what
she described as a destabilization of authoritative knowledge about the
objects of anthropological study due to the introduction of multiple points
of view, including Indigenous ones, onto those objects.[15]

 Downey's *Video Trans Americas* would suggest an initial version
of such parallax through the arrangement he devised for exhibiting the

work of art that resulted from the tapes recorded on his transcontinental journey. In the unique installation he created for the tapes at the Whitney Museum of American Art in the fall of 1976, which he would not repeat, the artist integrated a live, closed-circuit video camera and monitor loop within the space, such that the viewers of the installation would see themselves on screen even as they watched other individuals from across the Americas as they appeared on other screens (fig. 4). The viewers of the work were thus submitted to the same system of shifting points of view that had oriented the activating anthropology that earlier produced the tapes themselves, figuring as both the subjects and objects of screen images as they faced images of various cultural others immersed in the same process of shifting positions. The tapes that Downey produced with the Yanomami departed significantly from the earlier *VTA* project in their singular focus on the Amazonian group outside of any communication with other groups. And yet they offer their own form of parallactic presentation that suggests the continued working of this system of shifting views. In a key moment from *The Laughing Alligator*, the artist presents a tense scene in which two Yanomami hunters who had been leading him through the forest suddenly turn to direct their weapons at him as he films them with his video camera, producing striking evidence of how acutely the Yanomami understood the power and danger that the camera represented, which in that instant they considered a weapon on par with their own. While several authors writing on Downey have singled out this moment in the tape for special attention, of arguably equal interest is the edited sequence immediately following this scene, which shows a brief take of a Yanomami woman laughing as she declares that "the foreigner was afraid" in a subtitle the artist has added below (fig. 5).[16] Offered as a type of extradiegetic commentary on the prior scene, the sequence of the woman's reaction suggests that she has herself viewed, at some previous instant, the footage that the viewers of *The Laughing Alligator* have also just witnessed. The video thus introduces, within its own internal sequencing, another point of view onto the material it presents.[17]

If the photos Downey produced of Yanomami individuals holding video cameras (see fig. 3) offer a canny symbol of the type of parallax Ginsburg would later write of, they cannot capture the furthest implications of the artist's communicative anthropological framework. For they tend to simplify Downey's intervention by suggesting that it consisted of a mere reversal, of a symmetrical turning of the tables of the traditional anthropological relationship produced by the act of handing over the camera. Within the image of this reversal, the anthropologist would become the object of observation, yet the underlying structure of that observational relationship would remain the same. By contrast, Downey's installation at the Whitney Museum and the structure of his later tapes with the Yanomami each in distinct ways posit a qualitatively different conception of observation modeled on video technology's unique capacity

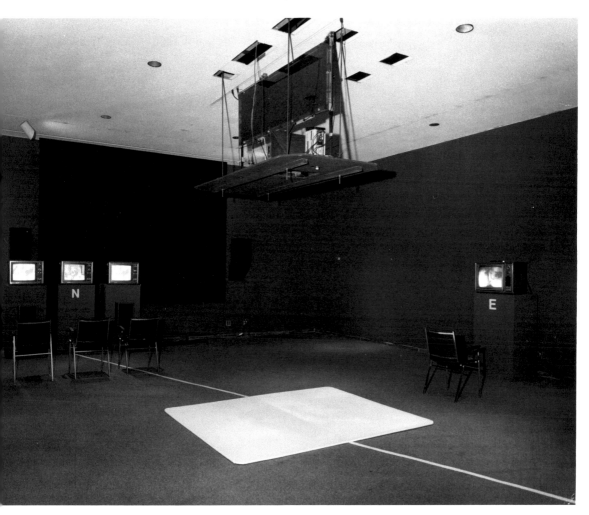

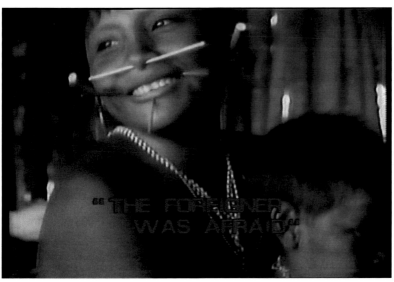

for easy and repeated playback. Within this model, the effect produced through the playback procedure is opened out to encompass an expanding set of observers, such that the act of viewing oneself always involves viewing another, and viewing that other's view of oneself and of yet another other. Anthropology, in the hands of Downey and his various Indigenous interlocutors, becomes precisely this endless crossing of views onto other views that breaks apart the binary relationship presupposed in an anthropology of documentation.

When, a decade after Downey's own experiments with the Yanomami, the Franco-Brazilian filmmaker and anthropologist Vincent Carelli initiated the ongoing Vídeo nas Aldeias project, he reprised a key aspect of Downey's own earlier conception, though perhaps unknowingly. The initiative, Carelli explained in an essay from 2011, was conceived as "an intertribal communication project using video" among various Indigenous groups throughout Brazil, and in this way it concretely echoed the communicational principle of Downey's activating anthropology.[18] Carelli carried out his first video experiments in collaboration with the Nambikwara, an Indigenous Amazonian group inhabiting northern portions of the Brazilian state of Mato Grosso, a society that had figured prominently in Lévi-Strauss's own account of the region.[19] In clear contrast to Lévi-Strauss's characterization of the society's constitutional eschewal of modern technologies, the initial minutes of the 1987 tape *A festa da moça* (The girl's celebration), the first video Carelli produced for Vídeo nas Aldeias, show a large group of Nambikwara individuals of all ages who stare with fascination into a television screen (fig. 6). Rotating, moments later, to show the content of the images that the television transmits, the camera reveals that the assembled group is watching a recording of themselves performing an outdoor ritual (fig. 7). Over the next eighteen minutes, the video goes on to toggle between various layers of recordings—between shots of the original outdoor ritual, shots of Nambikwara individuals as they watch this same recording on screen, and shots of a revised restaging of the same ritual and its subsequent screening—all of which together offer a striking document of the way in which the group used the technology Carelli offered them as a tool of critical self-observation. It was video's unique capacity for instant and easy playback, Carelli argued, that spurred the Nambikwara to alter the ritual after they had viewed its first performance on tape.[20] The ritual, performed by men from neighboring villages upon the occasion of a young woman's first menstruation, had lost crucial traditional elements, the group deemed upon screening the first recording. The Nambikwara therefore chose to reintroduce several of those elements for a second filming, for which they furthermore chose to revive a traditional lip-piercing ceremony, a related initiation rite performed on young men, which had fallen out of use in their community in recent years. Several months later, Carelli would show *A festa da moça* to members of the Gavião (Parkatêjê),

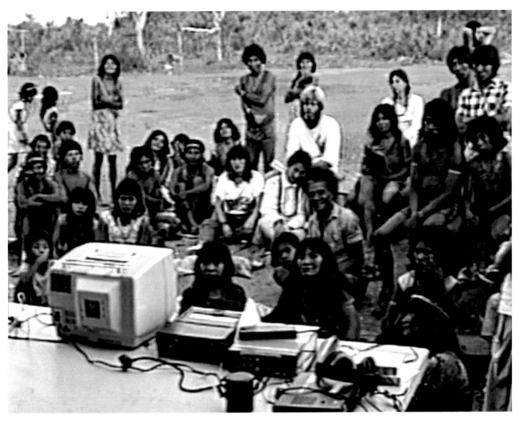

Fig. 6. Vincent Carelli
(Franco-Brazilian,
b. 1953). Video
still from *A festa
da moça* (The girl's
celebration), 1987.

Fig. 7. Vincent Carelli
(Franco-Brazilian,
b. 1953). Video
still from *A festa
da moça* (The girl's
celebration), 1987.

an Indigenous group inhabiting the neighboring Amazonian state of Pará. Under the leadership of their chief, Kokrenum, the Gavião had recently begun an ambitious project of reviving traditional cultural practices, which had declined during several years of traumatic interaction with the Brazilian State in its efforts to develop infrastructure in the Amazon. Impressed by the Nambikwara's performance of the lip-piercing, a ceremony that they had also ceased to practice relatively recently, the Gavião likewise decided to revive it so they could record it.[21]

These early exchanges of videos would lay the groundwork for an increasingly dense network of interchanges between various Indigenous peoples in Brazil, largely within the Amazon region of the country's northwest, facilitated through VNA's initiative. Soon after his experience with the Nambikwara, Carelli established a traveling workshop with the goal of training Indigenous people from this region in how to use video technology. The tapes that resulted from this learning process were traded between the groups that had produced them in a system that approaches a type of epistolary structure, often with the result that traditional cultural practices were recuperated and fortified as in the initial case of the exchange between the Nambikwara and the Gavião.[22] Through these activities to date, the project has produced dozens of tapes that Carelli then combines and edits for international distribution. In this way, Vídeo nas Aldeias can be understood as a particularly robust engagement with the terms of what I've called the Indigenous media paradigm, as it forcefully rejected earlier anthropological fixation on cultural purity and authenticity in favor of a model of agency that could conceptualize Indigenous recourse to audiovisual media as a tool of self-representation for specific political ends. Indeed, Carelli and many of VNA's commentators have characterized the project as an attempt to furnish Indigenous people with the means for "the design and recreation of their own image" that would facilitate efficacious political organizing.[23] A striking example of this conception of video as auto-representational tool would be offered in VNA's 1990 tape *O espírito da TV* (The spirit of TV), which documents various members of the Wajãpi group, who inhabit the state of Amapá just north of Pará, as they watch recordings of themselves and other members of their community on a small television monitor and debate heatedly about which images of themselves to present to a national Brazilian television audience (fig. 8).

Many of the most prominent voices within the anthropology of Indigenous media have taken an interest in this mode by which VNA's productions intervened into the problematic of anthropological representation, judging the productions as instances of effective Indigenous mobilization. Ginsburg herself, in a review of the 1993 video *Eu já fui seu irmão*, discussed in this essay's introduction, argues that the tape offers concrete refutation of the ultimately racist notion that Indigenous cultures are too delicate and statically brittle to withstand the erosive

| Fig. 8. Vincent Carelli (Franco-Brazilian, b. 1953). Video still from *O espírito da TV* (The spirit of TV), 1990.

effects of audiovisual technologies. *Eu já fui seu irmão* is composed of materials from a series of video exchanges between the Gavião and Krahô peoples, groups who share similar, mutually intelligible languages and who organized various video encounters between 1992 and 1993 during which they exchanged ritual and quotidian practices. These exchanges, carried out through video screenings and through live, interpersonal interactions, enabled the Gavião to resuscitate practices that had been abandoned or forgotten in their community, and offered the Krahô crucial knowledge for effective negotiation with the Brazilian State and encroaching mining and logging interests, entities with which they had experienced comparatively little interaction. Reflecting on the tape, Ginsburg counters the view that would bemoan Indigenous engagement with electronic media, writing that "the natives can tell and show you quite directly why these [video] tools are profoundly useful to them, and how they have been used in the service of strengthening cultural traditions and in political organizing." It is in this highly specific and demystified sense, she proposes, that the tape and others like it can be said to offer "representations of 'the native's point of view' rarely achieved in ethnographic film."[24]

Ginsburg offers a nuanced reading of *Eu já fui seu irmão*, attentive to the various dimensions of reflexivity generated through the video's layering within itself of different recordings of recordings and, by extension, of different configurations of viewers. And yet, her assessment that the tape offers a glimpse of "the native's point of view" signals a continued adherence to a curiously traditional anthropological paradigm. To be sure, the figure of the native has radically changed in Ginsburg's account, moving from the isolated and ultimately doomed "primitives" who reject

the technologies of civilization in Lévi-Strauss's telling, to shrewd and conscious political actors who strategically engage such technologies in order to survive. Anthropology itself, however, remains largely unchanged in Ginsburg's formulation, laboring still toward the goal Bronislaw Malinowski had set nearly a century ago when he defined it as an effort "to grasp the native's point of view, his relation to life, to realise *his* vision of *his* world."[25] And yet, much of the significance of Downey's *Video Trans Americas* and the later *Vídeo nas Aldeias* lies precisely in how these projects introduce a subtle slippage that disrupts this formulation. For *Eu já fui seu irmão* does not simply present a native's point of view—it presents, more exactly, a native's point of view of *other natives' points of view*, since the video revolves around the process of different Indigenous groups viewing tapes of each other and of themselves. The work thus immediately denaturalizes the notion of the "native" as such, not through the rhetorical novelty of showing Indigenous people using nonnative technology but rather by making this notion a function of relational positionality enabled through the unique structure of that technology.

The Krahô are foreigners to the Gavião, speaking in a foreign tongue and inhabiting a distant region; moreover, the Krahô appear to the Gavião to be more "native," since their relative lack of contact with Brazilian society has allowed them to retain more of their traditional customs. It is through the substantial differences between their points of view of each other as each other's other, and also the malleability of these viewpoints, that they are able to generate a strategy for interfacing with their *other* other, Carelli, whom both groups engage in order to facilitate exchanges with each other. And in this way, the dynamics undergirding *Eu já fui seu irmão* align with those that had oriented Downey's attempt at a communicative anthropology from two decades earlier. Downey's communicative system had been based on a critical retooling, within the intellectual context of anthropology, of the procedure of feedback then so popular among the video art communities with whom the Chilean artist was involved. Indeed, while the art-viewing publics who visited the artist's installation at the Whitney Museum in 1976 would have been familiar with such a procedure, based on experiences within the context of experimental art and on the more general expansion of home-recording technologies, the originality of the artist's intervention consisted precisely in the application of this procedure to anthropological method, a move that served to transform both anthropology and the concept of feedback itself: within the structure of *Video Trans Americas*, the act of viewing oneself onscreen enabled by the closed circuit would be always accompanied by the geographically expanded experience of viewing a cultural other. In *The Laughing Alligator*, Downey inserted, on top of his recording of his own interactions with a cultural other, another other's reaction to this same taped interaction. And *Vídeo nas Aldeias* made this folding of permutations of viewership enacted by

video's communicative structure into an orienting principle and, as such, it made the position of the native a relative one.

It is important to note that *VTA* and VNA were not isolated interventions. Downey carried out his project at a time when many artists, from Latin America and elsewhere, had begun to take serious interest in anthropology and its representation of Indigenous peoples, and specifically of peoples from the Amazonian region. During the 1970s, the Yanomami in particular would become the focus of various sustained artistic projects, most notably those of the German conceptual artist Lothar Baumgarten and the Swiss-Brazilian photographer Claudia Andujar.[26] Within this broader context of artists working in various media, the uniqueness of Downey's approach lay, to reiterate, precisely in his deployment of video's specific technological resources as a way to reformulate the structure of anthropological discourse. And if Carelli's Vídeo nas Aldeias can in many ways be seen as a later extension of Downey's initial reformulation, it in turn occurred simultaneously with a general increase in the use of video among Indigenous communities throughout Latin America. During the late 1980s and 1990s, various Indigenous-run video and television collectives emerged in countries including Bolivia, Mexico, Paraguay, and Peru, and their work was circulated and disseminated through the concurrent emergence of several inter–Latin American promotional organizations, most notably the Consejo Latinoamericano de Cine y Comunicación de los Pueblos Indígenas (CLACPI), which hosted various formative video festivals during those decades.[27]

The difference between these important organizations and the proposals of *VTA* and VNA is that, while the former endeavor to create a space for Indigenous voices outside the disciplinary frame of anthropology, the latter attempt to transform that discipline from within. In an important sense, many of the groups that participated in the CLACPI's forums effectively circumvented the traditional figure of the anthropologist, understood as a privileged outsider who records and transmits Indigenous custom, through their crucial efforts to forge channels for Indigenous self-representation. By contrast, *VTA* and VNA do not dispense with that figure: Downey and Carelli are still present, indeed central, in each project, though their relations to their Indigenous interlocutors have been radically altered. By devising a system in which the video camera is continually handed off between various figures, the anthropologist among them, both projects make the anthropologist, like the "native," a relative position within a broader system of shifting points of view. Rather than observing or recording, the anthropologist "activates" this system, as Downey had phrased it. And anthropology thus becomes nothing other than this ongoing process of alternating relative views.

Notes

1 Marshall Sahlins, "Goodbye to *Tristes Tropiques:* Ethnography in the Context of Modern World History," *Journal of Modern History* 65, no. 1 (1993): 21.

2 Sahlins, "Goodbye to *Tristes Tropiques*," 25.

3 Juan Downey, "Video Trans Americas," *Radical Software* 2, no. 5 (1973): 4.

4 Frank Gillette, Beryl Korot, Paul Ryan, Michael Shamberg, and Ira Schneider were some of the most prominent and active members of the Raindance Foundation. For a recent discussion of the group and other early video collectives, see William Kaizen, "Talkback," in *Against Immediacy: Video Art and Media Populism* (Hanover, NH: Dartmouth College Press, 2016), 78–125.

5 For an in-depth discussion of Downey's participation in the community surrounding *Radical Software*, see Julieta González, "Juan Downey's Communications Utopia," in *Juan Downey: Una utopía de la comunicación*, ed. Julieta González, exh. cat. (Mexico City: CONACULTA, 2013), 10–77; and Julieta González, "Beyond Technology: Juan Downey's Whole Earth," *Afterall*, no. 37 (2014): 17–27.

6 Downey, "Video Trans Americas," 4.

7 See Juan Downey, "Travelogues of Video Trans Americas, 1973–75," in *Juan Downey: With Energy beyond These Walls*, ed. Nuria Enguita and Juan Guardiola, exh. cat. (Valencia: IVAM Centre del Carme, 1998), 330–36.

8 For a detailed reconstruction of Downey's installations of *VTA* in 1976, see Sarah Montross, "'A Nostalgia for the Future': Time, Technology and Origins in Juan Downey's Art," in González, *Juan Downey*, 96–98.

9 In addition to his interest in Lévi-Strauss's writings, Downey was also particularly interested in those of Pierre Clastres and Jacques Lizot, the latter of whom would become a friend of Downey's after assisting the artist and his family during their time among the Yanomami. For more on Downey's engagement with this anthropological tradition, see Manuela Carneiro da Cunha and Helena Vilalta, "Yanomami, Let's Talk," *Afterall*, no. 37 (2014): 29–37; and Julieta González, "Notes on Juan Downey's Program for a Fake Anthropology," in *Juan Downey: El ojo pensante*, ed. Julieta González, exh. cat. (Santiago: Fundación Telefónica, 2010), 201–17.

10 Transcription of audio of *The Laughing Alligator* appears in Enguita and Guardiola, *Juan Downey: With Energy beyond These Walls*, 343–44.

11 In an essay on the concept of social structure, Lévi-Strauss drew on the definitions of communication offered by information theorists associated with early cybernetics, and specifically Claude Shannon, arguing that Shannon's theorization could be used to understand such classic categories as kinship, gift economies, and language. See Claude Lévi-Strauss, "Social Structure," in *Structural Anthropology* [1958], trans. Claire Jacobson and Brooke Grundfest Schoepf (New York: Basic, 1963), 277–323.

12 Claude Lévi-Strauss, *Tristes Tropiques* [1955], trans. John Weightman and Doreen Weightman (New York: Atheneum, 1974), 43.

13 James Clifford, "On Ethnographic Allegory," in *Writing Culture: The Poetics and Politics of Ethnography*, ed. James Clifford and George Marcus (Berkeley: University of California Press, 1986), 113. As Brian Hochman has demonstrated in a recent analysis of the salvage paradigm, anthropology's injunction to record "vanishing" native cultures in many ways relied on the technical and conceptual prosthesis of audiovisual recording media, with which it had existed in a complex reciprocal relationship since its disciplinary beginnings in the late nineteenth-century United States. See Brian Hochman, *Savage Preservation: The Ethnographic Origins of Modern Media Technology* (Minneapolis: University of Minnesota Press, 2014).

14 Faye Ginsburg, "The Parallax Effect: The Impact of Aboriginal Media on Ethnographic Film," *Visual Anthropology Review* 11, no. 2 (1995): 65 (emphasis in the original). See also Faye Ginsburg, "Culture/Media: A (Mild) Polemic," *Anthropology Today* 10, no. 2 (1994): 5–15; and Faye Ginsburg, "Indigenous Media: Faustian Contract or Global Village?," *Cultural Anthropology* 6, no. 1 (1991): 92–112.

15 Downey in fact collaborated directly with several early proponents of the Indigenous media paradigm in the United States, most notably the anthropologist Eric Michaels, who would later go on to research television programming produced by Indigenous Australians. Michaels wrote of his experience with Downey in his essay "How to Look at Us Looking at the Yanomami Looking at Us," in *A Crack in the Mirror: Reflexive Perspectives in Anthropology*, ed. Jay Ruby (Philadelphia: University of Pennsylvania Press, 1982), 133–46.

16 For an insightful discussion of Downey's brief face-off with his Yanomami guides in *The Laughing Alligator*, see González, "Juan Downey's Communications Utopia," 60. For a recent discussion of the implications of Downey's "the foreigner was afraid" subtitle in the following sequence, see Edward Shanken, "Pushing the Limits: Surrealism, Possession, and the Multiple Self; Juan Downey's *The Laughing Alligator*," in *Juan Downey: 1940–1993*, ed. Julieta González and Javier Rivero Ramos (Madrid: Ediciones MP, 2019), 538.

17 I have argued for this interpretation of this segment previously in Benjamin Murphy, "Juan Downey's Ethnographic Present," *ARTMargins* 6, no. 3 (2017): 28–49.

18 Carelli conceived Vídeo nas Aldeias during his time at the Brazilian NGO Centro de Trabalho Indigenista. The project was inspired by an earlier, unrealized initiative titled *Inter Povos*, proposed to the Centro in the early 1970s by the Italian-Brazilian filmmaker Andréa Tonacci. See Vincent Carelli, "Another Look, a New Image," in *Vídeo nas Aldeias, 25 anos: 1986–2011*, ed. Ana Carvalho, Ernesto Ignacio de Carvalho, and Vincent Carelli, exh. cat. (Olinda, Brazil: Vídeo nas Aldeias, 2011), 198.

19 Lévi-Strauss's famous "Writing Lesson" recounts an interaction between the anthropologist and a Nambikwara chief. See Lévi-Strauss, *Tristes Tropiques*, 294–304.

20 Carelli, "Another Look, a New Image," 198.

21 Carelli, "Another Look, a New Image," 198. See also Pat Aufderheide, "'You See the World of the Other and You Look at Your Own': The Evolution of the Video in the Villages Project," *Journal of Film and Video* 60, no. 2 (2008): 28–29.

22 As Jean-Claude Bernardet has noted, the videos exchanged between different Indigenous groups involved in VNA function almost as letters or missives. See Jean-Claude Bernardet, "Vídeo nas Aldeias, Documentary and 'Otherness,'" in *Mostra Vídeo nas Aldeias: Um olhar indígena*, ed. Mari Corrêa, Sérgio Bloch, and Vincent Carelli, exh. cat. (Rio de Janeiro: Centro Cultural Banco do Brasil, 2004), 9.

23 Vincent Carelli, "Moi, un indien," in Corrêa, Bloch, and Carelli, *Mostra Vídeo nas Aldeias*, 23. For further discussion of VNA as a project of Indigenous self-representation, see Ivana Bentes, "'Camera Very Good for Me to Work,'" in Corrêa, Bloch, and Carelli, *Mostra Vídeo nas Aldeias*, 53–55; and Lucas Bessire, "From the Ground, Looking Up: Report on the Vídeo nas Aldeias Tour," *American Anthropologist*, n.s., 111, no. 1 (2009): 101–3.

24 Faye Ginsburg, "Video Kinship: A Review of *Meeting Ancestors* and *We Gather as a Family*," in Carvalho, Ignacio de Carvalho, and Carelli, *Vídeo nas Aldeias, 25 anos*, 243.

25 Bronislaw Malinowski, *Argonauts of the Western Pacific: An Account of Native Enterprise and Adventure in the Archipelagoes of Melanesian New Guinea* (Long Grove, IL: Waveland, 1922), 25 (emphasis in the original).

26 For a discussion of Baumgarten's work with the Yanomami, see Craig Owens, "Improper Names" [1986], reprinted in *LB: Autofocus Retina*, ed. Lothar Baumgarten, Bartomeu Marí and Walter Nikkels, exh. cat. (Barcelona: Museo d'Art Contemporani de Barcelona, 2008), 105–32. On Claudia Andujar's engagement with the group, see *Claudia Andujar: A Luta Yanomami*, ed. Thyago Nogueira, exh. cat. (São Paulo: Instituto Moreira Salles, 2018).

27 Juan Francisco Salazar and Amalia Córdova have emphasized the importance of the CLACPI in their insightful overview of Indigenous video in Latin America. See Juan Francisco Salazar and Amalia Córdova, "Imperfect Media and the Poetics of Indigenous Video in Latin America," in *Global Indigenous Media: Cultures, Poetics, and Politics*, ed. Pamela Wilson and Michelle Stewart (Durham, NC: Duke University Press, 2008), 39–57.

Reflections on Vídeo nas Aldeias

Vincent Carelli (Franco-Brazilian, b. 1953) is an award-winning documentary filmmaker and activist best known for founding Vídeo nas Aldeias (VNA; Video in the Villages), a pioneering project in Indigenous media. Founded in 1986 and based in Olinda, Brazil, VNA has provided support to forty different Indigenous groups in fourteen Brazilian states to create media that examines issues faced by Indigenous communities in contemporary society. Since its formation, VNA has developed as a training program and production center, producing more than seventy works that have played a significant role in advancing public policy as well as the domestic and international visibility of Indigenous people in Brazil. The resulting videos and films aim to reshape the portrayal of Indigenous people in mainstream culture and serve as a means of communication among the diverse groups by giving them the resources to document and portray their rituals, political and cultural beliefs, and everyday experiences on their own terms.[1] These works have been screened at the Centro Cultural Banco do Brasil in Rio de Janeiro, Itaú Cultural in Belo Horizonte, the Museu da Imagem e do Som in São Paulo, the Festival de Cinema de Vitória, Itaú Cultural in São Paulo, the São Paulo Bienal, and the National Museum of the American Indian in New York City and Washington, DC.

ELENA SHTROMBERG Vincent, thank you for agreeing to this interview. We really wanted to have your work with VNA represented in this project, and especially to get you to talk about it in your own voice. I remember a lot of our conversation from when we met in 2015 and was hoping to include some of those stories for this publication. The first question I have is about how you became interested in video—in the medium. It was during the 1980s, correct?

VINCENT CARELLI I founded Vídeo nas Aldeias in 1986, but I was always interested in photography, and when I began to work in Indigenous communities, I felt an even greater desire to pursue video. Alongside photography, which I began when I made my first trip to an Indigenous community at sixteen years old, I also made sound recordings. I was witnessing and having the privilege of knowing worlds that were unfamiliar to me and that most people had likely never dreamed of. So that was a very strong motivation, to record both sonically and photographically when I started in the 1970s.

ES How did you manage to go to an Indigenous community while you were so young? Was it a school trip? How was it organized?

VC I had a brother who was a year and a half older than me who wanted to be a priest. He was close friends with an old missionary, the Dominican friar José Marie Caron, a Frenchman who taught philosophy.[2] He was part of the convent of the city of São Paulo, which had a lot of priests who were tortured during the dictatorship. The Dominicans have a big base at the intersection of Goiás and Pará, the Conceição do Araguaia. They went for a visit in the south of Pará, when the Dominican friar Gil Gomes Leitão said, "Now, you will visit the Gaviões who have just been contacted." This meeting was "the meeting," it was definitive for me. I saw the slides of the Indigenous people that this French Dominican friar had, and I was struck by his story. In 1969, the friar who had brought my brother in '68 took me on my first trip to the Xikrin people, which was definitive for me.

ES '69 was a bad year under the dictatorship. So you went with your brother?

VC No, I went one year after my brother did. I went with Lux Vidal, who was a professor of English at the French school. She was studying anthropology, and she went there for her first field experience. She then became an anthropologist and wrote a thesis about the Xikrin people. We went back for three consecutive years together, until I finally moved to live with the Xikrin people full time.

ES So you started developing this interest in the early 1970s. Had you already seen photos by Claudia Andujar, or did you know the videos of Juan Downey that they both did of the Yanomami people in the Amazon?

VC No, I hadn't seen them. I know Claudia, of course, because she was in Xikrin at the time I was there, but I didn't know her work yet. During that period, I was mostly focused on ethnography. I was reading a lot about ethnography in those years, but I had no specific interest in film and I didn't know many ethnographic films. I wasn't aspiring to do that type of work yet. But then later we met the Italian-Brazilian filmmaker Andréa Tonacci. He had been looking to become involved with the Centro de Trabalho Indigenista [CTI]. I was part of the group of students at the Universidade de São Paulo who cofounded CTI in 1979. It was the early days of portapak technology, black-and-white half-inch open reels, and we helped him [Tonacci] write a proposal for the Guggenheim, which we titled *Inter Povos* [Inter villages]. It attempted to facilitate communication among Indigenous villages. Tonacci wanted to develop a project with video, but he ended up doing a coproduction in collaboration with us in 16mm film. I wasn't participating directly, but he was collaborating with the CTI for the resulting film. It was this experience with Tonacci that made me think about the Vídeo nas Aldeias experiment that I started realizing ten years after, in 1986, when the industry released the portable VHS in K7 and with color.

ES And what was the name of that film?

VC *Conversas no Maranhão* [1977–83]. It was made at the same time as the mapping of the Canela tribe's territory in the Maranhão state of northeastern Brazil, and it is somewhat of a cinematic intervention. Gilberto Azanha and Maria Elisa Ladeira, anthropologists and members of CTI, arrived with a team during the physical demarcation of the territories, and they intervened by raising a discussion with the Indians stating that the borderlines that the Indian Service was demarcating did not comply with what had been demanded by the Indigenous people. This initiated a controversy, and the Indigenous population started putting together a written document for the president at FUNAI [Fundação Nacional do Índio].[3] It is a beautiful, musical film, very interesting, but shot on 16mm film, so the video part wasn't present there—this was a classic documentary.

ES Is your background in the discipline of anthropology? Did you study that or anything related?

VC No, I didn't study anything. Well, I did: after going through the French school system, I enrolled at the Universidade de São Paulo for social sciences, but I was already involved with the Indigenous groups. And I'd already read a lot about ethnography. But I spent a

year at university. I did the basic courses and attended a graduate course but then said bye.

ES The world was more interesting . . .

VC I first met Indigenous people while still in high school, and this had already completely changed my life and gave me a very strong drive toward a certain direction, a passion, a desire, which I thought academia couldn't satisfy for me. I really wanted a radical experience, an encounter, an immersion, and I dropped everything and left and never went back.

ES Did you regret it?

VC I don't regret anything at all. I was living life fully, I was very adventurous, following my passions, also living outside "the system" and such. I was a free spirit, living in the moment more than dwelling on regret. I think I had a great privilege in life to be this way, and I followed my interests. And when I saw that academia wasn't fulfilling to me, I was already having another life experience, I was there living with Indigenous people for two years. I stayed until I went to Brasília to enroll in a course, so that I could work for FUNAI. I ended up working for them for a couple of years, but I didn't really care for it; it wasn't a good place to be, between State interests and the Indigenous ones.

ES What was the first community you visited?

VC The Xikrin, in the south of Pará, next to the iron mine of Carajás. From there I went to do the course in Brasília, and returned to work as an employee for FUNAI, though it didn't quite happen the way I wanted it to. This was during the military dictatorship and the colonel called me and said that I couldn't serve in the village of Xikrin; he was sending me to another location. I complained because I had already been involved with the Xikrin, and when I said I'd prefer to stay with them, he said, "No, you can't go because you are a friend of that tribe."

ES And that's bad?

VC Yes, to him it seemed very bad. This was my first assignment as a public official, so I started in another position, with the Asurini community. Later, I finally went back to join the anthropologists that I had studied with to coordinate a project in Goiás, with the Krahô. It was after this time working as a State agent that we

founded the CTI per Krahô demand. I revisited several populations I had worked with, and video was a very welcome tool everywhere, received with much enthusiasm. Under the military dictatorship in Brazil, which lasted twenty-one years, people in civilian society were dreaming of freedom, of justice, of diversity. And it was a time of strong solidarity with the Indigenous peoples because of the military repression of Indigenous rights—the military's idea was to "emancipate" the Indigenous people of Brazil, stating that now that they are "civilized like us," they no longer need any special rights.

ES The rights to autonomy?

VC Yes. They don't have the right to territory, nor to citizenship, which suppresses any special rights. And justifiably, Brazilian society mobilized; it couldn't do so with other issues that were prohibited or censored by the press, but the Indigenous question was very present. And I think it started a movement, a collaborative effort between a minority of people, many of them university students, professors, and journalists, who were collaborating with the Indigenous people. This movement was basically an intense coming together; it was a time when Indigenous people, mainly from the northern region, many of whom were very isolated and were being contacted for the first time, were existing under an extremely authoritarian state, experiencing ethnocide and even banned from speaking their language. It was State repression, but also societal repression, from the surrounding villages.

ES Historically too, right?

VC And historically, yes. Later, there was a turning point in the '88 Constitution in Brazil. The dictatorship ended in '85 and Brazil was living a very happy moment, but the Indigenous question was marked by much infighting in the Congresso Nacional, even though in principle there was a generous constituency representing the Indigenous people. The Constitution basically recognized the right to self-determination, the right of free association, which FUNAI took about ten years to recognize, and the legal right to self-representation and to teach their own history in their schools. It was a moment of solidifying Indigenous rights, at least in principle, because all of that is now being dismantled and attacked. I am referring to this process of regression that we are currently living in, because now we see people dismantling this. People had advanced a lot. I think Brazil had a golden era during Lula's presidency,[4] mainly in the cultural arena. I think it was a real revolution

for the politics of culture, to decide "let's finance popular culture, hip-hop culture, the Indigenous people," they had never paid attention to them before. It's true!

ES Could you talk more about the moment you started VNA?

VC I went back to this idea in the mid-1980s, when the portable camcorder appeared—a recorder integrated with a camera. I returned to this idea because I had been semi-involved with previous movements: well, I was working at the CTI on one hand, and on the other with the Centro Ecumênico de Documentação e Informação [CEDI], which eventually became the Instituto Socioambiental [ISA]. I was also working on a project that dealt with preserving cultural memory, so I was in charge of creating a photographic file that would become a publication that was originally conceived of as an encyclopedia. In the end it became a virtual one.

ES And it still exists?

VC Yes, *Os Povos Indígenas no Brasil,* it's an online encyclopedia.[5]

ES And it was just you? Or were you working with many others?

VC No, it was a large team, but at that time it meant setting up the project and creating as wide a network as possible: journalists, missionaries, anthropologists, reporters, photographers, curious individuals—anyone who had gone to an Indigenous village. We compiled everything in a large database that hadn't existed during the 1970s.

ES And you were in São Paulo during this time?

VC I was in São Paulo, yes. And at this time a database, something with reliable information about the great majority of Indigenous populations in Brazil, didn't exist. Not even at FUNAI, which had opened in Acre. There were many things lacking. But it was an opportunity to sift through many important magazine archives such as those of *Cruzeiro,* museum archives, and many archives from the Benedictines, the Salesians. I was moved by this, these memories, tapes, files, and notes. This would become a record for the new generations to have as a reference to their ancestors, which is very important, and simultaneously it brings awareness of the fast pace of change, and the many things that were lost along the way.

So I got interested in this issue of the image as memory for Indigenous people, but it would be much more than that, honestly.

The experience showed me that while I was concerned with issues and questions about the circumstances of contact, of dependency, of autonomy, in fact the same audiovisual tool, the camera with sound, awoke the Indigenous peoples' curiosity in portraying themselves through their most personal experiences such as songs, gatherings, and stories [fig. 1]. More than talking about their problems, video became a way to document the celebrations and a way to recuperate things forgotten, surveyed, or despised in a certain way. And it sparked a type of "revival" of pride in self. At the beginning it was very difficult. People were unmotivated by FUNAI and it was difficult; we basically worked with international cooperation.

ES Like who? With the Guggenheim Foundation?

VC We started with a Guggenheim Foundation project, and then collaborated with American foundations that were very important—the MacArthur, Rockefeller, and Ford Foundations, and then the Norwegian Agency for Development Cooperation. It was good to gain traction and after something like twelve or eighteen years, I can't remember anymore, we were finally recognized in Brazil. Up to that point we had been working with the cooperation of US-based foundations, and this revealed the assimilationist politics in Brazil, the tradition of "apartheid" with regard to indigeneity; there were thousands of government employees in the country and only

| Fig. 1. Photograph showing the filming of *As hiper mulheres* (The Hiper women), dir. Carlos Fausto and Leonardo Sette, **2011.** 80 min.

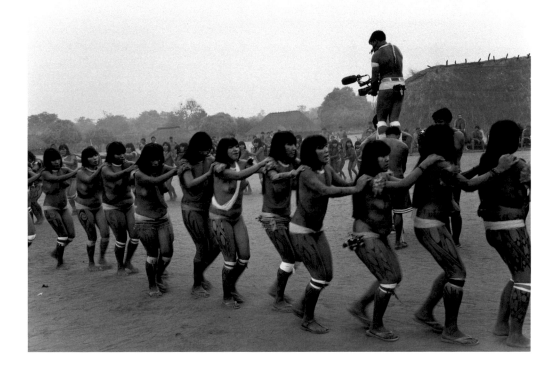

one response, which had always been no. "Can we do this?" "No, no you can't!"

ES And your contact with video before founding Vídeo nas Aldeias in 1986 was in São Paulo? That's where you got the camera?

VC No, I was only able to purchase a camera when Steve Schwartzman, who is now at the Environmental Defense Fund, gave me $3,000 to buy a camcorder. I had never filmed before beyond experimenting with a Super 8 camera during the 1970s. I bought a camera, a little twelve-inch television set, a VHS player, a generator, and I brought it all to the Nambikwara and it was a wonderful experience. And then I was taking the footage of this experience to other villages and it created a domino effect. Other people started to adopt this relationship too. Parallel in influence to our work was an important festival organized by the Smithsonian and presented in New York, which was a great meeting place for all Latin Americans.[6] I remember how similar projects began with the advent of VHS camcorder technology. I think it was a much bigger movement and an appropriation of this tool to document civil movement and collectives, especially in other countries such as Mexico and Bolivia. In Paris, there was also a training center and film school set up by Jean Rouch and the Blanchet brothers called the Ateliers Varan, a film school for the "Third World," as they used to say at that time.[7]

ES So you got to know about this project in Bolivia while in New York?

VC Yes.

ES So, Brazilians weren't collaborating with the Bolivians?

VC No, but from our participation in New York we joined the Consejo Latinoamericano de Cine y Comunicación de los Pueblos Indígenas, CLACPI, which was founded in 1985.[8] There wasn't a lot of inter-action after that. We tried to do joint projects with the European community, but it never worked out. The Parisians had a strong relationship with the Mexican projects, and after this, CLACPI held a festival every two years in a Latin American country, with workshops, etc. So now, the movement exists in Latin America in different ways, and today both in Latin America and Brazil, any event surrounding the Indigenous communities has something like ten camera operators. It was a process of progressive appropriation.

ES I would like to ask you some specific questions about the first attempts by VNA to present new technological devices to Indigenous people. When you introduced video to the community, did you do that by showing them some examples of what it could do? Did you show them videos with the indication that "this is what you can do, but you can also do x, y, z . . . ?" Did you give them some criteria for making their first videos? Or did they just do what they wanted?

VC When we first began, I would distribute cameras, but I wouldn't say anything. They could do whatever they wanted [fig. 2]. Even when classes on video training began, we didn't provide firm models. It was more of a focus on everyday life, very in line with direct cinema and all its dogmas. Especially for the beginners it was very interesting: no zoom, for instance; to do close-ups, you had to come close and establish a relationship without that mechanism.

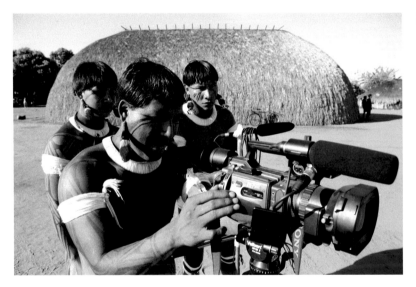

| Fig. 2. The director Takumã Kuikuro (with camera) and his team filming *Espero que vocês gostem destes filmes* (I hope you like these films) in the Ipatse village, Xingu, in 2007.

When we first started, there were few villages that had access to television; there still wasn't the widespread presence of television in the countryside. But in the mid-1980s and mostly 1990s, many switched to owning televisions, so when we started training them, they had already seen TV. Then it was much more direct cinema as a deconstruction of the televisual relationship. Or the microphone, the interviewer, asking the stupid questions—this was in line with observational cinema, a cinema of discussion and interaction with the people, which they had some experience with since I had already been living with them with a camera. I unintentionally fell into a cine-trance, or rather the equivalent: a video-trance. We would tape an activity and then return to the monitor, and people

would say: "Let's watch, there I am, there's something worthwhile, or that's not working."

ES But this deconstruction and editing, was it on the basis of content, or were aesthetics also important? Were they taking liberties with aesthetic strategies to show something they had seen on TV?

VC It was all very creative—I guess what I'm trying to say is that communities' fearlessness of the technology was remarkable! They weren't scared at all, not frightened by the technology . . . they had a very stable hand. And for many, the sense of aesthetics came naturally. It is clear that their style was evident throughout. There were people who had the gift of visualizing things, and there were others who thought or interacted more.

ES So it changed a lot from one village to another?

VC Yes, from one village to the next and from person to person. Some people have a more politicized focus, others less so. I was almost always working with young people, and young people still have few interactions, but there have been partnerships that grow between them.

ES And they reach out to you for advice, for example: "I want to make a video about this, or what would you suggest, what gestures or angles could be used?"

VC No, not like that. More in the sense of building a story, how to find someone, a character, a situation that interests you. Each has to create a sense of intimacy and build a relationship with their character, and at the end of the day they discuss what to do with the character next. And in this sense, the results of these workshops are not only the fruits of the cinematographer's labor but also the fruits of a collective synergy, of the desire of cinema. Often the characters have produced as much as the filmmaker, in the sense of proposing scenes, playing roles, storytelling, and ultimately taking initiative, asking to direct films [fig. 3].

ES Did they build sets or a stage?

VC No, the setting was life. For example, a guy wanted to film something set at the time of the Amazon's Rubber Boom, and the guy took the equipment and went out to perform that period, singing the song that was sung by the *seringueiros* [rubber tappers].

Fig. 3. Photograph showing the filming of *Para os nossos netos* (To our grandchildren), dir. Konoi Paraná, 2008. 10 min.

ES What is the name of this film?

VC *Xina bena, New Era* by Zezinho Yube [2006]. It's about a character who plays the role of the rubber tapper. He learns day by day, as he re-creates his character. This happens a lot in this dynamic, an improvised story without a script or a set, just an open mind to maximize the value of improvisation, which is always better than a script—at least that's what I think.

ES That is super interesting. And when people looked at the work of other people, did they react critically? Would they say, "No, that's not done"? What was the critical response from one group to another?

VC When I had said I didn't provide them with any references, that isn't entirely accurate, because I would show them the videos that other villages had made. Those were certainly a reference, and often important aspects of videos that others had made would appear in their productions.

ES So they appropriated each other's work?

VC Even jokes, or making direct or indirect references to other videos they had seen. So those always served as references, but it was also difficult. For example, we had an exchange project with Inuit filmmakers. I would share Inuit work in the villages, and many of their actions, such as shooting trees or filming a leaf, didn't generate a lot of interest. It was still a translation problem: it was

difficult because it was so unfamiliar. But with the work of other Amazonian villages, even when everything was different—the language, the customs—they still shared references to each other's basic ways of life. Their reaction was more like, "Ah, they are like that," that shows how the others are—

ES Showing off a little?

VC Yes. Much more than making judgments, they would discuss it, sometimes teasing, reflecting, but without bigger questions.

ES And was it both women and men who were doing this, or was it mostly men . . . ?

VC Initially it was mostly men; few women have participated in the project [fig. 4].

ES Even now?

VC Even with female teachers—there were two here in the workshop—it was all men and then two women who were watching in the middle of them all.

ES And now it has changed?

VC It has changed because today there are new initiatives, and many programs at universities include both men and women. They are people living between the two worlds—some are very urban and

| Fig. 4. The Indigenous filmmaker Zezinho Yube (Huni Kui) instructing Vanessa Ayani, an apprentice, 2008.

educated, but they also live in the villages. Life in the villages is much more difficult . . .

ES Of course.

VC In many places, I think women have a bigger role with media, recording with a cell phone, broadcasting with Bluetooth. It's fascinating. That's why we had this proposal to understand the moment of technological appropriation and how it has intensified. Today every Indigenous person has a cell phone with two SIM cards for storing images and footage they took. Now when we're sharing images, I'll get them on these cell phone SIM cards.

ES How did the videos produced by participants in the VNA project, and their aesthetics, impact or modify your understanding of video and film and then your own approach to making work? Could you cite some examples?

VC I think that my whole perspective changed when Indigenous people began to film. Their language and their intimacy with each other—these are key aspects that affect their descriptions of their lives, their feelings and desires. It opens a world that people outside of these communities don't have access to. I learned about their intense focus on the aesthetic, which is reproduced in different planes in ways that I wouldn't have imagined. For example, the Gavião communities are arranged in a circular layout, so they line up in the middle and move together in a spiraling path. I learned that there was a universe to which I had no access, but it formed the everyday life and culture of the Indigenous communities, completely different from mine. They open a window onto a reality that we don't have access to. Cinema can be extremely violent when it comes from the outside: people come in with their own ideas and themes, and they end up getting in the way instead of truly listening to the themes that people would like to know more about and the themes that the Indigenous people would like to address. I need to be really attentive to the violence of cinema when it comes to Indigenous communities so that I can have a position that is much more about listening, both to the aesthetics as well as how to approach life. These perspectives opened a new reality for me. I had never made film before straight from my head, at least not during the period of VNA, and now I am making more reflective films. The documentaries that the Indigenous people made are like a class for us, they continually teach us about life and only they can do that— express themselves in their language. This is fundamental.

ES The work that you did with video, did you consider it art or documentation?

VC I think in the first ten years it was more an action driven by Indigenous people themselves. It didn't feel like we were pretending to work with Indigenous filmmakers, it was a group with whom I had a working relationship, and then we had projects where video would be a good fit. It was an important time: projects of reconstruction, of whole traditions that had not been documented, and that the new generation hadn't known. It was living in a moment after contact. Contact is a hecatomb, you know? It is an extremely traumatic process, it would take decades for some communities to reestablish themselves; some lost 80 percent of the population and especially the older population, the population with knowledge of tradition. So it was traumatic in every sense, in both the population and with memory. Reestablishing tradition depends a little on the Indigenous leaders in charge of the group and on the government leaders promoted during the dictatorship, who often had the perspective that Indigenous people should become "white." And we felt they opposed tradition. This changed as soon as the whole process of renewal and reconstruction of memory occurred. The Latin American encounter of international Indigenous groups at the Smithsonian was very important, giving them the possibility to meet others from India, Asia, Canada, New Zealand, and Australia; there was also a TV channel of Indigenous people that closely followed the activity of the Inuits. The first VNA workshops began to quickly produce movies that people were very interested in, that made an impression on audiences, that surprised Brazilians with their intimacy and the reality from which the films came. This led to the development of Indigenous cinema in Brazil.

ES And did you have any contact with television in Brazil? TV Cultura?

VC Very little. In the beginning, the very first films won awards at festivals and such, and then twenty years later, during Lula's presidency, many things started coming together in Brazil and our program was thriving. The Ministry of Culture discovered what was coming from the villages. It was a large undertaking and there was a lot of interest; the slogan of this movement was "Brazil doesn't know Brazil." That Brazil was looking toward the future, knowing that the greatest Brazilian wealth was its cultural diversity. I think all the cultural development agencies turned to this philosophy, and suddenly they discovered that life in these villages is also inspirational. That there are many important things that

were crucial to talk about, such as the diversity of Indigenous peoples and the diversity of people of African descent in Brazil's public schools. This was also a topic people focused on. There was a lot of interest, there was space, there were several doors opening . . .

ES But the main space was the festival? Was there no public TV channel?

VC For two and a half years we had a program on TV Cultura, which was also broadcast by TV Brasil on the national network, a program called *A'Uwe*[9] presented by the actor and environmentalist Marcos Palmeira. During that time we produced seventy episodes. It was a very important experience to have the program on national television, it was a dream. It only lasted a little while because the government changed the policy, and with a new governor the first thing to go from TV Cultura (which is federally funded) was the Indigenous program. But it was something many people were writing about. It was on at 6:00 p.m. on Sundays, prime time, and people would be talking about the show with their neighbors.

ES Oh really?

VC Yes, yes. But it was a dream that didn't last long. Many ideas were expressed at that time to the point that there was a large shift in investment policy in national cinema, where the culture, the writing, and animation were all reflecting the diversity of Brazilian audiovisual production. Due to bureaucratic issues we, as an NGO, were refused access to development funds, and we got into a dispute with the Agência Nacional do Cinema. They had approached us with "What do you want? What do you need?" It was only when we said we wanted to make commercial productions that they agreed. So we wrote a large proposal for a national public policy for emerging Indigenous cinema, to map and evaluate contemporary production, and to create a portal for Brazilian Indigenous cinema, or better said: Indigenous Cinema in Brazil. We would also start a national competition for workshops that would produce a television series of twelve programs. The cinema agency immediately dedicated more than three million reais for the project, but then the bureaucratic battle over the finance package began. The decree, from President Dilma Rousseff, prohibited transferring resources to NGOs. We lost the funds. There were several rounds of meetings in Brasília and Minas Gerais, and ultimately, on the eve of Dilma's impeachment, the money was released by the end of the day—and then it was never talked about again. The tsunami had already hit the country. After we got the money, things picked up and took

shape, and I made some movies that had a lot of visibility. *Martírio* [2016] was a film I made before, during, and postimpeachment, a cruel portrait of Brazil. It utilizes footage that spans more than twenty years, documenting accounts of violence and the protests organized for the reclaiming of the sacred Guarani-Kaiowá territories starting in the 1980s. We were also invited to make a big installation at the São Paulo Bienal in 2016 called *O Brasil dos índios: Um arquivo aberto* [Indigenous Brazil: An open archive], which presented audiences with a space of immersion through videos of images, songs, and conversations from twenty Indigenous cultures.

ES I was going to tell you I saw *O Brasil dos índios* at the 32nd São Paulo Bienal, which you made with Ana Carvalho and Tita [Carelli] in 2016. I thought the layout of the installation with the three screens was very effective. The editing of the footage from various tribes highlighted their distinct cultures and approaches to self-representation while simultaneously drawing interesting commonalities between them. It was a condensed and yet very powerful introduction to different audiences of the work VNA has been producing for three decades. Now I would like to talk more about this relationship with the art world and its intersection with the work you were doing. When you were starting out, were you in contact with Solange Farkas at Videobrasil? Because it was an organization that was starting around more or less the same time as VNA did.

VC Yes.

ES Did you discuss the platform for spreading the work and ideas through Videobrasil?

VC Well, at the time, one of the fundamental projects, *O espírito da TV* [1990; The spirit of TV], was awarded a prize by Videobrasil, as was *A Arca dos Zo'é* [1993; Meeting the ancestors]. But it was very expensive, still is, to exist in the film world and art world. I did much more with the Indigenous movement than with the film world, I was always traveling to all the villages and I was always at the airport.

ES Do you still travel to visit Indigenous populations?

VC Yes, currently with the Gaviões, to do a feature called *Adeus Capitão* [Goodbye, Captain].

ES You are making it, or the people there are?

VC I am. It is part of a trilogy that I would like to do. *Corumbiara* [2009] is about the isolated peoples in Rondônia. This was a very personal filming experience. It focuses on the genocide of Indigenous populations in Rondônia and gives an account of the legal battle to preserve the territory in the Corumbiara municipality by searching for proof of survivors. *Martírio* is about the genocide of the Guarani-Kaiowá, and now *Adeus Capitão*. All tell stories of genocide, colonization was a genocide experience and is still happening . . .

ES And this one has a distributor in cinema?

VC Well, *Martírio* was shown in twenty-three cities in Brazil, but our audience isn't composed of cinemagoers, our audiences are usually accessing it through other means. We have a video platform "on demand" for our Vídeo nas Aldeias catalog on Vimeo. When the project surrounding Indigenous cinema failed and we were fighting to get our funds, we participated in a Brazilian Indigenous film festival, returning to the festival as a necessity. Making our own portal was very expensive, and we needed many resources from the cinema agency, so instead we've resorted to existing online platforms, especially if its purpose is more cultural than commercial, at least for the catalog of Vídeo nas Aldeias. We are waiting a bit to see if there will be a demand for our videos, but meanwhile we have at least made the catalog available.

ES So by way of concluding, what is the current state of VNA and your expectations for the future? How many villages are you working with now?

VC Because we no longer have international cooperation, we have a huge financial crisis and ended up with a collapsed country that has dismantled Lula's cultural policies. Dilma herself destroyed the whole prospect of state subsidies for culture. Since then, we have been stuck in a very precarious situation and had to reorganize our NGO as a commercial producer in order to gain access to cinema funds, to the Fundo Setorial do Audiovisual, but without the prospect of doing any formal training, it ended. Those who continue to receive the subsidized formal training, are projects getting compensation from bad companies that are destroying the reserves, like Companhia Vale do Rio Doce, a large mining company, and Eletronorte. We still continue to participate, and some of us worked with the Awa Guajá of Maranhão, the Guajajaras, and the Kayapó, but there has been a difficult backlash. Vale do Rio Doce, for example, wanted to censor films made by the Indigenous groups but had to give up in light of legal problems. I know we'll

probably demobilize everything by the end of the year[10] or next year, but we'll go out there and try. I'm trying to work with outside resources. We'll see, things fall apart, stop working, and persecution starts.

ES How many villages is VNA still working with? Do you have a school, or . . . ?

VC No, we're the distributor of their work, overseeing the catalog on Vimeo. We have good relationships with all of the villages, developing scripts, working with groups and such. This year I'm working with the Xikrin, and there's a big filming project for the Enawene in Mato Grosso, we have important recordings from there. And we are also doing an intense digitization project for recovered collections of the Indigenous groups from each town, which is meant to safeguard the collection. But what is going to change, what situations can develop under Brazil today? I wanted VNA to be a strong institution but it's not, it's completely precarious.

ES And the collection is based in your house, right?

VC Yes, we're returning to the 1980s, when we had the NGO at home. Without money, the main office had to be closed, things like that. It's a grim prospect; every day confirms our worst fears. Ultimately there is no future prospect of subsidizing training workshops, and I fear that everything will be over in the next year or year and a half. I'm not even sure if I'll stay in Brazil. I think they have already dismantled all the activities of the film agency. Cinema makes this government uncomfortable.

Notes

This interview was translated from the Portuguese by Sophia Serrano and Elena Shtromberg.

1 VNA's catalog of videos is currently available at http://www .videonasaldeias.org.br/2009/video.php.

2 In order to get additional funds for the Xikrin people, Friar Caron organized photo exhibitions focused on Indigenous peoples at the French Alliance, which Carelli frequented.

3 FUNAI is the Brazilian governmental agency in charge of Indigenous peoples' affairs.

4 Luiz Inácio Lula da Silva was the president of Brazil from 2003 to 2010.

5 See *Povos Indígenas no Brasil*, https://pib.socioambiental.org/pt /P%C3%A1gina_principal. For an English version, see *Povos Indígenas no Brasil*, https://pib.socioambiental.org/en/Main_Page.

6 The reference is to the Smithsonian National Museum of the American Indian's Film & Video Center and a published reference catalog that was drawn from festival programming; see Elizabeth Weatherford, ed., *Native Americans on Film and Video*, vol. 1 (New York: National Museum of the American Indian, 1981).

7 The Ateliers Varan association began informally in 1978 and then established an official workshop in Paris in 1981.

8 CLACPI is the oldest and largest Latin American organization for Indigenous film and media.

9 The program *A'Uwe* began in 2008.

10 This interview was conducted in April 2019.

Bibliography

Aargauer Kunsthaus and Centre d'Art Contemporain. *Ingrid Wildi: De palabra en palabra; Video Essays.* Exh. cat. Zürich: Edition Fink, 2004.

Abadia, Omaira. *Cronos Anárquico.* Exh. brochure. Bogotá: Galería Santa Fe, 1995.

———. *Effigies 98: Eidos–Imago.* Exh. brochure. Bogotá: Centro Colombo Americano, 1998.

———. *Obras/Works.* Exh. brochure. Bogotá: Galería Casa Cuadrada, 2001.

Academia Nacional de Bellas Artes. *Historia general del arte en la Argentina: XII.* Buenos Aires: Academia Nacional de Bellas Artes, 1982.

La acción y su registro II. Exh. cat. Buenos Aires: Fundación Federico Jorge Klemm, October/ November 2010.

Aceves Sepúlveda, Gabriela. "Imagining the Cyborg in Náhuatl: Reading the Videos of Pola Weiss through Haraway's Manifesto for Cyborgs." *Platform: Journal of New Media and Communication* 6, no. 2 (2015): 46–60. https:// platformjmc.files.wordpress .com/2015/10/sepulveda _platformvol6-2_2015.pdf.

———. "'Mujeres que se visualizan': (En)Gendering Archives and Regimes of Media and Visuality in Post-1968 Mexico." PhD diss., University of British Columbia, 2014.

———. "The Utopian Impulse in the Videos of Pola Weiss." In *Performing Utopias in the Contemporary Americas*, edited by Alessandra Santos and Kim Beauchesne, 283–300. New York: Palgrave Macmillan, 2017.

———. *Women Made Visible: Feminist Art and Media in Post-1968 Mexico City.* Lincoln: University of Nebraska Press, 2019.

Aceves Sepúlveda, Gabriela, and Sarah Shamash. "Feminizing Oswald De Andrade's 'Manifesto Antropófago' and Vasconcelos' *Raza Cosmica*: The Videos of Sonia Andrade and Pola Weiss." In "Mestizo Technology: Art, Design, and Technoscience in Latin America," edited by Paula Gaetano Adi and Gustavo Crembil. Special issue, *Media-N: Journal of the New Media Caucus* 12, no. 1 (2016): 12–19.

Acha, Juan. "El Video." *Arte en Colombia*, no. 16 (1981): 32–37.

Acosta, Daniel. *Tecnológico 2: Espadas de doble filo; 8 de abril al 14 de mayo 2003.* Exh. cat. San José: TEOR/éTica, 2003.

Acuña Ortega, Víctor Hugo, Alexandra Ortiz Wallner, and Dominique Ratton Pérez, eds. *Virginia Pérez-Ratton: Travesía por un estrecho dudoso = Transit through a Doubtful Strait.* San José: TEOR/éTica, 2012.

Adams Fernández, Carmen. "Instalaciones y nuevas formas expresivas en el arte chileno." *De Arte* 1 (2002): 145–51.

Adrenalina: A imagem em movimento no século XXI. Exh. cat. São Paulo: Red Bull Station, 2015.

Adrian Melis: The Value of Absence. Exh. cat. Barcelona: adngaleria ediciones, 2013.

Aedo, Tania. "(ready)Media: Towards an Archaeology of Media and Invention in Mexico." In *Proceedings of the 16th International Symposium on Electronic Art*, edited by Judith Funke, Stefan Riekeles, and Andreas Broeckmann, 322–23. Berlin: Revolver, 2010.

Aedo, Tania, and Liliana Quintero. *Tekhné 1.0: Arte, pensamiento y tecnología; Antología.* Mexico City: CONACULTA-CENART, 2004.

Aguerre, Enrique. "La condición vídeo 2.0 (25 años de videoarte en el Uruguay)." In *Vídeo en Latinoamérica: Una historia crítica*, edited by Laura Baigorri, 213–26. Madrid: Brumaria, 2008.

———. "NUVA–Núcleo Uruguayo de Video Arte." *ARTE:08* (March 2005): 50–52.

Aguerre, Enrique, and Fernando Álvarez Cozzi. *La condición vídeo: 25 años de videoarte en el Uruguay.* Exh. cat. Montevideo: Centro Cultural de España Montevideo, 2007.

———. *Interfaces: Abril–mayo de 2001.* Exh. cat. Montevideo: DobleEmme, 2001.

Aguilar, Gonzalo. "Televisión y la vida privada." In *História de la vida privada en la Argentina*, vol. 3, *La Argentina entre multitudes y soledades, de los años treinta a la actualidad*, edited by Fernando Devoto and Marta Madero. Buenos Aires: Taurus, 2000.

Albán, Jorge. "Desaceleraciones en el videoarte: Arte medial centroamericano." *Revista Escena* 31, no. 63 (2008): 69–76.

Almeida de Paula, Arethusa. "Imagem em movimento e movimento da imagem: Vídeoarte na coleção de Regina Vater." *PÓS* 4, no. 8 (2014): 66–81.

Alonso, Rodrigo. "Arte y tecnología en Argentina: Los primeros años." *Leonardo Electronic Almanac* 13, no. 4 (2005): 16–22.

———. *Elogio de la Low-Tech: Historia y estética de las artes electrónicas en América Latina.* Buenos Aires: Luna Editores, 2015.

——. "From Tango to Video Dance: Dance for the Camera in Argentina." Presented at Dance for the Camera Symposium, University of Wisconsin–Madison, 2000. http://www.roalonso.net/en/videoarte/tango.php.

——. "Hacia una genealogía del videoarte argentino." In *Vídeo en Latinoamérica: Una historia crítica*, edited by Laura Baigorri, 13–26. Madrid: Brumaria, 2008.

——. "Hazañas y peripecias del video arte en Argentina." *Cuadernos de cine argentino*, 3, Innovaciones estéticas y narrativas en los textos audiovisuales (Buenos Aires: Instituto Nacional de Cine y Artes Audiovisuales, 2005).

——. "Las primeras experiencias de videoarte en Argentina." *Avances* 1, no. 2 (1998–99).

——. "Zona de turbulencia: Video arte de Latinoamérica." http://www.roalonso.net/es/videoarte/turbulencia.php#.

Alonso, Rodrigo, and Graciela Taquini. *Buenos Aires Video X: Diez años de video en Buenos Aires*. Buenos Aires: ICI Centro Cultural de España, AECI Agencia Española de Cooperación Internacional, 1999.

Altunaga, Rewell, ed. *El extremo de la bala: Una década de arte cubano*. Exh. cat. Havana: Asociación Hermanos Saíz, 2011.

Alvarado, Narda, ed. *El videoarte en Bolivia: Aproximaciones teóricas y videografía*. La Paz: [Gobierno Autónomo Municipal de La Paz], 2010.

Álvarez, Esteban, ed. *Documentos para un futuro imperfecto*. Exh. cat. Bogotá: Alcaldía Mayor de Bogotá and Fundación Gilberto Alzate Avendaño, 2011.

Alvear, Miguel, ed. *Mecánica popular: Obras y proyectos = Popular Mechanics: Works and Projects [1989–2013]*. Exh. cat. Quito: Centro de Arte Contemporáneo, 2013.

Ana María Millán. Bogotá: UBS Enfoques, 2006.

Annemarie Heinrich: Intenciones secretas; Génesis de la liberación femenina en sus fotografías vintage = Secret Intentions: Genesis of Womens' Liberation in Her Vintage Photographs. Exh. cat. [Buenos Aires]: Museo de Arte Latinoamericano de Buenos Aires, 2015.

Anti-Personnel Mines Project: Installation by Carlos Trilnick = Proyecto minas anti-personas: Instalación por Carlos Trilnick. San Diego: gallery@calit2, 16 June 2009.

Aravena Abughosh, Claudia. *Proyecto Palestina*. Exh. cat. Santiago: Galería Gabriela Mistral, 2006.

Aravena, Claudia, and Ivan Pinto. *Visiones laterales: Cine y video experimental en Chile (1957–2017)*. Santiago: Ediciones Metales Pesados, 2018.

Ardila Luna, Oscar Mauricio, ed. *Erinnerungsfelder = Campos de memoria*. Exh. cat. Bogotá: Fundación Gilberto Alzate Avendaño, 2013.

Arriola Ranc, Magali. "The Sweet Burnt Smell of History: A Self-Reflexive Analysis on the Conception of the 8th Panama Biennial." Master's thesis, University of California, San Diego, 2009.

Arroyo Cella, Chiara, ed. *Yoshua Okon*. Exh. cat. Mexico: Landucci, 2010.

Artagaveytia, Verónica. *Arte*. N.d.

——. *Vida*. N.d.

ARTEACTUAL 2011. Quito: Arte Actual–FLACSO Ecuador, 2011.

ARTEACTUAL Registro 08. Quito: Arte Actual–FLACSO Ecuador, 2008.

ARTEACTUAL Registro 2007. Quito: Arte Actual–FLACSO Sede Ecuador, 2007.

ARTEACTUAL Registro 2009–2010. Quito: Arte Actual–FLACSO Ecuador, 2009.

ARTEACTUAL Registro 2012. Quito: Arte Actual–FLACSO Sede Ecuador, 2013.

Asociación Artico and Fundación Hivos. *Museo Rodante*. [Costa Rica]: n.p., 2002.

Associação Cultural Videobrasil, ed. *Caderno Videobrasil 1: Performance*. São Paulo: Associação Cultural Videobrasil, 2005.

——, ed. *Videobrasil: Três décadas de vídeo, arte, encontros e transformações*. São Paulo: Edições Sesc, 2015.

Aufderheide, Pat. "'You See the World of the Other and You Look at Your Own': The Evolution of the Video in the Villages Project," *Journal of Film and Video* 60, no. 2 (2008): 28–29.

Baigorri, Laura. "Vídeo en Latinoamérica: Entretejiendo memorias." In *Vídeo en Latinoamérica: Una historia crítica*, edited by Laura Baigorri, 7–9. Madrid: Brumaria, 2008.

——, ed. *Vídeo en Latinoamérica: Una historia crítica*. Madrid: Brumaria, 2008.

——. *Vídeo: Primera etapa; El vídeo en el contexto social y artístico de los años 60/70*. Madrid: Brumaria, 2007.

Baltar, Brígida, and Marcelo Campos. *E agora toda terra é barro*. Exh. brochure. Fortaleza: Centro Cultural Banco do Nordeste de Fortaleza, 2009.

——. *Brígida Baltar: O que é preciso para voar*. Rio de Janeiro: Aeroplano / Oi Futuro, 2011.

Bambozzi, Lucas. *Balmoral*. Exh. brochure. Künstlerhaus Schloss Balmoral, 2007.

——. *O gabinete de Alice: Imersão e interação em um projeto experimental*. Exh. brochure. Salvador: Museu de Arte da Bahia, 2014.

——. *Livro das panorâmicas que não cabem em livro*. São Paulo: Diphusa Mídia Digital e Arte, 2013.

Banz, Stefan, ed. *Shadows Collide with People: Gianni Motti, Shahryar Nashat, Marco Poloni, Ingrid Wildi*. Exh. cat. Zürich: Edition Fink, 2005.

Barreto, Meykén. "El puzzle infinito: Volver siempre al video." http://meykenbarreto.com/el-puzzle-infinito-volver-siempre-al-video.

Bäuerle Rivera, Germán. *El video popular en Chile hoy: Catastro y diagnóstico del video de base, 1994*. Santiago: Eco, Education y Comunicaciones, 1994.

Bayá Bolti, Cecilia. "Videoarte en Bolivia." In *Vídeo en Latinoamérica: Una historia crítica*, edited by Laura Baigorri, 41–48. Madrid: Brumaria, 2008.

Bentancur, Patricia. *Clemente Padín*. Exh. cat. Montevideo: Banco Central de Uruguay, 2006.

——. *Memories/On in Itself: Drawings, Photographs and Videos*. Exh. cat. Malmo: Galleri Rostrum, 2009.

Bessa, Antonio Sergio, ed. *Art Is Our Last Hope: Paulo Bruscky*. New York: Bronx Museum of the Arts, 2014.

——, ed. *Poesia viva: Paulo Bruscky*. São Paulo: Cosac Naify/APC, 2015.

Biblioteca Luis Angel Arango, ed. *TransHistorias: Historia y mito en la obra de José Alejandro Restrepo*. Exh. cat. Bogotá: Banco de la República, 2001.

Bienal de Artes Mediales. *Autonomía: 11 Bienal de Artes Mediales*. Santiago: Museo Nacional de Bellas Artes, 2014.

Bienal de Artes Visuales del Istmo Centroamericano, Carlos Cañas Dinarte, and Museo de Arte de El Salvador, eds. *V Bienal de Artes Visuales del Istmo Centroamericano*. San Salvador: MARTE, 2006.

Bienal de Fotografía de Lima: 2014. Exh. cat. Lima: Ediciones Centro de la Imagen, 2014.

Bienal de La Habana. *8 Bienal de La Habana: El arte con la vida*. Exh. cat. Havana: Centro de Arte Contemporáneo Wifredo Lam and Consejo Nacional de las Artes Plásticas, 2003.

——. *Novena Bienal de La Habana, 2006: Dinámicas de la cultura urbana*. Exh. cat. Havana: Centro de Arte Contemporáneo Wifredo Lam and Consejo Nacional de las Artes Plásticas, 2006.

Bienal de La Habana and Wanda Canals Fleitas, eds. *Oncena Bienal de La Habana, 2012*. Exh. cat. Havana: Centro de Arte Contemporáneo Wifredo Lam, Artecubano Ediciones, and Consejo Nacional de las Artes Plásticas, 2012.

Bienal de La Habana, Nelson Herrera Ysla, and Lourdes A. Ricardo Suárez, eds. *Séptima bienal de la Habana 2000*. Exh. cat. Havana: Centro de Arte Contemporáneo Wifredo Lam and Consejo Nacional de las Artes Plásticas, 2000.

Bienal de La Habana, Rubén del Valle Lantarón, and Isabel María Pérez Pérez, eds. *Décima Bienal de La Habana 2009: Integración y resistencia en la era global*. [Havana]: Artecubano Ediciones, Centro de Arte Contemporáneo Wifredo Lam, and Consejo Nacional de las Artes Plásticas, 2009.

Bienal de la imagen en movimiento. Exh. program. Buenos Aires: Universidad Nacional Tres de Febrero, 29 October to 4 November 2012.

Bienal de la imagen en movimiento, Andrés Denegri, and Gabriela Golder, eds. *Bienal de la imagen en movimiento: Catálogo 2014*. Exh. cat. Buenos Aires: EDUNTREF, 2014.

——, eds. *Bienal de la imagen en movimiento: Memoria 2012*. Exh. cat. Buenos Aires: EDUNTREF, 2014.

Bienal de Montevideo, Alfons Hug, Paz Aburto Guevara, and Patricia Bentancur, eds. *1.a Bienal de Montevideo: El gran sur = 1st Montevideo Biennial: The Great South*. Exh. cat. Montevideo: Banco de la República, 2012.

Bienal de Video y Artes Mediales and Enrique Rivera Gallardo, eds. *9º Bienal de Video y Artes Mediales: Resistencia*. Exh. cat. Santiago: n.p., 2010.

Bienal de Video y Artes Mediales et al, eds. *Deus ex media: 10 bienal de video y artes mediales, Chile 2012*. Exh. cat. N.p.: 2012.

Bienal de Video y Nuevos Medios. *Autonomía: 11 Bienal de Artes Mediales*. Exh. cat. Santiago: Museo Nacional de Bellas Artes, 2013.

Bienal de Video y Nuevos Medios and Museo de Arte Contemporáneo. *8ª bienal de Video y Nuevos Medios de Santiago: Ciudad, ciudadanos y ciudadanías*. Exh. cat. Santiago: n.p., 2007.

Bienal de Video y Nuevos Medios, Museo de Arte Contemporáneo, Universidad de Chile, and Facultad de Artes. *Quinta Bienal de Video y Nuevos Medios: Noviembre de 2001*. Exh. cat. [Santiago]: Patrocinadores, Gobierno de Chile, Ministerio de Educación, División de Cultura, 2001.

Bienal Iberoamericana Inquieta Imagen and Museo de Arte y Diseño Contemporáneo. *Bienal Iberoamericana Inquieta Imagen V*. San José: Museo de Arte y Diseño Contemporáneo, 2008.

La Biennale di Venezia: 49. Esposizione internazionale d'arte: Platea dell'umanità = Plateau of Humankind = Plateau der Menschheit = Plateau de l'humanité. Exh. cat. Milan: Electa, 2001.

Blondet, José Luis, et al. *A Universal History of Infamy*. Exh.

cat. Los Angeles: Los Angeles County Museum of Art, 2018.

Bonet, Eugeni. *En torno al video.* Barcelona: Gustavo Gili, 1980.

———. "El VII Encuentro Internacional de Video en la Fundación Miró." *Zoom: Revista de la Imágen* 5 (1977).

Botella Diez del Corral, Ana, ed. *Emergentes.* Exh. cat. Gijón, Spain: LABoral, Centro de Arte y Creación Industrial, 2008.

Brasil, André, Marília Rocha, and Sérgio Borges, eds. *Teia: 2002–2012.* Belo Horizonte: Teia, 2012.

Bruscky, Paulo. *Arte e multimeios = Art and Multimedia = Arte y multimedios.* Edited by Cristiana Tejo. Recife: Zolu, 1998.

———, ed. *Vicente do Rego Monteiro: Poeta, tipógrafo, pintor.* Recife: CEPE, 2004.

Bruscky, Paulo, and Adolfo Montejo Navas. *Poiesis Bruscky.* São Paulo: Cosac Naify, APC, 2013.

Bruscky, Paulo, Marília Andrés Ribeiro, and Fernando Pedro da Silva. *Paulo Bruscky: Depoimento.* Belo Horizonte: Circuito Atelier, 2011.

Bueno, Patricia. *Patricia Bueno: Videos.* Lima: n.p., 2014.

Buenos Aires Monte-VIDEO 1989. Exh. brochure. Buenos Aires: Instituto de Cooperación Iberoamericana, May 1989.

Buenos Aires video: Catálogo. Buenos Aires: Instituto de Cooperación Iberoamericana, 1993.

Buenos Aires video: 5 años en 5 días. Exh. brochure. Buenos Aires: Instituto de Cooperación Iberoamericana, March 1989.

Buenos Aires video en Montevideo. Exh. brochure. N.p.: Instituto de Cooperación Iberoamericana, 26 May 1990.

"*Buenos Aires video en Montevideo.*" Poster. N.p.: Instituto de Cooperación Iberoamericana, 5–7 May, n.d.

Buenos Aires video II: Un año en tres días. Buenos Aires: Instituto de Cooperación Iberoamericana, March 1990.

Buenos Aires Video III. Exh. brochure. Buenos Aires: Instituto de Cooperación Iberoamericana, April 1991.

Burga, Teresa. *Teresa Burga: Informes, esquemas, intervalos 17.9.10.* Exh. cat. Lima: Instituto Cultural Peruano Norteamericano, 2011.

Bursztyn, Feliza, Bernardo Salcedo, and Jorge Jaramillo Jaramillo. *Bursztyn Salcedo: Demostraciones.* Bogotá: Fundación Gilberto Alzate Avendaño, 2007.

Calderón, Elkin, ed. *Colombia, el riesgo es que te quieras quedar . . . = Colombia: The Risk Is Wanting to Stay . . .* Bogotá: Cain Press, 2013.

Calvo, Ernesto. "¿Videocreación en Centroamérica?: Eppur se mueve." In *Vídeo en Latinoamérica: Una historia crítica,* edited by Laura Baigorri, 91–101. Madrid: Brumaria, 2008.

Calvo, Ernesto, and María José Monge. "New Technologies in Central American Contemporary Art: A Partial Archaeology and Some Critical Appreciations from the Institutional Realm." *Third Text* 23, no. 3 (2009): 281–92.

Camnitzer, Luis. *Conceptualism in Latin American Art: Didactics of Liberation.* Austin: University of Texas Press, 2007.

Campuzano, Giuseppe. *Saturday night thriller y otros escritos, 1998–2013.* Edited by Miguel A. López. Lima: Estruendomudo, 2013.

Capote, Iván, Gerardo Mosquere, Cylena Simonds, and Institute of International Visual Arts. *States of Exchange: Artists from Cuba = Estados de intercambio: Artistas de Cuba.* London: Iniva, 2008.

Carelli, Vincent. "Another Look, a New Image." In *Vídeo nas Aldeias, 25 anos: 1986–2011,* edited by Ana Carvalho, Ernesto Ignacio de Carvalho, and Vincent Carelli, 197–200. Exh. cat. Olinda: Vídeo nas Aldeias, 2011.

"Carlos Trilnick: Ciclos; Video-instalación." Exh. postcard. Córdoba, Argentina: Centro de Arte Contemporáneo Córdoba, n.d.

Carlos Trilnick: Todos somos iguales bajo la piel; Video-instalación. Exh. brochure. Buenos Aires: Espacio de Arte Amia, August 2010.

Carrion, Caroline, and Rudolf Schmitz. *Eccoci!: Berna Reale.* Exh. cat. [Belém do Pará]: [RM Graph e Editora], 2015.

Casa França-Brasil. *Dias & Riedweg: Histórias frias e chapa quente.* Exh. cat. Rio de Janeiro: Casa França-Brasil, 2014.

Casas, Ricardo, and Graciela Dacosta. *Diez años de video uruguayo.* Exh. cat. Montevideo: GEGA, 1996.

Castañer López, Xesqui. "Video Art by Mexican Women Artists in the 21st Century: Context and Dissemination." *Review of Arts and Humanities* 4, no. 1 (2015): 80–90.

Castillo de Huarmey: El Mausoleo Imperial Wari. Exh. brochure. Lima: Museo de Arte de Lima, 2014.

Castro, Jorge, ed. *Sudamérica Electrónica: Vol. 07 Colombia; Una red de representaciones electrónicas contemporáneas.* Exh. cat. Bogotá: Fundación Gilberto Alzate Avendaño, 2012.

Catálogo general de exposiciones en la Galería Santa Fe y otros espacios. Exh. cat. Bogotá: Alcaldía Mayor de Bogotá and Galería Santa Fe, 2006.

Catálogo general de exposiciones en la Galería Santa Fe y otros espacios. Bogotá: Alcaldía Mayor de Bogotá and Galería Santa Fe, 2007.

Catálogo general de exposiciones en la Galería Santa Fe y otros espacios, 2009. Exh. cat. Bogotá: Alcaldía Mayor de Bogotá and Galería Santa Fe, 2009.

CAYC. *Alternative Video: Museum of Modern Art Study Conference, Open Circuits: The Future of Television.* Program. New York: Museum of Modern Art, 19 January 1974.

——. *Video Arte: 8th International Video Art Festival*. Exh. cat. Lima: n.p., 1977.

——. *Video Art 1978: X International Open Encounter on Video*. Exh. cat. Buenos Aires: CAYC, 1978.

CAYC and Fundació Joan Miró. *VII Encuentro Internacional de Video*. Exh. brochure. N.p.: n.d.

——. *Seventh Open International Encounter, Barcelona*. Exh. cat. Buenos Aires: Ediciones Argentinas, 1977.

CAYC and MACC. *1977 Video: Encuentro Internacional de Video*. Exh. cat. Caracas: Ediciones Amon, 1977.

Cenni, Roberto, ed. *10. Videobrasil: Festival Internacional de Arte Eletrônica*. Exh. cat. São Paulo: Videobrasil, 1994.

Centro Colombo Americano. *1er Salón Colombiano de Video-Arte*. Exh. cat. Bogotá: ESCALA, 1989.

Centro Cultural de España. *Nuevos Medios 2008*. Exh. cat. Montevideo: Centro Cultural de España Montevideo, 2008.

——. *Nuevos Medios 2010*. Exh. cat. Montevideo: Centro Cultural de España Montevideo, 2010.

Centro Cultural Recoleta and Universidad Maimónides. *Recorridos: Arte, ciencia y tecnología*. Exh. cat. Buenos Aires: Universidad Maimónides / Centro Cultural Recoleta, 2012.

Charalambos, Gilles. "Colombia videoartística: Apuntes básicos sobre algunos aspectos problemáticos del videoarte en Colombia." In *Vídeo en Latinoamérica: Una historia crítica*, edited by Laura Baigorri, 117–27. Madrid: Brumaria, 2008.

Charalambos, Gilles, and Nasly Boude Figueredo. "Aproximación a una historia del videoarte en Colombia." http://www.bitio.net/vac/contenido/historia/index.html.

Chaves, Marcos, Sonia Barreto, and Alberto Saraiva. *Marcos Chaves*. Exh. cat. Rio de Janeiro: Aeroplano Editora / Oi Futuro, 2008.

Christ, Hans D., and Iris Dressler, eds. *Subversive Practices: Art under Conditions of Political Repression, 60s–80s, South America, Europe = Subversive praktiken: Kunst unter bedingungen politischer repression 60er–80er, Sudamerika, Europa*. Exh. cat. Ostfildern, Germany: Hatje Cantz, 2010.

Ciclo de video arte: Un recorrido antológico por la obra de Carlos Trilnick. Exh. brochure. Buenos Aires: Museo de Arte Moderno de Buenos Aires, 27 October 2008.

Concurso de Arte Eduardo León Jimenes and Grupo León Jimenes. *Mitos y realidades del Caribe contemporáneo: Catálogo de obras 2002*. Exh. cat. Santiago de los Caballeros, Dominican Republic: Grupo León Jimenes, 2002.

Cooperativa de Arte en Video et al. "Recopilación del maratón mexicano de arte en video." DVD, 85 min. Mexico City: Cooperativa de Arte en Video, 2009.

Copello, Francis David. *Fotografía de performance: Análisis autobiográfico de mis performances*. Santiago: Ocho Libros, 2000.

Cornejo, Kency. "Indigeneity and Decolonial Seeing in Contemporary Art of Guatemala." *Fuse Magazine* 36, no. 4 (2013): 24–31.

Correa Vigier, José. *Cossette Zeno: Antología 1951–2014*. Exh. brochure. Caguas, Puerto Rico: Museo de Arte de Caguas, 2015.

Corredor-Matheos, J. "Festival Internacional de Video." *Destino*, no. 2057 (3–9 March 1977).

Costa, Helouise, ed. *Sem medo da vertigem: Rafael França*. Exh. cat. São Paulo: Marca D'Agua, 1997.

Cozier, Christopher, and Tatiana Flores. *Wrestling with the Image: Caribbean Interventions*. N.p.: Artzpub / Draconian Switch, 2010.

Creatividad = Capital: Segundo Encuentro Iberoamericano de Arte, Trabajo y Economía. Quito: Arte Actual—FLACSO Ecuador, 2012.

Crivelli Visconti, Jacopo, ed. *Do corte: Pablo Lobato*. Exh. cat. São Paulo: Ipsis Gráfica e Editora, 2012.

Crouch, Robert, and Ciara Ennis, eds. *Juan Downey: Radiant Nature*. Exh. cat. Claremont, CA: Pitzer College Art Galleries, 2017.

Un cuerpo ambulante: Sergio Zevallos en El Grupo Chaclacayo (1982–1994). Exh. brochure. Lima: Museo de Arte de Lima, 2014.

D'Amico, Margarita. "La bohemia hipermediática: La Imagen—Arte de Video 1975." http://labohemiahipermediatica.weebly.com/festival-de-videoarte.html.

——. "Video Internacional en Buenos Aires." *El Nacional* (Caracas), 14 December 1975.

Debroise, Olivier, ed. *La era de la discrepancia: Arte y cultura visual en México 1968–1997*. Exh. cat. Mexico City: UNAM, 2006.

De frente y de perfil: Retratos antropológicos en México y Ecuador. Exh. cat. Quito: FLACSO—Sede Ecuador, 2010.

De Jesus, Eduardo, ed. *Arte e novas espacialidades: Relaçoes contemporaneas = Art and New Spacialities: Contemporary Relations*. Exh. cat. Rio de Janeiro: F10 Editora / Oi Futuro, 2011.

——. *Circuito Audiovisual Minas Gerais*. Exh. booklet. N.p.: 2006.

——. "Electronic Image: Identities and the Experience of Globalisation in the International Festival of Electronic Art—Videobrasil." *Third Text* 23, no. 3 (2009): 269–79.

——. "Interview [with Ernesto Salmerón]." *Videobrasil* (December 2004). http://site.videobrasil.org.br/dossier/textos/542048/1777212.

De la adversidad ¡Vivimos! 1 Encuentro Iberamericano sobre arte, trabajo y economía. Quito: Arte Actual—FLACSO Ecuador, 2011.

Delfín, Mauricio, and Miguel Zegarra. "Electronic Art in Peru: The Discovery of an Invisible Territory in the Country of the Incas." *Third Text* 23, no. 3 (2009): 294–301.

Delgado Masse, Cecilia, and Sol Henaro, eds. *Sarah Minter: Ojo en rotación; Imágenes en movimiento 1981–2015 = Rotating Eye; Images in Motion 1981–2015.* Mexico: Museo Universitario Arte Contemporáneo, UNAM, 2015.

Democracy in Communication: A Video Festival of Work Made by Latin American and U.S. Latino Independent Producers. Exh. booklet. N.p.: International Media Resource Exchange, 1992.

Denegri, Andrés. *Aurora: Instalaciones fílmicas.* Exh. brochure. Salta, Argentina: Museo de Bellas Artes de Salta, 8 May to 4 July 2015.

Denegri, Andrés, and Gabriela Golder. *Catálogo BIM 2014.* Exh. cat. Buenos Aires: Universidad Nacional de Tres de Febrero, 2015.

Denegri, Andrés, and Jorge La Ferla. *Cine de exposición: Instalaciones fílmicas de Andrés Denegri.* Exh. cat. Buenos Aires: Fundación OSDE, 2013.

El día electrónico: Arte y tecnología en el Museo Emilio A. Caraffa. Exh. booklet. Córdoba, Argentina: Museo Emilio A. Caraffa, June 1993.

Diálogos con lo cotidiano: Carlos Trilnick. Exh. brochure. Rosario, Argentina: Museo de la Memoria, 23 March–31 May 2015.

Diario de Pernambuco. "Artistas postais vão ao ar hoje pela Rádio Clube." 2 June 1979.

Dias, Antonio, ed. *Antonio Dias: [Trabalhos = Works 1965–1999].* N.p.: Cosac & Naify, 1999.

Díaz Bringas, Tamara, ed. *Situaciones artísticas latinoamericanas.* San José: TEOR/éTica, 2005.

Díaz Bringas, Tamara, and Virginia Pérez-Ratton, eds. *Situaciones artísticas latinoamericanas II: Arte crítico y crisis del arte; Seminario internacional.* San José: TEOR/éTica, 2007.

Dinamarca, Hernán. *El video en América Latina: Actor innovador del espacio audiovisual.* Santiago: Centro El Canelo de Nos: ArteCien, 1991.

Ditrén, María Elena, José Rafael Lantigua, and Michèle Dalmace. *Arte + medioambiente: Primera Trienal Internacional del Caribe, Santo Domingo 2010 = Art and Environment: I International Triennial of the Caribbean, Santo Domingo 2010 = Art et environnement: I Triennale Internationale de la Caraïbe, Santo-Domingue 2010.* Exh. cat. Santo Domingo: Museo de Arte Moderno, 2010.

Domschke, Gisela, Lucas Bambozzi, and Margot Pavan, eds. *LABMOVEL 2012–2014.* São Paulo: Edições Diphusa, 2014.

Donoso, Claudia, and Paz Errázuriz. *La manzana de Adán.* Santiago: Fundación AMA, 2014.

Downey, Juan. *Juan Downey: With Energy Beyond These Walls = Con energía más allá de estos muros.* Valencia: IVAM Centre del Carme, 1998.

Duarte, Luisa. *Rodrigo Cass.* Exh. cat. São Paulo: Galeria Fortes Vilhaça, 2014.

Die Ecke Arte Contemporáneo, ed. *Recreaciones: Claudia Joskowicz.* Exh. cat. Santiago: Die Ecke Arte Contemporáneo, 2015.

Emergencia: Contextos volcánicos. Exh. brochure. San José: TEOR/éTica, 2014.

En construcción. Exh. cat. Quito: Arte Actual—FLACSO Ecuador, 2007.

"Encuentro de Video Arte harán en Banco Continental." *La Prensa, Lima,* 6 September 1977.

Enrique Ježik: Lines of Division. Exh. cat. El Paso: Stanlee and Gerald Rubin Center for the Visual Arts, 2011.

En torno a En torno al video. Exh. cat. Vitoria, Spain: Museo Centro Cultural Montehermoso, 2010.

Entre concreto. Exh. brochure. San José: TEOR/éTica, n.d.

"En 24 televisores proyectan muestra 'video arte.'" *La Prensa, Lima,* 27 August 1976.

ERRATA#: Revista de artes visuales. Vols. 3–7. Bogotá: Fundación Gilberto Alzate Avendaño, 2010–12.

Escenas de los '80: Los primeros años. Exh. brochure. Buenos Aires: Fundación Proa, November 2003.

Espacio Fundación Telefónica. *Televisión: El Di Tella y un episodio en la historia de la TV.* Exh. cat. Buenos Aires: Espacio Fundación Telefónica, 2011.

Estevez, Ruth, ed. *La Trampa—Edgardo Aragón = The Trap—Edgardo Aragón.* Los Angeles: Misprint Press, 2013.

Experiencias de la carne: Encuentro de performance 2011. Exh. brochure. Lima: elgalpon.espacio, 2011.

Experimenta Colombia: Festival Latinoamericano de Artes Electrónicas; Version 1.0—Catálogo de Videos. Exh. cat. Bogotá: n.p., 2005.

Fajardo-Hill, Cecilia, and Andrea Giunta, eds. *Radical Women: Latin American Art, 1960–1985.* Exh. cat. Los Angeles: Hammer Museum, 2017.

Farkas, Solange Oliveira. *15° Festival Internacional de Arte Electronica Videobrasil = 15th Videobrasil International Electronic Art Festival.* São Paulo: Associação Cultural Videobrasil, 2005.

Farkas, Solange Oliveira, Gabriel Bogossian, Luisa Duarte, and Miguel A. López, eds. *21a Bienal de Arte Contemporânea SESC_Videobrasil: Comunidades imaginadas = 21st Contemporary Art Biennial: Imagined Communities.* Exh. cat. São Paulo: SESC—Serviço social do comércio / Associação Cultural Videobrasil, 2019.

Farkas, Solange Oliveira, and Helio Hara, eds. *13. Festival Internacional de Arte Eletrônica: Videobrasil.* Exh. cat. São Paulo: SESC / Associação Cultural Videobrasil, 2001.

Farkas, Solange Oliveira, and Alfredo Volpi. *Coleção MAM-BA: 50 anos de arte brasileira = MAM-BA Collection: 50 Years of Brazilian Art.* Exh. cat. Salvador: Museu de Arte da Bahia, 2010.

Fernández, María, ed. *Latin American Modernisms and Technology.* Trenton, NJ: Africa World Press, 2018.

Fernando 'Coco' Bedoya: Lima/ Buenos Aires 1979–1999. Exh. brochure. Lima: Museo de Arte de Lima, 2014.

Ferrer, Claudia. "Hacia una genealogía del videoarte en México: Década de los 70." Master's thesis, Universidad Nacional Autónoma de México, 2017.

Ferry, Stephen. *Violentología: Un manual del conflicto colombiano.* Bogotá: Icono, 2012.

Festival Franco Chileno de Video Arte. *I Festival Franco Latinoamericano de Video Arte.* Exh. cat. Santiago: Museo Nacional de Bellas Artes, 1992.

———. *II Festival Franco Latinoamericano de Video Arte.* Exh. cat. Santiago: Museo Nacional de Bellas Artes, 1993.

———. *III Festival Franco Latinoamericano de Video Arte, XII Festival Franco Chileno de Video Arte.* Exh. cat. Santiago: Museo Nacional de Bellas Artes, 1994.

———. *IX Festival Franco-Chileno de Video-Arte = IX Festival francochilien d'art video.* [Santiago]: Museo Nacional de Bellas Artes, 1989.

———. *X Festival Franco/Chileno de Video/Arte.* [Santiago]: Festival Franco-Chileno de Video Arte, 1990.

———. *XI Festival Franco-Chileno de Video Arte 1991.* Santiago: n.p., 1991.

Festival Internacional Video Danza and Rodrigo Alonso. *Quinto Festival Internacional Video Danza: (Buenos Aires) '99.*

Buenos Aires: Universidad de Buenos Aires, Secretaría de Extensión Universitaria, Centro Cultural Ricardo Rojas, 1999.

Fetzer, Fanni, ed. *Dias & Riedweg.* Exh. cat. Zurich: JRP/Ringier, 2014.

Figueiredo, Luciano, ed. *Sonia Andrade, vídeos 2005–1974.* Exh. cat. Rio de Janeiro: Centro Cultural Banco do Brasil, 2005.

Filmoteca de Andalucía, Museo Nacional Centro de Arte Reina Sofía, and Centro Galego de Artes da Imaxe. *Panorama del vídeo de creación en América Latina.* Granada: Filmoteca de Andalucía, 1993.

Fin del mundo. Exh. brochure. Córdoba, Argentina: Centro Cultural de España en Córdoba, 22 May 2003.

First Latin American and Caribbean Video Art Competition and Exhibit, 2003. https://issuu .com/idb_publications/docs /_en_7822.

Flusser, Vilém. *Gestures.* Translated by Nancy Ann Roth. Minneapolis: University of Minnesota, 2014. Originally published in German as *Gesten: Versuch einer Phänomenologie.* Braunschweig: Bollmann, 1991.

Forch, Juan. *Animitas: Templos de Chile.* Santiago: Cuarto Propio, 2003.

IV Encuentro Latinoamericano de Video: Catálogo de la II Muestra Latinoamericana de Video. [Lima]: Asociación de Video de Lima, 1992.

La fotografía después de la fotografía. Exh. brochure. Lima: Museo de Arte Contemporáneo Lima, 2014.

Fuentes Guaza, Luisa. *Lenguajes contemporáneos desde Centro América = Contemporary Languages from Centro América.* Madrid: Turner, 2013.

Fuentes Rodríguez, Elvis, ed. *Rewind . . . Rewind . . . : Video-arte puertorriqueño.* Exh. cat. San Juan: Instituto de Cultura Puertorriqueña, 2005.

Fundación de Arte Contemporáneo. *05982:04 Lost Highway.*

Exh. brochure. Montevideo: Fundación de Arte Contemporáneo, July 2009.

———. *Jessie Young: Obra Reciente.* Exh. brochure. Montevideo: Fundación de Arte Contemporáneo, n.d.

Fundación ICO. *Lo que las imagenes quieren: Vídeo desde Hispanoamérica.* Exh. cat. Madrid: Fundación ICO, 2007.

Fundación Telefónica. *Magnetica: Propuestas para el próximo milenio.* Exh. cat. Santiago: Sala de Arte Fundación Telefónica, 2000.

Fusco, Coco. *Internal Exile: New Films and Videos from Chile.* Exh. cat. New York: Third World Newsreel, 1990.

Galaz, Gaspar, and Milan Ivelic. "El video arte en Chile (Un nuevo soporte artístico)." *Aisthesis* 19 (1986): 5–21.

Galeno, Claudio, Paz López, and Jocelyn Muñoz. *Ensayos sobre artes visuales: Prácticas y discursos de los años 70 y 80 en Chile. Volumen IV.* Santiago: LOM Ediciones, 2015.

Garavelli, Clara. "Viaje caleidoscópico: Acercamiento a la escena del video experimental en Rosario." *Anuario: Registro de acciones artísticas, Rosario* (2010): 154.

———. *Video experimental argentino contemporáneo: Una cartografía crítica.* Buenos Aires: Universidad Nacional de Tres de Febrero, 2014.

———. "El video experimental en Argentina y sus procesos (2000–2010)." PhD diss., Universidad Autónoma de Madrid, 2012.

García, Isabel. "The Video Archive, Chile." *Artlink* 27, no. 2 (2007): 28–29.

Garcia, Maria Claudia. *Inmemorial: Óscar Muñoz.* Exh. cat. Bogotá: Republic of Colombia, Ministry of Foreign Affairs, 2010.

García Ramos, Marialina, and Meykén Barreto Querol. "Radiografía de una imagen indócil (Diagnóstico para un trazado de la historia

del videoarte en Cuba)." In *Vídeo en Latinoamérica: Una historia crítica*, edited by Laura Baigorri, 129–37. Madrid: Brumaria, 2008.

García Waldman, Alexandra, and Antonio Dias, eds. *Antonio Dias*. São Paulo: Associação para o Patronato Contemporâneo, 2015.

Geometrías de la turbulencia: Vídeo de Carlos Trilnick. Exh. brochure. Buenos Aires: Museo Nacional de Bellas Artes, 4 May 2000.

Gilbert, Zanna. "Mediating Menesundas: Marta Minujín from Informalismo to Media Art." In *Marta Minujín: Menesunda Reloaded*, edited by Helga Christoffersen and Massimiliano Gioni, 10–35. New York: New Museum, 2019.

Gilbert, Zanna, and Cristiana Tejo. *Daniel Santiago: De que é que eu tenho medo?* Recife: Museu de Arte Moderna Aloisio Magalhães, 2012.

Giralt-Miracle, Daniel. "Barcelona, Capital del Video Alternativo." *Batik* 32 (March 1977).

———. "VII Festival Internacional de Video." *Guadalimar* 2, no. 21 (March 1977).

Giunta, Andrea. *Avant-garde, Internationalism, and Politics: Argentine Art in the Sixties*. Durham, NC: Duke University Press, 2007.

Glenda León: Cada sonido es una forma del tiempo. Artist's book.

Glusberg, Jorge. "Arte y cibernética." In *Primera muestra del Centro de Estudios de Arte y Comunicación de la Fundación de Investigación Interdisciplinaria presentada en la Galería Bonino de Buenos Aires*. Exh. cat. Buenos Aires: Centro de Estudios de Arte y Comunicación, 1969.

———. *Ediciones Tercermundo presenta CAYC video alternativo*. [Buenos Aires]: [Centro de Arte y Comunicación], 1974.

———. "Introducción: Videoarte; Una comunicación creativa." In *I Bienal Internacional de Video-Arte*. Exh. cat. Medellín: Museo de Arte Moderno de Medellín, 1985.

———. "1977 Symposium on Video and Communication, Barcelona, Spain." *Leonardo* 11, no. 811 (1978).

———. "Vida y milagros del videoarte." In *Video Arte Internacional: Buenos Aires 1990*, n.p. Exh. cat. Buenos Aires: Museo Nacional de Bellas Artes, Asociación Argentina de Críticos de Arte, and Instituto de Cooperación Iberoamericana, 1990.

———. "Video in Latin America." In *The New Television: A Public/Private Art, Essays, Statements, and Videotapes, Based on "Open Circuits: An International Conference on the Future of Television,"* edited by Douglas Davis and Allison Simmons, 203–5. Cambridge, MA: MIT Press, 1977.

Glusberg, Jorge, and Laura Buccellato, eds. *Video arte internacional: Buenos Aires 1990*. Exh. cat. Buenos Aires: Museo Nacional de Bellas Artes / Asociación Argentina Criticos de Arte Instituto, 1990.

Godoy Vega, Francisco. "Cuerpos que manchan, cuerpos correccionales: Sedimentación y fractura de la escritura de/sobre arte en Chile en 1980." In Felipe Baeza, José Parra, Amalia Cross, and Francisco Godoy Vega, *Ensayos sobre artes visuales: Prácticas y discursos de los años 70 y 80 en Chile. Volumen II*. Santiago: LOM Ediciones, 2011.

Goic, Andrea. *Maruri Tour*. Santiago: Máquina de Comunicar Ediciones, 2013.

———. *Video Tremens: Entre fantasía y realidad*. Santiago: Máquina de Comunicar Ediciones, 2010.

Golder, Gabriela, and Andrés Denegri, eds. *Ejercicios de memoria: Reflexiones sobre el horror a 30 anos del Golpe (1976.2006)*. Caseros, Argentina: EDUNTREF, 2007.

Gómez-Barris, Macarena. "The Occupied Forest." *Afterall: A Journal of Art, Context and Enquiry* 49 (2020): 101–6.

González, Julieta. "Beyond Technology: Juan Downey's Whole Earth." *Afterall: A Journal of Art, Context and Enquiry* 37 (2014): 17–27.

González, Julieta, Sharon Lerner, Jacopo Crivelli Visconti, and Andrea Giunta. *Memories of Underdevelopment: Art and the Decolonial Turn in Latin America, 1960–1985 = Memorias del subdesarrollo: Arte y el giro descolonial en América Latina, 1960–1985*. Exh. cat. San Diego: Museum of Contemporary Art San Diego, 2018.

González, Julieta, and Arely Ramírez Moyao, eds. *Juan Downey: Una utopía de la comunicación = A Communications Utopia*. Exh. cat. Mexico City: Fundación Olga y Rufino Tamayo, AC, 2013.

González Duque, Lucía. "Musa paradisíaca: José Alejandro Restrepo." *Arcadia* 100, 27 February 2014, 51.

Groenenboom, Roland. *Funk Staden: Dias & Riedweg*. Exh. cat. Middelburg: De Vleeshal, 2008.

Grüner, Eduardo, and Bérénice Reynaud. *Leandro Katz: Arrebatos, diagonales y rupturas*. Exh. cat. Buenos Aires: Espacio Fundación Telefónica, 2013.

Grupo Proceso Pentágono: Políticas de la intervención 1969–1976–2015. Exh. cat. Mexico City: Museo Universitário Arte Contemporáneo, UNAM, 2015.

Guimarães, Cao, and Moacir dos Anjos. *Cao*. Exh. cat. São Paulo: Cosac Naify, 2015.

Guimarães, Cao, and Teodoro Rennó Assunção. *Histórias do não-ver*. Belo Horizonte: C. Guimarães, 2001.

Gurfinkel, Inbal Miller, and Edgar Alejandro Hernández, eds. *Déjà vu: Celda contemporánea, 2004/2007*. Exh. cat. Mexico City: Promotora Cultural Cubo Blanco A.C., 2014.

Gutiérrez, Laura G. "Mexican Nationalism, Mass Media, and Gender/Sexuality: Unmasking Lies in Ximena Cuevas' Video Art." *Latin American Literary*

Review 29, no. 57 (2001): 104–15.

Hamilton, Patrick, Mónica Carballas, and Guillermo Machuca. *Video otra vez: Once muestras de video arte contemporáneo.* Exh. cat. Santiago: Ediciones Metales Pesados, 2010.

Helena Producciones. *CoCo Show*, no. 1 (n.d.).

——, ed. *Cumbre Cartagena de Indias.* Cali: Helena Producciones, 2011.

——. *8 Festival de Performance de Cali: Programa de mano.* Exh. program. 2012.

——, ed. *Festival de Performance de Cali-Colombia.* Exh. cat. Cali: Helena Producciones, 2006.

——. *Monte Oscuro 1897*, no. 1 (2009).

Henaro, Sol. *Melquiades Herrera.* Mexico City: Alias, 2014.

Hernández Calvo, Max. "Towards a Video Art Scene in Peru." In *El mañana fue hoy: 21 años de videocreación y arte electrónico en el Perú (1995–2016) = The Future Was Now: 21 Years of Video and Electronic Art in Peru (1995–2016)*, edited by Max Hernández Calvo, José-Carlos Mariátegui, and Jorge Villacorta, 316–27. Lima: Alta Tecnología Andina, 2018.

Hernández Calvo, Max, José-Carlos Mariátegui, and Jorge Villacorta, eds. *El mañana fue hoy: 21 años de videocreación y arte electrónico en el Perú (1995–2016) = The Future Was Now: 21 Years of Video and Electronic Art in Peru (1995–2016).* Lima: Alta Tecnología Andina, 2018.

Hernández Calvo, Max, and Jorge Villacorta. *Franquicias imaginarias: Las opciones estéticas en las artes plásticas en el Perú de fin de siglo.* Lima: Pontificia Universidad Católica del Perú, Fondo Editorial, 2002.

Hernández Campos, José Alberto. *Entre 4 paredes.* Artist's book. San José: TEOR/éTica, 2003.

Hernández Chong Cuy, Sofía. "Yoshua Okón." In *Blanton Museum of Art: Latin American Collection*, edited by Gabriel

Pérez-Barreiro, 304–5. Austin: University of Texas Press, 2006.

Hernández Hernández, Pablo. *Imagen-palabra: Lugar, sujeción y mirada en las artes visuales centroamericanas.* San José: Arlekín, 2012.

Hernández Miranda, Dante. *Pola Weiss: Pionera del videoarte en México.* Mexico City: D. Hernández Miranda, 2000.

Herrera, María José, and Kristina Newhouse, eds. *David Lamelas: A Life of Their Own.* Exh. cat. Long Beach: University Art Museum, College of the Arts, California State University, Long Beach, 2017.

Herrera Ysla, Nelson, and Humberto Díaz. *Humberto Díaz: Installations.* N.p.: n.d.

High, Kathy, ed. *Risk = Riesgo.* New York: Standby Program, Inc., 2003.

Historias del video: 3 seminarios sobre videoarte. Program. Bogotá: Museo de Arte Moderno de Bogotá, n.d.

Hoffmann, Nancy, and Frank Verputten, eds. *Who More Sci-Fi than Us? Contemporary Art from the Caribbean.* Exh. cat. Amsterdam: KIT Publishers, 2012.

Huberman, Anthony, et al., eds. *Mexico City: An Exhibition about the Exchange Rates of Bodies and Values.* Exh. cat. Long Island City: P.S. 1 Contemporary Art Center, 2002.

Iberoamérica: Últimas tendencias; Música por ordenador y videoarte. Exh. program. Madrid: Amigos de la Residencia de Estudiantes, 19 December 1989.

"Ícaro Zorbar." Exh. cat. San José: TEOR/éTica, 2009.

IDB Cultural Center. *V Inter-American Biennial of Video Art.* Exh. cat. Washington, DC: Inter-American Development Bank, 2010.

Imágen magnética. Invitation. Bogotá: Cinemateca Distrital, 1991.

Injerto urbano: Proyectos de injerción urbana para la ciudad de Quito. Quito: Arte Actual— FLACSO Ecuador, 2010.

Instituto Chileno Francés de Cultura. *Catálogo Cuarto Encuentro Franco-Chileno de Video Arte.* Exh. cat. Santiago: Servicio Cultural de la Embajada de Francia / Instituto Chileno Francés de Cultura.

——. *Catálogo Décimo Festival Franco-Chileno de Video Arte.* Exh. cat. Santiago: Servicio Cultural de la Embajada de Francia / Instituto Chileno Francés de Cultura, 1990.

——. *Catálogo Primer Encuentro Franco-Chileno de Video Arte.* Exh. cat. Santiago: Servicio Cultural de la Embajada de Francia / Instituto Chileno Francés de Cultura, 1981.

——. *Catálogo Segundo Encuentro Franco-Chileno de Video Arte.* Exh. cat. Santiago: Servicio Cultural de la Embajada de Francia / Instituto Chileno Francés de Cultura, 1982.

——. *Catálogo Sexto Festival Franco-Chileno de Video Arte.* Exh. cat. Santiago: Servicio Cultural de la Embajada de Francia / Instituto Chileno Francés de Cultura, 1986.

——. *Catálogo Tercer Encuentro Franco-Chileno de Video-Arte.* Exh. cat. Santiago: Servicio Cultural de la Embajada de Francia / Instituto Chileno Francés de Cultura, 1983.

Instituto Cultural Itaú. *On_off: Experiências em live image.* Exh. cat. São Paulo: Itaú Cultural, 2009.

Instituto de Cultura Puertorriqueña, ed. *Imagine r Survivor: Rabindranat Díaz-Cardona.* Exh. cat. San Juan: Instituto de Cultura Puertorriqueña, 2014.

——, ed. *Muestra Nacional de Arte 2013.* Exh. cat. San Juan: Instituto de Cultura Puertorriqueña, 2013.

——, ed. *Renuncias y adopciones: Fronteras en la pintura puertorriqueña contemporánea.* Exh. cat. San Juan: Instituto de Cultura Puertorriqueña, 2014.

——. *16a Edición de la Muestra Nacional de Artes.* Exh. cat. San Juan: Instituto de Cultura Puertorriqueña, 2015.

Inter-American Development Bank. *Flow: Economies of the Look and Creativity in Contemporary Art from the Caribbean.* Exh. cat. Washington, DC: Inter-American Development Bank, 2014.

Interconnect@ Between Attention and Immersion: Medienkunst aus Brasilien. Exh. cat. Karlsruhe: ZKM — Zentrum für Kunst und Medientechnologie Karlsruhe, 2006.

"Internacional Video Arte 1." Recife: 20 Festival de Inverno Unicap, 15 August 1979.

"International Exhibition of Mail Art = Exposição Internacional de Arte Correio." *ENCICLOPÉDIA Itaú Cultural de Arte e Cultura Brasileira.* São Paulo: Itaú Cultural, n.d. http://enciclopedia.itaucultural.org.br/evento634166/exposicao-internacional-de-arte-correio.

Itinerância Videobrasil = Itinerancia Videobrasil = Videobrasil on Tour, 2006–2007. São Paulo: Associação Cultural Videobrasil, 2006.

It's Mine: Baltazar Torres. Exh. brochure. San José: TEOR/éTica, 2005.

Jager, Maarten, ed. *Tropisch Koninkrijk: Hedendaagse kunst van Aruba, Curaçao, St. Maarten, Bonaire, Saba en St. Eustatius.* Exh. cat. Zwolle: Museum de Fundatie, 2013.

Jara Cobo, David. *Somos los que estamos.* Exh. brochure. 2009.

Jaremtchuk, Dária, and Fabrícia Jordão, eds. *Paulo Bruscky em movimento.* Exh. cat. São Paulo: n.p., 2014.

Jarpa, Voluspa. *No-History's Library: The Backyard Edition; Chile, Argentina, Uruguay, Brazil.* N.p.: 2015.

Jasso, Karla, ed. *Possessing Nature: Tania Candiani, Luis Felipe Ortega.* Exh. cat. Mexico City: Instituto Nacional de Bellas Artes y Literatura, 2015.

Jasso, Karla, and Daniel Garza Usabiaga, eds. *(Ready) Media: Hacia una arqueología de los medios y la invención en México.* Exh. cat. Mexico City:

Instituto Nacional de Bellas Artes y Literatura, 2012.

Jungle, Tadeu. *Tadeu Jungle: Videofotopoesia.* Exh. cat. Rio de Janeiro: F10 Editora / Oi Futuro, 2014.

Katzenstein, Inés. "Marta Minujín's *Minucode* Code and Context." In *Marta Minujín: Minucodes,* edited by Gabriela Rangel. New York: Americas Society, 2015.

Kay, Ronald. *Tentativa Artaud.* Exh. cat. Santiago: Museo Nacional de Bellas Artes, 2008.

Kelley, Bill, Jr., and Rebecca Zamora, eds. *Talking to Action: Art, Pedagogy, and Activism in the Americas.* Exh. cat. Chicago: University of Chicago Press, 2017.

Kronfle Chambers, Rodolfo. *1998–2009: Historia(s)_ en el arte contemporáneo del Ecuador.* [Guayaquil]: Río Revuelto Ediciones, 2009.

La Ferla, Jorge, ed. *Carlos Trilnick.* Bogotá: Editorial Pontificia Universidad Javeriana de Bogotá, 2007.

———. *Cine, video y multimedia: la ruptura de lo audiovisual.* Buenos Aires: Universidad de Buenos Aires, 2001.

———, ed. *Contaminaciones: Del videoarte al multimedia.* Buenos Aires: Centro Cultural Rojas, 1997.

———, ed. *Historia crítica del video argentino.* Buenos Aires: MALBA-Fundación Eduardo F. Costantini and Fundación Telefónica, 2008.

———, ed. *Medios audiovisuales: Ontología, historia y praxis; Cine, TV, video, instalaciones, multimedia.* Buenos Aires: Eudeba, 1999.

La Ferla, Jorge, and Mariela Cantú, eds. *Video argentino. Ensayos sobre cuatro autores: Carlos Trilnick, Arteproteico, Marcello Mercado, Iván Marino.* Buenos Aires: Nueva Librería, 2007.

La Ferla, Jorge, and Sofía Reynal, eds. *Territorios audiovisuales: Cine, video, televisión, documental, instalación, nuevas tecnologías, paisajes mediáticos.*

Buenos Aires: Libraria Ediciones, 2012.

Labiano, Estela. *Nuevo catálogo de espiecies: Dibujos.* Exh. brochure. Buenos Aires: Museo de Artes Plásticas Eduardo Sívori, 2014.

Lagnado, Lisette, and Daniela Castro, eds. *Laura Lima on_off.* Rio de Janeiro: Cobogó, 2014.

Latina! New Film & Video from Argentina, Chile and Mexico. Exh. booklet. Sydney: Museum of Contemporary Art Sydney, June 1993.

Lauria, Adriana. *Besos brujos: Homenaje a Alberto Greco.* Exh. booklet. Buenos Aires: Fundación Federico Jorge Klemm, 2015.

Lemos de Sá Galeria de Arte. *Fotografia e natureza.* Exh. cat. Nova Lima, Brazil: Lemos de Sá Galeria de Arte, 2015.

Lerner, Jesse, and Rubén Ortiz Torres, eds. *How to Read El Pato Pascual: Disney's Latin America and Latin America's Disney = Para leer al Pato Pascual: La América Latina de Disney y el Disney de América Latina.* Exh. cat. London: Black Dog Publishing Limited, 2017.

Lerner, Jesse, and Luciano Piazza, eds. *Ismo, Ismo, Ismo: Cine experimental en América Latina = Ism, Ism, Ism: Experimental Cinema in Latin America.* Oakland: University of California Press, 2017.

Lerner, Sharon, ed. *Arte contemporáneo: Colección Museo de Arte de Lima.* Lima: Asociación Museo de Arte, 2013.

Light Factory and University of Colorado Art Galleries. *Cuban Allure: Photography and Video.* Exh. cat. Charlotte: Light Factory, 2000.

Lima Oliva, A. de. *Visions from the South: A Travelling Exhibition of Independent Cinema and Video from Argentina-Brazil-Chile = Miradas desde el Sur: Muestra itinerante de cine y video independientes, de Argentina-Brasil-Chile = Olhares do Sul: Mostra itinerante da produção independente de films e vídeos.*

Exh. cat. Buenos Aires: Fundación Antorchas, 1996.

Liñero Arend, Germán. *Apuntes para una historia del video en Chile.* Santiago: Ocho Libros, 2010.

Lista, Marcella, and Musée du Louvre. *Corps étrangers: Danse, dessin, film: Francis Bacon, William Forsythe, Peter Welz, Sonia Andrade, Samuel Beckett, Edgar Degas, Eugène Delacroix, Hohann Heinrich Füseli, Charles Le Brun, Bruce Nauman, Kazuo Ohno.* Lyon: Fage, 2006.

Llanos, Fernando. "Arte en video: Antes, ahora y después . . . aquí." *La Revista, El Universal,* n.d. http://www.fllanos.com /txt/larevista.html.

———, ed. *Felipe Ehrenberg.* Exh. cat. Mexico City: Editorial Diamantina, 2007.

———. "Vídeo mexicano actual: Un hoy sin ayer y un ayer con un mañana." In *Vídeo en Latinoamérica: Una historia crítica,* edited by Laura Baigorri, 169–77. Madrid: Brumaria, 2008.

Llanos, Fernando, and Museo de Arte Contemporáneo Alfredo Zalce. *Videoman: Catálogo de la exhibición de Fernando Llanos.* Exh. cat. Mexico City: Ediciones Necias, 2008.

Lobato, Pablo. *Rua.* São Paulo: Ipsis Gráfica e Editora, 2016.

Lockward, Alanna. *Apremio: Apuntes sobre el pensamiento y la creación contemporánea desde el Caribe.* Murcia: Cendeac, 2006.

———. "Disolvencias y yuxtaposiciones: Ecos para un relato polifónico en materia de videoarte desde Haití, Puerto Rico y República Dominicana." In *Vídeo en Latinoamérica: Una historia crítica,* edited by Laura Baigorri, 81–87. Madrid: Brumaria, 2008.

———. "Towards a Utopian Archeology; Moving-Image, Decolonization and Continuities in Haiti, Puerto Rico and the Dominican Republic."

https://alannalockward.files .wordpress.com/2010/11/maya -deren-meshes.jpg.

Longoni, Ana, and Fernanda Carvajal, eds. *Minuphone, 1967–2010.* [Buenos Aires]: Espacio Fundación Telefónica, 2010.

Longoni, Ana, Jesse Lerner, and Mariano Mestman. *Leandro Katz.* Buenos Aires: Fundación Espigas, 2013.

López, Miguel, ed. *Caderno Sesc_Videobrasil 11: Alianças de corpos vulneráveis; Feminismos, ativismo bicha e cultura visual.* São Paulo: Edições Sesc, 2015.

———, ed. *Un cuerpo ambulante: Sergio Zevallos en el Grupo Chaclacayo (1982–1994) = A Wandering Body: Sergio Zevallos in the Grupo Chaclacayo (1982–1994).* Exh. cat. Lima: Museo de Arte de Lima, 2014.

López, Miguel, et al. *Líneas, palabras, cosas: Luz María Bedoya.* Exh. cat. Lima: ICPNA, 2014.

López, Miguel, and Agustín Pérez Rubio, eds. *Teresa Burga: Estructuras de aire = Structures of Air.* Buenos Aires: MALBA Fundación Eduardo F. Costantini, 2015.

Lora, Félix Manuel. *Encuadre de una identidad audiovisual: Evolución y perspectivas en República Dominicana.* Santo Domingo: Valdivia, 2007.

Lucas, Martín, ed. *Marta Minujín: Happenings, Performances.* Buenos Aires: Ministerio de Cultura, 2015.

Lucas Bambozzi: O espaço entre nós e os outros. Exh. brochure. Mexico City: Laboratorio Arte Alameda, 2011.

Macchiavello, Carla. "The Power of Pink: Performing the Archive in the Works of Ernesto Salmerón." *E-Misférica: After Truth* 7, no. 2 (2010).

Machado, Arlindo. "El arte del vídeo en Brazil." In *Vídeo en Latinoamérica: Una historia crítica,* edited by Laura Baigorri, 53–60. Madrid: Brumaria, 2008.

———, ed. *Made in Brasil: Três décadas do vídeo brasileiro = Three*

Decades of Brazilian Video. Exh. cat. São Paulo: Itaú Cultural, 2007.

———. "Video Art: The Brazilian Adventure." *Leonardo* 29, no. 3 (1996): 225–31.

Maciel, Katia, and Berta M. Sichel, eds. *Cinema sim: Narrativas e projeções.* São Paulo: Itaú Cultural, 2008.

Mader Paladino, Luiza. "Exhibition Trajectories: The *Grupo de Los Trece* at the Museu de Arte Contemporânea da Universidade de São Paulo." *Caiana: Revista de Historia del Arte y Cultura Visual del Centro Argentino de Investigadores de Arte* 11, 2nd semester (2017): 129–34.

Madrid Letelier, Alberto. *Gabinete de lectura: Poesía visual chilena.* Santiago: Ediciones Metales Pesados, 2011.

The Making of Miguel Angel Ríos: Landlocked. Tempe: Arizona State University Art Museum, 2016.

Manguel, Alberto, and Adolfo Castañón. *La aventura imperdible.* Edited by Cristóbal Zapata. Cuenca: Casa de la Cultura Núcleo del Azuay, 2014.

"Marathon." *Artes Visuales* 17 (Spring 1978): 50. (The Spanish-language original, titled "Maraton," is on 28.)

Mariátegui, José-Carlos. "Background: The Beginnings of Video and Electronic Media in Peru." In *El mañana fue hoy: 21 años de videocreación y arte electrónico en el Perú (1995–2016) = The Future Was Now: 21 Years of Video and Electronic Art in Peru (1995–2016),* edited by Max Hernández Calvo, José-Carlos Mariátegui, and Jorge Villacorta, 308–15. Lima: Alta Tecnología Andina, 2018.

———. "Días de videoarte: Una intensa década de videoarte en el Perú." In *Vídeo en Latinoamérica: Una historia crítica,* edited by Laura Baigorri, 201–9. Madrid: Brumaria, 2008.

———. *Disruptive, Expandable and Planetarian: Technology in Arts*

and Culture in Latin America. Booklet. [Amsterdam]: Prince Claus Fund, n.d.

——. *Emergentes: Itinerancia Argentina, Brasil, Chile, Colombia, México, Perú.* Exh. cat. Buenos Aires: Espacio Fundación Telefónica, 2008.

——. "The Influx of a Video and Electronic Art Festival in Peru." In *El mañana fue hoy: 21 años de videocreación y arte electrónico en el Perú (1995–2016) = The Future Was Now: 21 Years of Video and Electronic Art in Peru (1995–2016)*, edited by Max Hernández Calvo, José-Carlos Mariátegui, and Jorge Villacorta, 330–39. Lima: Alta Tecnología Andina, 2018.

——, ed. *Perú/video/arte/ electrónico: Memorias del Festival Internacional de Video/Arte/Electrónica.* Exh. cat. [Lima]: Alta Tecnología Andina, 2003.

——. "Video-arte-electrónico en el Perú." *Butaca sanmarquina* 4, no. 11 (2002): 20–22.

Mariátegui, José-Carlos, and Jorge Villacorta. "Insular Areas of Media Creativity in Latin America: Initial Findings on Art, Science and Technology in Groups and Non-Represented Areas of Latin America." [Lima]: Alta Tecnología Andina, 2004.

Mariátegui, José-Carlos, and Miguel Zegarra. *Vía satélite: Panorama de la fotografía y el video en el Perú contemporáneo.* Exh. cat. Buenos Aires: Espacio Fundación Telefónica, 2005.

Marino, Iván, and Claudia Giannetti. *Ivan Marino: Tampoco [Nor in This Case].* Exh. cat. Badajoz: Museo Extremeño e Iberoamericano de Arte Contemporáneo, 2009.

Marisy, Luisa. "Avance rápido: Una vez más." *Arte Cubano,* no. 1 (2009): 23–32.

Marta Minujín: Comunicando con tierra. Exh. brochure. Buenos Aires: Galería Henrique Faria, 2014.

Martínez Valladares, María Manuela, Ana María Vass Avendaño, and Marcelino Bisbal. *Videoarte: Expresión de la posmodernidad; Una tecnología mass-mediática aplicada al arte.* Caracas: Fundación Carlos Eduardo Frías, 1997.

Martinho, Teté, and Solange Farkas, eds. *Videobrasil: Três décadas de vídeo, arte, encontros e transformações.* São Paulo: Edições Sesc, 2015.

Massetti, Claudio, and Rodrigo Alonso, eds. *Grata con otros: Muestra antológica de Graciela Taquini.* Exh. cat. Buenos Aires: Centro Cultural Recoleta, 2011.

Mazzoldi, Bruno. *Verme dormido: Jobs de Benjamín, Derrida y Restrepo.* Exh. booklet. Bogotá: Tercer Mundo Editores, 2007.

McGrew, Rebecca, and Terri Geis, eds. *Prometheus 2017: Four Artists from Mexico Revisit Orozco.* Exh. cat. Claremont, CA: Pomona College Museum of Art, 2017.

Medeiros, Virgínia de. *Studio Butterfly.* [São Paulo]: Eloísa Cartonera na Bienal de São Paulo [for Dulcinéia Catadora], 2006.

Meijer-Werner, Alexandra, Luis Angel Duque, and Glenda Dorta. *Alexandra Meijer-Werner: Luz sobre luz.* Exh. cat. Caracas: Museo de Arte Contemporáneo, 2006.

Mello, Christine. *Extremidades do vídeo.* São Paulo: Editora SENAC São Paulo, 2008.

Memoria RAM / Reminiscencia visual: Video intervención y vi deo performance. Exh. brochure. Córdoba, Argentina: Archivo Provincial de la Memoria, June 2010.

Mercado, Marcello. *Bitte Abstand Halten = Please Keep Distance.* N.p.: Marcello Mercado, 2015.

——. *From 9H to 9B.* N.p.: Marcello Mercado, 2014.

Mesías Maiguashca: Los sonidos posibles. Exh. brochure. Quito: Centro Experimental Oído Salvaje, 2013.

Mes iberoamericano Uruguay. Exh. brochure. Buenos Aires:

Instituto de Cooperación Iberoamericana, November 1992.

Mezza, Gonzalo, Margarita Schultz, and Justo Pastor Mellado. *[infinidade]: I Virtual Museum Project; Gonzalo Mezza.* Exh. cat. São Paulo: Caixa Cultural São Paulo—Galeria Vitrine da Paulista / Rio de Janeiro: Caixa Cultural Rio de Janeiro—Galeria 2, 2010.

Mignolo, Walter D., Freya Schiwy, and Nelson Maldonado Torres. *(Des)colonialidad del ser y del saber: Videos indígenas y los límites coloniales de la izquierda en Bolivia.* Buenos Aires: Ediciones del signo, 2006.

Minter, Sarah. "A vuelo de pájaro, el vídeo en México: Sus inicios y su contexto." In *Vídeo en Latinoamérica: Una historia crítica,* edited by Laura Baigorri, 159–67. Madrid: Brumaria, 2008.

Moarquech Ferrera-Balanquet, Raúl. "Videoarte transnacional Latino en EEUU-Canadá: 1960–2007." In *Vídeo en Latinoamérica: Una historia crítica,* edited by Laura Baigorri, 151–56. Madrid: Brumaria, 2008.

Modé, João. *Algumas coisas Que Estão comigo.* Exh. cat. Rio de Janeiro: A Gentil Carioca, 2015.

Moncayo, María Belén. "Al Zur-Rich Encuentro de Arte Urbano." In *LatinArt.com: An Online Journal of Art and Culture.* http://www.latinart.com/spanish/aiview.cfm?start=3&id=352.

——. "Ecuador: Improntas mediales desde el no-lugar." In *Vídeo en Latinoamérica: Una historia crítica,* edited by Laura Baigorri, 141–48. Madrid: Brumaria, 2008.

——, ed. *Ecuador 1929–2011: 100 artistas del audiovisual experimental = 100 Experimental Audiovisual Artists.* Quito: Associación Archivo Nuevos Medios Ecuador, 2011.

——. "Poderes Propios: Entrevista a Jhoffre Flores." *Revista Katalizador,* no. 1 (2004).

——. "Robando el fuego de los dioses." 2005.

——. "Solamente para visionarios." *Ocho y Medio*, no. 90 (February 2009): 5.

——. "Video y performance de Jenny Jaramillo: 'La idea y el actor soy yo mismo.'" N.d.

Monterroso, Sandra. "Del arte político a la opción decolonial en el arte contemporáneo guatemalteco." *Iberoamérica Social: Revista-Red de Estudios Sociales* 3, no. 5 (2015): 127–35.

Montes, Francisca. *Vahído: Consideraciones espaciales y temporales sobre la Latitud 33*. Exh. brochure. Santiago: Die Ecke Arte Contemporáneo, 2015.

Morais, Frederico. *Las artes plasticas en la América Latina: Del trance a lo transitorio*. Havana: Casa de las Américas, 1990.

Moreira, Rubén Alejandro. *Cuerpo de motivos: Panorámica plástica de Martín García Rivera (1980–2014)*. Exh. cat. San Juan: Instituto de Cultura Puertorriqueña, [2014].

Mosaka, Tumelo, ed. *Infinite Island: Contemporary Caribbean Art*. Exh. cat. New York: Brooklyn Museum in association with Philip Wilson, 2007.

Motta, Carlos. *Carlos Motta: La buena vida = The Good Life*. Exh. cat. Bogotá: Fundación Gilberto Alzate Avendaño, 2009.

Moulin, Fabíola, and Marconi Drummond, eds. *Lupa: Ensaios Audiovisuais*. Exh. booklet. N.p.: Minas Gerais Audiovisual Expo, 2016.

——, eds. *Lupa: Ensaios Audiovisuais; Envelope Investigativo*. Exh. booklet. Minas Gerais Audiovisual Expo, 2016.

Moura, Sabrina, ed. *Panoramas do Sul: Leituras; Perspectivas para outras geografias do pensamento = Southern Panoramas: Readings; Perspectives for Other Geographies of Thought*. São Paulo: Edições Sesc, 2015.

Moure, Fernando. "Sopa paraguaya: Recetario híbrido para una videografía." In *Vídeo en Latinoamérica: Una historia crítica*, edited by Laura Baigorri, 183–96. Madrid: Brumaria, 2008.

Moya Barrios, Daleysi. "Videocreación en Cuba: Las generaciones encontradas." Master's thesis, Universidad de La Habana, 2014.

Muestra VIDEOARDE. Exh. program. Quito: Universidad Andina Simón Bolívar, 2009.

Multitude: Quando a arte se soma à multidão. Exh. brochure. São Paulo: SESC Pompeia, 2014.

Munder, Heike, ed. *Resistance Performed: An Anthology on Aesthetic Strategies under Repressive Regimes in Latin America*. Zurich: Migros Museum für Gegenwartskunst, 2015.

——, ed. *Teresa Burga: Aleatory Structures*. Exh. cat. Zurich: Migros Museum für Gegenwartskunst & JRP/Ringier in collaboration with Kestner Gesellschaft, 2018.

Murphy, Benjamin. "Juan Downey's Ethnographic Present." *ARTMargins* 6, no. 3 (2017): 28–49.

Museo de Arte Contemporáneo de Monterrey. *Oscar Muñoz*. Exh. cat. Monterrey: Museo de Arte Contemporáneo de Monterrey, 2014.

Museo de Arte de Caguas. *El juego de la diferencia: Penúltima imagen de la fotografía y el video in Santo Domingo*. Exh. cat. [Caguas, Puerto Rico]: Museo de Arte de Caguas, 2007.

Museo de Arte Latinoamericano de Buenos Aires. *Políticas de la diferencia, arte iberoamericano fin de siglo: Museo de Arte Latinoamericano de Buenos Aires—Colección Constantini*. [Valencia]: Generalitat Valenciana, [2001].

Museo de Arte Latinoamericano de Buenos Aires and Fundación Espigas. *Arte y documento: Fundación Espigas 1993–2003 = Art and Document: Fundación Espigas 1993–2003*. Exh. cat. Buenos Aires: MALBA Colección Constantini, 2003.

Museo de Arte y Diseño Contemporáneo. *Inquieta imagen 2011*. Exh. cat. San José: Museo de Arte y Diseño Contemporáneo, 2011.

——. *Memoria audiovisual 2002–2004*. Exh. cat. San José: Museo de Arte y Diseño Contemporáneo, 2004.

——. *Memoria audiovisual 2005: 4ta muestra Controamericana de Videocreación y Arte Digital; Inquieta imagen: Espacios a la experimentacion IV*. Exh. cat. San José: Museo de Arte y Diseño Contemporáneo, 2005.

Museo Nacional de Artes Visuales de Montevideo. *Centenario del MNAV*. Montevideo: Museo Nacional de Artes Visuales, 2011.

Museum of Modern Art. *Video from Latin America at MoMA*. Press release. New York: MoMA, 1981.

Nobis, Norbert, Petra Oelschlägel, and Wiebert Rauschert, eds. *Kunst aus Costa Rica: Die expressionistischen Tendenzen. . . .* Exh. cat. Hannover: Sprengel Museum, 1992.

Noorthoorn, Victoria, ed. *Marta Minujín: Obras 1959–1989*. Exh. cat. Buenos Aires: MALBA, 2010.

Nuevas realizaciónes en video. Program. Buenos Aires: Centro Cultural General San Martín, April 1987.

Observatório de Favelas, ed. *Travessias 2: Arte contemporânea na maré*. Exh. cat. Rio de Janeiro: Observatório de Favelas, 2013.

Occupying, Building, Thinking: Poetic and Discursive Perpectives on Contemporary Cuban Video Art (1990–2010). Exh. brochure. Tampa: UCF Contemporary Art Museum, 2013.

Ochoa, Tomás. *Relatos transversales: Una curaduría de María Fernanda Cartagena*. Quito: Centro de Arte Contemporáneo, n.d.

Olhagaray, Néstor. "Breve reseña de la historia del videoarte en Chile." In *Vídeo en Latinoamérica: Una historia crítica*, edited by Laura Baigorri,

105–13. Madrid: Brumaria, 2008.

———. *Del video-arte al net-art.* Santiago: LOM Ediciones, 2002.

———. *Sobre video & artes mediales.* Santiago: Ediciones Metales Pesados, 2014.

Olivares, Rosa, ed. *100 Video Artists = 100 videoartistas.* Madrid: Exit Publicaciones, 2009.

Ordóñez, Juan Pablo. *Tiempos pequeños.* Exh. cat. Cuenca: Fundación Municipal Bienal de Cuenca, 2012.

Ospina, Nadín. *POP-colonialismo.* Exh. cat. San José: TEOR/éTica, 2001.

Ossa, Catalina. *Cybersyn: Sinergía Cibernética, 1970–1973.* Santiago: Ocho Libros, 2008.

Padín, Clemente. *Poemas visuales semánticos.* Navarrés [Valencia]: Babilonia, 2011.

Paladino, Luiza Mader. "Conceitualismos em trânsito: Intercâmbios artísticos entre Brasil e Argentina na década de 1970s—MAC USP e CAYC." PhD diss., Universidade de São Paulo, 2015.

Palomeque, Patricio. *La otra parte de la diversión: Obra escogida 1989–2012.* Edited by Cristóbal Zapata. Exh. cat. Cuenca: Casa de la Cultura Benjamín Carrión, 2012.

Panoramas do Sul: Artistas convidados. São Paulo: Edições Sesc, 2015.

Pato, Ana. "Digital Archives: The Experience of Videobrasil." In *Futuros possíveis: Arte, museus e arquivos digitais = Possible Futures: Art, Museums and Digital Archives,* edited by Ana Gonçalves Magalhães and Giselle Bciguelman, 84–95. São Paulo: Editora Peirópolis, 2014.

Paz, Valeria. "Intromisiones femeninas en el arte boliviano de fines de los noventa: La obra de Guiomar Mesa, Erika Ewel y Valia Carvalho." *Revista Ciencia y Cultura,* no. 4 (1998): 69–74.

Pech, Cynthia. *Fantasmas en tránsito: Prácticas discursivas de videastas mexicanas.* Mexico City: Universidad Autónoma de la Ciudad de México, 2009.

———. "Género, representación y nuevas tecnologías: Mujeres y video en México." *Revista Mexicana de Ciencias Políticas y Sociales* 48, no. 197 (2006): 95–104.

Peralta Ramos, Federico Manuel, and Clelia Taricco. *Federico Manuel Peralta Ramos: Retrospectiva.* Exh. cat. [Buenos Aires]: Museo de Arte Moderno de Buenos Aires, 2003.

Pérez-Barreiro, Gabriel. "Oríllese a la orilla." 6a Bienal Do Mercosul, Zona Franca. 2007.

Pérez-Ratton, Virginia, ed. *Centroamérica y el Caribe: Una historia en blanco y negro; XXIV Bienal Sao Paulo, 1998.* Exh. cat. San José: Museo de Arte y Diseño Contemporáneo, 1998.

———. *Del estrecho dudoso a un Caribe invisible: Apuntes sobre arte centroamericano.* Valencia: Universitat de València, 2013.

Pérez Rubio, Agustín, ed. *Memorias imborrables: Una mirada histórica sobre la colección Videobrasil.* Exh. cat. [São Paulo]: [Associação Cultural Videobrasil], [2015].

———, ed. *Memórias inapagáveis: Um olhar histórico no acervo Videobrasil.* São Paulo: Edições Sesc and Associação Cultural Videobrasil, [2014].

Polk, Patrick Arthur, Roberto Conduru, Sabrina Gledhill, and Randal Johnson. *Axé Bahia: The Power of Art in an Afro-Brazilian Metropolis.* Los Angeles: Fowler Museum at UCLA, 2018.

Posner, Helaine, and Eugenio Valdés Figueroa. *Utopia Post-Utopia: Conceptual Photography and Video from Cuba.* Exh. cat. New Paltz, NY: Samuel Dorsky Museum of Art, 2003.

Post-ilusiones, nuevas visiones: Arte crítico en Lima 1980–2006 = Post-Illusions, New Visions: Critical Art in Lima 1980–2006. Lima: Fundación Augusto N. Wiese, 2006.

(Pre)Fase de video chileno. Exh. brochure. Buenos Aires: Instituto de Cooperación Iberoamericana, November 1988.

Premio Nuevo Mariano: Becas de creación e investigación artistica 2012–2013. Quito: Centro de Arte Contemporáneo, 2012.

1er Festival Internacional de Video y Artes Electrónicas. Exh. cat. Buenos Aires: Centro Cultural Recoleta, 22–26 November 1995.

Proyecto Circo. *Videocreación 2003–2012.* Havana: Circuito Líquido, 2013. http://www.circuitoliquido.com/anuncios/disponible-ya-el-catalogo-video-creacion-2003-2012-proyecto-circo-circuito-liquido-formato-pdf-descargalo-ahora-111-obras-67-artistas.

Punto de Quiebre: II Bienal de Artes Musicales de Loja. Exh. cat. Quito: Centro Experimental Oído Salvaje, 2010.

Quiles, Daniel R. "Double Binds: Technology and Communications in Argentine Art, 1965–1977." In *Latin American Modernisms and Technology,* edited by María Fernández, 235–64. Trenton, NJ: Africa World Press, 2018.

———. "Network of Art and Communication." Paper presented at Expanded Conceptualism conference, Tate Modern, London, 18–19 March 2011.

Quiles, Daniel R., and Jaime Davidovich. *Jaime Davidovich: In Conversation with Daniel R. Quiles.* New York: Fundación Cisneros, 2017.

Rada, Douglas Rodrigo, and Alejandra Dorado, eds. *Somos artistas bolivianos: Arte Acción en Bolivia 1980–2014.* N.p.: 2014.

Ramírez, Enrique. *Océan: 33°''2''47''S 51°''4''00''N.* Exh. cat. Steenvoorde, France: Pylône, 2013.

Ramírez, Mari Carmen, and Héctor Olea. *Inverted Utopias: Avant-Garde Art in Latin America.* New Haven: Yale University Press, 2004.

Ramírez, Mari Carmen, Laura Buccellato, Marta Calderón, and Margarita Fernández

Zavala, eds. *San Juan Poly/ Graphic Triennial: Latin America and the Caribbean*. 2 vols. San Juan: Office of the San Juan Triennial, the Visual Arts Program, Instituto de Cultura Puertorriqueña, 2004.

Rangel, Daniel. *Arnaldo Antunes: Palavra em movimento*. Exh. cat. São Paulo: Centro Cultural Correios, 2015.

Realidad y utopía: Argentiniens künstlerischer Weg in die Gegenwart. Exh. brochure. [Berlin?]: Akademie der Künst, 2 October–14 November 2010.

Regina José Galindo: Vulnerable. Exh. cat. Long Beach, CA: Museum of Latin American Art, 2012.

Rennó, Rosângela, and Maria Angélica Melendi. *Notas de um viagem de um turista transcendental*. Exh. cat. Curitiba: Caixa Cultural, 2012.

Rennó, Rosângela, and Alícia Duarte Penna. *Espelho diário*. Belo Horizonte: UFMG, 2008.

Restrepo, José Alejandro. *Dar la cara*. [Bogotá]: Fundación Gilberto Alzate Avendaño, 2013.

———. *Hacer el sacrificio*. Exh. cat. Bogotá: Museo Nacional de Colombia, 2011.

———. *Iconomía: Video-instalación*. Exh. brochure. Bogotá: Alcaldía Mayor de Bogotá and Galería Santa Fe, 2000.

———. *José Alejandro Restrepo: Colombia; XXIII Bienal internacional de São Paulo, Brasil 1996*. Bogotá: Instituto Colombiano de Cultura, 1996.

———. *Musa paradisiaca: Una video-instalación, José Alejandro Restrepo [1997]*. Exh. booklet. Bogotá: n.p., 1997.

———. *Variaciones sobre el Purgatorio*. Exh. brochure. Bogotá: Museo de Arte, Universidad Nacional de Colombia, 2011.

———. *Vidas ejemplares*. Exh. booklet. Bogotá: n.p., 2007.

———. *Video-Veronica: 2000/2003 Video Projection*. Exh. booklet. [Colombia?]: [José Alejandro Restrepo], [2007?].

Restrepo, José Alejandro, Andrés García La Rota, and María Belén Sáez de Ibarra. *Religión catódica*. Exh. cat. Bogotá: Universidad Nacional de Colombia, 2011.

Restrepo, José Alejandro, Instituto Colombiano de Cultura, and Bienal Internacional de São Paulo. *José Alejandro Restrepo: Colombia; XXIII Bienal Internacional de São Paulo, Brasil 1996*. Exh. cat. Santafé de Bogotá: Colcultura, 1996.

"Retrospectiva Corporación Chilena de Video." In *Deux Ex Media: 10° Bienal de Video y Artes Mediales, Chile*, 204–5. N.p.: 2012.

Reynaud, Ana. "Sandra Kogut's 'What Do You Think People Think Brazil Is?': Rephrasing Identity." In *Cultural Encounters: Representing Otherness*, edited by Elizabeth Hallam and Brian V. Street, 72–88. London: Routledge, 2000.

Ribeiro, Marília Andrés. *Introdução às artes visuais em Minas Gerais*. Belo Horizonte: Editora C/Arte, 2013.

Richard, Nelly. "Contra el pensamiento-teorema: Una defensa del video arte en Chile." In *Catálogo Sexto Festival Franco-Chileno de Video Arte*. Exh. cat. Santiago: Servicio Cultural de la Embajada de Francia / Instituto Chileno Francés de Cultura, 1986.

———, ed. *Poéticas de la disidencia = Poetics of Dissent: Paz Errázuriz—Lotty Rosenfeld*. Barcelona: Polígrafa, 2015.

Rincón, Omar, ed. *Zapping TV: El paisaje de la tele latina*. Bogotá: Friedrich Ebert Stiftung, 2013.

Rivera, Nelson. "Arte vídeo de Puerto Rico." *Diálogo Digital*, n.d.

Roa, Luisa. *LU: Cosas viejas, cosas nuevas*. Bogotá: Cain, 2013.

Roca, José, and Alejandro Martín, eds. *Waterweavers: A Chronicle of Rivers*. New York: Bard Graduate Center, 2014.

El roce de los cuerpos: Cine y video sobre los años 80 latinoamericanos. Exh. program. Madrid: Museo Nacional Centro de Arte Reina Sofía, 2013.

Rojas, María José, Patricio Muñoz Zárate, Lucía Nieves, José Fernandez, and Francisco Huichaqueo. *Kalül Trawün = Reunión del cuerpo: Francisco Huichaqueo*. Exh. cat. Santiago: Museo Nacional de Bellas Artes, 2012.

Rojas González, José Miguel. *Arte costarricense: Un siglo*. San José: Editorial Costa Rica, 2003.

Ross-Mix, Daniel. "Videoarte en Centroamérica: Entrevista con Ernesto Calvo." LatinArt.com, n.d. http://www.latinart.com/spanish/aiview.cfm?id=180.

Salazar, Juan Francisco, and Amalia Córdova. "Imperfect Media and the Poetics of Indigenous Video in Latin America." In *Global Indigenous Media: Cultures, Poetics, and Politics*, edited by Pamela Wilson and Michelle Stewart, 39–57. Durham, NC: Duke University Press, 2008.

Saldaña Hernandez, Juan Carlos. "El génesis de una investigación: El video arte en México." *Revista Interiorgráfico*, December 2010. http://www.interiorgrafico.com/edicion/decima-edicion-diciembre-2010/el-genesis-de-una-investigacion-el-video-arte-en-mexico.

Salmerón, Ernesto, and Virginia Pérez-Ratton. *Auras de guerra: Intervenciones dentro del espacio público revolucionario nicaragüense*. Exh. cat. San José: TEOR/éTica, 2007.

Sánchez, Osvaldo, and Cecilia Garza, eds. *InSITE 2000–2001: Parajes fugitivos = Fugitives [sic] Sites*. Exh. cat. San Diego: Installation Gallery, 2002.

Santana, Andrés Isaac. *Nosotros, los más infieles: Narraciones críticas sobre el arte cubano (1993–2005)*. Murcia: Centro de Documentación y Estudios Avanzados de Arte Contemporáneo, 2007.

Santos, Eder, Fernando Pedro da Silva, and Marília Andrés Ribeiro. *Eder Santos: Depoimento*. Belo Horizonte: Editora C/Arte, 2010.

Santos, Eder, et al. *Atrás do porto tem uma cidade.* Exh. cat. Vila Velha, Brazil: Museu Vale, 2010.

Saquel, Carolina. *Selected Video Works, 1999–2015.* N.p.: 2015.

Sarti, Graciela. "Grupo CAYC: Cronología; January 1974." *Centro Cultural Recoleta: Centro Virtual de Arte Argentina,* 2013. http://cvaa.com.ar/02dossiers /cayc/07_crono_1974a.php.

Schraenen, Guy. *Dear Reader: Don't Read; Ulises Carrión.* Exh. cat. Madrid: Museo Nacional Centro de Arte Reina Sofía, 2016.

Schraenen, Guy, Rob Perrée, Pool Andries, and Ulises Carrión. *Ulises Carrión: "We Have Won! Haven't We?"* Exh. cat. Amsterdam: Museum Fodor, 1992.

"II International Ra(u)Dio Art Show = II Exposição/Audição Internacional de Ra(u)Dio Arte." Recife: 20 Festival de Inverno Unicap, 15 August 1979.

Sedeño, Ana. "Revisión general sobre la videocreación en México." *Razón y Palabra,* no. 69 (July–August 2009). https://www.redalyc.org /articulo.oa?id=199520330087.

Sempronio, "¡Hola, video-arte!" *Tele/eXpres,* 28 February 1977, 6.

Sepúlveda, Magda. "Metáforas de la higiene y la iluminación en la ciudad poetizada bajo el Chile autoritario." *Acta Literaria,* no. 37 (2008): 67–80. https://doi.org/10.4067/S0717 -68482008000200006.

Serna, Julián, Nicolás Gómez, Felipe González, María Teresa Hincapié, and En un Lugar de la Plástica. *Elemental: Vida y obra de María Teresa Hincapié.* [Bogotá?]: Laguna Libros, 2010.

Shaul, Sandra. "Video-Art." *Artes visuales,* no. 17 (Spring 1978): 47. (The Spanish-language original, titled "Video Arte," is on 23.)

Shtromberg, Elena. *Art Systems: Brazil and the 1970s.* Austin: University of Texas Press, 2016.

——. "Bodies in Peril: Enacting Censorship in Early Brazilian Video Art (1974–1978)." In *The Aesthetics of Risk,* edited by John C. Welchman, 265–83. Zurich: JRP/Ringier, 2008.

Shtromberg, Elena, and Marisa Flórido Cesar, eds. *Sonia Andrade: Vídeos.* Exh. cat. Rio de Janeiro: Aeroplano / Oi Futuro, 2010.

Sibaja Hidalgo, María Antonieta. "Museo Centroamericano de Videoarte (MUCEVI): Implementación de un museo virtual de videoarte centro-americano." Master's thesis, Universidad Nacional, Costa Rica, 2010.

Sichel, Berta, ed. *Bienal Internacional de Arte Contemporáneo Cartagena de Indias, 7 de febrero a 7 de abril 2014 = International Biennial of Contemporary Art, Cartagena de Indias, February 7 to April 7, 2014.* [Cartagena de Indias, Colombia]: BIACI, 2014.

——. "Lotty Rosenfeld: For a Poetics of Rebellion." Centro Andaluz de Arte Contemporáneo, 2013. http://www.caac.es /docms/txts/lotty_txt01b.pdf.

——, ed. *Primera generación: Arte e imagen en movimiento, 1963–1986.* Madrid: Museo Nacional Centro de Arte Reina Sofía, 2006.

Significação: Revista de Cultura Audiovisual 36, no. 32 (2009). https://www.revistas.usp .br/significacao/issue/view /5340/149.

Soares, Teresinha, Marília Andrés Ribeiro, and Fernando Pedro da Silva. *Teresinha Soares: Depoimento.* Belo Horizonte: Editora C/Arte, 2011.

Sobre una realidad ineludible: Arte y compromiso en Argentina. Exh. brochure. Burgos: Centro de Arte Caja de Burgos, 13 April–13 June 2005.

Spielmann, Yvonne. *Video: The Reflexive Medium.* Translated by Anja Welle and Stan Jones. Cambridge, MA: MIT Press, 2007.

Stallings, Tyler, ed. *Gabriela León: Sunday Walk to the Zócalo of Oaxaca = Gabriela León: Paseo Dominical por el Zócalo de Oaxaca.* Exh. cat. Riverside: University of California, Riverside, Sweeney Art Gallery, 2007.

Stern, Gerd. "Encuentro de Video." In CAYC and MACC, *1977 Video: Encuentro Internacional de Video.* Exh. cat. Caracas: Ediciones Amon, 1977.

——. "La polémica sobre el video-arte: Comenzada en Caracas toma vuelo internacional." *El Nacional Caracas,* 3 June 1975.

Sturken, Marita. "The Politics of Video Memory: Electronic Erasures and Inscriptions." In *Resolutions: Contemporary Video Practices,* edited by Michael Renov and Erika Suderburg, 1–12. Minneapolis: University of Minnesota Press, 1996.

Sur del cono sur 2: Art vidéo latino américain. Program. Mons-en-Baroeul, France: Station Vidéo d'Heure Exquise, 1995.

Susz Kohl, Pedro. *Filmo-videografía boliviana básica (1904–1990).* La Paz: Cinemateca Boliviana, 1991.

Tácticas sagradas / Ensayos profanos: Arte de mujeres (18 artistas cuencanas). Exh. cat. Cuenca: Casa de la Cultura Benjamín Carrión, 2014.

Tannenbaum, Judith, and René Morales. *Island Nations: New Art from Cuba, the Dominican Republic, Puerto Rico, and the Diaspora = Islas Naciones: Arte nuevo de Cuba, la Republica Dominicana, Puerto Rico y la diaspora.* Exh. cat. Providence: Museum of Art, Rhode Island School of Design, 2004.

Tapia, Mabel, and Mercedes Pineda Torra, eds. *Perder la forma humana: Una imagen sísmica de los años ochenta en América Latina.* Exh. cat. Madrid: Museo Nacional Centro de Arte Reina Sofía, 2012.

Taquini, Graciela. "Una crónica del videoarte en la Argentina: De la transición a la era digital." In *Vídeo en Latinoamérica: Una historia crítica,* edited by Laura Baigorri, 27–36. Madrid: Brumaria, 2008.

Tarazona, Emilio. *Accionismo en el Perú (1965–2000): Rastros y fuentes para una primera cronología.* Lima: Instituto Cultural Peruano Norteamericano, 2005.

Taylor, Diana. *The Archive and the Repertoire: Performing Cultural Memory in the Americas.* Durham, NC: Duke University Press, 2003.

———. *Performance.* Durham, NC: Duke University Press, 2012.

Teixeira da Costa, Calcida. "Videoarte no MAC." In *Made in Brasil: Três décadas do video brasileiro,* edited by Arlindo Machado, 69–73. São Paulo: Itaú Cultural, 2003.

Torres, María Dolores G., and Werner Mackenbach. *Arte en Centroamérica, 1980–2003: Últimas tendencias.* San José: Universidad de Costa Rica, Vicerrectoría de Acción Social, 2004.

TransHistorias: Historia y mito en la obra de José Alejandro Restrepo. Exh. cat. Bogotá: Banco de la República / Biblioteca Luis Ángel Arango, 2001.

Trilnick, Carlos. "About Video in Argentina." In *Americas With/Out Borders,* 13–14. Chicago: Video Data Bank, 1998.

———. *"Ex Data": Instalación.* Exh. brochure. Rosario, Argentina: Centro de Expresiones Contemporáneas, 3 August 2011.

———. *Proyecto Archivos del Terror: Apuntes sobre El Plan Cóndor.* Exh. booklet. Buenos Aires: Parque de la Memoria—Monumento a las Víctimas del Terrorismo del Estado, 15 May 2014.

Trilnick, Carlos, and Ticio Escobar. *Carlos Trilnick.* Rosario, Argentina: Ediciones Castagnino + Macro, 2013.

Turner, Terence. "Representation, Politics, and Cultural Imagination in Indigenous Video: General Points and Kayapo Examples." In *Media Worlds: Anthropology on New Terrain,* edited by Faye D. Ginsburg, Lila Abu-Lughod, and Brian Larkin, 75–89. Berkeley: University of California Press, 2002.

20 Salón Nacional de Video Experimental 1999. Exh. brochure. Bogotá: Centro Colombo Americano, 1999.

Ulloa V., Yéssica. *Video independiente en Chile.* Santiago: CENECA, 1985.

Unidad Pelota Cuadrada. *Unidad Pelota Cuadrada: 2007–2014.* Quito: n.p., 2014.

Universidad Central de Venezuela. *Muestra de video del Primer Festival de Caracas.* Exh. cat. Caracas: UCV, 1977.

Uribe, Conrado. *Teofanías: Exposición de José Alejandro Restrepo.* Exh. brochure. Medellín: Museo de Antioquia, 2008.

"VB na TV: 30 anos de Videobrasil." Exh. brochure. Porto Alegre: Galeria Mamute, 2014.

Vélez, Marta Lucía, and Arlindo Machado. "Persistência da reality TV." *Significação: Revista de cultura audiovisual* 32 (2009): 9–39.

———. "Televisão e arte contemporânea." *VIS: Revista do Programa de Pós-Graduação em Artes Visuais* 10, no. 19 (2012): 25–37.

Vélez Jaramillo, Liliana. *LI: Del otro lado.* Bogotá: Cain Press, 2013.

Venet, Jacqueline, and Miryorly García. "Antecedents y orígenes del video-clip en Cuba: El mundo al revés." *Circuito Líquido: C Textos* (2013): 1–8.

Vergara, Erandy. "Apuntes sobre una revisión histórica de curadurías de video." In *(Ready) Media: Hacia una arqueología de los medios y la invención en México,* edited by Karla Jasso and Daniel Garza Usabiaga, 325–48. Exh. cat. Mexico City: Instituto Nacional de Bellas Artes y Literatura, 2012.

———. "Electronic Traces: Archaeological Perspectives of Media Art in Mexico." *Luna Córnea* 33 (2012): 385–95.

———. "Remixing the Plague of Images: Video Art from Latin America in a Transnational Context." In *The Routledge Companion to Remix Studies,* edited by Eduardo Navas, Owen Gallagher, and Xtine Burrough, 166–78. New York: Routledge, 2015.

Vergara Gerstein, Juan Jorge. "Sujetos contemporáneos, arte y estética: Una aproximación teórica al videoarte en la voz de expertos peruanos y de otras partes de Latinoamérica en los últimos diez años, de 1999 al 2009." Master's thesis, Pontifica Universidad Católica del Perú, 2010. http://hdl.handle.net/20.500.12404/1019.

Vidal, Sebastián. *En el principio: Arte, archivos y tecnologías durante la dictadura en Chile.* Santiago: Ediciones Metales Pesados, 2012.

Videoarco '90: Video arte del sur; Selección de videos realizados en Argentina, Brasil, Chile y Uruguay. Exh. brochure. Buenos Aires: Instituto de Cooperación Iberoamericana, 1990.

VIDEOARDE: Vídeo crítico en latinoamérica y Caribe. http://videoarde.net.

Video Argentino. Exh. brochure. Buenos Aires: Instituto de Cooperación Iberoamericana, December 1990.

Video Art: Videocinta de vanguardia estética Televisual. Exh. cat. N.p.: 1973.

Video arte. Exh. cat. Bogotá: Centro Colombo Americano, 1976.

"Video arte." *La Prensa, Lima,* 10 September 1977.

"Video arte/Archivo Abierto: Coloquio sobre transferencias documentales y el origen del video en Chile." Santiago: Centro Cultural Palacio La Moneda, n.d.

Videoarte 92: 1a Muestra Franco-Colombiana. Exh. cat. Bogotá: n.p., 1992.

"Video artistas de Buenos Aires." Exh. brochure. Mexico City: Museo de Arte Moderno México, 20 September 1990.

Videobrasil. *Acervo Videobrasil 1984/2001.* São Paulo: Paço das Artes, 2001.

Videobrasil. Exh. brochure. Buenos Aires: Instituto de Cooperación Iberoamericana, September 1989.

Video Brasil. Exh. brochure. Buenos Aires: Instituto de Cooperación Iberoamericana, November 1990.

Video de Creación: Brasil, Paraguay, Uruguay. Exh. brochure. Buenos Aires: Instituto de Cooperación Iberoamericana, October 1991.

Vilas, Mauricio. *Videohábitats: IV Muestra de Videoarte en el Marco del Festival Universitario de Video, Viart 2000.* Exh. cat. Caracas: Museo de Bellas Artes, 2000.

Villacorta, Jorge, and José-Carlos Mariátegui. *Videografías invisibles: Una seleccion de videoarte latinoamericano 2000–2005.* Exh. cat. Valladolid: Museu Patio

Herreriano de Arte Contemporaneo Espanol, 2005.

Villares Presas, Benjamín. "Videoarte en Venezuela: Cuatro generaciones de arte audiovisual." In *Vídeo en Latinoamérica: Una historia crítica,* edited by Laura Baigorri, 231–38. Madrid: Brumaria, 2008.

VIS: Revista do Programa de Pós-Graduação em Artes Visuais da UnB 10, no. 19 (2012).

Visionários: Audiovisual na América Latina = Audiovisual en Latinoamérica. Exh. cat. São Paulo: Itaú Cultural, 2008.

Vives, Cristina, and Hans-Michael Herzog. *El espacio inevitable = The Inevitable Space: Alexandre Arrechea.* Madrid: Turner, 2014.

Vivo. *Circuito Vivo Arte.Mov 2012.* Exh. cat. São Paulo: Vivo, 2012.

——, ed. *Festival Vivo Arte.Mov: Belo Horizonte 2012.* Exh. cat. Belo Horizonte: Diphusa Mídia Digital e Arte, 2012.

Vivo and SESC, eds. *Festival Arte. Mov: Belém 2010.* Exh. cat. N.p.: n.d.

——, eds. *Festival Arte.Mov: Arte em mídias moveis, São Paulo 2010.* Exh. cat. São Paulo: Edições Sesc, 2010.

——, eds. *Festival Vivo Arte.Mov: Arte em mídias moveis, Belo Horizonte 2010.* Exh. cat. Belo Horizonte: Edições Sesc, 2010.

Welchman, John C., ed. *Yoshua Okón: Colateral = Collateral.* Exh. cat. Mexico City: Museo Universitario Arte Contemporáneo, Universidad Nacional Autónoma de México, 2017.

Wildi Merino, Ingrid. *Arquitectura de las transferencias; La hybris del Punto Cero 1.* Gallery guide. N.p.: 2013.

——. *Ingrid Wildi Merino* [CV]. 2015.

Wildi Merino, Ingrid, and Kathleen Bühler. *Dislocación: Kulturelle Verortung in Zeiten der Globalisierung = Cultural Location and Identity in Times of Globalization.* Exh. cat. Ostfildern, Germany: Hatje Cantz, 2011.

Winkler, Andreas, and Sebastiaan A. C. Berger. *Cuba: Arte contemporáneo = Contemporary Art.* New York: Overlook, 2012.

"Wolf Vostell: Selección de videos organizada por el teórico y curador Ronald Kay," In *Catalogo 10° Bienal de Video y Artes Mediales, Chile 2012,* 76–77. N.p.: 2013.

Yard, Sally, ed. *InSITE94: A Binational Exhibition of Installation and Site-Specific Art; San Diego, Tijuana Guide = InSITE94: Una exposición binacional de arte-instalación en sitios específicos; San Diego, Tijuana Guía.* Exh. cat. San Diego: Installation Gallery, 1994.

——, ed. *InSITE97: Private Time in Public Space; San Diego, Tijuana = InSITE97: Tiempo privado en espacio público; San Diego, Tijuana.* Exh. cat. San Diego: Installation Gallery, 1998.

Yoel, Gerardo, ed. *Imagen, política y memoria.* Buenos Aires: Universidad de Buenos Aires, 2002.

Yúdice, George, Jean Franco, and Juan Flores, eds. *On Edge: The Crisis of Contemporary Latin American Culture.* Minneapolis: University of Minnesota Press, 1992.

Yuyanapaq: Para Recordar. Exh. brochure. São Paulo: Asociação Pinacoteca Arte e Cultura, 2015.

Zabala, Horacio, and Fernando Davis. *Horacio Zabala, desde 1972.* Exh. cat. [Sáenz Peña, Argentina]: EDUNTREF, 2013.

Zapett Tapia, Adriana, and Rubí Aguilar Cancino. *Videoarte en México: Artistas nacionales y residents.* Mexico City: Instituto Nacional de Bellas Artes, 2014.

Zegarra, Miguel, Jorge Villacorta, and Víctor Mejía. *Miguel Zegarra: Selección de textos.* Lima: Forma e Imagen, 2013.

Zeitlin, Marilyn, Gerardo Mosquera, and Antonio Eligio. *Contemporary Art from Cuba: Irony and Survival on the Utopian Island = Arte contemporáneo de Cuba: Ironía y sobrevivencia en la isla utópica.* New York: Delano Greenidge, 1999.

Zumbado, Manuel. *Estructuras: Documentos sobre video-instalaciones, obra pictórica y gráfica.* Exh. cat. San José: Centro Cultural de España en Costa Rica, 2008.

Contributors

Gabriela Aceves Sepúlveda is a media artist, associate professor in the School of Interactive Arts and Technology at Simon Fraser University in Surrey, Canada, and the director of the Critical Media Arts Studio.

Vincent Carelli is a documentary filmmaker and activist best known for founding Vídeo nas Aldeias, a pioneering project in Indigenous media.

Ximena Cuevas is an artist who works primarily with video, film, and performance. Based in Mexico City, Cuevas has presented her work at museums around the world and has participated in numerous international film festivals.

Francisco Huichaqueo is a filmmaker, artist, and curator from the Indigenous Mapuche community in Concepción, Chile. He is a professor in the College of Humanities and Arts at the Universidad de Concepción.

José-Carlos Mariátegui is a writer and curator and the founder of Alta Tecnología Andina (ATA), a cultural organization that focuses on the use, preservation, and dissemination of electronic media in Peru and elsewhere in Latin America.

Oscar Muñoz is a visual artist based in Cali, Colombia. He is best known for a wide diversity of works that bridge the media of film, video, photography, installation, and sculpture.

Benjamin O. Murphy is a scholar of modern and contemporary art from Latin America, with a focus on the intersections between art, technology, and politics during the last half century.

Glenn Phillips is senior curator of modern and contemporary collections and head of exhibitions at the Getty Research Institute in Los Angeles.

Sophia Serrano is assistant curator at the Academy Museum of Motion Pictures in Los Angeles.

Elena Shtromberg is associate professor of art history at the University of Utah in Salt Lake City.

Sebastián Vidal Valenzuela works as assistant professor of Chilean art and curatorship at the Universidad Alberto Hurtado and the Escuela de Arte at the Pontificia Universidad Católica de Chile.

Illustration Credits

Photographs of items in the holdings of the Getty Research Institute (GRI) are courtesy of the Research Institute. The following sources have granted additional permission to reproduce illustrations in this volume.

Shtromberg and Phillips
Figs. 1, 2. Photo by John Kiffe, GRI.

Phillips and Serrano
Fig. 1. GRI, Jean Brown papers, 890164, box 72, folder 4. Used by permission of the Glusberg family.
Fig. 2. GRI, Jean Brown papers, 890164, box 72, folder 3. Used by permission of the Glusberg family.
Figs. 3, 4. Photo: GRI.
Fig. 5. Photo: Tate.
Figs. 6, 12–14, 18, 19, 20–24, 27–29. Courtesy of Pedro and Matias Roth.
Figs. 7, 8. GRI, Jean Brown papers, 890164, box 72, folder 14. Used by permission of the Glusberg family.
Fig. 9. © Nam June Paik Estate. Photo: GRI.
Figs. 10, 11. Courtesy of Bill Vazan.
Fig. 15. Courtesy of Rosángela D'Amico / Archivo Margarita D'Amico Biblioteca de la Universidad Católica Andrés Bello (UCAB).
Figs. 16, 17. Photo by Pascual de Leo. Courtesy of Rosángela D'Amico / Archivo Margarita D'Amico Biblioteca de la Universidad Católica Andrés Bello (UCAB).
Figs. 25, 26. Fondo Pola Weiss, Centro de Documentación Arkheia. Museo Universitario Arte Contemporáneo, UNAM.

Photo Essay
Fig. 1. GRI, 86–S611. Used by permission of the Glusberg family.
Figs. 2, 3, 5, 6, 7. Used by permission of the Glusberg family.
Fig. 4. Photo: The Museum of Modern Art, New York. Used by permission of the Glusberg family.
Fig. 8. Digital Image © The Museum of Modern Art / Licensed by SCALA / Art Resource, NY.

Mariátegui
Fig. 1. Photo by Mariela Víquez.
Fig. 2. Photo by Almendra Otta.
Fig. 3. © Gilles Charalambos.
Fig. 4. Photo by Martha González.

Aceves Sepúlveda
Fig. 1. Courtesy of Marta Minujín Archive and Henrique Faria, New York.
Fig. 2. Catalogación Edna Torres-Ramos, Fondo Pola Weiss, Centro de Documentación Arkheia. Museo Universitario Arte Contemporáneo, UNAM.
Figs. 3a, 3b. Sandra Llano-Mejía and Humberto Jardón. Courtesy of the artists.
Fig. 4. Sandra Llano-Mejía. The Museum of Modern Art, New York; Gift of the artist.
Figs. 5a, 5b. Sandra Llano-Mejía, Humberto Jardón, and Rafael Mejía. Courtesy of the artists.
Fig. 6. Sandra Llano-Mejía. Courtesy of the artist.
Fig. 7. © Anna Bella Geiger.
Fig. 8. © Letícia Parente.
Fig. 9. © Sonia Andrade.
Fig. 10. SVES Fonds, The Crista Dahl Media Archive (CMDLA), VIVO Media Arts, Vancouver, BC.

Cuevas
Fig. 1. © The Estate of Man Ray / Artists Rights Society (ARS), New York, US.
Fig 2. Photo by Mariana Cuevas.
Fig. 3. Photo by François Duhamel.
Figs. 4, 5. © Ximena Cuevas.

Shtromberg
Fig. 1. © Oscar Muñoz.
Figs. 2–6. © Clemente Padín.
Figs. 7–9. © Ernesto Salmerón.

Vidal Valenzuela
Fig. 1. Magali Meneses / Instituto Francés en Chile.
Fig. 2. © Dominique Belloir.
Fig. 3. © Carlos Altamirano.
Figs. 4, 5. © Carlos Leppe.
Fig. 6. © Eugenio Dittborn.

Fig. 7. © Diamela Eltit. Hemispheric Institute Digital Video Library (HIDVL).
Fig. 8. © Juan Downey, Eugenio Dittborn, Carlos Flores. Still provided by Centro de Documentación de las Artes Visuales—Centro Nacional de Arte Contemporáneo (CEDOC-CNAC) Chile.

Muñoz
Figs. 1–4. © Oscar Muñoz.

Huichaqueo
Figs. 1–4. © Francisco Huichaqueo Pérez.
Figs. 5–7. Photo by Fernando Melo Pardo.

Murphy
Figs. 1, 2, 6–8. © Vincent Carelli / Vídeo nas Aldeias.
Figs. 3, 5. Estate of Juan Downey.
Fig. 4. Digital image © Whitney Museum of American Art / Licensed by Scala / Art Resource, NY. Estate of Juan Downey / Artists Rights Society (ARS), New York, US. Photo by Geoffrey Clements.

Carelli
Figs. 1–4. © Vincent Carelli / Vídeo nas Aldeias.

Index

Note: page numbers in italics refer to figures. Those followed by n refer to notes, with note number.

AANME. *See* Asociación Archivo Nuevos Medios Ecuador
Aboroa, Eduardo, 141
Abramović, Marina, 33
Abs, Marina, 93
Acconci, Vito, 33, 41
Aceves Sepúlveda, Gabriela, 58
Acha, Juan, 56, 58
Adiauvision TV Studio, 43
AGORA SOMOS TODXS NEGRXS? (2017), 93–94
Albrecht/d., 43
Alcantara, Pedro, 181
Aliaga, Ignacio, 167
Alma Punk (Minter), 140–41
Alonso, Rodrigo, 163–64
Altamirano, Carlos, 165, 166, *169*, 169–70, 173–74
Alta Technología Andina (ATA) [Peru], 55, 98, 101–2, 105
Altmann, Roberto, 32
Alvarado, Narda Fabiola, 99
Álvarez Cozzi, Fernando, 177
Amèrica Llatina '76 (Barcelona, 1977), 50
Ando, Kohei, 63–64
Andrade, Sonia, 37, 74–75n77, 111, 122, 124–26, *125*
Andujar, Claudia, 223, 228–29
Añiñir, David, 199, 200
Ansaloni, Carlo, 32, 33
anthropology
 circumvention of, by CLACPI events, 223
 communicative, Downey and, 213
 disruption by Indigenous use of video technology, 221–23
 Downey's engagement with, 213–14, 224n9
 and Indigenous media, parallax introduced by, 215–18
 reconfigured relationship to technology, in VTA and VNA projects, 211
 representation of Indigenous peoples, artists addressing, 223
Antin, Eleanor, 32, 38, 75n83
Antonacci, Horacio, 54
Aproximaciones a una historia del videoarte en Colombia 1976–2000 (Charalambos), 100, 102–3
Aquino, Angelo de, 22, 33, 74–75n77
Araiza, Raúl, 59
A Arca dos Zo'é (VNA), 242
Arca Video Argentino, 99–100
archives for video art
 alternative narratives contained in, 106
 archival organization issues, 92
 archives created by individuals, 99–101

cataloging, inadequate, 105
cataloging, power relationships in, 106
complex work required of, 105
conservation issues in, 92, 146
copyright and, 105
Cuevas's collection, 101, 134, *143*, 143–46, *145*
exhibitions and, 101–4
festivals and, 93–95
four models for, 92, 105
funding shortages and, 105
institutionalization of, 91
in museums and institutions, 95–99
museums' initial lack of interest in, 91
needed improvements in, 105
participatory archive projects, 100, 106
preservation and maintenance, 105
recovery work by, 91, 105
restoration work by, 97–98
scholarly uses of, 91
as still scattered, 105
sustainability of, 99–100, 101, 105, 106
websites, 100
Archivo Digital of the Cineteca Nacional (Santiago), 98
Archivo Nacional de Imágenes en Movimiento de Bolivia, 98
Arévalo, Francisco, 175–76
Argentina
 birth of video art in, 20
 coup of 1976, fear surrounding, 36
 Revolución Liberadora (1955), 20
 video art archives in, 97
 See also Buenos Aires; Centro de Artes Visuales (CAV) [Buenos Aires]
Art de systèmes en Amérique Latine (Paris, 1974–75), 29, *29*
Arte conceptual frente al problema latino-americano (1974), 56
Arte de sistemas (CAYC, 1971), 22, 23
Arte de video (Caracas, 1975), 46–48
 artists also in Caracas Encuentro, 48
 catalog, 45
 criticisms of video art quality, 47–48
 critics' *vs.* public's response to, 44–45
 display of posters from other shows, 47
 events and performances at, *46*, 46–47, *47*
 number of attendees, 47
 organizers of, 46
 videos screened at, 46, 77n109
Artes Visuales, video art issue, 59–61
Arte y cibernética (Buenos Aires, 1969), 66
Art Systems in Latin America (CAYC). *See Arte de sistemas* (CAYC, 1971)
Art Systems in Latin America (London, 1974), 22, 25, 28, 50
art/tapes/22 group, 30, 33, 37, 74n67
arTV (Mexico City), 59, 116, 117
Art Vidéo Confrontation 74 (Paris, 1974), 32

Asociación Archivo Nuevos Medios Ecuador (AANME), 100
Asurini, 230
ATA. *See* Alta Technología Andina [Peru]
Ateliers Varan, 234
A'Uwe (TV program), 241
Avel-lí Artís, Andreu (Sempronio), 51–52
Awa Guajá, VNA and, 243
Ayani, Vanessa, *238*
Azanha, Gilberto, 229
Aziosmanoff, Florent, 178
Azulay, Jom, 122

Baldessari, John, 32, 56
Ballerina and the Bum (Antin), 75n83
Ballón, Enrique, 54
BAM. *See* Bienal de Artes Mediales (BAM) [Santiago]
Barrios, Álvaro, 39
Barteig, Gerry, 63
Barthes, Roland, 192
Baumgarten, Lothar, 223
Beck, Stephen, 48, 77n109, 80n173
Bedel, Jacques, 26
Belgium Conceptual Video Contest (1977), 43
Belloir, Dominique, *168*, 169
Bemberg, María Luisa, 114
Benjamin, Walter, 192
Benning, Sadie, 140
Berger, John, 114
Berger, René, 31
Berger, Sally, 140, 144
Bernardet, Jean-Claude, 225n22
Berni, Antonio, 31, 39
Betancur, Patricia, 97
Beuys, Joseph, 33, 43
Bex, Florent, 35, 41, *42*, 43, 50
Bicocchi, Maria Gloria, 30, 33, 59–61
Bienal de Artes Mediales (BAM) [Santiago], 94, 176, 178
Bienal de la Imagen en Movimiento (BIM) [Buenos Aires], 94
Bienal de Video y Artes Electrónicas, 176, 178
BIM. *See* Bienal de la Imagen en Movimiento (BIM) [Buenos Aires]
Birnbaum, Dara, 140
Blanco, Desiderio, 54
Block, René, 37
Blom, Ina, 150
body as vehicle of expression
 in Brazilian video art, 122–26, 129
 in Chilean video art, 121–22, 126–28, 129
Boetti, Alighiero, 33
Boezem, Marinus, 59
biofeedback technology in art, 132n34
 Llano-Mejía and, 117–21, *119*
Bonet, Eugenio, 51–52, 78n130
Bonora, Lola, 32, 33, 50–51

Borges, Jacobo, 45, 47
Borges, Jorge Luis, 39, *40*
Boschi, Gabriel, 97
Boulton, Jack, 37
Bousquet, Patrick, 169
Brazil, Indigenous peoples of
 anthropology and, 209–10
 political rights, 231–32
 See also Vídeo nas Aldeias (VNA)
 [Brazil]; *specific groups*
Brazilian video art
 in Antwerp Encuentro, 43
 body as vehicle of expression in,
 122–26, 129
 in Buenos Aires Encuentro, 36, 39,
 74–75n77
 and Festival Franco-Latinoamericano,
 176–77
 origin of, 96
 video art archives in, 93, 96, 101
 and *Video Art* exhibition (Philadelphia,
 1975), 37, 38
 See also Videobrasil festival
Brett, Guy, 26, 31
Brigada Ramona Parra, 165, 179n4
Brintrup, Sybil, 126
Bruscky, Paulo, 101
Buccelato, Laura, 97
Buenos Aires
 as center of video and new media
 production, 96
 cultural changes of 1950s, 20
 See also Encuentro IV (IV International
 Open Encounter [on Video], Buenos
 Aires, Oct.–Nov. 1975)
Buenos Aires Video I (Buenos Aires,
 1989), 96
Buñuel, Luis, 135–36, *136*
Burbano, Andrés, 102
Burden, Chris, 33, 43, 48, 141–42
Buren, Daniel, 33
Burga, Teresa, 79n151
Burgy, Donald, 32

Cabrera Infante, Guillermo, 26
CADA. *See* Colectivo Acciones de Arte
Cage, John, 47, 64
Cahen, Robert, 175
Caldini, Claudio, 177
Calfuman, Silvia, 206, 207
Calle Viamonte 452, 21–22
Calzolari, Pier Paolo, 33
Camiruaga, Gloria
 background and education, 173
 challenging of gender stereotypes, 111
 exhibitions of video art, 126, 127–28, 173
 and female body as site of violence and
 political articulation, 111
 Popsicles, 127, 173–74
 La venda, 128
Camnitzer, Luis, 17–19, 74n75

Campo, Oscar, 161n16, 181
Campus, Peter, 47, 77n109, 80n173
Canadian video artists, at Buenos Aires
 Encuentro, 39, 75–76n90
Cantinflas, 58
Cantú, Mariela, 99–100, 106
Capello, Domenico, 143
CAR. *See* Centro Audiovisual Rosario
Caracas
 video art exhibitions prior to
 Encuentro VI, 44–48
 See also Arte de video (Caracas, 1975);
 Encuentro VI (VI International
 Open Encounter on Video, Caracas,
 Jan. 1977)
Cardenal, Ernesto, 157–58, 159–60
Cardena-Warming Up, Etc. Etc. Etc. Co.,
 78n123
Cardin, Pierre, 31
Carelli, Tita, 242
Carelli, Vincent
 Adeus Capitão, 242–43
 career of, 227, 232
 Corumbiara, 243
 early engagement with Indigenous
 communities, 228–29, 230
 education, 229–30
 A festa da moça, 218–20, *219*
 on Indigenous videos' influence on his
 work, 239
 Martírio, 242, 243
 ongoing projects with Indigenous
 peoples, 242–43
 Shtromberg interview with, 227–44
 training of Indigenous people to use
 video technology, 220
 Videobrasil, and 242
 and Vídeo nas Aldeias (VNA), founding
 of, 218, 225n18, 227, 228, 232–34
 video work in Indigenous communities,
 origin of interest in, 228–29, 232–33
 on violence to Indigenous communities
 from outside videos, 239
 work for FUNAI, 230
Carne de tu carne (Mayolo), 181
Carrión, Ulises, 59
Carvajal, Eduardo, 182
Carvalho, Ana, 242
Casablanca I (Oster), 43
Casanova, Eduardo, 177
Casanova, Guillermo, 177
Castrillón, Alfonso, 79
CAV. *See* Centro de Artes Visuales (CAV)
 [Buenos Aires]
Cavestani, Frank and Laura, 77n109
CAYC. *See* Centro de Arte y Comuni-
 cación (CAYC) [Buenos Aires]
CCE. *See* Centro Cultural de España
 (CCE) [Montevideo]
CChV. *See* Corporación Chilena de Vídeo
 y Artes Electrónicas

CCLM. *See* Centro Cultural La Moneda
 (CCLM) [Santiago]
CDPL. *See* Centro de Documentación
 Príamo Lozada (CDPL) [Mexico]
CEAC. *See* Centro de Estudios de Arte
 y Comunicación (CEAC) [Buenos
 Aires
CEDOAL. *See* Centro de Documentación
 de Artes y Literaturas (CEDOAL)
 [Bolivia]
Centre National pour l'Animation
 Audiovisuelle (Paris), 32, 36
Centro Audiovisual Rosario (CAR), 97
Centro Costarricense de Producción
 Cinematográfica, 105
Centro Cultural de España (CCE)
 [Montevideo], 97–98, 103
Centro Cultural La Moneda (CCLM)
 [Santiago], 98
Centro de Artes Visuales (CAV) [Buenos
 Aires], 20
Centro de Arte y Comunicación (CAYC)
 [Buenos Aires]
 Amèrica Llatina '76 exhibition
 (Barcelona, 1977), 50
 artists associated with, 68–69n2
 bulletins, 17–19, *18*, 69n9
 early focus and exhibitions, 21–23,
 70–71n22, 71n26
 and Ediciones Tercermundo, 22, 67
 18 Latin American Artists (Kyoto,
 1977), 66
 Encuentros Internacionales Abiertos
 de Video and, 15
 exhibition program of, 68, 81n202
 filming of early activities, 22
 *From Figuration Art to Systems Art in
 Argentina* exhibition (1971), 28
 Glusberg's push for international
 recognition of, 19, 22, 70–71n22
 Glusberg's work with, 15, 67–68
 and goal of distributing Latin Ameri-
 can video art, 67
 ICC and, 41, 43
 influence on Latin American video
 art, 23
 international attention, political pro-
 tection provided by, *23*, 23–24, 71n29
 international network of, 19, 30, 33, 35,
 52, 66, 68
 *Japan Video Art Festival: 33 Artists at
 CAYC* (Buenos Aires, 1978), 65, 66
 lack of follow-through on opportuni-
 ties opened by, 68, 81n202
 and Lima Encuentro, 53
 media collective of, 22
 and Mexico City Encuentro, 56
 origin of, 21–22
 promotion of video art, 96
 ties to government, critics of, 24, 25
 ties to Poland, 43

Centro de Arte y Comunicación
(continued)
Tokyo Encuentro and, 64
21 Artistas argentinos: Década del 70
(Mexico City, 1977), 56, 58
in The Video Show exhibition (1975), 28
See also individual Encuentros
Centro de Documentación Artes Visuales
(Santiago), 98
Centro de Documentación de Artes y
Literaturas (CEDOAL) [Bolivia],
99
Centro de Documentación Príamo
Lozada (CDPL) [Mexico], 104
Centro de Estudios de Arte y Comu-
nicación (CEAC) [Buenos Aires],
21–22
Centro de Recursos Audiovisuales
(CRAS) [Uruguay], 97
Centro de Teleducación de la Pontificia
Universidad Católica (CETUC),
53, 54
Centro de Trabalho Indigenista (CTI)
[Brazil], 229, 230–31
Centro Video Arte (Ferrara), 32, 34
CETUC. See Centro de Teleducación de la
Pontificia Universidad Católica
Chamber Music (Kosugi), 47
Chapman, Richard, 78n123
Charalambos, Gilles, 75n86, 100, 102,
177, 182
Chiari, Giuseppe, 33
Chile
democratic, new video art spaces
in, 176
obstacles to video art in, 164
video art archives in, 94, 98
See also Festival Franco-Chileno de
Video Arte; Mapuche
Chile, under Pinochet dictatorship
censorship, 165, 179n5
Festival Franco-Chileno as space of
resistance to, 163, 166
galleries exhibiting video art, 166
influence of TV and advertising in,
165–66
and neoliberal policies, 165–66
and opening of space for the
marginal, 126
video artists' work in advertising,
165–66
Chilean video art
artists abroad and, 166
body as vehicle of expression in,
121–22, 126–28, 129
origin in performance practices, 165, 166
Churchill, Angiola, 19
Cinedata repository (Uruguay), 105
Cinemateca Boliviana, 98
Cine Video U.C.V., 49
CLACPI. See Consejo Latinoamericano
de Cine y Comunicación de los
Pueblos Indígenas
Clifford, James, 214
Cocchiarale, Fernando, 37, 39, 74–75n77
Codocedo, Victor Hugo, 174
Colectivo Acciones de Arte (CADA), 165,
166, 169, 173
Colectivo Al Margen, 166
Colegio Nacional de la Comunicación
(Mexico City), 56
Coleridge's Dream (Trotta), 26–27

Colombia
Centro Nacional de Memoria
Histórica, 153
political violence, Muñoz on, 151–52
Columbus on Trial (Portillo), 140
Computer Movie #1 (CTG), 66
Computer Technique Group (CTG), 66
Concurso Internacional Juan Downey, 94
Concurso Nacional de Proyectos de
Preservación (Peru), 105
La condición video: 25 años de videoarte en el
Uruguay (Montevideo, 2007), 97–98
Consejo Latinoamericano de Cine y
Comunicación de los Pueblos
Indígenas (CLACPI), 223, 234
Contacta-Festival de Arte Total, 53
Contemporary Arts Museum
Houston, 213
Contemporary Belgian Artists (Argentina,
1976), 43
CONTINENTE, 94
"Contra el pensamiento-teorema"
(Richard), 174
Conversas no Maranhão (Tonacci), 229
Cordeiro, Analívia, 33
Corkidi, Rafael, 142
Corporación Chilena de Vídeo y Artes
Electrónicas (CChV), 94
Corredor-Matheos, J., 51
Costa, Joan, 50–51, 78n130
COUM Transmissions, 43
CRAS. See Centro de Recursos
Audiovisuales (CRAS) [Uruguay]
Cravo Neto, Mario, 74–75n77
Crown, Peter, 77n109
CTG. See Computer Technique Group
CTI. See Centro de Trabalho Indigenista
(CTI) [Brazil]
Cuevas, José Luis, 134–35
Cuevas, Ximena, 137, 138
on AIDS in 1980s, 139–40
on art and playfulness, 135
Buñuel and, 135–36, 136
career of, 137–39, 142
childhood and José Luis Cuevas's
influence, 134–35
early experiences with films, 136–37
exhibitions and awards, 134
on father's interest in video art, 141
on film industry and women, 139
forming of connections with video
artists, 140–41
interview with, 134–46
on isolation of Latin American
artists, 142
on Mexican history, rewriting of, 146
on power of invisible elements in
film, 138
on structuring of video art by
medium, 140
Las tres muertes de Lupe, 144
turn to video art, 139
on video art and self-expression,
142–43
video art collection, 101, 134, 143,
143–46, 145
on video art in Mexico City, 141–42
Weiss and, 141
"Cultural Reconversion" (Canclini), 24
Cunningham, Merce, 64
Cut Piece (Ono), 47, 47
Cytlak, Katarzyna, 22

D'Amico, Margarita
at Arte de video (1975), 47
and Barcelona Encuentro, 50, 52
and Buenos Aires Encuentro, 36, 39,
74–75n77
and Caracas Encuentro, 44, 45
and Mexico City Encuentro, 56
newspaper column of, 49
Danowski, Miriam, 74–75n77
Davidovich, Jaime, 26, 32, 74–75n77
Davis, Douglas, 32, 46, 46, 59, 77n109
De Appel art center (Amsterdam), 43
Deblé, Colette, 169
La década de los 70s (Lima, 1977), 53
de Jesús, Luis M., 43, 76n101
Delehanty, Suzanne, 37
Deleu, Luke, 43
Denegri, Andrés, 94
D'Hamer, Margaret, 80n173
Diamond, Sara, 133n53
Dias, Antonio, 33, 37
Díaz, Ramiro, 92
Dirección Nacional de Comunicación
Social (DINACOS) [Chile], 165, 179n5
Dirty Wars of 1970s–80s, impact of, 1, 25
Di Tella. See Instituto Torcuato Di Tella
(Buenos Aires)
Dittborn, Eugenio, 166, 169, 171–73, 175,
175, 180n16
documenta 4 (1968), 53
documenta 6 (1977), 41
Dondo, A., 26
Dorfles, Gillo, 30, 50–51
Dowe, David, 77n109, 80n173
Downey, Juan
and anthropologist as cultural commu-
nicant, 212, 214
in Artes Visuales' video art volume, 59
and Buenos Aires Encuentro, 39,
74–75n77
Camiruaga and, 173
and Caracas Encuentro, 77n109
and disruption of anthropology,
222–23
engagement with anthropology, 213–14,
224n9
exhibitions at CAYC, 22
and feedback videos, 212, 222
at Festival Franco-Chileno de Video
Arte, 174–75
and Indigenous media paradigm,
225n15
The Laughing Alligator, 214, 216, 217, 222
residence in US, 166, 211–12
Satelitenis, 175, 175
Shifters, 175
and video as experimentation, 165
See also Video Trans Americas [Downey]
(VTA); Yanomami project (Downey)
Drama Queens (Villaseñor), 144

E.A.T. See Experiments in Art and
Technology
Echeverry, Clemencia, 102
Echeverry, Santiago, 177
Eco, Umberto, 58
Ecuador 1929–2011 (AANME), 100
Ediciones Argentinas, 17
Eguren, José María, 54
Eh Joe (Dondo and Glusberg), 26, 28
Ehrenberg, Felipe, 26, 32, 56, 59, 62,
74–75n77

18 Latin American Artists (Kyoto, 1977), 66
Electronics Arts Intermix, 27
Eltit, Diamela
 challenging of gender stereotypes, 111
 and female body as site of violence and
 political articulation, 111, 126–27, 166
 at Festival Franco-Chileno, 166, 173
 and Grupo CADA, 126
 El padre mio (with Rosenfeld), 126–27
 and Women, Art and the Periphery
 exhibition, 126
 Zona de dolor I, 126
 Las zonas de dolor, 174
Emshwiller, Ed, 77n109, 80n173
Enawene, 244
Encuentro I (I International Open
 Encounter on Video, London,
 Dec. 1974), 25–28
 cultural change as goal of, 28
 Europe-based artists in, 26, 27
 experimental video in UK prior to,
 27–28
 films and events at, 26–27
 I International Open Encounter on Video
 (catalog), 83
 goals of, 35
 and local artists' tapes, 28
 as only Encuentro with works selected
 by Glusberg, 25–26
 as part of Latin American Week, 25, 26
 planners of, 26
 pre-Encuentro events leading to, 22
 as research for Latin American En-
 cuentros, 34
 reuse of videos in later Encuentros, 28
 technical challenges of, 27
 venue for, 16
Encuentro II (II International Open
 Encounter on Video, Paris, Feb.
 1976), 29, 29–32
 bulletins, 29, 30, 30, 31, 31
 goals of, 35
 increased size vs. London
 Encuentro, 29
 international group of artists in,
 29, 30, 32
 notable persons attending, 31
 organizers of, 29–30
 Parisian video artists in, 32, 73n59
 Recontre international ouverte de video
 (catalog), 29, 30, 84
 recordings of group discussions at,
 31–32
 as research for Latin American
 Encuentros, 34
 reuse of videos in later Encuentros,
 32, 33
 success of, 29
 venue for, 16, 31
Encuentro III (III International Open
 Encounter on Video, Ferrara, May
 1975), 32–34
 artists from Paris Encuentro at, 34
 filming of discussions at, 34
 films by Latin American artists in, 33
 goals of, 35
 organizers of, 32
 as research for Latin American
 Encuentros, 34
 Third International Open Encounter on
 Video (catalog), 33, 34, 85
 venue for, 16, 32

works from Paris Encuentro at, 34
Encuentro IV (IV International Open
 Encounter [on Video], Buenos Aires,
 Oct.–Nov. 1975), 35–41, 41
 Argentine artists and cultural figures
 at, 39
 Bex panel at, 41
 Brazilian artists at, 36, 39
 Canadian artists at, 39, 75–76n90
 described, 36
 effect of impending coup on, 36
 events and programs, 35, 39–41
 expanded international participation,
 35–36
 extension of, 35
 Glusberg's promotion of, 35
 goals of, 35
 importance of, 35
 international artist network as goal
 of, 35
 Latin American artists at, 39
 retitling of, 35
 reuse of tapes from earlier Encuen-
 tros, 36
 venue for, 16
 Video Alternativo: Fourth International
 Open Encounter (catalog), 36, 86
 workshops and training component
 of, 35
Encuentro V (V International Open
 Encounter on Video, Antwerp, Feb.
 1976), 41–43
 countries represented in, 43
 lack of catalog for, 41
 number of tapes and artists, 41
 panel discussions at, 42
 press coverage of, 43
 reuse of tapes from earlier Encuentros,
 41, 43
 special program on Polish video art,
 41–43
 statement on contextual art, 41–43,
 76n97
 venue for, 16
Encuentro VI (VI International Open
 Encounter on Video, Caracas, Jan.
 1977), 43–49
 artists in, 48
 and Caracas as center of media arts, 44
 countries represented in, 49
 goal of, 49
 1977 Video: Encuentro Internacional de
 Video (catalog), 43–45, 48–49, 87
 organizers of, 44
 panels at, 49
 planners of, 48
 submissions, number and variety of,
 43–44
 venue for, 16
 video art exhibitions following, 49
 video art exhibitions preceding, 44–48
Encuentro VII (VII International Open
 Encounter [on Video], Barcelona,
 Feb. 1977), 50–52
 chaotic presentation of videos, 51–52
 Colloquium on Communication at, 50
 concurrent exhibition, 50
 as final European Encuentro, 50
 Glusberg's summary of, 50–51
 organizer of, 50
 panels at, 50–51, 78n130
 political context of, 50

quality of videos as issue, 51
 reviews of, 51–52
 Seventh International Open Encounter
 (catalog), 88
 venue for, 16, 50
Encuentro VIII (VIII International
 Open Encounter on Video, Lima,
 Sept. 1977)
 as also first Nacional Encuentro de
 Video Arte for Peru, 53, 55–56
 artists and notable figures at, 54–55
 concurrent exhibition, 53
 concurrent Festival de Teleducación, 54
 press for, 54
 sponsors of, 53
 venue for, 16
 and video art, as ill-defined in Peru, 54
 Video Arte: 8th International Video Art
 Festival (catalog), 53, 88
Encuentro IX (IX International Open
 Encounter on Video, Mexico City,
 Nov.–Dec. 1977), 56–62, 57
 as also first Nacional Encuentro de
 Video Arte for Mexico, 56
 artists at, 56, 59
 booklet for, 59, 60
 chaotic atmosphere of, 61
 concurrent exhibition, 56, 58
 criticism for corporate ties, 61–62
 criticism of elitism of, 61
 as key event in Mexican video art, 56
 lack of catalog, 56
 panels at, 57
 planning of, 59
 reviews of, 61
 venue for, 16, 56
 video art exhibition preceding, 56
Encuentro X (X International Open En-
 counter on Video, Tokyo, May 1978)
 artists at, 63
 audience for, as unclear, 66
 emphasis on symposium and events, 63
 organizers of, 62
 panels at, 63
 public interest in, 64–65
 reviews of, 64–65
 venue for, 16, 62, 62
 Video Art 1978: X International Open En-
 counter on Video (catalog), 62, 64, 89
Encuentro Franco-Chileno de Video
 Arte. See Festival Franco-Chileno de
 Video Arte
Encuentros catalogs
 vs. accepted early video history, 16
 archives of videos from, 94
 broad dissemination of, 16
 countries represented in, 16, 69n6
 essays by Glusberg in, 17, 34, 36
 now-lost works listed in, 16
 publication of, 17
 as source of Encuentros information, 17
 typical content of, 17
 See also individual Encuentros
Encuentros Internacionales Abiertos de
 Video (International Open Encoun-
 ters on Video)
 acceptance of videos from anywhere, 15
 ambition vs. available means, 52, 68
 art periodicals' failure to mention, 17
 bringing video to public as goal of, 15
 CAYC exhibition program and, 15, 68,
 81n202

Encuentros Internacionales Abiertos de
	Video (*continued*)
	and circulation of video art in 1970s,
		19, 96
	complex logistics of, 17
	and connections between artists, 17
	events and programs within, 16
	global scope of, 16
	Glusberg's organization of, 15, 17
	Japanese video art in, 64
	local artists and, 28, 52
	locations for, 16
	loss of focus over time, 61–62
	networks established by, 52
	pre-Encuentros events, 22
	records of, as imperfect, 67
	reviews of, as rare, 51
	scholarship on, 69–70n11
	social change as goal of, 15–17
	technological resources as challenge
		for, 17
	themes of, 34
	videos from, as no longer available,
		67
	See also individual Encuentros
Enzensberger, Hans Magnus, 59–61
ePPA. *See* espacio-Plataforma de Preser-
	vación Audiovisual (ePPA) [Peru]
Escuelab, 102
Escuela de Bellas Artes (Cali), 151
Escuela Nacional de Artes Plásticas
	(ENAP) [Mexico City], 117, 129
espacio-Plataforma de Preservación
	Audiovisual (ePPA) [Peru], 98, 105
Espaço B, 96
Esparragoza, Carolina, 143
Espero que vocês gostem destes filmes
	(Kuikuro), 235
Estudios Churubusco, 49
Etra, Bill, 80n173
Etra, Louise, 77n109, 80n173
Eu já fui seu irmão (VNA), 209–11, *210*,
	220–22
	and disruption of anthropology, 221–22
	Downey's *Video Trans Americas* and, 211
	Ginsburg's reading of, 220–21
	and Indigenous media paradigm,
		221–22
Evangelista, Roberto, 96
Experiencias visuales (Di Tella, 1967), 20
Experimental Cinema Group, 181–82
Experiments in Art and Technology
	(E.A.T.), 64, 113, 128
Export, Valie, 41

Fabrega, Francisco, 176
Fandangos, 24, 29
Fargier, Jean-Paul, 169, 175, 176, 178
Farina, Franco, 32
Fariña, Soledad, 126
Farkas, Solange, 54, 55, 93, 242
Fausto, Carlos, *233*
Fauvet, Jacques, 58
feedback videos, 212, 222
Feliciano, Richard, 80n173
feminism in Latin America
	history of, 110–11
	and opportunities of video art, 110,
		112–13, 128–29
	and television, demand for greater
		influence over, 112
A festa da moça (Carelli), 218–20, *219*, 222

Festival de Cine Latinoamericano
	Rosario, 97
Festival de Teleducación, Cine, Radio y
	Televisión (Lima, 1977), 54
Festivales Internacionales de Video/Arte/
	Electrónica, 102
Festival Franco-Chileno de Video Arte
	artists appearing at, 169, 173, 174–75
	and artists' international contact, 167
	and body art actions, 166, 170–71, *171*,
		172, 173, *174*
	and Bolsa de Productores, 176
	broad concept of video art in, 167
	catalogs/programs, 174
	as center of audiovisualism, 166–67, 168
	continuity over time, impact of, 166
	debate on inclusion of documentaries
		and music videos in, 167–68
	and Diario de Viaje award, 175–76,
		180n24
	early Chilean submissions to, 169–72
	evolution under democracy, 176–77, 178
	5th (1985), 173, 175–76
	focus on dissemination of video art, 167
	as French-founded space of cultural
		exchange, 163, 167
	French political support and, 166
	importance in history of video art,
		164–65
	original name of (1981–1985), 163, 176
	political oppression, works on, 170–71
	selection committee, 167
	6th (1986), *164*, 173
	as space of political resistance, 163, 166
	theoretical texts in catalogs of, 176
	as unique space for artistic expression
		and debate, 164, 166, 168, 176, 178
	women video artists at, 173–74, *174*
Festival Franco-Latinoamericano de
	Video Arte, 94, 176–78, 180n28
festivals, video archives of, 93–95
Fischer, Hervé, 50–51, 55
Flores, Carlos, 167, 169, 172, 175, *175*
Flusser, Vilém, 150
Forch, Juan, 165–66, 174, 175, 180n24
Forest, Fred, 30
Forti, Simone, 33
Fox, Terry, 32
França, Rafael, 93
Fried, Sara, 177
*From Figuration Art to Systems Art in Argen-
	tina* (CAYC, 1971), 28
Fuller, Peter, 28
FUNAI [Fundaçao Nacional do Índio],
	229, 230, 231, 232, 233

Galasse, Danilo, 22
Gale, Peggy, 37
Galleria Civica d'Arte Moderna (Ferrara),
	32, 33
Gallet, Pascal-Emmanuel, 94, 163, 176, 177
Gamboa, Harry, Jr., 59
Gámez, Rubén, 144
García Canclini, Néstor, 24, 25, 39, 56
García-La Rota, Andrés, 102–3
García Uriburu, Nicolás, 26
Gaumnitz, Michaël, 178
Gavião (Parkatêjê), 209–10, *210*, 218–20,
	221–22, 239, 242–43
	See also A festa da moça (Carelli); *Eu já
		fui seu irmão* (VNA)
Gaviola, Tatiana, 126

Geiger, Anna Bella
	and Antwerp Encuentro, 43
	and Buenos Aires Encuentro, 74–75n77
	career of, 122
	challenging of gender stereotypes, 111
	experiments with video art, 122
	and female body as site of violence and
		political articulation, 111
	and ICA *Video Art* exhibition, 37
	networks with other artists, 128
	Passagens, 122, *123*
	Wireless Telephone, 43
Giaccari, Luciano, 33
Gilbert, Zanna, 69n9
Ginsburg, Faye, 215, 220–22
Giralt-Miracle, Daniel, 50–51, 78n130
Giunta, Andrea, 164
Glueck, Grace, 48
Glusberg, Jorge, *42,* 55, 57, 63, 65
	and Argentina's leadership in concep-
		tualism, 19
	arrest, international protest of, *23,*
		23–24
	"Art and Ideology in Latin America," 26
	articles in *Testigo,* 21, *21*
	and Barcelona Encuentro, 50–51
	Bex and, 41, 43
	and Buenos Aires Encuentro, 35, 36, *40*
	and Caracas Encuentro, 43–44, 48, 49
	career of, 19
	and CAYC bulletins, 17–19
	and CAYC media collective, 22
	and CEAC, founding of, 21
	childhood and education, 19–20
	criticism of corporate ties of, 62
	as director of Museo Nacional de
		Bellas Artes, 25
	distribution of Encuentros catalogs,
		17–19
	on Encuentros, goal of, 15–16
	and Ferrara Encuentros, 32, 34
	and Grupo de los Trece, 15
	interest in British television industry, 28
	and Japanese and Argentine video art
		exchange, 66
	and *Japan Video Art Festival: 33 Artists at
		CAYC* (Buenos Aires, 1978), 65
	on Latin American art as necessarily
		political, 36
	and Lima Encuentro, 53, 54
	and London Encuentro, 25–26
	many roles in CAYC, 67–68
	and Mexico City Encuentro, 59
	and MNBA video art archive, 97
	and Modulor lighting company, 20–21,
		24–25, 28, 67, 72n36
	network of artists created by, 19, 30,
		35, 52, 68
	and Open Circuits International Con-
		ference on the Future of Television
		(MoMA), 15–16
	and Paris Encuentros, 29–30
	promotion of video art, 96
	reputation of, 48
	and Segundo Festival Internacional de
		Video Arte (Peru, 1998), 55
	Stern on, 48
	on television, viewers' lack of critical
		response to, 34
	ties to government, critics of, 24–25,
		72n36
	and Tokyo Encuentro, 62–63, 64

on video art and social change, 48–49
and video equipment acquisition, 22–23
See also Centro de Arte y Comunicación (CAYC) [Buenos Aires]
Godfrey, John, 77n109, 80n173
Goldberg, Michael, 63, 64, 66
Golder, Gabriela, 94
Goldstein, Michele, 174
González, Guillermo, 180n16
González, Juan Francisco, 169–70
Gonzalez, Rita, 142
"Goodbye to *Tristes Tropiques*" (Sahlins), 209, 210, 211, 215
Graham, Dan, 33
Grayson, Susan, 28
Gronk, 59
Grotowski, Jerzy, 43
Group CAYC, 32, 50, 74–75n77
Group Videamus, 39, 49, 74–75n77
Grupo CADA (Colectivo Acciones de Arte), 126
El Grupo de los Trece, 15, 43, 67
El Grupo de los Trece (CAYC, 1973), 22, 26, 28
Guajajaras, VNA and, 243
Guirnalda project, 176
Guiton, Jean-François, 178
Guzmán, Rubén, 97
Gwin, William, 77n109

Hagiwara, Sakumi, 81n191
Hall, David, 28, 43, 50
Hallock, Don, 80n173
Hastings, Rafael, 22, 53, 54
Healy, Juan Ruiz, 59
Herkenhoff, Paulo, 39, 74–75n77, 96
Hernández Calvo, Max, 54
Hernaro, Sal, 146
Herzogenrath, Wulf, 35, 39–41, 50
Hickey, Neil, 58
As hiper mulheres (Fausto and Sette), 233
Hirsch, Narcisa, 33
Historia del videoarte en Colombia (website), 100
history, video art accounts of, 149–50, 153, 160
See also memory, contemporary turn to; memory, distortion and gaps in
Hochman, Brian, 224n13
Homo Sapiens (film), 28
Hoover, Nan, 43
Horn, Rebecca, 33, 63
Horsfield, Kate, 143
Houston, John, 138, *138*, 139
Howkins, John, 28
Huertas, Laura, 182
Hugo, Ian, 77n109
Huichaqueo, Francisco
Adentu/Retrato, 202
on art as spirit of culture, 195, 202
dreams as inspiration for, 196, 201
exhibition at Museo Nacional de Bellas Artes gallery, 199–200
Ilwen: La tierra tiene olor a padre, 203
on Indigenous cinema, 201–2, 204
Kalül Trawün/Reunión del cuerpo, 199, 199–201, 204
on making space for Mapuche art, 199
on Mapuche films, complex cultural elements to be included in, 202–3

on Mapuche oppression in Chile, 195, 196
on Mapuche world and surrealism, 201
Mencer: Ñi pewma, 196–98, *198*, 201, 204
on narrative conventions, 203–4
and neocolonial demand for Indigenous immobility, 202–3
on sequence shooting, 203
on silences in his work, 203
on spirituality as bridge between past and future, 202
on spirituality of Mapuche cinema, 204
on tyranny of Hollywood conventions, 203–4
The Unified Field, 201
on work of art needed to promote spiritual healing, 196
See also Wenu Pelón exhibition (Santiago, 2015–20)
Hunt, Jerry, 77n109, 80n173
Huyssen, Andreas, 149–50

ICA. See Institute of Contemporary Art (ICA) [Philadelphia]; London Institute of Contemporary Arts
ICC. See Internationaal Cultureel Centrum (ICC) [Antwerp]
ICI. See Instituto de Cooperación Iberoamericana
ICTUS TV, 169, 179n12
Ignacio, José, 46, 77n108
Iimura, Takahiko, 81n189
The Illustration of Art / o. video (Music Piece) (Dias), 33
Imagen de Caracas (Caracas, 1968), 45–46
Imagen y semejanza (Williams), 95
Imai, Norio, 64
Imber, Sofía, 44–45, 46, 48, 49
Independent Curators International (ICI), 38
Indigenous media paradigm, 215, 220–21, 226n15
Indigenous peoples
artists addressing anthropology's representation of, 223
of Brazil, political rights of, 231–32
cell phone use, 239
impact of contact on, 240
and Indigenous media paradigm, 215, 220–21
and *Os Povos Indígenas no Brasil*, 232
and television, access to, 235
TV channel, 240
and violence done by outside cinema, 239
See also specific groups
Indigenous peoples, cultural decline with outside contact
critiques of concept, 214, 220–21
Downey's rejection of, 214
Lévi-Strauss on, 209, 214
Sahlins on, 209
and salvage paradigm, 214–15
Indigenous peoples, use of video technology, 235
cultural exchanges prompted by, 210, 211–13, 214, 218–21, 222, 227
and cultural revival, 218, 221, 233, 240
demand for, 233
and denaturalizing of "native" concept, 222

and disruption of anthropology, 221–23
growth in 1980s–1990s, 223
for political empowerment, 220, 221, 229
and reconfiguring relationship of anthropology to technology, 211
Sahlins on, 209
video and television collectives, 223
webs of viewers and makers, 210–11, 223
women and, *238*, 238–39
See also A festa da moça (Carelli); *Eu já fui seu irmão* (VNA); *O espírito da TV* (VNA); *Vídeo nas Aldeias* (VNA) [Brazil]; *Video Trans Americas* [Downey] (VTA)
Indigenous peoples' encounters with other Indigenous groups
through Smithsonian National Museum of the American Indian, 234, 240
value of, 240
See also Indigenous peoples, use of video technology; *specific groups*
Inquieta imagen competition, 95, *95*
Institute of Contemporary Art (ICA) [Philadelphia], 37, 122
Instituto Chileno Francés de Cultura (Santiago), 163
Instituto de Arte Contemporáneo (Lima), 53–54
Instituto de Cooperación Iberoamericana (ICI), 96
Instituto Torcuato Di Tella (Buenos Aires), 20, 21, 96, 112–13, 114
Internationaal Cultureel Centrum (ICC) [Antwerp], 41, 43
International Video Exchange Directory, 64
Intersticios: Cuerpos políticos, estrategias conceptualistas y experimentalismos cinematográficos (Montevideo, 2019), 98, 103–4, *104*
Inuit videos, 237–38
Italy
state-owned television in 1970s, 34, 74n69
video production in early 1970s, 33
See also Encuentro III (III International Open Encounter on Video, Ferrara, May 1975)
Itriago, Salvador, 49
Iveković, Sanja, 32
IWY. See World Conference of the International Women's Year

Jaar, Alfredo, 166, 169, 173
Jacoby, Roberto, 39, 113
Jaffrennou, Michel, 169, 175
Japanese video art
origins of, 63–64, 66, 81n188
in São Paulo Bienal (1975), 75n81
See also Encuentro X (X International Open Encounter on Video, Tokyo, May 1978)
Japan Video Art Festival: 33 Artists at CAYC (Buenos Aires, 1978), 65, 66
Jara, Reina Isabel, 101–2
Jardón, Humberto, 118, 119–20, *120*
Jepson, Warner, 80n173
Jikken Kōbō, 63
Jodorowsky, Alejandro, 142

Joe DiMaggio (McGuire), 143–44
Jonas, Joan, 33, 41, 111
Jones, Amelia, 111
Jovem Arte Contemporânea (MAC USP, 1974) [JAC], 37
Juguetes (Bemberg), 114
Julian Cairol's Portrait (Minujín), 26
July, Miranda, 144

Kamien, Ana, 26
Kaprow, Allan
 at Encuentros, 32, 33, 56, 61, 77n109
 Levine on, 47
 networks with other artists, 128
 Simultaneidad en simultaneidad (with Minujín and Vostell), 114
Katzenstein, Inés, 115
Kawanaka, Nubohiro, 64, 81n191
Kayapó, 243
Kidnappening (Minujín), 26, 27
The King (Antin), 75n83
Klüver, Billy, 113
Knights, Karen, 133n53
Kobayashi, Hakudo, 62, 64, 81n191
Kölnischer Kunstverein, 41
Komura, Masao, 81n191
Konieczny, Marek, 78n123
Kosugi, Takehisa, 47
Kounellis, Jannis, 33
Krahô, 209–10, 210, 220–221, 222, 230–31
 See also Eu já fui seu irmão (VNA)
Krasniansky, Bernardo, 22
Krauss, Rosalind, 173
Kubota, Shigeko
 Behind the Video Door, 112
 and camera as extension of body, 111–12
 and Caracas Encuentro, 48, 77n109
 and circulation of Japanese video art, 81n189
 fusing of genres by, 112
 and Mexico City Encuentro, 59, 61
 networks with other artists, 128
 Weiss and, 59, 117
Kuikuro, Takumã, 235
Kunstsystemen in Latijn-Amerika (Antwerp, 1974), 41
Kwak, Duck Jun, 64

Labadié, 22–23, 28
Laboratorio Arte Alameda (LAA) [Mexico City], 104
Laboratorio de Cine FAC (Montevideo), 100
Ladeira, Maria Elisa, 229
La Ferla, Jorge, 92, 177
LA Freewaves festival, 182–83
Lahosa, Joan Enric, 78n130
Lamelas, David, 20
Latin American Week (London, 1974), 25, 26
Lawson, Julie, 26
LAXART, *Video Art in Latin America* exhibition (2017), 2, 6, 12
Leitão, Gil Gomes, 228
Leone, Sergio, 58
Leppe, Carlos, 165, 166, 169, 170–71, 171
Lerner, Jesse, 142, 144
Le Tacon, Jean-Louis, 175
Levine, Les, 32, 47–48, 56, 59
Lévi-Strauss, Claude, 209, 213–14, 218, 224n11

Lima, Daniel, 93–94
Lima, Roberto, 54
Lindsay, Robert, 58
Liñero, Germán, 167–68
Lippard, Lucy, 22
Lipsid, Donald, 59
Liscano, Juan, 49
Llano-Mejía, Sandra, 117–21
 biofeedback in art of, 117–21, 119
 challenge to gendering of technology, 111
 and corporeal relation of self and technology, 111, 112, 117
 De la energía vital y otras emo-ciones—1976–7, 118
 as early pioneer in video art, 128–29
 experimental videography, 111
 In-Pulso, 119, 119–20
 installations and Happenings by, 118, 131n29
 Música imitada, 120, 120, 132n36
 networks with other artists, 128
 Piano experimental, 120
 and sociological approach to art, 119
 Vidarte: Un suceso, 118, 119
 Video Book, 120–21, 121
 and viewer as active participant, 118, 119
Lomelí, Raúl, 56, 59, 61–62
London, Barbara, 5, 37, 65, 66
London Institute of Contemporary Arts (ICA), 25, 27
Long Beach Museum of Art, 213
López Ruiz, Ángela, 100
Lozada, Príamo, 104
Lublin, Lea, 26, 32, 50, 74–75n77
Lucie-Smith, Edward, 26, 27
Lugar a Dudas (Cali), 183
Luis Benedit at the CayC (film), 28
Lula da Silva, Luiz Inácio, 231–32

MACC. *See* Museo de Arte Contemporáneo de Caracas
Machado, Ivens Olinto, 37
MAC USP. *See* Museu de Arte Contemporânea da Universidade de São Paulo
MADC. *See* Museo de Arte y Diseno Contemporáneo (MADC) [Costa Rica]
Magueyes (Gámez), 144
Maler, Leopoldo, 19–20, 26, 56, 59, 74–75n77
MALI. *See* Museo de Arte de Lima
Malinowski, Bronislaw, 222
El mañana fue hoy (Hernández et al.), 102
Manzano, Manuel, 52
Mapuche
 and art to promote reconciliation, 196
 making space for art of, 199
 oppression in Chile, 195, 196
 and *Wenu Pelón* exhibition (Santiago, 2015–20), 204–8, 205, 207
Margolles, Teresa, 141
Mariano, Héctor, 207
Mariátegui, José-Carlos, 54, 55, 101–2
Marin, Jonier, 26, 39, 49
Mariotti, Francesco, 53
Marras, Amerigo, 39, 40, 56, 59
Marroquin, Raúl, 17, 24, 26, 27, 29, 32, 74–75n77
Martinez, Itamar, 49

mass media
 history in, *vs.* video art, 149, 160
 video art as critique of, 1
 See also television
Matsumoto, Toshio, 62, 63–64, 81n191
Matsushita, Shoko, 81n191
Matsushita, Tetsuo, 81n191
Matta-Clark, Gordon, 24
Mayer, Mónica, 119
Mayolo, Carlos, 181
Mayor, David, 62
McGlade, Terry, 39
McGuire, Anne, 143–44
McLuhan, Marshall, 58
Medalla, David, 31
Mediateca Libre, 94
Mejía, Rafael, 119–20, 120
Mellado, Justo Pastor, 167, 168
Memórias inapagáveis: Um olhar histórico no Acervo Videobrasil (2014), 93
memory, contemporary turn to, 149–50
memory, distortion and gaps in
 as common video art subject, 149
 Muñoz's video art and, 150–53, 160
 Padín's video art and, 150–51, 154–56, 160
 Salmerón's video art and, 150–51, 156–60
Meneses, Magali, 126, 173, 175
La Menesunda (Minujín and Santantonín), 20
metadATA: 20 años de Cultura, Arte y Tecnología (Lima, 2016), 101–2, 102
Metálicos Unión, 53
Mexican Video: Thorn of the Mountain (Berger), 144
Mexico
 and sociological approach to art, 119
 Televisa and, 112
 and UN International Women's Year, 111
Mexico, and video art
 archives, 97, 101, 104
 and Buenos Aires Encuentro, 39
 and Caracas Encuentro, 49
 Cuevas on, 141–42
 exhibitions, 56–58, 59, 80n173
 pioneers of, 59, 130n10
 See also Cuevas, Ximena; Encuentro IX (IX International Open Encounter on Video, Mexico City, Nov.–Dec. 1977); Llano-Mejía, Sandra; Weiss, Pola
Mexperimental Cinema (Lerner and Gonzalez), 142
Mezza, Gonzalo, 165, 166, 169, 173
Michaels, Eric, 225n15
Una milla de cruces sobre el pavimento (Rosenfeld), 126
Minkoff, Gerald, 43
Minter, Sarah, 59, 140–41, 142, 146
Minujín, Marta, 113–15
 and Buenos Aires as video art center, 96
 challenge to gendering of technology, 111, 113, 128
 Circuit, 119
 and collapse of viewer/object barrier, 113–14, 119
 and corporeal relation of self and technology, 111, 112, 113–14, 115
 critique of gendered dimension of art, 114

early career of, 113
as early pioneer in video art, 113
experimental engagement with
 videography, 111
Julian Cairol's Portrait, 27
Kidnappening, 27
and London Encuentro, 26, 27
La Menesunda (with Santantonín),
 20, 114
Minucode, 119
Minuphone, 115, 128
networks with other artists, 128
and Paris Encuentro, 32
Simultaneidad en simultaneidad (with
 Kaprow and Vostell), 114, *115*
themes in work of, 113–14
Miyai, Rikuro, 81n191
MNBA. *See* Museo Nacional de Bellas
 Artes (MNBA) [Buenos Aires]
Modulor lighting company, 20–21, *21*,
 24–25, 28, 67, 72n36
Moles, Abraham, 58
Moncayo, María Belén, 100
Montagu, Arturo, 74–75n77
Montes, Nataly, 101–2
Moorman, Charlotte, *45*, 46–47, *47*, 48
Morales, Inés, 142
El movimiento circular de la luz (Mariotti),
 53
MUCA. *See* Museo Universitario de
 Ciencias y Arte (MUCA) [Mexico
 City]
MUCEVI. *See* Museo Centroamericano
 de Videoarte
*Muestra de video del Primer Festival de
 Caracas* (1979), 49
Mulvey, Laura, 114
El mundo de la mujer (Bemberg), 114
Muñoz, Oscar
 Aliento series, 184, 186, *187*
 Ante la imagen, 184, *185*
 background and career, 151
 on Cali artistic scene, 181
 El coleccionista, 189–90
 development of ideas within media, 183
 on diversity of Latin American video
 art, 182
 earliest videos of, 182
 on early photography, 185
 Editor solitario, 189–90
 and Experimental Cinema Group,
 181–82
 first video art exhibition, 182–83
 Fundido a blanco, 184, 190–92, *191*
 on image's instability as theme, 184
 interview with Shtromberg, 181–83
 on irresolution of memory, 150–53, 160
 Línea del destino, 184, 189, *189*
 La mirada del cíclope, 182
 Narciso, 182, 184, *188*, 189
 Narcisos en proceso series, 184, 186, 189
 Re/trato, 151–53, *152*, 182, 184, 190
 on video vs. film, 182
Muñoz Zárate, Patricio, 199
Muntadas, Antoni, 32, 35, 39, 52
Museo Arqueológico de Santiago, *Wenu
 Pelón* exhibition (2015–20), 204–8,
 205, *207*
Museo Castagnino + Macro (Rosario,
 Argentina), 97
Museo Centroamericano de Videoarte
 (MUCEVI), 99

Museo de Antioquia (Medellín), 102, 103
Museo de Arte Carrillo Gil (Mexico City),
 16, 56, 97, 142
Museo de Arte Contemporáneo de
 Caracas (MACC), 44, 46, 47, 48
Museo de Arte de Lima (MALI), 98, 105
Museo de Arte Moderno (Bogotá), 119
Museo de Arte Moderno (Buenos Aires),
 20, 97
Museo de Arte Moderno (Mexico City),
 56, 120
Museo de Arte y Diseno Contemporáneo
 (MADC) [Costa Rica], 94–95
Museo Monumento a los Héroes
 (Bogotá), 102
Museo Nacional de Bellas Artes (San-
 tiago), 94, 169, 170, 176, 177, 199,
 200
Museo Nacional de Bellas Artes (MNBA)
 [Buenos Aires], 19, 20, 25, 97,
 199–200
Museo Universitario de Ciencias y Arte
 (MUCA) [Mexico City], 56
Museu de Arte Contemporânea da
 Universidade de São Paulo (MAC
 USP), 37, 96
museums
 and preservation of video art, initial
 lack of commitment to, 91, 96
 video archives of, 95–99
 See also specific museums

***El Nacional* (Caracas),** 49
Nacional Encuentro de Video Arte for
 Peru, 53, 55
Nakahara, Michitaka, 81n191
Nakahara, Yusuke, 64–65
Nakai, Tsuneo, 64
Nakajima, Ko, 64
Nakaya, Fujiko, 37, 62, 64, 81n191
Nambikwara
 and Carelli's *A festa da moça*, 218–20,
 219
 and VNA, 234
Naranjo, Silvia, 59
National Center for Experiments in
 Television (San Francisco), 58,
 77n109
Navarro, Patricia, 126
Neuer Berliner Kunstverein, 27
Niblock, Phill, 77n109
Nicaragua, Sandinista Revolution,
 Salmerón's *Documentos* series on,
 156–60, *158*
Nicobis—Archivo Audiovisual de los
 Pueblos Indígenas, 98–99
Nicolayevsky, Ricardo, 139–40, 143
Nisic, Hervé, 169, 175
Nogales, Toya, 78n130
"Notes from the Video Underground"
 (Hickey), 58
Nyst, Jacques-Louis, 43

***O Brasil dos índios: Um arquivo aberto*
 (VNA),** 242
O espírito da TV (VNA), 220, *221*, 242
Olhagaray, Néstor, 54–55, 94, 167
Ono, Yoko, 47, *47*, 142
Open Circuits International Confer-
 ence on the Future of Television
 (MoMA), 15–16
Orensanz, Marie, 26

Orsi, Valeria, 97
Ortega, Damián, 141
Ospina, Luis, 181
Os Povos Indígenas no Brasil, 232
Oster, Yürgen, 43
Osterhout, Mike, 59

Pacheco, Hector, 141, 143, 145
Pacific Standard Time: LA/LA, 2, 6
Padín, Clemente
 imprisonment of, 154
 on irresolution of memory, 150–51,
 154–56, 160
 Missings Miss, 154–55, 154–56, 161n14
Paik, Nam June
 in *Artes Visuales* video art issue, 59
 and Caracas Encuentro, 46–48, 77n109,
 78n123
 Cuevas on, 142
 Levine on, 47–48
 and Lima Encuentro, 55
 and Mexico City Encuentro, 56, 59, 61
 and Paris Encuentro, 31, 32
 and Tokyo Encuentro, 63, 64
 TV Bra for Living Sculpture, 46–47
 TV Garden, 54
 in *Video arte* exhibition, 54
 Weiss and, 59
Paillalef, Juana, 204–6
Pain, François, 169
Palmeira, Maros, 241
Pane, Gina, 43
Paolini, Giulio, 33
Paraná, Konoi, *237*
Para os nossos netos (Paraná), *237*
Parente, Letícia, 43, 74–75n77, 96, 111,
 122
 Marca registrada, 123–24, *124*
 Preparation II, 43
Parkatêjê (Gavião), 209–10, *210*, 218–20,
 221–22, 239, 242–43
 See also Eu já fui seu irmão (VNA)
Partridge, Steve, 28
Paso, Paulina del, 144
Pato, Ana, 91, 93, 106
Pérez, Régulo, 47, 48
Pérez-Ratton, Virginia, 98
Pérez Rubio, Agustín, 93
Perón, Isabel, 36
Perón, Juan, 20
Peru
 archive and preservation work in,
 98, 105
 and ATA, 55, 98, 101–2, 105
 and Buenos Aires Encuentro, 39
 experimental arts in, 53
 video art exhibitions, 53–54, 55, 75n86,
 101–2, 102
 video artists, Encuentros and, 53
 See also Encuentro VIII (VIII Interna-
 tional Open Encounter on Video,
 Lima, Sept. 1977)
Piene, Otto, 77n109
Pilea Sprucena (de Jesús), 43
Pinacoteca do Estado de São Paulo, 96
Pinochet, Augusto, 94, 121–22, 126, 127,
 128, 212
 See also Chile, under Pinochet dicta-
 torship
"Pioneers of Brazilian Video Art 1973–
 1983" (Shtromberg and Phillips), 2
Polanski, Roman, 58

portable video camera recorders (portapaks)
 and early video artists, 22, 37, 63, 71n24, 169–70, 229
 and women's video art, 110–13, 116, 122
Portillo, Lourdes, 140
Posani, Juan Pedro, 45
Prado, Patrick, 169
Premio Arte y Nuevas Tecnologías MAMbA—Fundación Telefónica, 97
preservation of video art
 lack of institutional support for, 92
 need for, with proliferation of works, 91
 personal initiatives in, 92
 urgency of, 92
 value of video art works and, 92
 See also archives for video art
Price, Jonathan, 80n173
Primer Encuentro Mundial de la Comunicación (Acapulco, 1974), 58–59
Processart Inc., 64
Producciones Cinematográficas Nacionales (PROCINE), 53
Pulido, Guillermo, 59
Pulquillanca, Eliana, 207

Quilaqueo, Sandra, 126
Quiroz, Susana, 142

Radical Software, 212
Raindance Foundation, 212
Rainer, Arnulf, 33
Ramírez Amaya, Arnoldo, 26
Rangel, Carlos, *46*
(Ready) Media: Hacia una arqueología de los medios y la invención en México (Mexico City, 2010), 104
Reindeer Werk, 43
Rennó, Rosângela, 93
Resenterra, Fiorella, 95
Restany, Pierre, 31, 33, 73n57
Restrepo, José Alejandro, 102, 177, 182
Restrepo, Ricardo, 177
Retro Visión Espectral: Aproximaciones a una historia del videoarte en Colombia (Colombia, 2018–19), 102–3, *103*
"Rhetoric of the Body" (Richard), 121–22
Rich, B. Ruby, 140
Richard, Nelly, 121–22, 125, 126, 166, 173, 174
Road (Davidovich), 26, 27
Robles, Mario, 45
Roca, José, 185
Rojo, Elias Levin, 55
Romero Brest, Jorge "Coco," 20
Rondônia, Carelli film on, 243
Rosenbach, Ulrike, 41
Rosenfeld, Lotty, 111, 126, 133n53, 165, 166, 173
Rosenquist, Willard, 77n109, 80n173
Rosler, Martha, 32
Ross, David, 37–38, 47, 48
Roth, Pedro, 22
Rottner, Nadja, 114
Rouch, Jean, 201, 234
Rousseff, Dilma, 241, 243
Ruiz, Raúl, 204
Rusiñol, Joaquim Dols, 78n130

Sahlins, Marshall, 209, 210, 211, 215
Salinas Gortari, 145
Sallaberry, Carlos, 54
Salmerón, Ernesto
 Documentos series, 156–60, *158,* 161n15
 education, 156, 161n16
 on irresolution of memory, 150–51, 156–60
 Muñoz's *Re/trato* and, 182
Santantonín, Rubén, 20, 114
Santos, Eder, 93
São Paulo Bienales, CAYC participation in, 24, 36
São Paulo Bienal X (1969), 53
São Paulo Bienal XI (1971), 24
São Paulo Bienal XIII (1975), 36, 37–38, *38,* 53
São Paulo Bienal XXXII (2016), 242
Sarrat, Chris, 43
Sasaki, Tomiyo, 59
Satelitenis (Downey et al.), 175, *175*
Schaaff, Sergi, 78n130
Schlesinger, John, 138
Schramm, Wilbur, 58
Schwartz, Francis, 49
Schwartz, Lillian, 77n109
Schwartzman, Steve, 234
Seawright, James, 77n109
Segundo Festival Internacional de Video Arte (Peru, 1998), 55
Sekula, Allan, 32
Sentias, Mireia, 52
Serpentine Gallery, *The Video Show* (1975), 28
Serrano, Marcela, 126, 173
Sette, Leonardo, *233*
Shaul, Sandra, 61, 66
Shtromberg, Elena, 123–24
Sibaja, Antonieta, 99
Sicard, Daniel, 78n123
Sicardi Gallery (Houston), 182–83
Silver, David, 80n173
Simultaneidad en simultaneidad (Minujín et al.), 114, *115*
Situación de tiempo (Lamelas, 1967), 20
Smithsonian National Museum of the American Indian, VNA and, 234, 240
Sobell, Nina, 132n34
sociological approach to art, Llano-Mejía and, 119, 132n32
Solá Franco, Eduardo, 100
Sonnier, Keith, 47
Spandorfer, Merle, 59
Stellweg, Carla, 56, 59
Stern, Gerd, 43–44, 46, 47–48, 49, 77n108
Sturken, Marita, 160
Sub-Secretaría de Radio Difusión, 49
"Surveying the Border" (Shtromberg and Phillips), 123
Świdziński, Jan, 41

Táboas, Sofía, 141
Tadlock, Thomas, 77n109
Tambellini, Aldo, 77n109
Taquini, Graciela, 96, 97, 177
Teatro ICTUS, 169, 179n12
Technology/Transformation: Wonder Woman (Birnbaum), 140
Telesud Peruana S.A., 53
television
 alternative, as goal of video artists, 34

Andrade's *Untitled, Desligue a televisão* and, *125,* 125–26
 and consumerism, 123–24
 critical reflection on, as goal of video art, 1
 critiques of, at Festival Franco-Chileno de Video Arte, 170–71, 172
 Glusberg essay on, 34
 increased cultural influence in 1970s, 112
 Indigenous access to, 235
 influence in Chile under Pinochet, 173
 influence on video art, 1
 state-owned monopoly in 1970s Italy, 34, 74n69
El tendedero (Mayer), 119
TEOR/éTica (Costa Rica), 98
Terán, Pedro, 48
Testigo, Glusberg's articles in, 21, *21*
themes in video art, 2
Third World Editions (Ediciones Tercermundo), 22, 67
Tisdall, Caroline, 28
Tonacci, Andréa, 229
Tono, Yoshiaki, 81n191
Topless on Tahiti Beach (Ehrenberg), 26
T.O.T. (Technological Oak Tree) (Vostell), 43
Trilnick, Carlos, 96
Tristes Tropiques (Lévi-Strauss), 209, 214
Trotta, Antonio, 26–27
Truffault, Philippe, 169
Tudor, David, 64
21 Artistas argentinos: Década del 70 (Mexico City, 1977), 56, *58*
26'1.1499 for a String Player (Cage), 47

United States Information Agency, and São Paulo Bienal, 37–38
Universidad Nacional de Tres de Febrero (UNTREF) [Buenos Aires], 94
Uruguay, military dictatorship, Padín's *Missings Miss* on, *154–55,* 154–56
USCO, 46

Valls, Manel, 78n130
Varela, Bruno, 142
Vasulka, Woody and Steina, 46, 77n109
Vater, Regina, 39
Vazan, Bill, 39, *40*
Vedova, Emilio, 78n123
Venezuela
 and Buenos Aires Encuentro, 39
 See also Caracas
VER archive, 99
Vicens, Francesc, 50
video, *vs.* film, 5
Video 1—M5 (Ehrenberg), 26
video art
 accounts of history in, 149–50, 153, 160
 artists' reasons for this medium, 5–6
 definition of, 5, 54
 Giralt-Miracle on major trends in, 51
 as not taught in art schools, 5
 standard of quality as issue in, 47–48, 51
Video Art exhibition (1975–76), 37–39
 artist selection process, 39
 artists from, in Encuentros, 39
 artists in, as pioneers of video art, 39
 museums hosting, 37
 original version of, 37, 38–39
 second, US-only version of, 37–38, *38*

third version, touring Latin America, 37–38, *38*, 53–54
video art in Latin America
 access to equipment and, 1, 5, 27, 112
 early focus on human body, 173
 gaps in scholarship on, 4
 importance in military dictatorships, 95–99
 obstacles faced by, 163–64
 See also specific cities and countries
Video Art in Latin America exhibition (LAXART, 2017), 2, *2*, 3, 6, 12, 12n3
Video Art in Latin America research project, 2–5, 12
Video Art: Videocinta de vanguardia estética televisual (Mexico City, 1973), 56–58, 59, 80n173
Videobrasil festival, 93, 242
Videobrasil festival video art archives, 93–94, 106
Video Color, 59
Video Data Bank (Chicago), 143
Video from Tokyo to Fukui and Kyoto (MoMA, 1979), 65
Video Hiroba, 63, 64, 81n191
Video México (New York City, 1977), 59
Vídeo nas Aldeias (VNA) [Brazil]
 and access to Indigenous world, 239
 and Brazilian TV, 240–41
 and disruption of anthropology, 222–23
 Downey's *Video Trans Americas* and, 218
 first camera, 234
 foundations' support for, 233–34
 founding of, 218, 225n18, 227, 228, 232–34
 government funding and, 241–42, 243
 impending collapse of, 243–44
 improvisation of scripts and sets, 236–37
 and Indigenous cinema, 240, 241
 and Indigenous media paradigm, 220–21
 and Indigenous media projects, 227
 Indigenous responses to videos made by other groups, 237–38
 and Indigenous visibility, 227
 instructions on video provided by, 236
 introduction of cameras to Indigenous people, 235–36
 and larger Latin American movement, 234
 number of works produced by, 227
 online video catalog of films, 243
 relationship with villages, 244
 and Smithsonian National Museum of the American Indian, 234, 240
 as training and production center, 227
 varying focus of videos in different villages, 236
 venues showing videos of, 227
 video editing process, 235–36
 videos, and cultural revival, 240
 videos' influence on Carelli's artistic practice, 239
 videos of, as driven by Indigenous filmmakers, 240
 and women, videos by, *238*, 238–39
 See also A festa da moça (Carelli); *Eu já fui seu irmão* (VNA); *O espírito da TV* (VNA)
Video-Nou Collective, 52

The Video Show (London, 1975), 28
Video Studio 970/2, 33
Video Tapes lecture series (1974), 22–23
video technology, artists' early ambivalence about, 150
"Video: The Aesthetics of Narcissism" (Krauss), 173
Video Trans Americas [Downey] (VTA), 211–13
 and anthropological parallax, 215–18
 countries visited for videotaping, 212
 and disruption of anthropology, 222
 Eu já fui seu irmão (VNA) and, 211
 exchange of videos among Indigenous peoples, 211–13
 and feedback video, 212, 222
 as museum installation, 213, 216–18, *217*
Villacorta, Jorge, 101–2
Villaseñor, Maria-Christina, 144
Viñoly, Rafael, 39, 49
Viola, Bill, 33, 63, 66
VNA. *See* Vídeo nas Aldeias (VNA) [Brazil]
von Trier, Lars, 201
Vostell, Wolf, 43, 55, 78n123, 114, 128
VTA. *See Video Trans Americas* [Downey] (VTA)

Wada, Morihiro, 64
Wajãpi. *See O espírito da TV* (VNA)
Walking and Whistling (Trotta), 26–27
Warhol, Andy, 142
We Gather as a Family (VNA). *See Eu já fui seu irmão* (VNA)
Weiss, Pola
 and artists' networks, 117
 and arTV, 116, 117
 Autovideato, 59
 and breaking of media border, 116–17
 career of, 59
 challenge to gendering of technology, 111, 115
 conception of mission, 117
 and corporeal relation of self and technology, 111, 112, 115, 117
 Cuevas and, 141
 as early pioneer in video art, 128–29
 eccentric personality of, 129
 experimental videography, 111
 Flor cósmica, 59
 hybrid forms and categories of art, 115
 and Mexico City Encuentro, 59, *60*
 networks with other artists, 128
 and reformulation of subject-object relation, 116–17
 television work, 115–16
 use of image distortion in videos, 56–58
 Video Art exhibition (Mexico City, 1973) and, 56–58
 videodanzas, 59, *116*, 116–17
 Video México exhibition (1977), 59
 and video production as incestuous copulation, 117
Welch, Roger, 56
Wenu Pelón exhibition (Santiago, 2015–20), 204–8, *205*, *207*
 curators for, 204–6
 films used in, 207
 as first Mapuche-designed exhibition, 204

Huichaqueo's dream providing design for, 206, 208
 and shift from Western logic, 206
 spiritual guidance in design of, 206
 spiritual power of, 206–7
Whitefeather, Selena, 59
Whitney Museum of American Art, 213, 216–18, *217*, 222
Williams, Stephanie, 95
Wireless Telephone (Geiger et al.), 43
Women, Art and the Periphery (Vancouver, 1987), 126, *127*, 133n53
women video artists in Latin America
 and blurring of subject-object boundaries, 111
 challenging of gendering of technology, 111
 challenging of gender stereotypes, 128
 challenging of media representations, 111
 and embodied model of perception, 111
 first and second generations of, 111
 networks between, 128
 and opportunities of video art, 110, 112–13, 128, 129
 relative invisibility of, 110
 videos of female bodies subjected to violence, 112, 121–28, 129
 See also individual artists
Workshop of Film Form (Poland), 41–43
World Conference of the International Women's Year (IWY) [1975], 111, 112

Xikrin, 228, 230, 244
Xina bena, New Era (Yube), 237

Yalkut, Jud, 77n109
Yamaguchi, Katsuhiro, 50–51, 62–65, 75n81, 81n191
Yamamoto, Keigo, 62, 63–64, 75n81, 78n123, 81n191
Yanomami, artistic projects focusing on, 223
Yanomami project (Downey), 213–14
 anthropological parallax introduced by, 216–18
 and salvage paradigm, rejection of, 214–15
 Yanomami videotaping of themselves in, 213, 214–15, *215*
Yi, Po-Chu, 54
Young, James, 150
Yube, Zezinho, 237, *238*

Zabaleta, Guillermo, 100, 103
Zagone, Robert N., 80n173
Zanini, Walter, 37, 96
"Zona de turbulencia" (Alonso), 163–64

Titles in the
ISSUES & DEBATES series

Purity Is a Myth: The Materiality of
Concrete Art from Argentina, Brazil,
and Uruguay
Edited by Zanna Gilbert, Pia Gottschaller,
Tom Learner, and Andrew Perchuk
ISBN 978-1-60606-723-7 (paper)
ISBN 978-1-60606-724-6 (e-book)

Visualizing Empire: Africa, Europe,
and the Politics of Representation
Edited by Rebecca Peabody, Steven
Nelson, and Dominic Thomas
ISBN 978-1-60606-668-3 (paper)
ISBN 978-1-60606-677-5 (e-book)

Canons and Values: Ancient to Modern
Edited by Larry Silver and
Kevin Terraciano
ISBN 978-1-60606-597-6 (paper)

London and the Emergence of a
European Art Market, 1780–1820
Edited by Susanna Avery-Quash
and Christian Huemer
ISBN 978-1-60606-595-2 (paper)

Photography and Sculpture:
The Art Object in Reproduction
Edited by Sarah Hamill and
Megan R. Luke
ISBN 978-1-60606-534-1 (paper)

Qing Encounters: Artistic Exchanges
between China and the West
Edited by Petra ten-Doesschate Chu
and Ning Ding
ISBN 978-1-60606-457-3 (paper)

Lawrence Alloway: Critic and Curator
Edited by Lucy Bradnock,
Courtney J. Martin, and Rebecca Peabody
ISBN 978-1-60606-442-9 (paper)

Manuscript Cultures of Colonial Mexico
and Peru: New Questions and Approaches
Edited by Thomas B. F. Cummins,
Emily A. Engel, Barbara Anderson,
and Juan M. Ossio A.
ISBN 978-1-60606-435-1 (paper)

World Antiquarianism:
Comparative Perspectives
Edited by Alain Schnapp with
Lothar von Falkenhausen, Peter N. Miller,
and Tim Murray
ISBN 978-1-60606-148-0 (paper)

Photography's Orientalism:
New Essays on Colonial Representation
Edited by Ali Behdad and Luke Gartlan
ISBN 978-1-60606-151-0 (paper)
ISBN 978-1-60606-267-8 (e-book)

Provenance: An Alternate History of Art
Edited by Gail Feigenbaum and Inge Reist
ISBN 978-1-60606-122-0 (paper)

Surrealism in Latin America:
Vivísimo Muerto
Edited by Dawn Ades, Rita Eder,
and Graciela Speranza
ISBN 978-1-60606-117-6 (paper)

Sacred Possessions: Collecting Italian
Religious Art, 1500–1900
Edited by Gail Feigenbaum
and Sybille Ebert-Schifferer
ISBN 978-1-60606-042-1 (paper)

Cultural Identity and the
Ancient Mediterranean
Edited by Erich S. Gruen
ISBN 978-0-89236-969-0 (paper)

Bernard Picart and the First Global
Vision of Religion
Edited by Lynn Hunt, Margaret Jacob,
and Wijnand Mijnhardt
ISBN 978-0-89236-968-3 (paper)

Harry Smith: The Avant-Garde
in the American Vernacular
Edited by Andrew Perchuk and
Rani Singh
ISBN 978-0-89236-735-1 (paper)

The Fragment: An Incomplete History
Edited by William Tronzo
ISBN 978-0-89236-926-3 (hardcover)